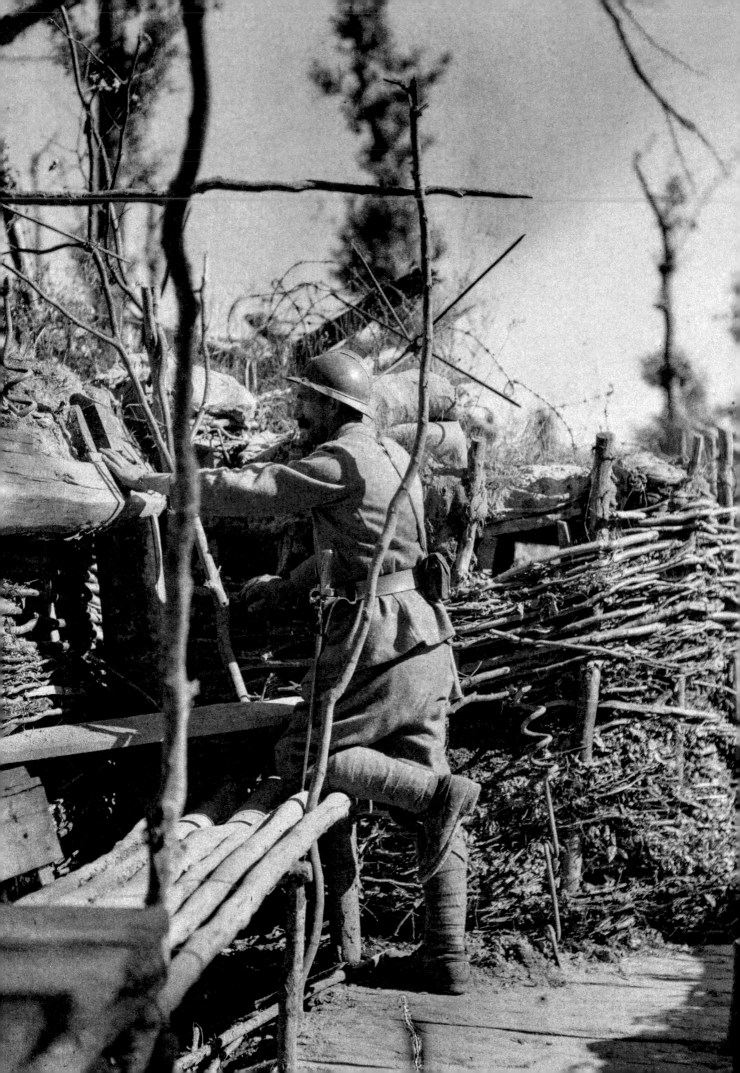

Peter Walther

The
First World War
in Colour

TASCHEN

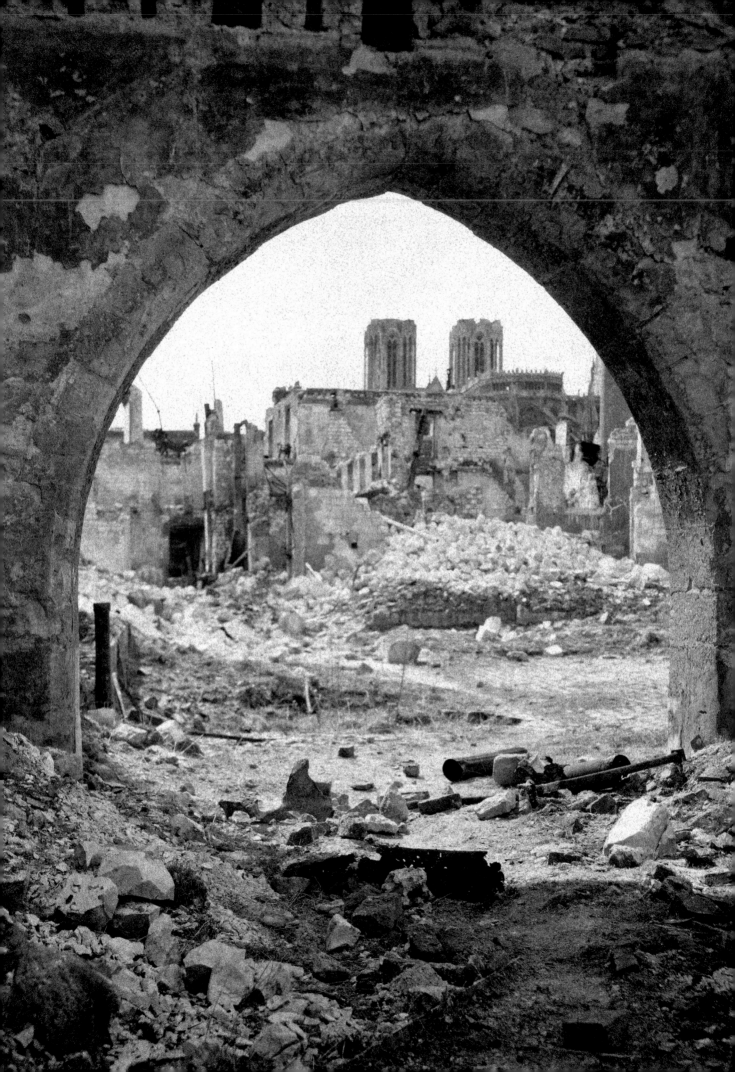

Introduction

In Colour for the First Time

Countless photo books on the First World War have been published in the last hundred years. The present volume differs from all of these in one respect: for the first time the historical events, everyday life, and horrors of war are illustrated throughout in colour photographs.

Brought together from archives in Europe, the United States, and Australia, more than 320 colour photos document the most important events of the time—from the mobilisation of 1914 to the victory celebrations in Paris, London, and New York in 1919. The images were taken at the front lines and in the hinterlands of France, Belgium, Germany, the United States, Russia, England, the Netherlands, Palestine, Algeria, Tunisia, and Saudi Arabia.

Even today it is not well known that the world war of 1914 to 1918 was the first large conflict in which the still-young medium of *colour photography* was used—still there are only a few thousand photographs that have been preserved in archives. At the time colour photography technology had already been in development for half a century.

PAGE 1
Satirical composition of two pieces of bread, 1915.
Atop the taller piece of white bread the French tricolour
triumphs, at least symbolically, over the flag of
the German Reich on the hard scrap of brown bread.
Photo : Léon Gimpel

PAGE 2
Lookout post in a trench at the front near Hirtzbach, 1917.
Photo: Paul Castelnau

PAGE 4
View across the ruined landscape of Reims
to the cathedral, 1917. Photo: Fernand Cuville

The Beginnings of Colour Photography

In May 1861 the Scottish physicist James Clerk Maxwell (1831–79) projected a colour image of a tartan ribbon to an academic audience in London. It stands today as the first colour photo in the world. The physical fundamentals of colour photography were defined early on. It had begun with the realisation that all of the colours visible to the human eye are represented by a combination of three primary colours. The task of researchers was to break down the image of natural colour into three basic hues, record them separately, and then merge them back together. Yet there is scarcely a technical innovation that was so often rediscovered as colour photography.

In the early days of colour photography laboratory prototypes brought countless breakthroughs, each time celebrated anew—though they were all created according to methods that quickly proved to be impractical. Including, for example, the interference method of the



Luxembourger scientist Gabriel Lippmann (1845–1921). The process yielded a colour image that could only be seen at a sharp angle with a colour gradient that was reminiscent of an oil slick.

The general public was eager for colour photos, and anticipation was spurred by ever new announcements. In the meantime people made do with the method of colouring black-and-white photographs that was already in practice since the early days of photo history. The development of print technology since the 1880s allowed the large-scale reproduction of colourful originals. The so-called Photochrom celebrated its triumphant march in the years before the turn of the 20th century. Even when they were at times sold as "photographs in natural colour," Photochroms were reproductions of technically refined black-and-white photographs.

Three-Colour Photography

The breakthrough in the field of colour photography brought two methods that were practiced in parallel for a long time: the three-colour process, which was developed for practical application primarily by the American researcher Frederic Ives (1856–1937) and the German photochemist Adolf Miethe (1862–1927), and the Autochrome plate photography of the Lumière Brothers.

Ives had already achieved the first practical results with three-colour photography in the 1890s. He made three black-and-white photographs of the same subject using filters in the three primary colours. The positive transparencies produced from negatives were projected onto one another, through the same coloured filters once again, thus reproducing a natural colour image. A number of stereoscopic colour photos made by this method were recently discovered in the Ives estate. They were taken in October 1906 and show a San Francisco destroyed by earthquake. As the nature of this process requires that subjects in front of the camera remain still while the three photographs are taken, people, clouds, and water posed significant challenges as subjects.

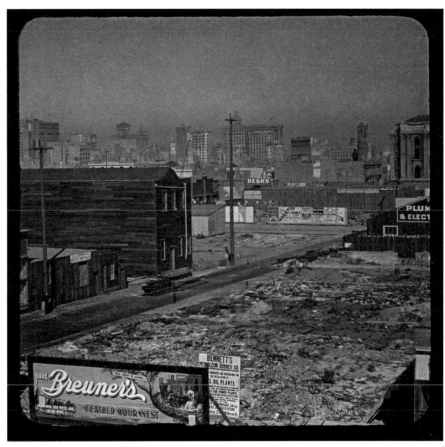

San Francisco after the Earthquake, 1906, half of a stereoscopic three-colour photograph. More than 3,000 people died as a result of the earthquake. A large part of the city was destroyed; the fires that spread after the quake were even more devastating than the earthquake itself.
Photo: Frederic Ives

In 1902 in Berlin Adolf Miethe successfully made photo plates sensitive to the red-orange part of the light spectrum, which prompted three-colour photos to gain widespread currency. In the same year Miethe, who also had a keen business acumen, published a test photograph in one of the trade journals he edited. The year 1904 saw the release of a book of over 200 of Miethe's colour photographs, images he shot for collector cards, included with products of the Stollwerck chocolate company. It was the world's first book of colour photography.

The usefulness of colour photography for documentary purposes was recognised early on and led to great encyclopaedic ventures. As early as 1908 the Berlin publisher Weller sent various photographic troops on excursions to Africa and Southeast Asia to document in colour the architecture, nature, and living environment of the German colonies. The German landscape was likewise photographed in colour up until 1930.

Russian photographer Sergei Prokudin-Gorskii (1863–1944) of St. Petersburg spent time with Adolf Miethe in Charlottenburg in 1902. In the years 1907 to 1915 he travelled across the czarist empire with his three-colour camera, which he had made according to the model of Miethe's natural-colour camera, and photographed the land, people, and architecture of Russia on numerous expeditions. Fleeing the communists in 1918, Prokudin-Gorskii was fortunately able to bring more than 2,000 glass positives with him, which were purchased by the Library of Congress in Washington after his death and digitally reconstructed by combining three colour scans a few years ago. Prokudin-Gorskii also shot the only surviving colour photo portrait of Leo Tolstoy in 1908.

Peterstraße during the Leipzig Trade Fair, early 1914. In three-colour photography three different plates were exposed one after another with different filters, which made photographing moving subjects a challenge.
Photo: Franz de Grousilliers, Rudolf Hacke

The Autochromes of the Lumière Brothers

Miethe's technique was especially suited for print publication because the colours were already separated, but for amateur photographers it was too laborious. From the year 1907 onward the Autochrome plates of the Lumière Brothers became popular with amateurs. With the Autochrome process one single shot was enough to create a colour transparency. Tiny coloured starch grains took on the function of the three colour filters. They lent Autochrome photographs an especially aesthetic appeal and gave them the appearance of a pointillist painting.

Auguste Lumière (right) in uniform during the First World War. This Autochrome was probably taken by his brother Louis. Auguste Lumière carried out biomedical research during World War I in Lyon.

Auguste Lumière (1862–1954) and Louis Lumière (1864–1948), who were significantly involved in the invention of cinema, had already worked on various colour photography processes since the turn of the century. In 1904 they registered a patent for the Autochrome; three years later the process was ready for practical application and was introduced in the offices of the journal *L'Illustration* in Paris on 10 June 1907. Soon the Autochrome developed into a formidable commercial success. Famous photographers received product samples and, with their photographs, contributed to the great popularity of the process across Europe and North America. Today the Autochromes taken in the early days of the technique by Alfred Stieglitz (1864–1946), Heinrich Kühn (1866–1944), Frank Eugene (1865–1936), or Edward Steichen (1879–1973) are considered photographic incunabula.

A treasure trove of surviving sources of colour photography, Autochromes often illustrated reportages from all regions of the world in *National Geographic* starting from 1914. In the ensuing decades *National Geographic* has accumulated more than 15,000 photographs in their archive. In 1912 *Die Farbenphotographie,* the first worldwide trade journal solely dedicated to the theme of colour photography, began publishing in Leipzig. When the editor put out a call for Autochromes for the journal, more than 3,000 plates were sent in, mostly from amateur photographers. The response gave an indication of how widely disseminated the technique was, even outside the country it was invented in.

Contemporaneously the images were circulated through print in illustrated magazines, books, and in the form of postcards. Unlike in France, where the templates for colour photographs in print consisted almost exclusively of Autochromes, other early colour photography processes were common in Britain and in Russia. In Germany three-colour photos were employed as reproduction templates for printing for example, by the large-scale encyclopaedic venture of Carl Weller's "publisher of colour photography," while Autochromes were used as templates for postcards.

The Stuttgart photographer Hans Hildenbrand (1870–1957) had established a market-leading position in this division into wartime with his "Colour Photographic Society." From at least 1909 onwards he shot with Autochrome plates and produced not only hundreds of postcard subjects but also so-called Chromoplasts, pairs of colour stereoscopic photographs that were intended for viewing using a special device called a stereoscope.

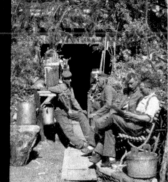

ABOVE
Dugout in Champagne, late summer 1915, stereoscopic Autochrome. Stereoscopic photography had already existed from the middle of the 1850s. Apart from the series of photo pairs that Hildenbrand shot in 1915, very few individual copies of colour stereoscopic photographs depicting events of the war have come to be known thus far.
Photo: Hans Hildenbrand

OPPOSITE
Hot-air balloon in the Grand Palais in Paris. In 1909 the first international air show took place here. Gimpel had become acquainted with the Lumière Brothers and their Autochrome process as early as 1904. He was the first photographer to introduce the new technique in a publication: four of Gimpel's Autochrome photographs were published in a special issue of L'Illustration.
Photo: Léon Gimpel

The French Autochromists and Les Archives de la Planète

The Parisian banker Albert Kahn (1860–1940) maintained the largest inventory of Autochromes that has survived to this day; he initiated and financed Les Archives de la Planète which comprised photos and films from all over the world. The contribution of this philanthropist cannot be appreciated highly enough: over 72,000 Autochromes and about 4,000 stereoscopic plates, stored today in the Musée Albert Kahn, were taken in the years 1908 to 1931, in addition to over a hundred hours of film.

Kahn was born the son of a Jewish cattle dealer in Alsace. The family left Alsace after the territory was annexed by the German Reich. The young man found a position in Paris at a bank and at the same time studied literature and law. Here he met Henri Bergson (1859–1941), the philosopher and 1927 Nobel Prize laureate, with whom he shared a life-long friendship.

In 1885 Kahn completed his studies and soon joined the senior management of the Goudchaux Bank. In a few years he was able to build a private fortune through speculation in gold mines and South African diamonds, founding in 1898 his own financial institution, with which he became one of the richest men in Europe. Kahn acquired a property in Boulogne-Billancourt (Boulogne-sur-Seine until 1924) near Paris, and there developed an extensive garden with examples of international garden design. He utilised a large part of his fortune on ventures that would foster understanding between cultures.

Les Archives de la Planète was the most important project of this kind. The representation in photographs and films of the daily life and customs of different peoples was intended to cultivate understanding for foreign cultures and a mutual tolerance. At the time it was the largest ethnographic photo and film venture in the world. The unique value of these photographs taken on over a hundred expeditions to more than fifty countries was achieved through the use of the Autochrome process. In summer 1908 on a trip through the United States, Canada, Japan, and China initially Kahn's chauffeur Alfred Dutertre had shot Autochromes; the following year Kahn hired Auguste Léon (1857–1942) as the first photographer for Les Archives de la Planète.

With the appointment of Jean Brunhes (1869–1930), the originator of human geography, as research director of Les Archives de la Planète the collection project took on a systematic,

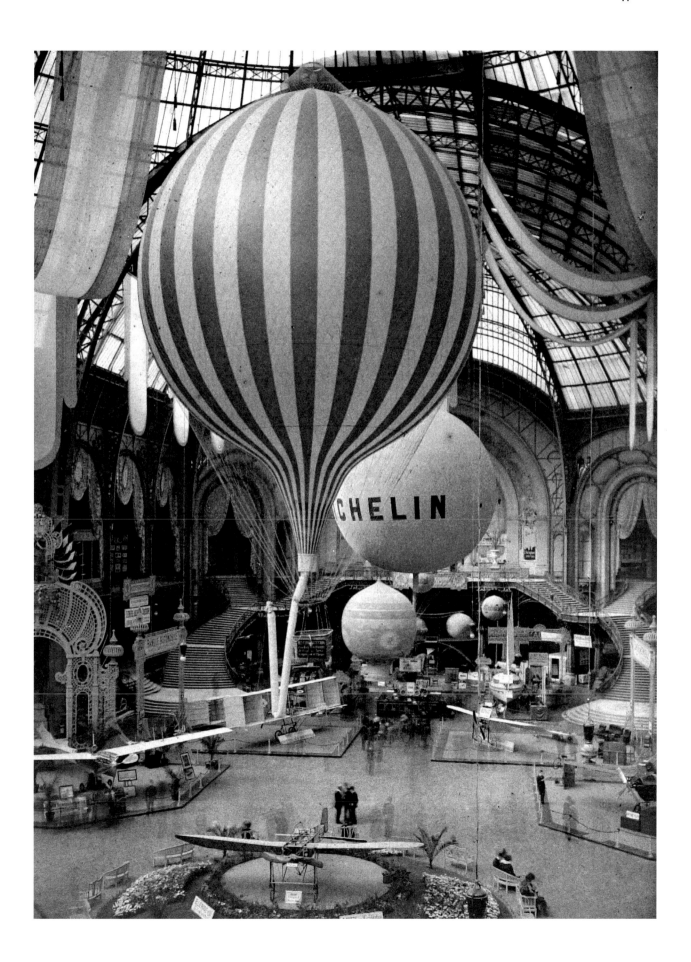

academic character. The photographic and filming expeditions led the camera operators through large parts of Europe and North Africa, through the Middle East, India, Indochina, and Japan. Photographers who regularly worked for Kahn included Léon Busy (1894–1951), Paul Castelnau (1880–1944), Georges Chevalier (1882–1967), and Fernand Cuville (1887–1927). Stéphane Passet (1875–unknown), Frédéric Gadmer (1878–1954), and Roger Dumas (1891–1972) filmed as well as photographed. Jules Gervais-Courtellemont (1863–1931), among others, worked only occasionally on Kahn's project.

Thanks to Kahn's undertaking we have colour images of a lost world: in 1913 a journey led the photographers to the Balkans, where they used a last opportunity to document in colour the centuries-old, soon to be threatened development of diversity and the juxtaposition of peoples and cultures. During the Great War several photographers worked simultaneously for Kahn and for the photography department of the army. With the stock market crash of 1929 Kahn's financial empire began its decline. Due to cost concerns the work on Les Archives de la Planète was cut back and photographers were let go. In order to meet the demands of his creditors, Kahn found himself forced to sell his property. Luckily the building, a part of his holdings, as well as the entire film and photo collection was acquired by the Département de la Seine in 1936, its continued existence thus secured. Kahn obtained a guarantee of residency rights on the property that no longer belonged to him, and he died there in November 1940.

Belgian Lancers, 1911. This highly traditional regiment, which was founded as early as 1830, participated in the defence of Antwerp in September 1914. Photo: Alfonse Van Besten

Photography in the First World War

The outbreak of the First World War in summer 1914 shattered all hopes for a lasting intercultural understanding—the very foundation of Kahn's undertaking. From this point on photography served militaristic and propagandistic purposes on all sides. In Germany alone in autumn 1916, 400 personnel were tasked with the photographing and interpretation of aerial photos. In addition, hundreds of thousands of passport photos used in the registration of the population were collected in the German-occupied territories. And for the first time in a war, private photographs were shot by the million as personal mementos or as visualisations of life at the front lines for family back home. There were prohibitions on photography on the French side, yet they seem to not have been taken very seriously. On the German side, soldiers could take photos with permission from their superiors. Away from the war zones, there were limitations set on photographing potential military targets. They were, however, only regionally mandated (Berlin, Rhineland, Hamburg) and affected just the publication of photos, not the photography itself.

In comparison to the host of amateur photographers, the number of official or accredited photojournalists appeared rather modest: there were fifteen in the French army, nineteen in the German, sixteen with the British, three with the Australian–New Zealand armed forces, and two with

the Canadian troops. As the war was also a war of words from the outset—a verbal combat which dealt with the sovereignty of interpretation of terms like "culture" and "barbarism"—the value of photography as propaganda was initially underestimated on all sides. Playing a role in this was the military's deep distrust of anything to do with publicity. It was also believed in the beginning that the campaign would be brief. However, the more the conflict developed into a gruelling static war, the more important the role of public opinion became at home and abroad. From this point on the armed forces relied on the propagandistic power of photography.

Initially it was professional photographers like Gervais-Courtellemont or Hildenbrand who independently, and at their own expense, documented the war zones, but of course with the pertinent permissions that were needed to capitalise on the photographs. After 1915 photography and film work began to be institutionalised within the structure of the military. Churchill, then First Lord of the Admiralty, very early on recognised the importance of propaganda. After the defeat of the British and French armed forces in April 1915 in the battle for the Turkish peninsula of Gallipoli, the enlistment of official photojournalists into the British armed forces was first discussed. Ernest Brooks (born 1878), who had earlier worked as a press photographer for the *Daily Mirror,* was selected. The photos were intended to comfort the population on the home front, rather than frightening them with a representation of the true horror of the war.

Two British war photographers working on behalf of Canada, William Ivor Castle (born 1877) and William Rider-Rider (1889–1979), from 1916 and 1917, respectively, captured the devastation of the war at the front lines with a much more realistic point of view. Likewise with the commission of Australian photographer and adventurer Frank Hurley (1885–1962) and Hubert Wilkins (1888–1958) beginning in 1917. The responsible authorities of the Australia and New Zealand Army Corps (ANZACs) were committed to objective, documentary-style photography. Wilkins above all fulfilled this ideal, albeit not continuously. Hurley, on the other hand, made staging part of the agenda. For him what was paramount was not the authenticity of the photograph, but rather the intended message of the image. In order to illustrate this message almost all forms of subsequent manipulation were legitimate, in his opinion. Both Wilkins and Hurley photographed in colour as well, using colour screen plates from the Paget Prize Plate Company.

The United States was formally neutral until 1917; however, they stood economically and morally on the side of the Entente almost from the beginning. With their entry into the war in April 1917 a patriotic wave washed over the country: parades to promote the allied armed forces and war bond subscriptions took place in numerous cities. Photographers like Charles C. Zoller (1856–1934) and John D. Willis (died 1928) captured these events in colour. In many places committees were formed in support of the European allies. These organisations were often run by women, including the American Committee for Devastated France (1917–24). Founded by Anne Morgan (1873–1952), a daughter of financier J. P. Morgan, this committee tried to assuage the suffering of French war refugees. Photographs, including Autochromes, were taken in war-torn France on behalf of the American Committee to aid in the collection of donations for their mission and to illustrate the situation to Americans.

Out of the over 500 professional photographers in Germany who tried to obtain official war photographer accreditation only nineteen were selected. There is no indication that Hans Hildenbrand, the only photographer on the German side whose war-themed Autochromes have been

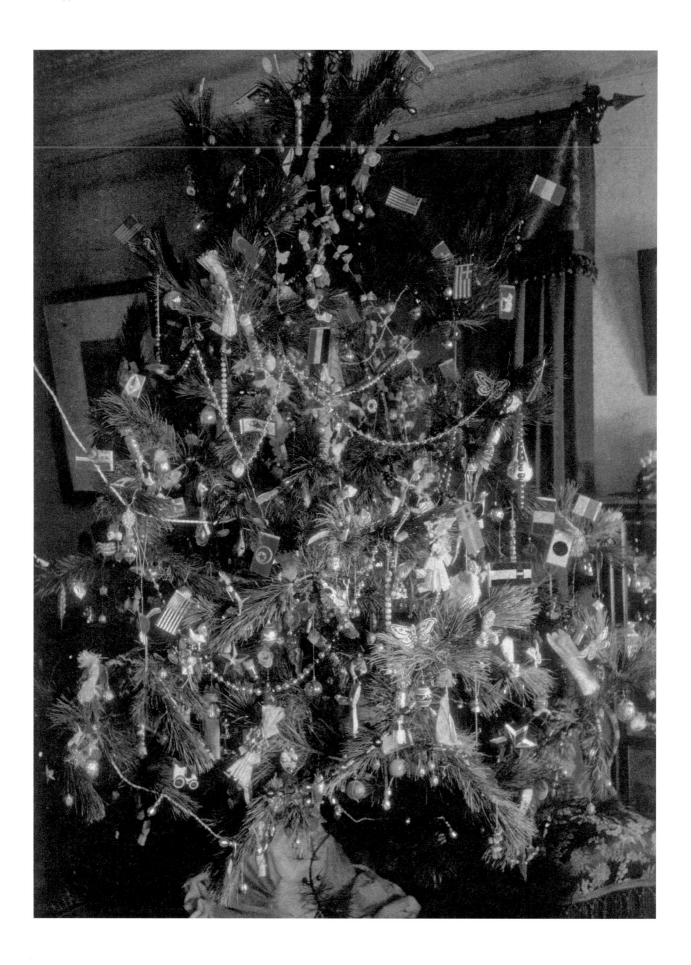

preserved, belonged to this group. But without authorisation from the military authorities even he could not travel to the war zones. His colour photographs can be largely dated based on the records of front line passes issued to him and his wife. In Germany the centralisation of war photography began relatively late. In 1916 the Photo and Film Office (Bild- und Filmamt–BuFA) developed out of the Military Film and Photo Post (Militärische Film und Photostelle) of the news department of the Foreign Office. Starting in 1917 seven photo and film troops went to the fronts, and in the same year the inventory of BuFA grew to over 200,000 photos, a part of which were purchased on site.

Likewise in France it was initially professional photographers working on independent assignments who were active during the first months of the war. The Autochromes that Jules Gervais-Courtellemont took at the Battle of the Marne were released in individual consignments in 1915; photos from the Battle of Verdun followed in 1917. In reaction to the propaganda efforts of the Germans, the Section Photographique de l'Armée française (S.P.A.) was founded in early 1915, and was later renamed Sections Photographiques et Cinématographiques des Armées in 1917 after merging with the film department and expanding the scope of their activities. The mission of the S.P.A., in answer to the corresponding German efforts, was to convey "a propagandistically useful, strong impression of the material and moral strengths of the French army and its discipline," as it stipulated in November 1915. Last but certainly not least, it was about swaying the public in the neutral countries towards their position.

At its founding, initially seven employees worked in the S.P.A., as well as three lab assistants. They had military rank and were incorporated into the army hierarchy; the administration and financing of the S.P.A. was, however, incumbent on the Ministry of Culture. By the end of the war around 150,000 plates had been exposed, as well as about 20,000 stereoscopic plates. In October 1916 Albert Kahn appealed to the Ministry of War with a proposal to shoot colour photographs at the front, which resulted in the two photographers Paul Castelnau and Fernand Cuville joining the S.P.A. In accordance with the agreement all subjects were photographed in duplicate, whereby one copy remained at the Ministry of War and the other was intended for Kahn's Archives de la Planète. Almost all of the Autochrome

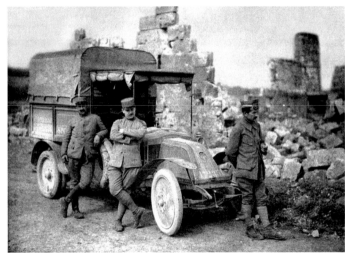

ABOVE
Three members of the Photographic Department of the French Army (S.P.A.), 1917. On both sides of the front professional photographers travelled by automobile, which was indispensible considering the weight of the equipment they carried. Photo: Fernand Cuville

OPPOSITE
Christmas in Nikolskoye, Russia, 1911. A Christmas tree with tiny paper flags of various nations symbolised the hope of cultural understanding at a time when the political horizon had already darkened. Photo: Piotr Vedenisov

photographs that depicted the war were more or less connected to the Kahn project. In October, Jean-Baptiste Tournassoud (1866–1951), whose more than 800 Autochromes from the four years of war are preserved to this day, became the last director of the S.P.A. to be appointed during the war.

On the Value of Colour in the Photograph

Autochromes have in recent years increasingly left the museum-like niche where they were only appreciated by specialists and enthusiasts, and entered into the consciousness of a wider public. This is not just connected with a growing sense of history, but rather with the new technical possibilities for photographic processing, reproduction, and presentation. Through the successive catastrophes of the 20th century many collections of Autochromes have been destroyed. Where they are still preserved, they have, in the meantime, been digitally processed and their value acknowledged in exhibitions and publications.

In this way the Belle Époque is illustrated effortlessly in colour with examples of images from nearly all regions of the world, for instance with pictures from Leonid Andreyev (Russian, 1871–1919), Karel Smirous (Czech, 1890–1981), Tadeusz Rzaca (Polish, 1868–1928), Käthe Buchler (German, 1876–1930), Charles Corbet (Belgian, 1868–1936), Léon Herlant (Belgian, 1873–1968), Paul Sano (Belgian, 1874–1960), Stephen Pegler (British, 1852–1937), or Arnold Genthe (Berlin-born American,1869–1942).

The number of colour photographs that resulted, when compared to the entire photographic records from the First World War, seem remarkably small: about 4,500 Autochromes with subjects relating to the war and its aftermath have been preserved, of which most were taken by Castelnau, Cuville, Gervais-Courtellemont, and Tournassoud. That amounts to less than one-thousandth of the black-and-white photos from the same period. When questioning what part of reality these images convey to us, the conditions under which the photos were taken at the time, and with what intent, should not be disregarded. What applies to most of the black-and-white photos is all the more true for the Autochromes: they are not spontaneous images of moments of reality, but rather careful productions in which technical and aesthetic considerations play a role just as much as the intended visual message.

Hardly any of the photos were created under threat of mortal danger at the front lines. This possibility was excluded partly because of the cumbersome nature of the photo equipment, which, with plates, tripod, and various lenses, weighed up to 33 pounds (15 kilograms). The relatively long exposure times of Autochrome plates hampered the taking of snapshots—the photo subject was obliged to hold still for six seconds under cloudy skies, and even in sunny weather for a full second. Movement was thus impossible to capture. It is hardly surprising that the banners of the nations and regiments as well as the colourful uniforms of the colonial troops were the favourite subjects of the French Autochrome photographers. Traditional costumes of various ethnic groups had attracted the interest of photographers beginning in 1902 with Adolf Miethes's various encyclopaedic undertakings through to the expeditions initiated later by Kahn. In autumn 1914 Gervais-Courtellemont captured in colour the first uniforms of members of the participating armies: the French—still in red trousers at the beginning—the Scottish and English, and especially the Senegalese tirailleurs and the Algerian spahis or the troops from British India. Starting in December 1914 he organised presentations of his colour photos in Paris which were so successful that they took place three times a week.

The Stuttgart photographer Hans Hildenbrand proceeded with the same mix of patriotism and business acumen on the German side, but here the subject of uniforms—field grey with very little variation—was less appealing. His Autochromes show the daily life in camp, soldiers posing

in trenches, but also, time and again, destroyed cities. As far as the representation of ruins in photographs is concerned, it served different purposes on the two sides of the front. The images fostered the belief in a successful war leadership on the German side; on the French side they were meant to be an indictment against the aggressor, contributing to the strengthening of the resistance, and sparking in neutral countries a solidarity with the aggrieved allies. The images were biased on both sides, and we are often only permitted to see what was intended to be shown. The colour in the photographs seems disconcerting from the distance of a century, yet at the same time it allows the events to move into frightening proximity with the present. Taking into account the effects intended at the time and the specific segment of reality captured in the photos, these unique visual witnesses allow a surprising look into a world forever lost through the war of attrition and propaganda battles of the First World War.

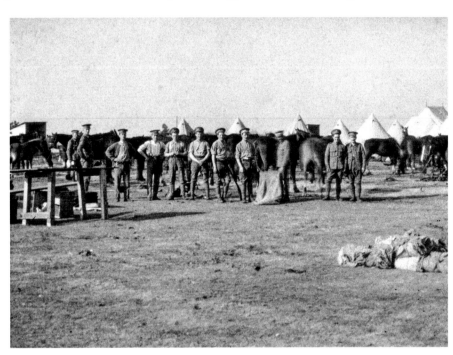

British soldiers pose in a summer camp in 1914 shortly before the outbreak of the First World War for the camera of an unknown Autochrome photographer. By the Second Moroccan Crisis in summer 1911 the danger of war in Europe was at hand.

1914 – On the Precipice

The economic and cultural rise of the German Reich since the late 19th century had led to a shift in the European balance of power. Britain and France signed the Entente Cordiale in 1904 in an alliance against Germany's growing power. An agreement followed in 1907 which led to a balancing of interests between Britain and Russia. Thus Germany, whose only ally Austria-Hungary represented more a burden due to the prolonged conflict in the Balkans, felt surrounded. A mutual distrust led in the coming years to a rapid military and ideological build-up and to a series of international conflicts, which made the outbreak of war seem increasingly likely in the consciousness of the people at the time.

The assassination of the successor to the Austrian-Hungarian throne, Archduke Franz Ferdinand, by Serbian nationalists was like a spark in a powder keg. Without having any idea what dimensions this war would take on, in addition to moderating forces there were those—on all sides—who were inclined to use the assassination as a convenient opportunity to resolve the pent-up conflicts in Europe. Austria's declaration of war on Serbia on 28 July set a fatal chain of mutual defence agreements in motion. In August 1914 standing in opposition to each other in Europe were the Entente—France, Britain, and Russia—with ca. 5.7 million soldiers altogether, and the Central Powers of Germany and Austria-Hungary with ca. 3.8 million soldiers.

Germany's strategy for war conformed largely to the Schlieffen Plan of 1905, which, given their inferiority in size, aimed for selective large-scale actions and the avoidance of a long two-front war. Thus the French fortifications in the north were to be bypassed and the enemy army attacked from behind. Then the majority of the troops were to have staved off the Russian army in the East. The march through neutral Belgium which this plan required led to Britain's entry into war and to Germany's first defeat in the international propaganda war.

The decisive military event of 1914 was the Battle of the Marne, in September. With the counter-attack of the Entente in defence of Paris the German plan to force a rapid outcome in the West was thwarted. The attempt of the Germans in October and November to recover the military initiative through an advance towards the Channel coast also failed. At the end of the year the mobile war solidified into a trench war.

OPPOSITE
Étrepilly, ruins of a hangar that was used by the Germans as a hospital for the severely wounded. During the German withdrawal in September 1914, 250 wounded died here.

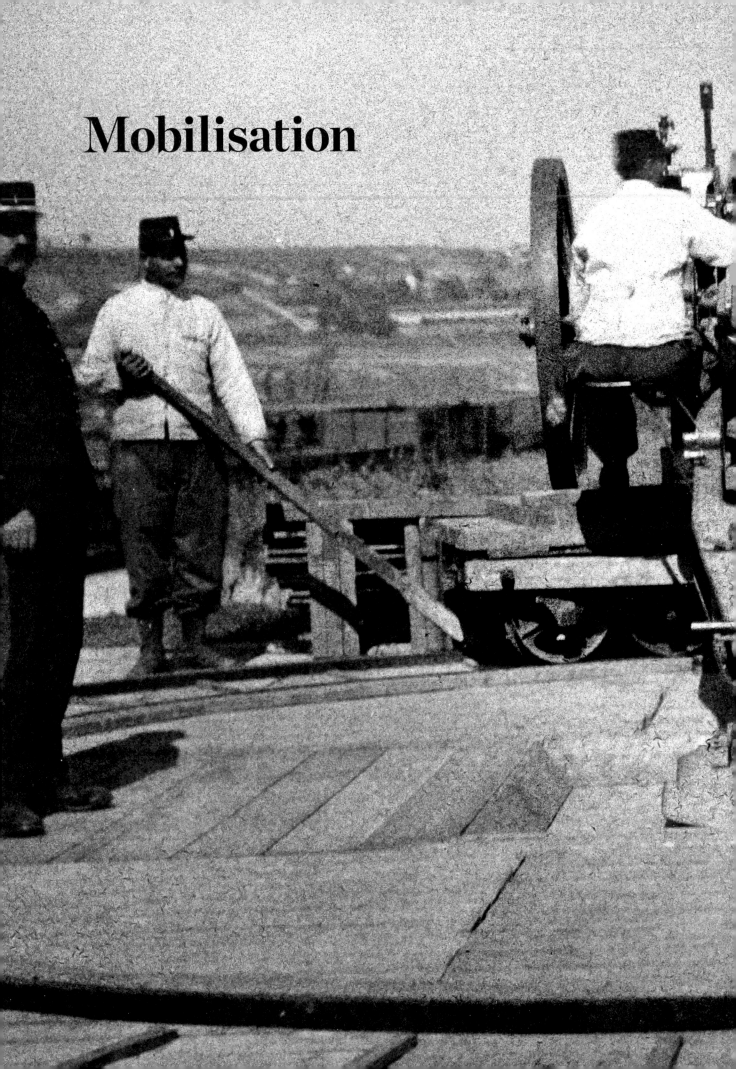

Mobilisation

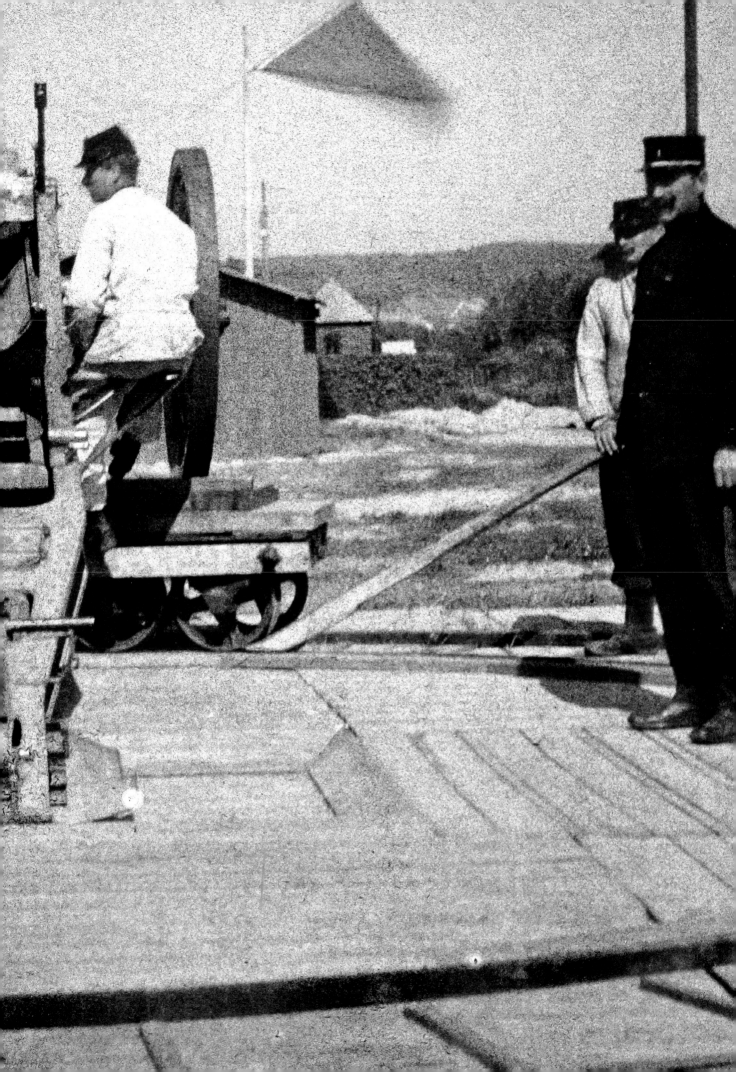

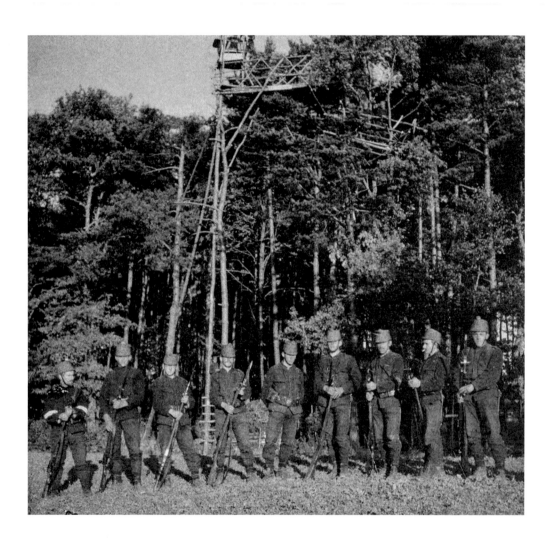

French artillery at the start of the
First World War.
Unknown photographer

ABOVE
In front of a tree platform near Neuwiller,
at the border of the then-German Alsace,
Canton Basel-Land, half of a stereoscopic
Autochrome. The closure of the German
border led to food shortages and escalating
food prices in the Swiss border regions in the
first months of the war. The time of the First
World War is known as the "border occupa-
tion" to this day in Switzerland.

OPPOSITE
Swiss soldiers pose in 1914 with uniformed
dummies made of loam to represent the
enemy, half of a stereoscopic Autochrome.
More than 220,000 Swiss men were drafted
in August 1914 because it was feared that the
Germans might advance through the neutral
Swiss region to France. The majority of the
Swiss-German population was sympathetic
to Germany at the time.
Photos: Mangold

1914 Mobilisation

*The air is sweet, the scent of wisteria floats in
the night; and the stars sparkle in such perfect brilliance!
In this divine tranquility and tender beauty the nations
of Europe begin the great slaughter.*
ROMAIN ROLLAND, DIARY, 31 JULY 1914

RIGHT
*Swiss soldiers with rifles and fixed bayonets
in late summer 1914 near the Swiss–German
border at the Hegenheim customs post,
Canton Basel-Land, half of a stereoscopic
Autochrome. Until the outbreak of the First
World War the border played no role in this
region, passports being first introduced
in 1915.*
Photo: Mangold

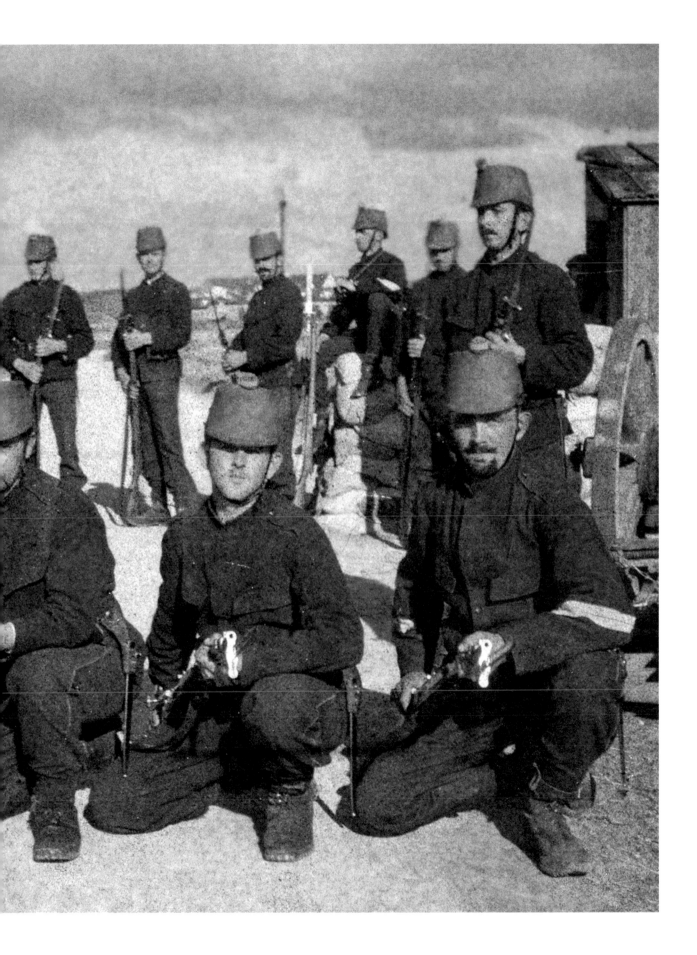

The Battle
of the Marne

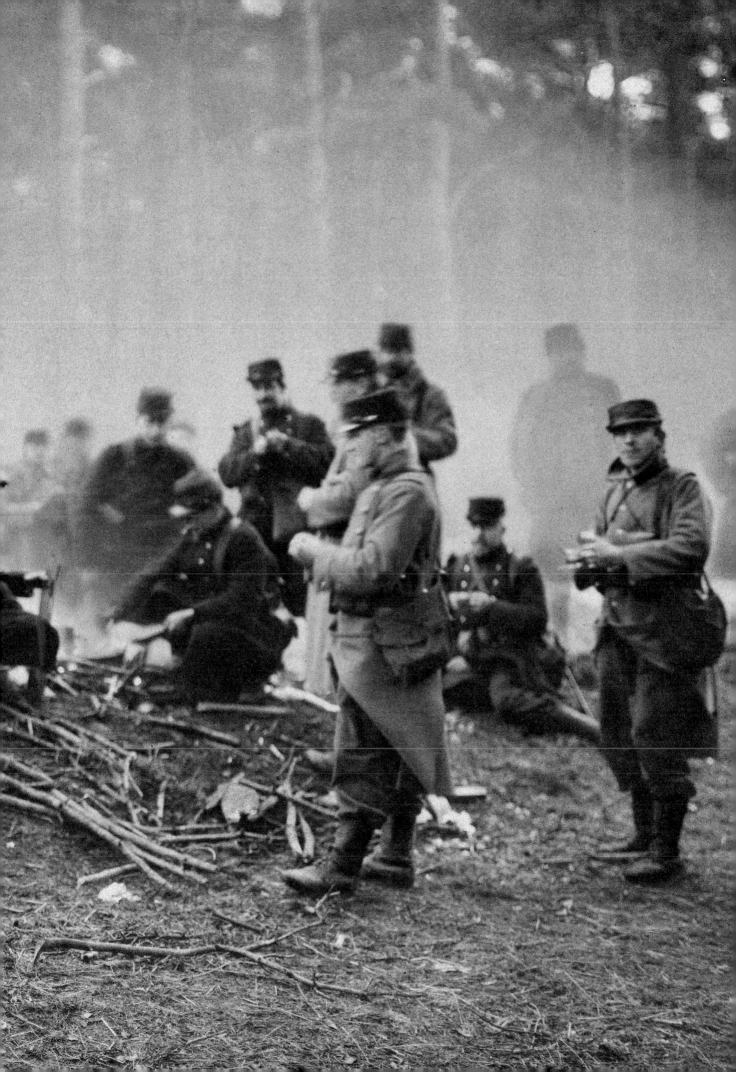

1914 The Battle of the Marne

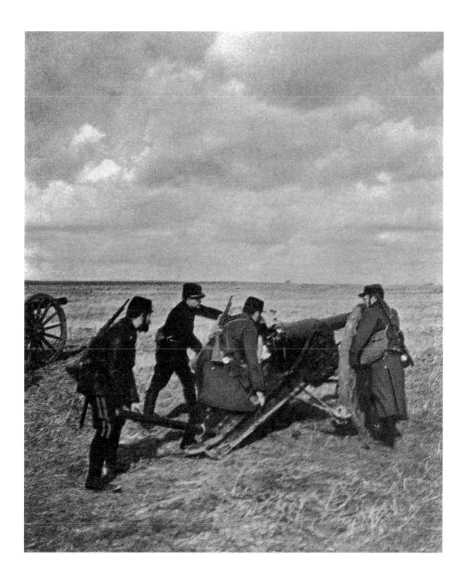

PAGE 26/27
French soldiers at rest, 1914. The Battle of the Marne, which was initially successful for the Germans, was photographed in September 1914 by Jules Gervais-Courtellemont as it became the first turning point in the war. In the halting of the advance, the Schlieffen Plan failed. It had aimed to avoid a two-front war in Germany.

OPPOSITE
The various uniforms of the French army are seen in the images: the red trousers, visible from a great distance, and light blue coats were replaced in 1915 with navy blue uniforms.

ABOVE
Operating a 3.5 inch (90 mm) cannon. The weapons used since 1877 by the French army were already outdated in 1914 and were increasingly replaced with modern artillery. Some examples of these cannons were still in use in 1940 during the Soviet–Finnish Winter War.
All photos from page 26/27 to page 55: Jules Gervais-Courtellemont

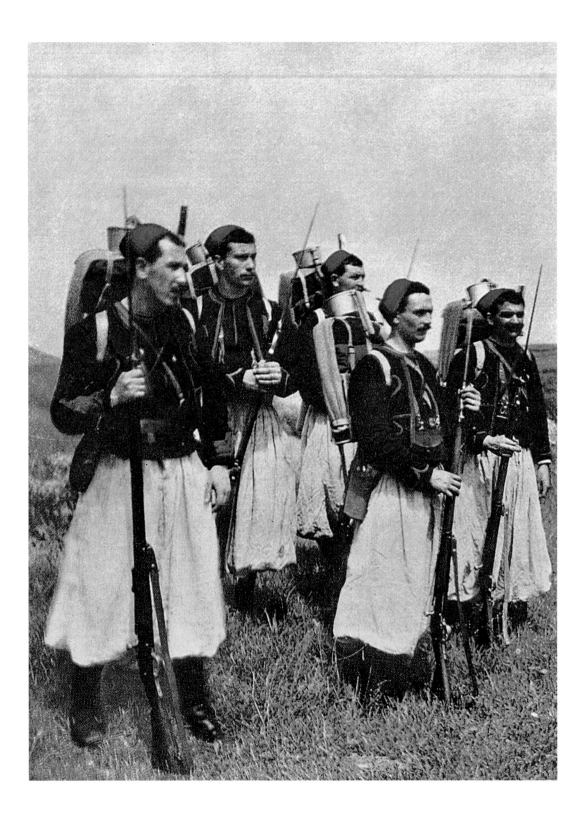

1914 The Battle of the Marne

We are experiencing a tremendous moment in world history. In a few days the vision of the world has completely changed. It seems like a dream! Everyone is at a loss.

ARTHUR SCHNITZLER, DIARY, 5 AUGUST 1914

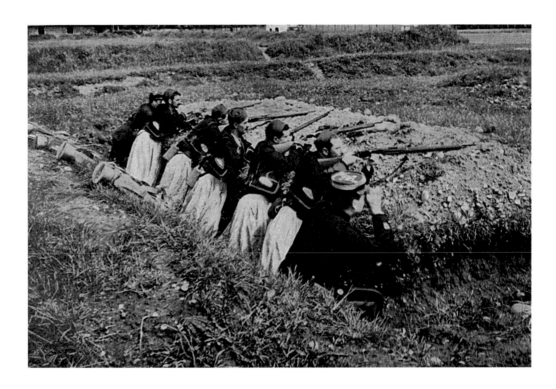

OPPOSITE
Soldiers of a Zouave Unit, taken in Barcy, Île-de-France. Their colourful garb made them an easy target for the machine-gun fire of the German troops. After 1915 the Zouave troops wore khaki-coloured uniforms.

ABOVE
Zouaves near Barcy, Île-de-France. 190,000 North Africans from the French colonies fought during the First World War in Europe. In Germany the deployment of colonial troops was condemned as a cultural breach.

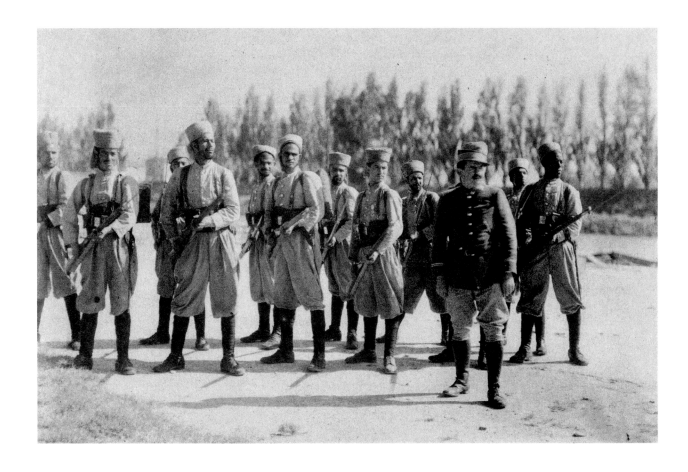

1914 The Battle of the Marne

OPPOSITE, TOP
Moroccan Spahis in their new uniforms.
The Spahis were a light cavalry unit in the
French African army.

OPPOSITE, BELOW
Moroccan riflemen. Six regiments of
Moroccan infantry fought for the French
until 1918.

BELOW
Algerian infantry. The critical contribution
in the defeat of the German troops at the
Marne was attributed to the deployment of
Algerian Tirailleurs.

The brute force of the Germans does not astound me
as much as their incredible ineptitude. They are their own
worst enemies; they do everything to make themselves
hated, and afterwards wonder why; no understanding of
the psychology of other people whatsoever.
ROMAIN ROLLAND, DIARY, 12 SEPTEMBER 1914

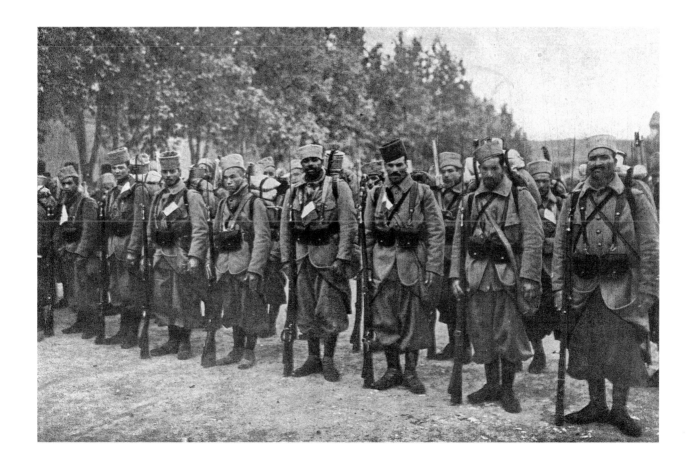

The Battle of the Marne 1914

We marched down to Dover, highly excited, only knowing that we were bound for Dunkirk, and supposing that we'd stay there quietly, training, for a month. Old ladies waved handkerchiefs, young ladies gave us apples, and old men and children cheered, and we cheered back, and I felt very elderly and sombre and full of thoughts of how human life was like a flash between darknesses, and that x per cent of those who cheered would be blown into another world within a few months; and they all seemed to me so innocent and patriotic and noble, and my eyes grew round and tear-stained.

**RUPERT BROOKE TO CATHLEEN NESBITT,
17 OCTOBER 1914**

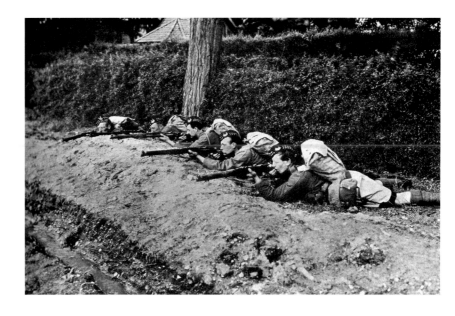

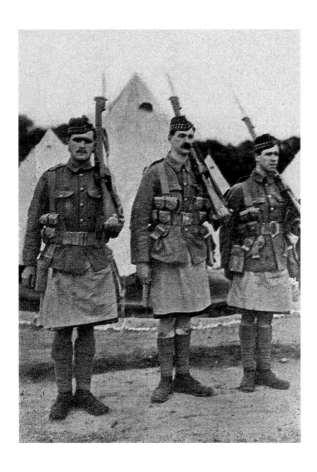

ABOVE
Scottish infantry. Four Scottish regiments deployed to the Western Front suffered great losses.

LEFT
Scottish infantry. A tunic matched with a kilt and a cap with a multicoloured tartan band signifying military rank were typical for the Highlanders.

OPPOSITE
Senegalese riflemen. The first Tirailleur Units were established in 1857. Around 200,000 black African soldiers served the French side in the First World War; about 30,000 of them lost their lives.

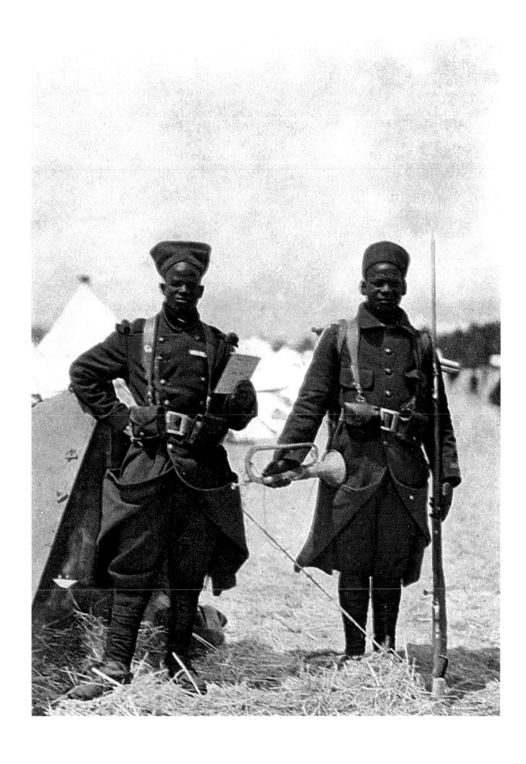

The war is something tremendously awesome.
Like a delirium that changed everything.
I firmly believe in widespread suggestion.

WILHELM KLEMM TO HIS WIFE, 28 AUGUST 1914

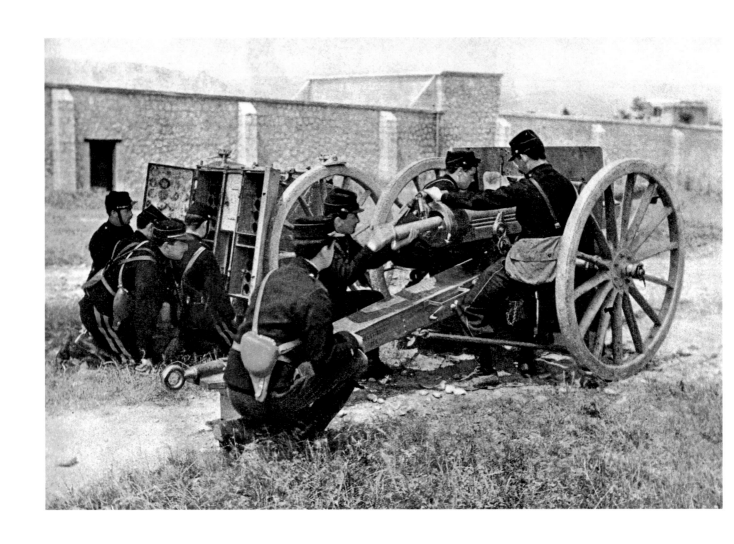

1914 The Battle of the Marne

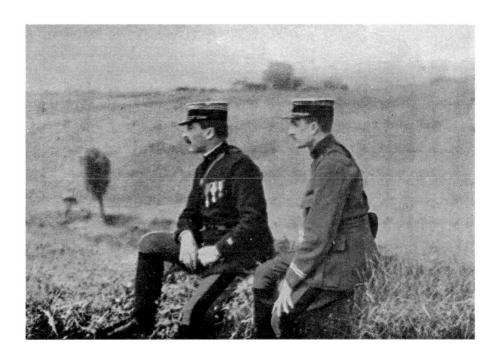

OPPOSITE
*A 2.5 inch (75 milimetre) field gun with am-
munition cart (caisson). This field gun was
introduced in 1897 and was still up-to-date in
1914. About 4,000 of these field guns were in
use by the French army at the start of war. Af-
ter 1917 they were also manufactured under
licence in the United States.*

ABOVE
*Two officers of a Zouave Regiment. The
Zouave Units were founded in 1830 during
the French conquest of Algeria. Primarily
mercenaries and later also conscripts from
North Africa were recruited for these units.
Not until 1963 were the last Zouave regi-
ments disbanded.*

But the grandest thing is the horse riding, you smoke, you tower above the throng, you radiate and feel important, and that you are the force on which the freedom of a nation and existence itself rests. To feel that makes it worth it to be a soldier.

GUILLAUME APOLLINAIRE TO JANE AND ROBERT MORTIER, 18 DECEMBER 1914

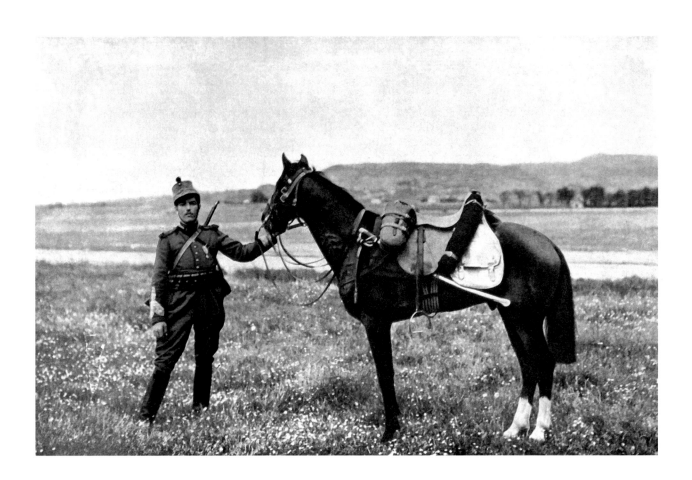

ABOVE
Corporal of the French African army. The Chasseurs d'Afrique were a light cavalry unit recruited from France's North African colonies. The officers were usually French. At the outbreak of the war six regiments, who were from and were serving in North Africa, were brought to the front in France.

OPPOSITE
British cavalry. At the beginning of the war over 15,000 troopers served in the British cavalry, with just a part in the British Expeditionary Force, the troops sent to the Western Front. The British Cavalry Corps was established only after the Battle of the Marne in October 1914.

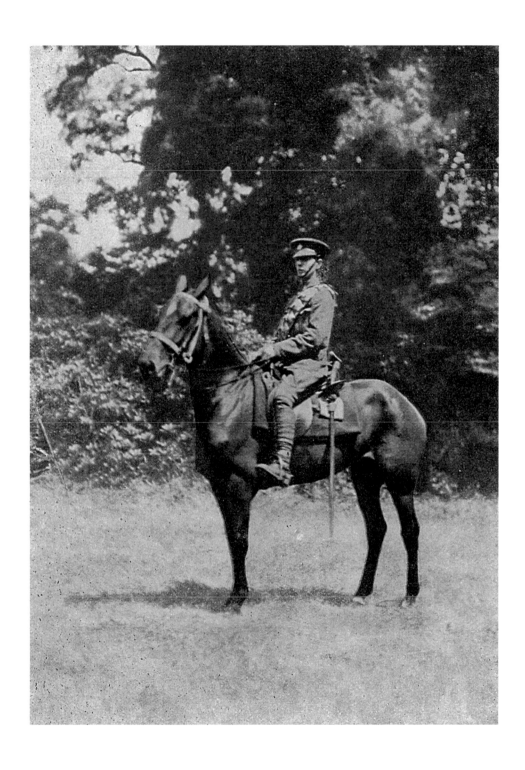

The Battle of the Marne 1914

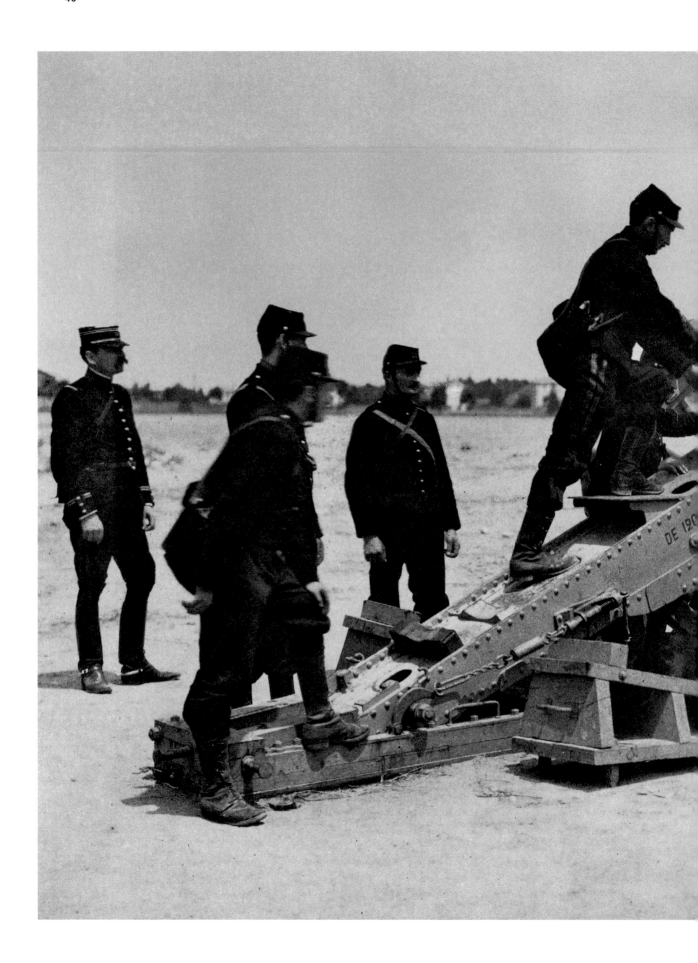

1914 The Battle of the Marne

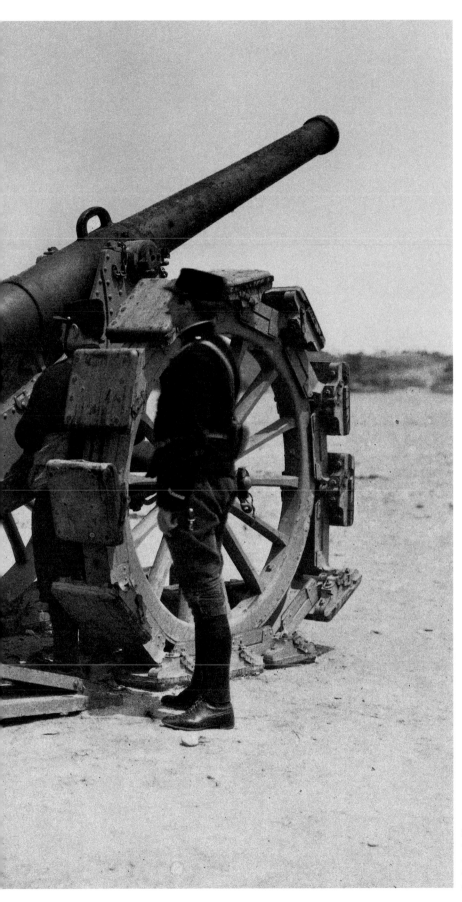

*Only the guns are against
France, not the heart: it is still
the German dream to have an
alliance with France, to be friends.
I do know that this love is
one-sided, but it shouldn't be
disavowed for that alone.*

**STEFAN ZWEIG TO ROMAIN ROLLAND,
19 OCTOBER 1914**

LEFT
*4.75 inch (120 milimetre) field gun.
Belonging to the armoury of the French army
since 1878, 125 of these field guns were still
in use in August 1914.*

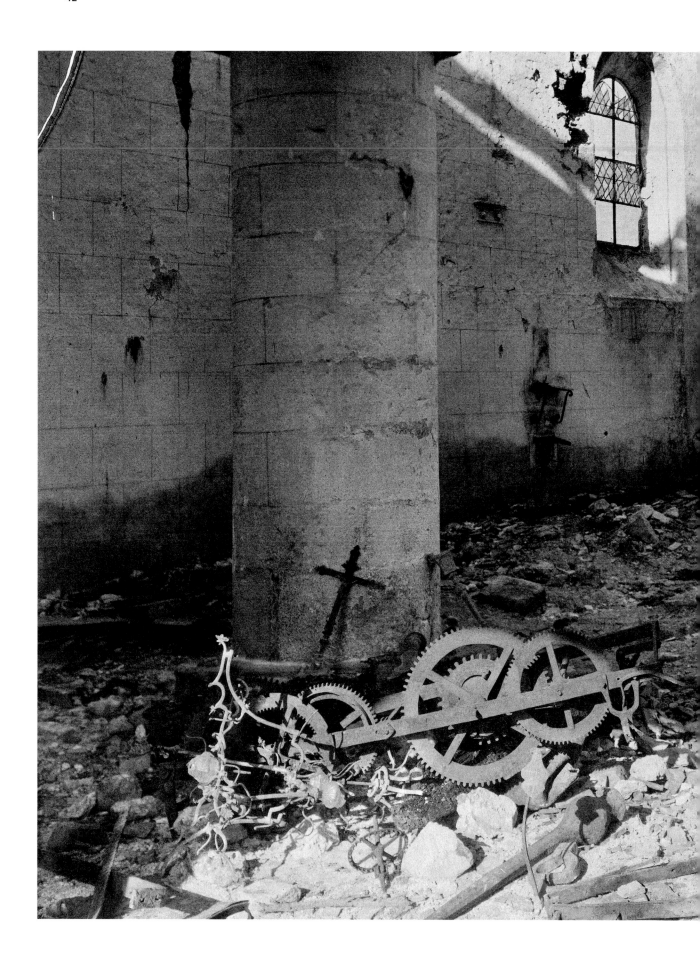

1914 The Battle of the Marne

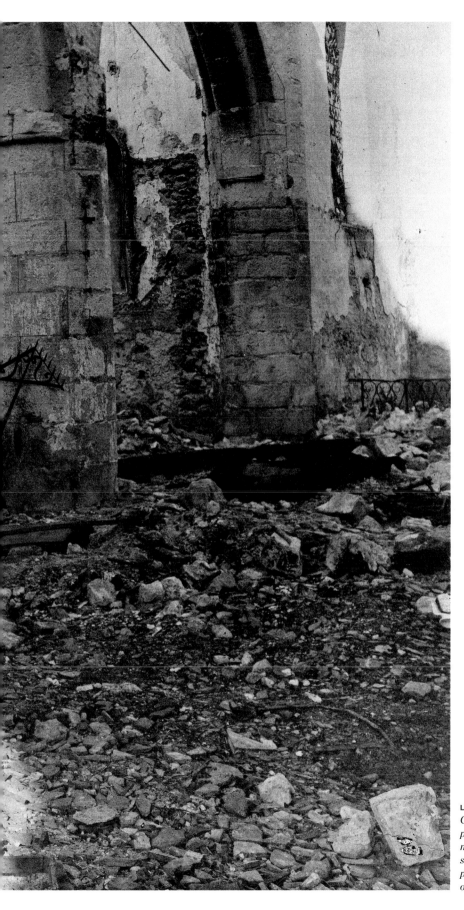

LEFT
Church in Charleville. Due to their exposed position, churches were part of the tactical military targets of the aggressors. At the same time devastated places of worship provided powerful images which proved the ostensibly barbaric warfare of the enemy.

The Battle of the Marne 1914

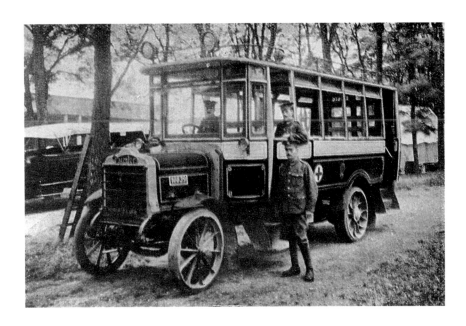

We have been engaged in the hardest kind of hard work—two weeks of beautiful autumn weather on the whole, frosty nights and sunny days and beautiful colouring on the sparse foliage that breaks here and there the wide rolling expanses of open country. Every day, from the distance to the north, has come the booming of the cannon around Reims and the lines along the Meuse.... But imagine how thrilling it will be tomorrow and the following days, marching toward the front with the noise of battle growing continually louder before us.

ALAN SEEGER TO HIS MOTHER, 10 OCTOBER 1914

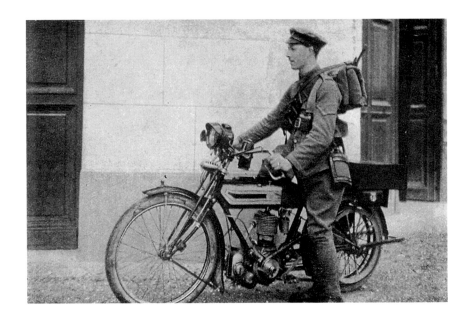

1914 The Battle of the Marne

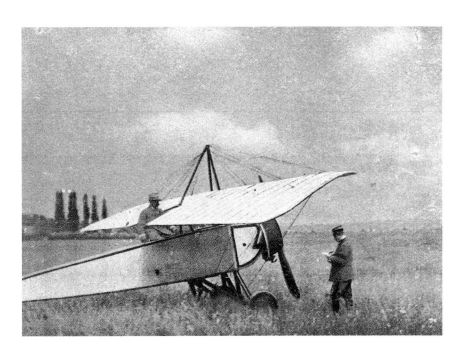

OPPOSITE, ABOVE

A bus converted into a British ambulance. The First World War brought about an enormous advance in motorisation on all sides. At the beginning of the war the German army had over 5,000 trucks at their disposal, and by 1918 the number was already 25,000. The United States was the most advanced in motorisation at the beginning of the war with a substantial lead over Britain, France, and Germany.

OPPOSITE, BELOW

British motorcyclist. Motorcycles were already sporadically in use in the Boer Wars. Seen in the photo is a Triumph brand motorcycle of 1912 from British production. The company founder was a German immigrant who sold bicycles and sewing machines in England under the Triumph brand. As the danger of war intensified, the German factory was split from the British parent company as a precaution in 1913.

ABOVE

Light military plane. Air forces emerged in Europe almost simultaneously just a few years before the outbreak of war; armies were already using balloons before the first airplanes were put into service in 1909/10. At the beginning of the war the French army had more than 132 airplanes at their command.

Faust, Hegelianism, Wagnerism have all paved the way for Germany and led to the burning of our villages.

MAURICE BARRÈS, DIARY, AUTUMN 1914

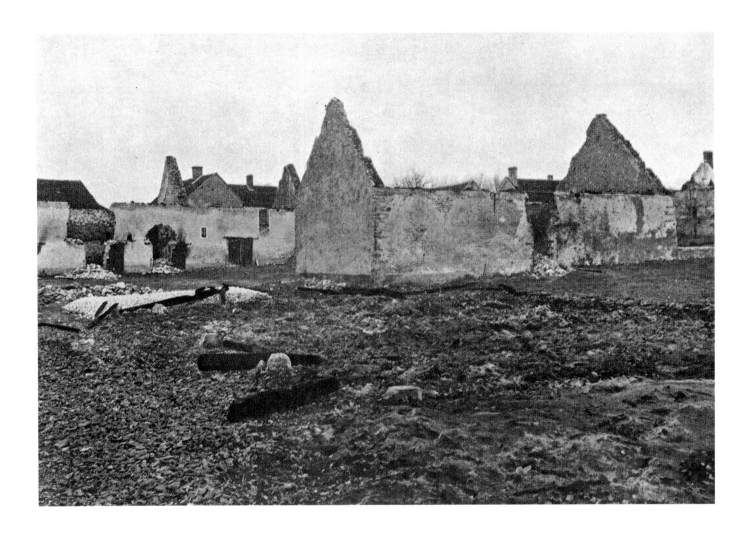

ABOVE
Courtacon. The tiny village in Île-de-France was transformed into a sea of ruins during the Battle of the Marne of 1914.

OPPOSITE
La Villeneuve-lès-Charleville. The German troops were pushed back here on 7 September 1914. The windmill, seen in the background, was helpful in pinpointing the German battery positions.

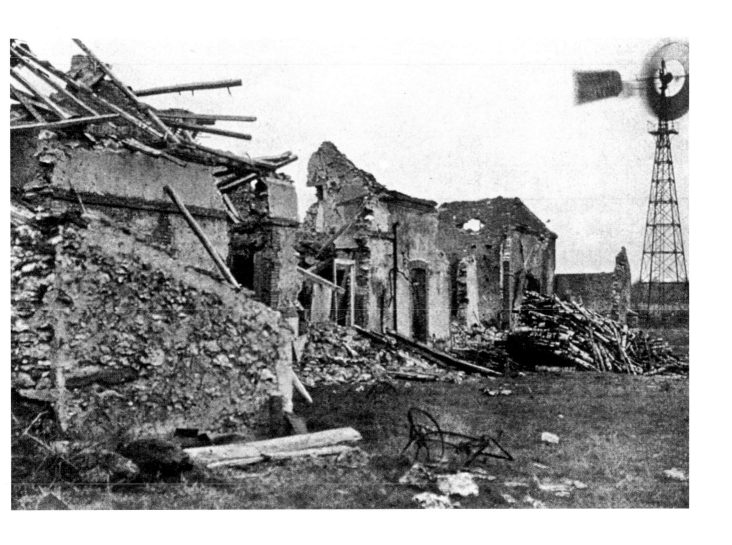

The Battle of the Marne 1914

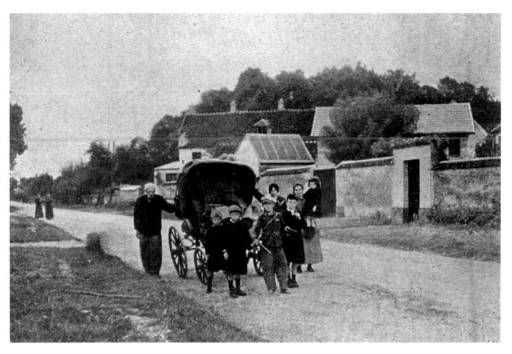

ABOVE
Escape before the invasion. The civilian population, here on the road from Soissons in the direction of Paris, fled before the fighting and were only able to take a few possessions with them.

BELOW
Clean-up efforts in Vincy. The town of 200 residents was recaptured at the beginning of September 1914 by the French army.

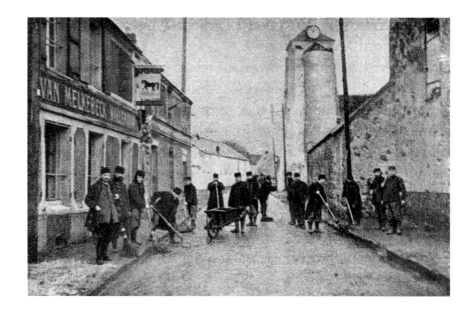

1914 The Battle of the Marne

*We all hope that the war with France
will come to an end soon, the French suffer
even more than our people ...*

WILHELM KLEMM TO HIS WIFE, 19 SEPTEMBER 1914

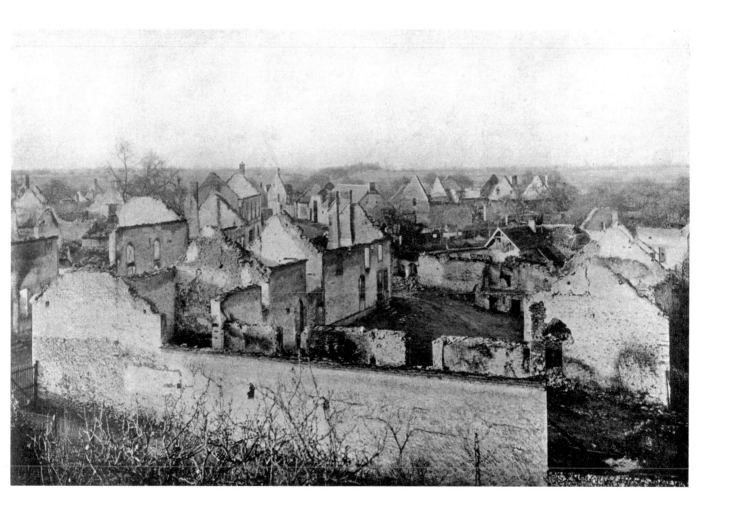

ABOVE
*Châtillon-sur-Morin. This village, where
a meagre 300 people lived at the time,
was almost completely destroyed on the
morning of 6 September 1914.*

PAGE 50/51
*A 2.5 inch (75 milimetre) field gun. As the
first rapid-fire gun it could discharge 15–20
shots per minute. The munitions had to be
loaded by hand and were carried in a limber
(left).*

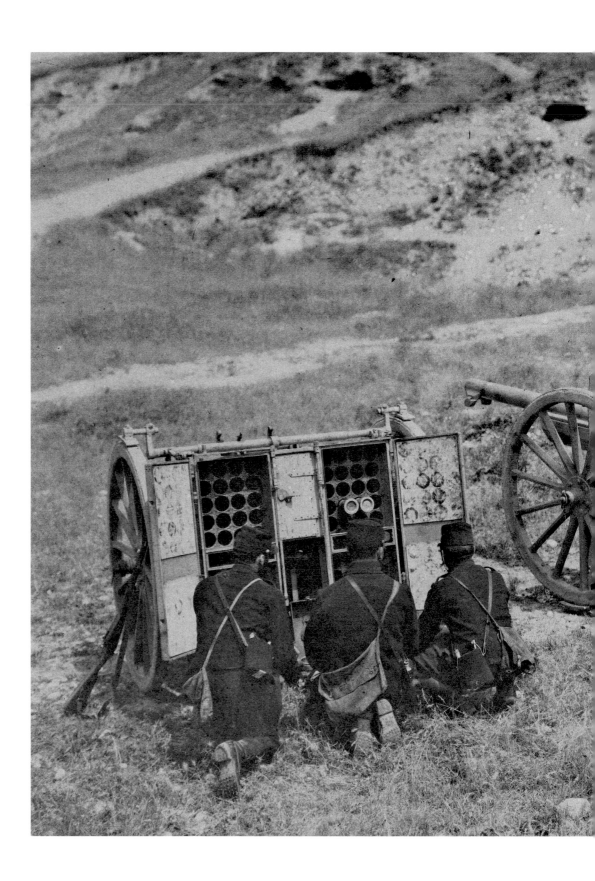

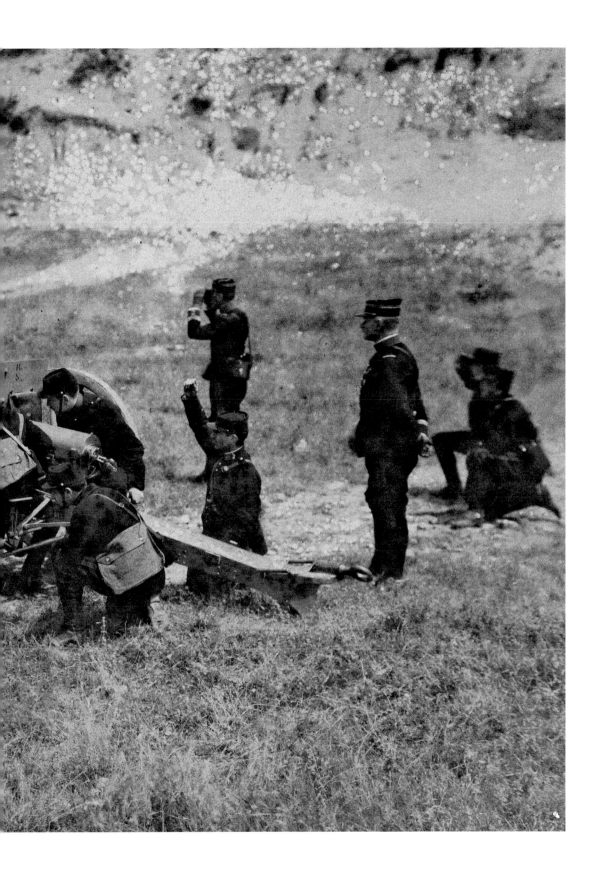

The Battle of the Marne 1914

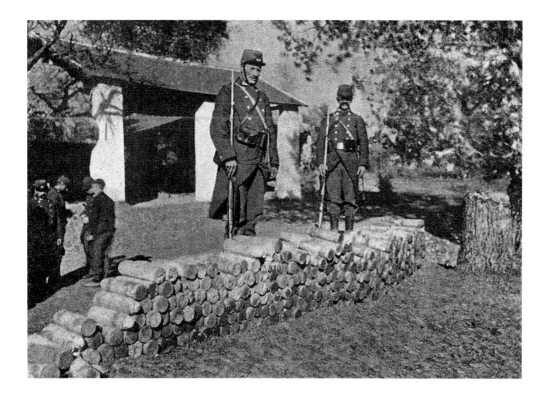

ABOVE
Seized German shells. On their retreat the
Germans had to leave behind a munitions
depot, which was taken over by the French
army.

OPPOSITE
Remains of a masonry dugout of the German
troops after the recapture of the area
by soldiers of the Entente, September 1914.

The rule of the poor common soldier is simply to dig himself a hole in the ground and to keep hidden in it as tightly as possible. Continually under the fire of the opposing batteries, he is yet never allowed to get a glimpse of the enemy. Exposed to all the dangers of war, but with none of its enthusiasm or splendid elan, he is condemned to sit like an animal in its burrow, and hear the shells whistle over his head, and take their little daily toll from his comrades.

ALAN SEEGER TO HIS MOTHER, 10 DECEMBER 1914

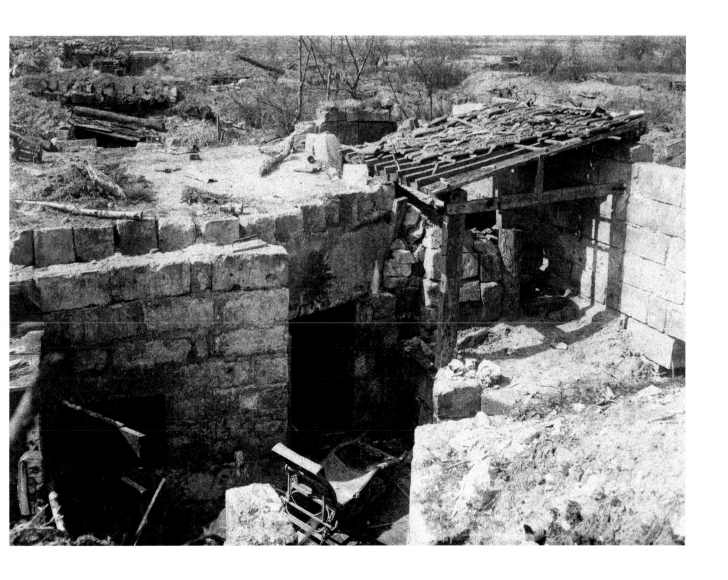

The Battle of the Marne 1914

*I had to imagine, supposing I was killed. There was nothing but
a vague gesture of goodbye to you and my mother and a friend or two.
I seemed so remote and barren and stupid. I seemed to have missed
everything. Knowing you shone out as the only thing worth having ...*

RUPERT BROOKE TO CATHLEEN NESBITT, 17 OCTOBER 1914

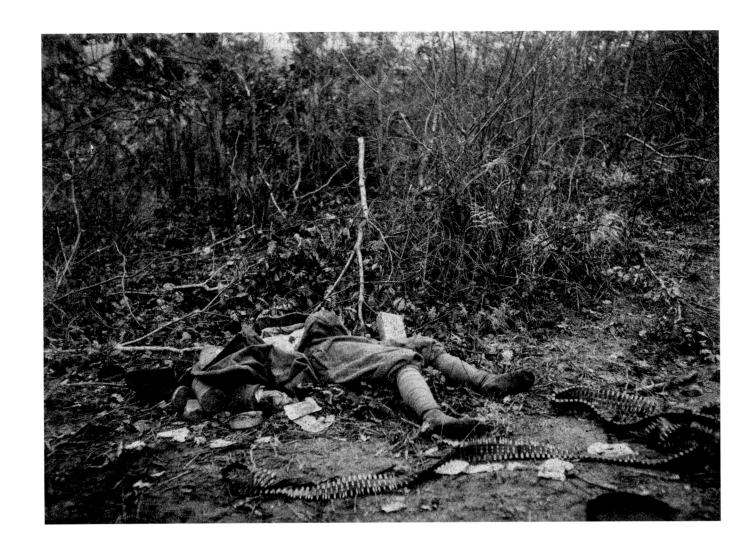

1914 The Battle of the Marne

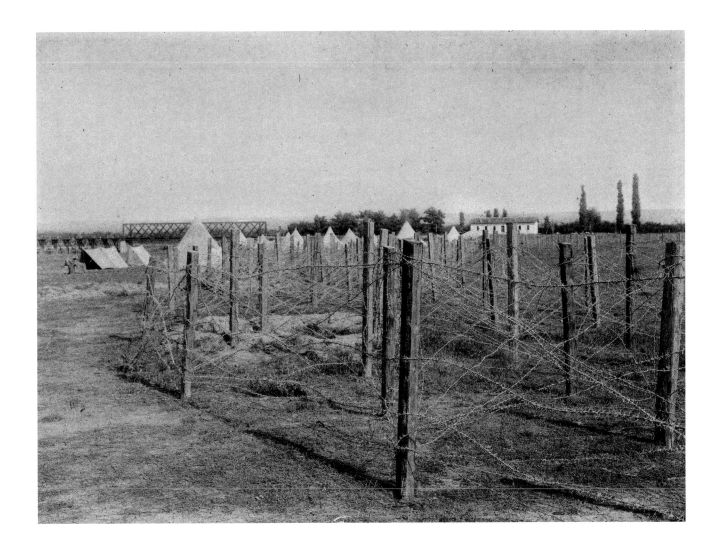

OPPOSITE
*Corpse of a German soldier in a forest, 1914.
Photos in which the dead were seen were
generally not allowed to be published, which
applied above all to soldiers from within
one's own ranks.*

ABOVE
*Provisional camp for German prisoners of
war, 1914. In Europe the warring nations lar-
gely adhered to the stipulations of the Hague
Convention on the treatment of prisoners of
war. Apart from the particular situation in
Russia and the Ottoman Empire, the chances
of surviving the war in captivity were dispro-
portionately higher than as an active soldier.*

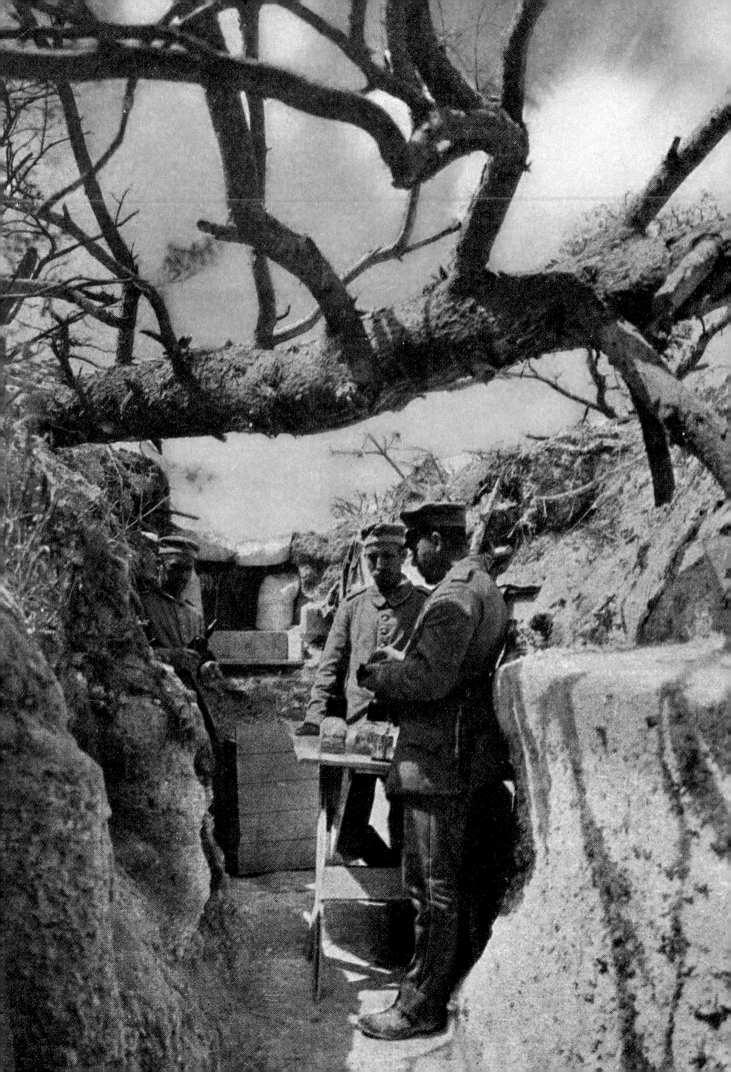

1915 – Paralysed Fronts

The year 1915 began with the German offensive against the Russian troops that had invaded Germany. In February 1915 they were forced out of East Prussia. However, they managed to build a new line of defence, so that following the New Year's battle in December 1915 the Eastern Front was also entrenched. The main theatre of the war remained the Western Front where starting in mid-February the French army attacked the positions of the Germans in Champagne, but without achieving any great success.

The first large-scale use of deadly poison gas by German troops in Ypres in April 1915 represented a turning point in warfare. It sparked an inhuman race in the development of more and more effective poisons. Also in April, in the Dardanelles Campaign, the Allies attempted to liberate the sea route to allied Russia against Central Power ally, the Ottoman Empire. Originating from the Gallipoli peninsula, the undertaking in the strait failed due to the Turkish resistance. Outside Europe there were numerous secondary theatres of war that were created by Britain's decision to attack all German colonies with Allied troops.

Italy had declared its neutrality in 1914 although it was allied with Germany and Austria-Hungary in the Triple Alliance. After secret negotiations with the Entente confirmed the promise of territorial expansion at the expense of Austria-Hungary, Italy declared war on the Habsburg monarchy in May 1915. A new front emerged in the south on the Isonzo River and in the Alps. As a result almost a million soldiers died in 15 bloody battles without significant changes in the front line. After entering the war allied with the Central Powers, Bulgaria succeeded in establishing a land connection to the Ottoman Empire, which had fought for the Central Powers since November 1914. In autumn, in violation of the neutrality of Greece, French and British armed forces landed at Salonika.

The Entente began an offensive in the West at the end of September to relieve the Russian front. The Second Battle of Champagne is considered the first major materiel battle. Despite four-fold superiority in soldiers and weapons the advance of the Entente remained grounded after initial successes. By the end of October ca. 250,000 Allied soldiers and 150,000 German soldiers had lost their lives, the bitter combat pushing the numbers of dead into the millions for the first time in 1915.

OPPOSITE
German trench canteen.
Photo: Hans Hildenbrand

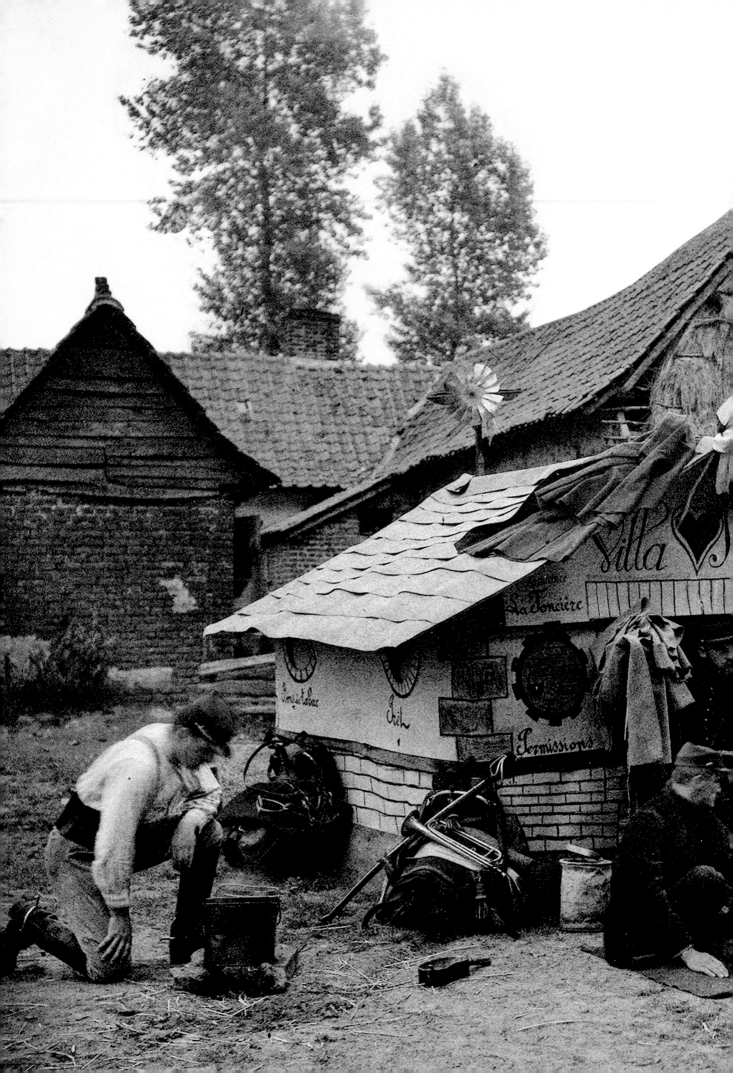

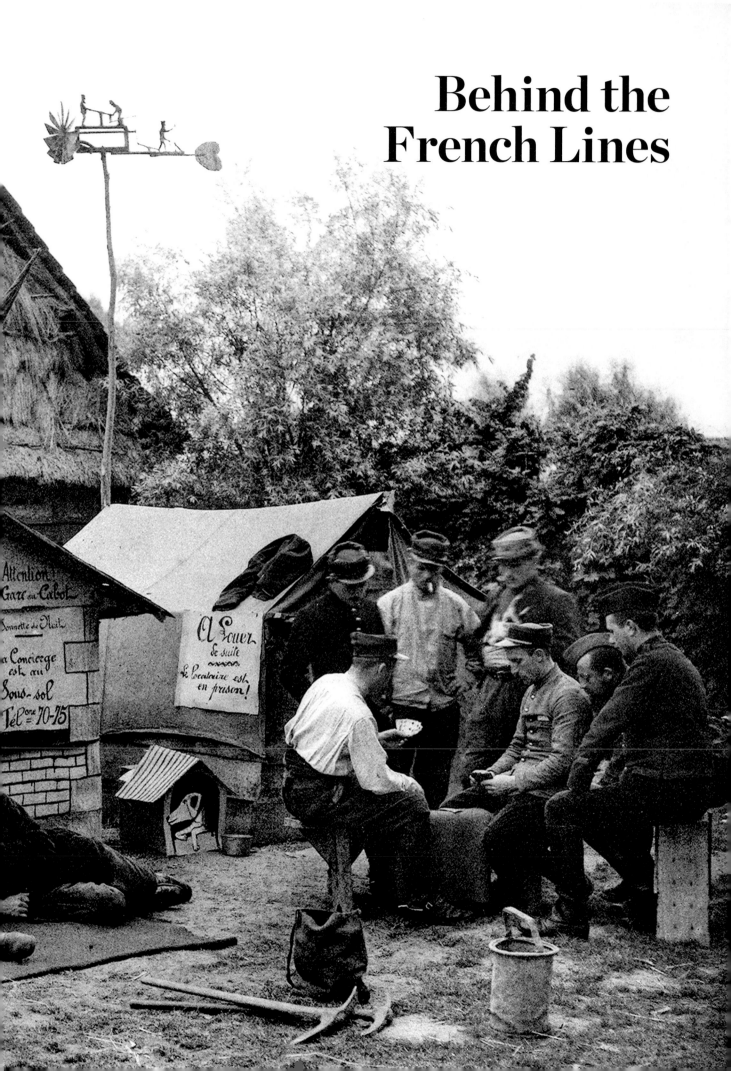

Behind the
French Lines

The impossibility of coping in the trenches the way they are at the front, and the need to maintain them, have caused the French and the Germans at certain points to be exposed without cover on the front, and to not shoot at each other.

HENRI BARBUSSE TO HIS WIFE, 11 DECEMBER 1915

PAGE 58/59
French soldiers in a parody of domesticity. Tournassoud was one of the most productive Autochrome photographers during the First World War; at the end of the war he took over the direction of the photography department of the French army.
All photos from page 58/59 to page 67:
Jean-Baptiste Tournassoud

BELOW
Soldiers in a trench. Steel helmets, like the ones worn by three of the soldiers in the image, were a part of military gear beginning in the First World War. The French army employed them on a large scale starting in March 1915, the British followed in November 1915, and the Germans from February 1916.

ABOVE

French soldiers in front of a dugout eating a
meal and reading mail. According to letters
and diaries of the participants the war mostly
consisted of phases of inactivity and waiting.

62

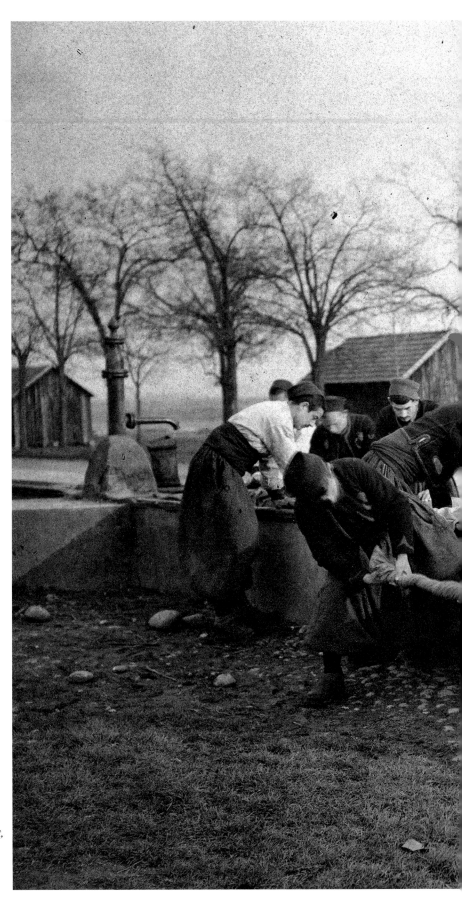

Members of the 3rd Zouave Regiment wash their clothes. Tournassoud captured the everyday military life of this regiment.

PAGE 64/65
Soldiers bathe in a river. The scene is staged; picture detail, distribution of colour and light, and composition of fore- and background are carefully considered. The participants in the image appear frozen since they had to hold a pose due to the long exposure time.

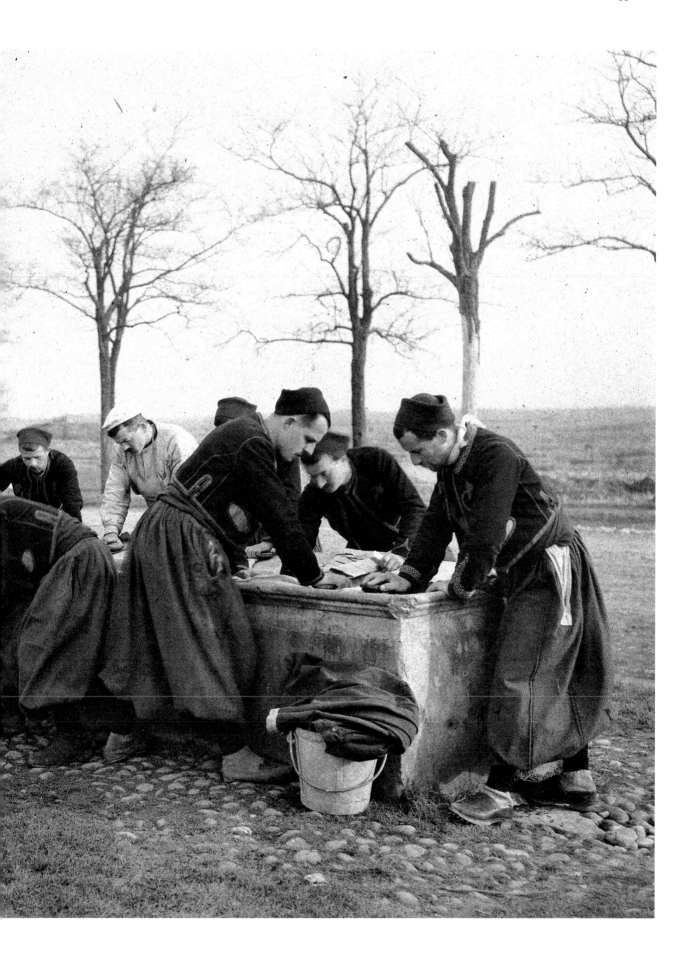

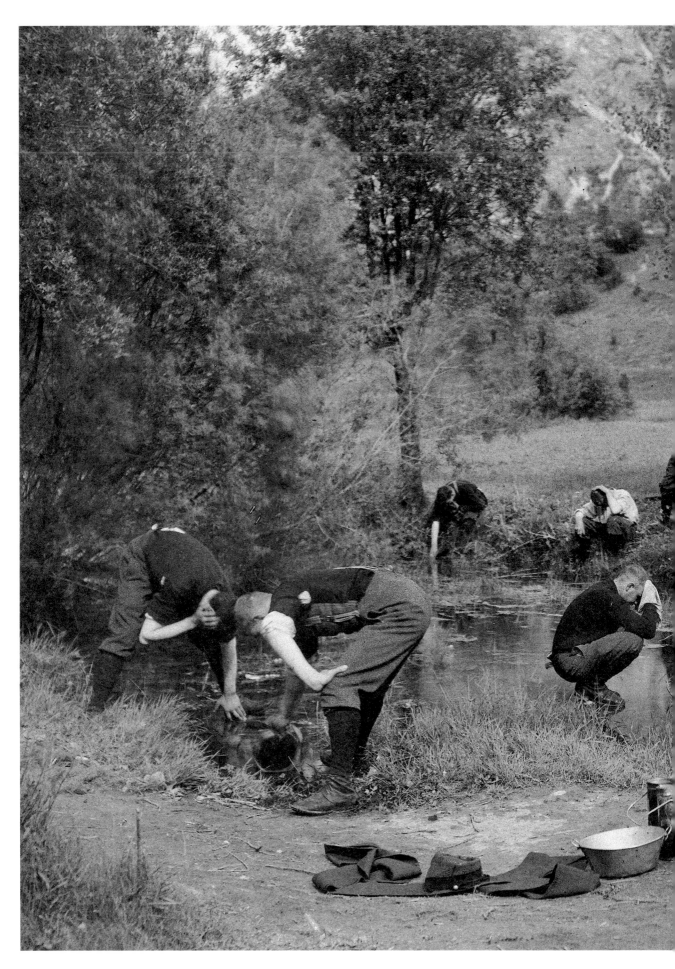

1915 Behind the French Lines

We have made a march of about 75 kilometres [46.6 miles] in four days, and are now on the front, ready to be called on at any moment. I am feeling fine, in my element, for I have always thirsted for this kind of thing, to be present always where the pulsations are liveliest. Every minute here is worth weeks of ordinary experience. How beautiful the view is here, over the sunny vineyards! And what a curious anomaly. On this slope the grape pickers are singing merrily at their work, on the other the batteries are roaring.
Boom! Boom!

ALAN SEEGER TO HIS MOTHER, 23 OCTOBER 1914

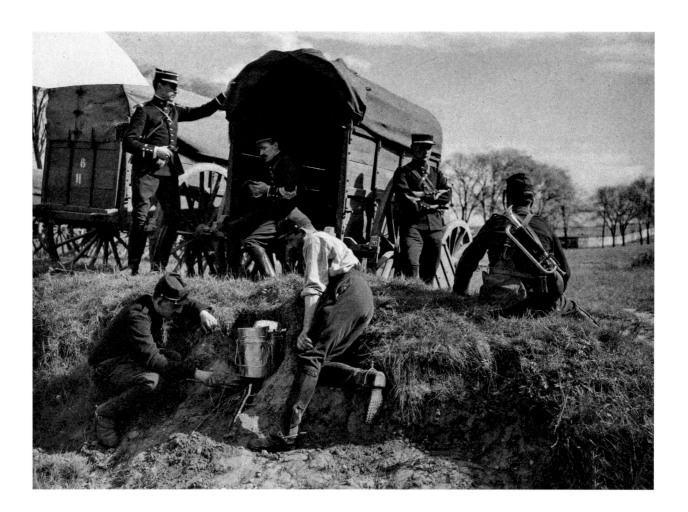

1915 Behind the French Lines

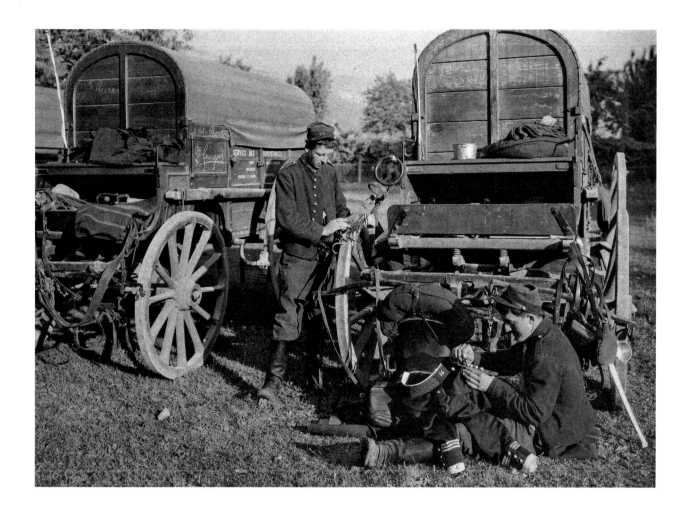

*Soldiers of the 14th Infantry Regiment
attend to their gear.*

*Soldiers of the 14th Infantry Regiment
prepare a meal.*

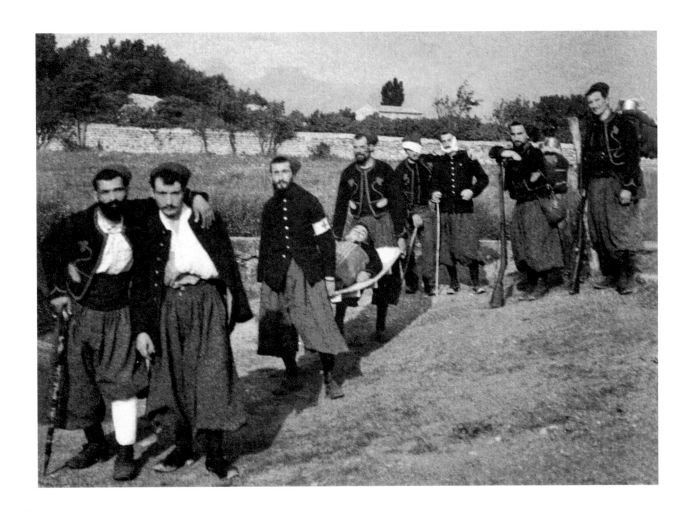

ABOVE
The wounded are brought to safety,
Tulette (Drôme), 22 May 1915.
Photos: Pierre Grange

OPPOSITE
Field hospital near Chavannes in
Alsace, 21 March 1916.

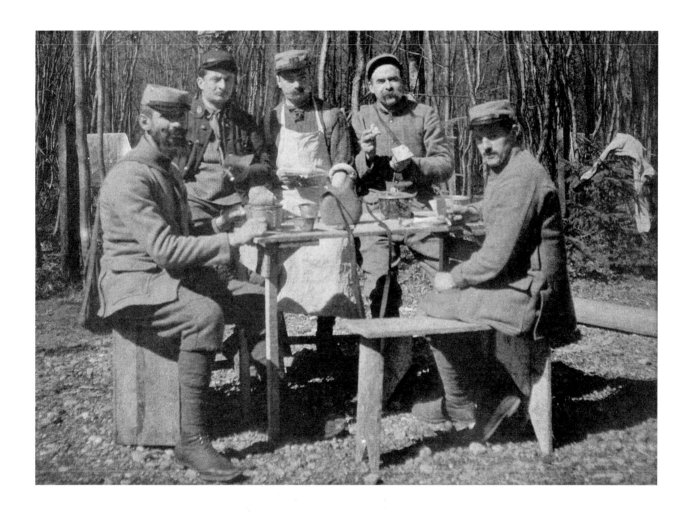

You must not be anxious about my not coming back. The chances are about ten to one that I will. But if I should not, you must be proud, like a Spartan mother, and feel that it is your contribution to the triumph of the cause whose righteousness you feel so keenly. Everybody should take part in this struggle which is to have so decisive an effect, not only on the nations engaged but on all humanity. There should be no neutrals, but everyone should bear some part of the burden.

ALAN SEEGER TO HIS MOTHER, 18 JUNE 1915

To tell the truth, neither of the two countries deserves to crush the other, and Germany, by obliging us to oppose her, committed a frightful mistake.

ANDRÉ GIDE, THE JOURNALS, 22 OCTOBER 1915

TOP RIGHT
Captured Prussian colours in Les Invalides, Paris, 1915.

RIGHT
General Alfred Galopin honours wounded soldiers, Esplanade des Invalides, Paris, 22 April 1915.
Photos: Léon Gimpel

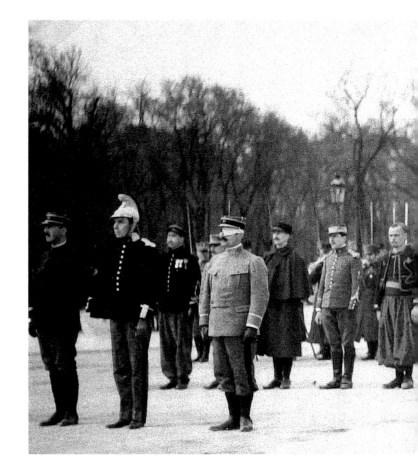

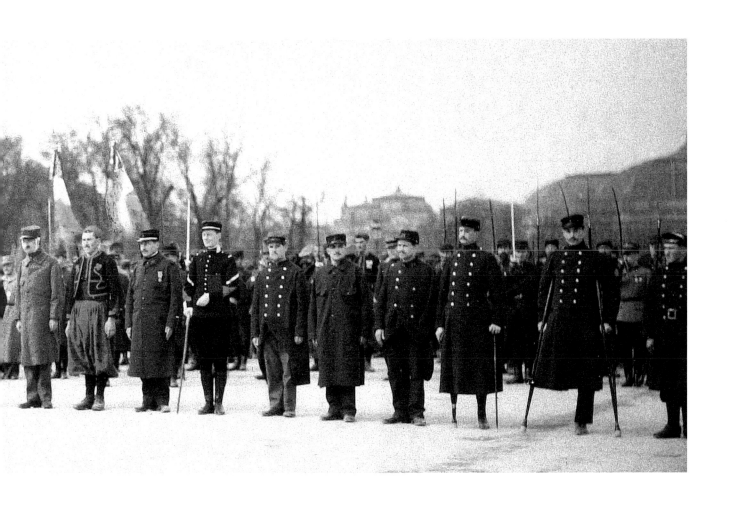

1915

BELOW
Major Moog with soldiers of the 4ᵗʰ Spahi Regiment. The regiment was stationed in Tunisia and relocated to the Paris area in early September 1914.

OPPOSITE
In the quarters of the 4ᵗʰ Spahi Regiment.
All photos from page 72 to page 75:
Jean-Baptiste Tournassoud

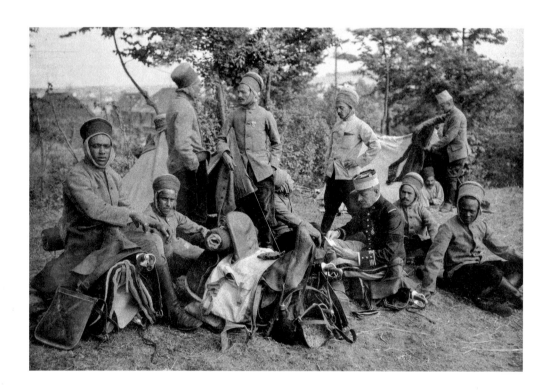

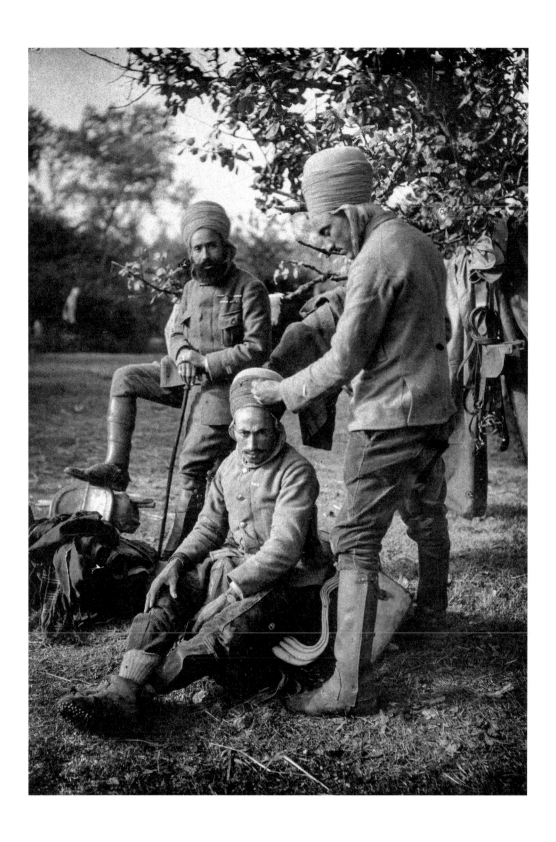

LEFT

A colour bearer of the 37th Infantry Regiment decorated with a war cross (1915/16). The history of this regiment reaches far back in the Ancien Régime. During the First World War it was deployed to Flanders, Verdun, at the Somme, and at the second Battle of the Marne of 1918, among other places.

Behind the French Lines 1915

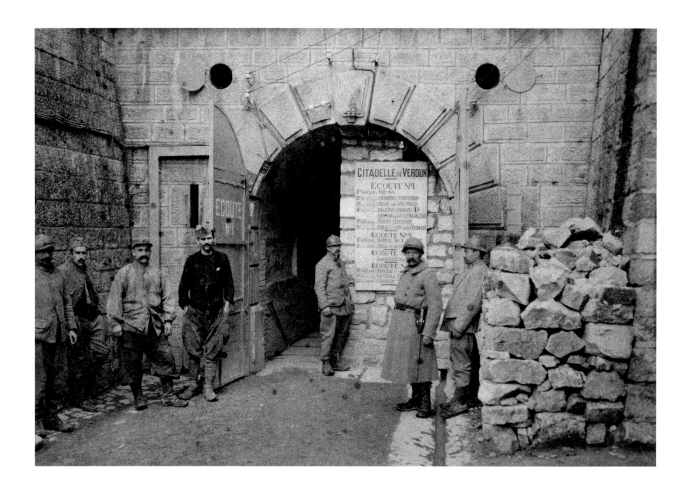

*Entrance to the citadel of Verdun. Beneath
the fort, subterranean shafts were excavated
between 1886 and 1893, which at the start of
the war reached 2.5 miles (4 kilometres). By
the end of the war the shafts were lengthened
to 4.3 miles (7 kilometres). The entry to the
fortress is well preserved even today.*
Photo: Paul Castelnau

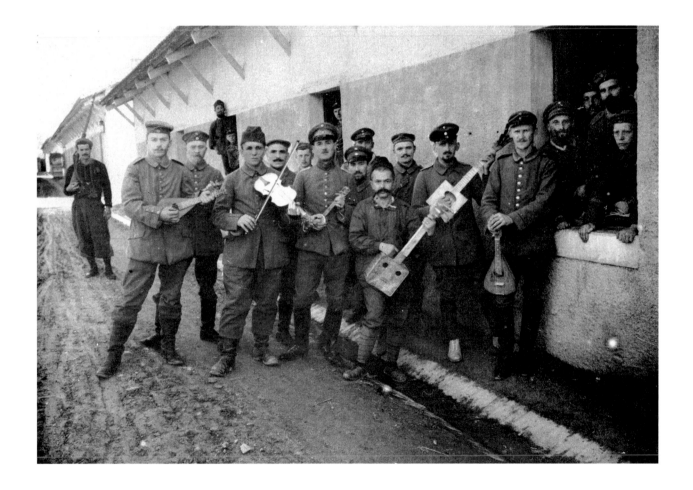

ABOVE
Orchestra in a German POW camp
in Tizi-Ouzou (near Algiers). The men
built their own instruments.
Photo: Albert Samama-Chikli

The current war has trampled all political neutrality, and that of the invisible powers: the Church, Art, and Science ... I demand an inviolable asylum for human reason. Philosophers, academics, artists to your posts! Your eyes should not stay fixed on the turmoil of combat or riveted on its mindless carnage!

ROMAIN ROLLAND, DIARY, 28 JULY 1915

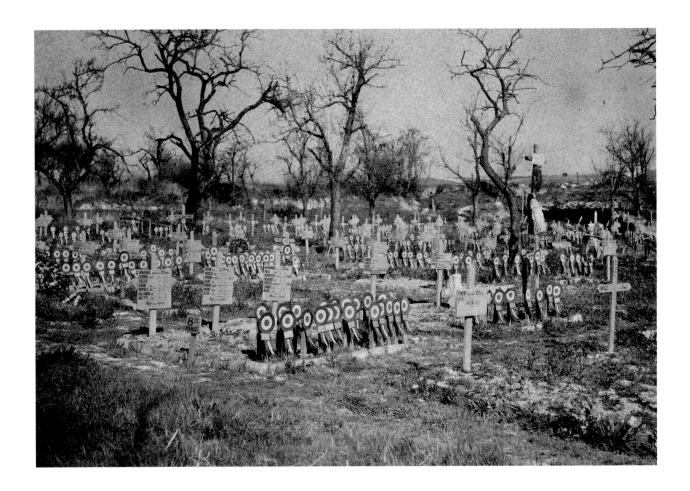

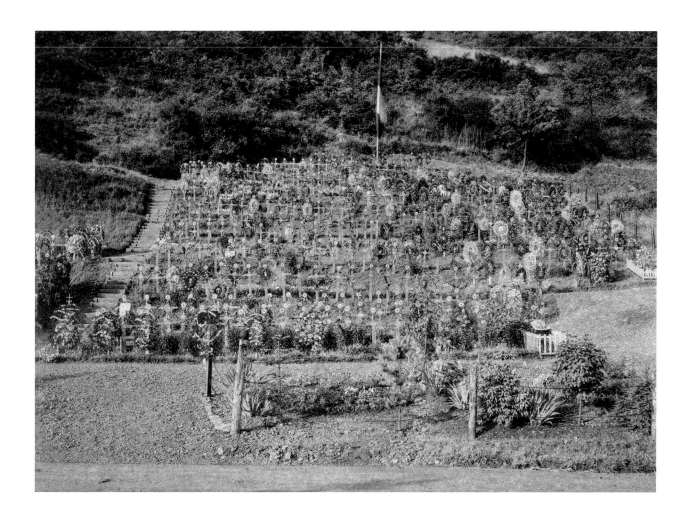

OPPOSITE
*French military cemetery. The graves
are decorated with cockades in the colours
of the tricolour and the names of the dead.*
Photo: Jean-Baptiste Tournassoud

ABOVE
*Moosch cemetery in Alsace as it
still exists virtually unchanged today.*
Photo: Paul Castelnau

The War
in the East

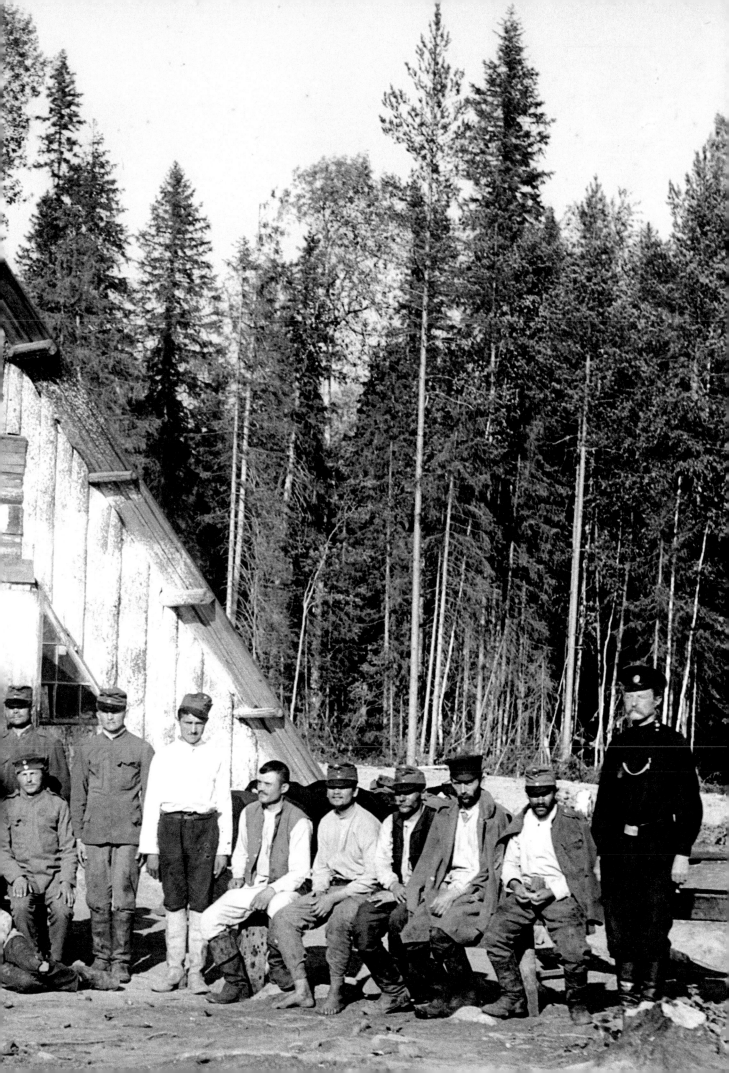

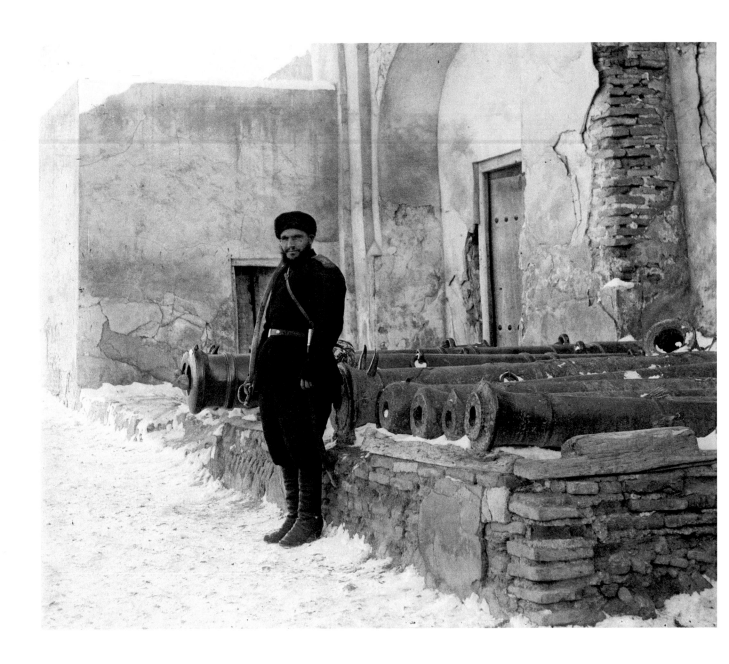

1915 The War in the East

PAGE 80/81
Austrian prisoners of war in Karelia, near Kiappeselga, 1915. In the First World War every fourth soldier of the Central Powers held in Russian captivity lost their life.

OPPOSITE
Sentry at the palace, Bukhara, ca. 1915

BELOW
The only colour photographs that capture the events of the First World War in the East were taken by Sergei Prokudin-Gorskii. In the image the photographer is seen at the front right of a handcar on the Murmansk railway near Petrozavodsk (1915). This rail line was mostly built by German and Austrian prisoners of war.
Photos: Sergei Prokudin-Gorskii

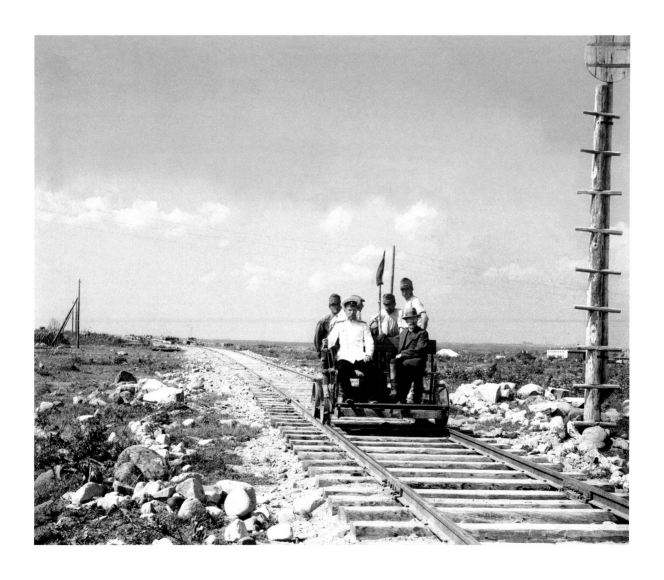

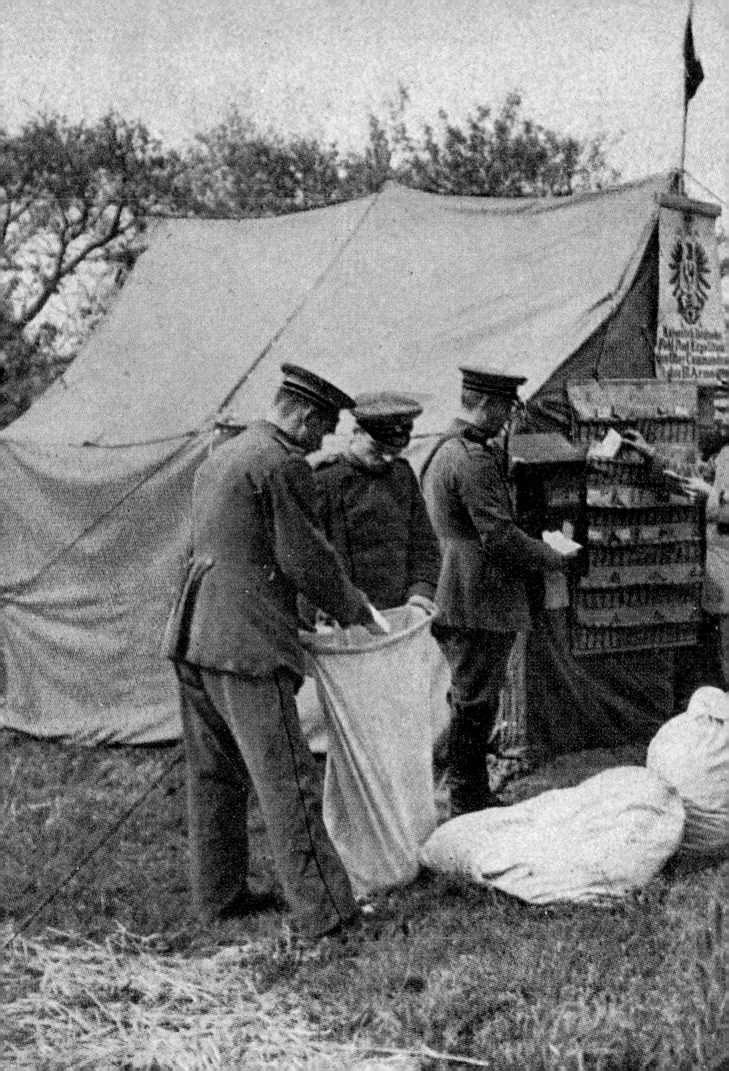

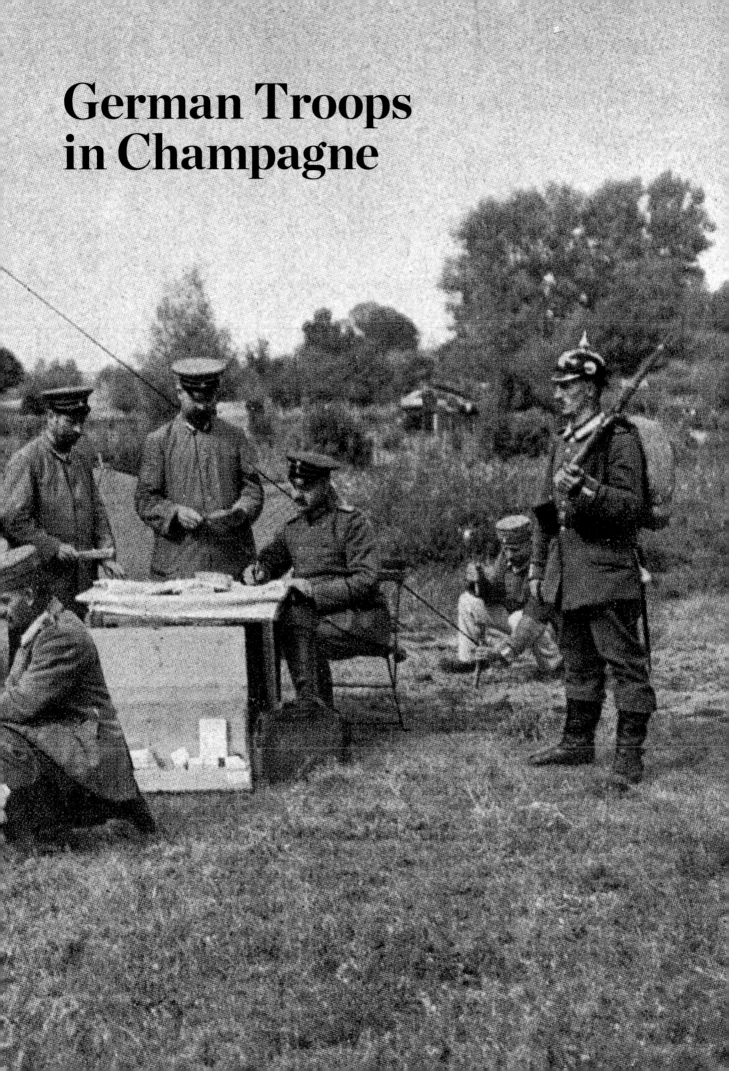

German Troops
in Champagne

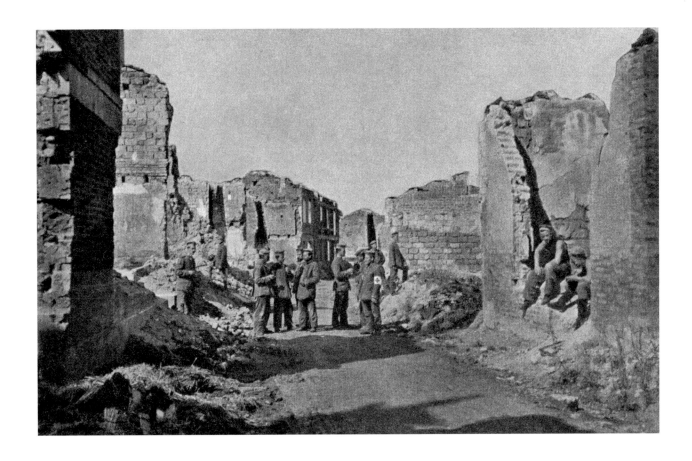

PAGE 84/85
Field post office on the front. The German field post alone delivered over 28.7 billion cards and letters during wartime.

ABOVE
German soldiers on a street in Sommepy, 1915.

OPPOSITE
Rethel, near the Aisne.
All photos from page 84/85 to page 100/101: Hans Hildenbrand

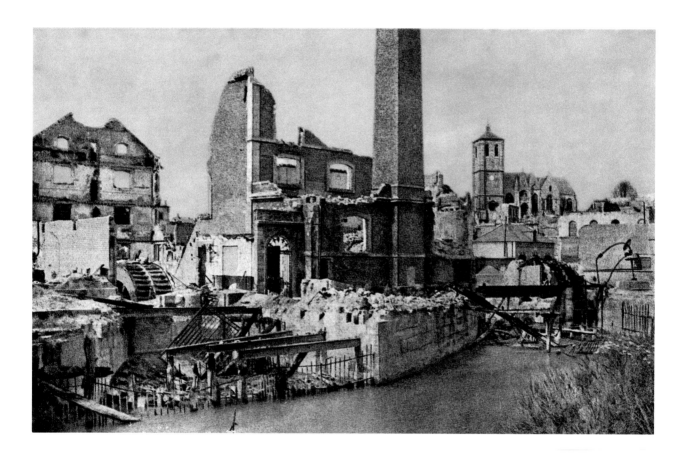

The greatest was Rethel. We arrived around one, the moon shone dead clear. First a gathering of gallows, the chimneys of the destroyed factories. Through a field of rubble we came to a dark old street, from time to time a high burned-out façade, a half caved-in house, a cellar yawning black. There was no sound— only the usual smell of decomposition and the muffled noises of the half-asleep platoons.

WILHELM KLEMM TO HIS WIFE, 6 OCTOBER 1915

German Troops in Champagne 1915

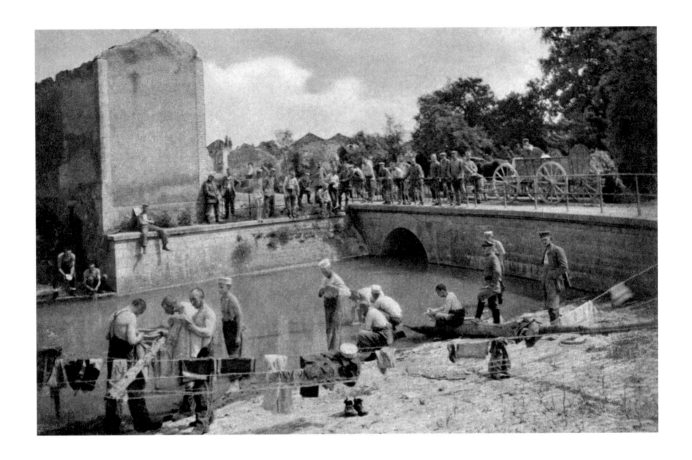

1915 German Troops in Champagne

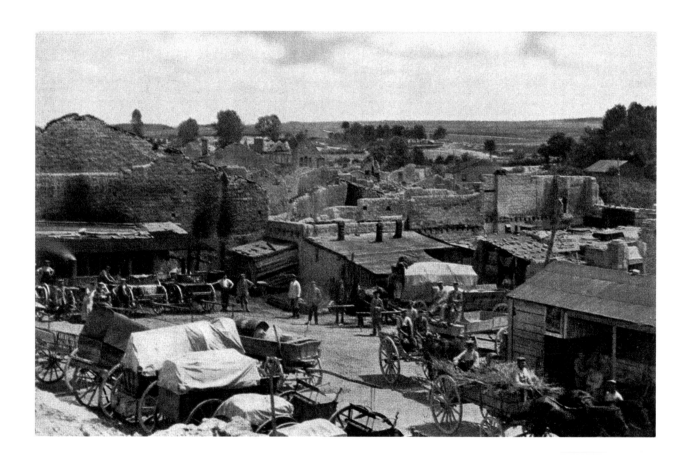

ABOVE

German soldiers make use of a lull in the fighting to wash laundry in the river. The German-occupied village of Sommepy in the Marne department formed the front line from September 1914 to October 1918.

OPPOSITE

Quarters in Sainte-Marie-à-Py (summer 1915). Hildenbrand was the only photographer on the German side who captured the events of the war in colour. The photographs were distributed as postcards at the time.

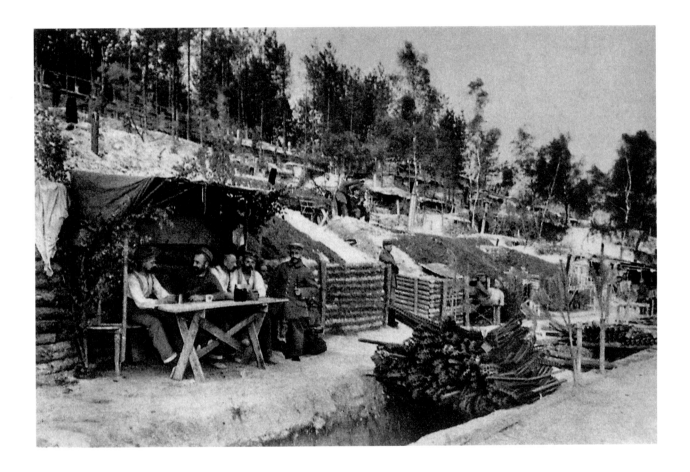

ABOVE
From June 1915 to January 1916 Hilden-
brand accompanied the German troops in
Champagne. The image shows a military
camp (1915). On the back of the postcard
Senior NCO Bräuer wrote in February 1916:
"We would be happy to leave here, but there
is war elsewhere too. The best would be to
be at home. Hopefully the year 1916 brings
a long-awaited peace."

OPPOSITE
Filling up with water in Sommepy (Marne).
The horses were used not only in the cavalry;
first and foremost they were used as draught
animals.

1915 German Troops in Champagne

*Now this dreadful war will soon rage over the whole of Asia, Persia,
China will be irretrievably destroyed, and I do not think that
America can avoid the war until the end. This global catastrophe may
well be the most terrible moment in the whole history of the world.*

FRANZ MARC TO HIS MOTHER, 11 NOVEMBER 1914

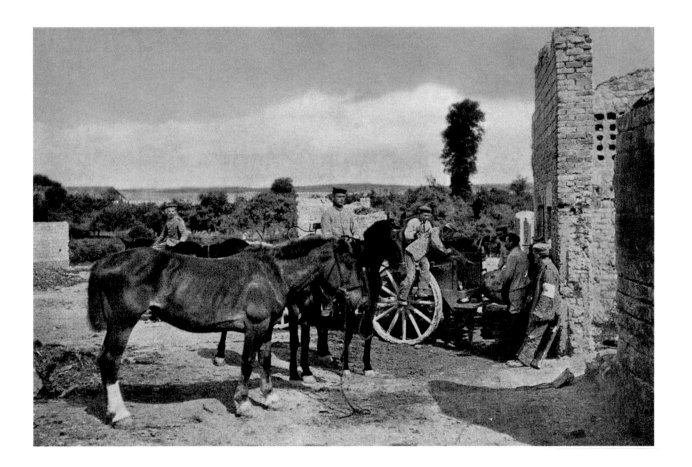

German Troops in Champagne　　1915

BELOW
German soldiers at the machine-gun post of a dugout.

OPPOSITE
Soldiers pose in a concrete trench.

I sit in a hole in the ground called a dugout! How grand! A candle, stove, armchair, table. Everything according to modern times. The culture of the 20th century.
And up on top it clatters constantly! Clack! Clack! Shh. Bzzz! That is the ethics of the 20th century.
And next to me earthworms curl out of the wall.
That is the aesthetic of the 20th century.

AUGUST STRAMM, 5 MAY 1915

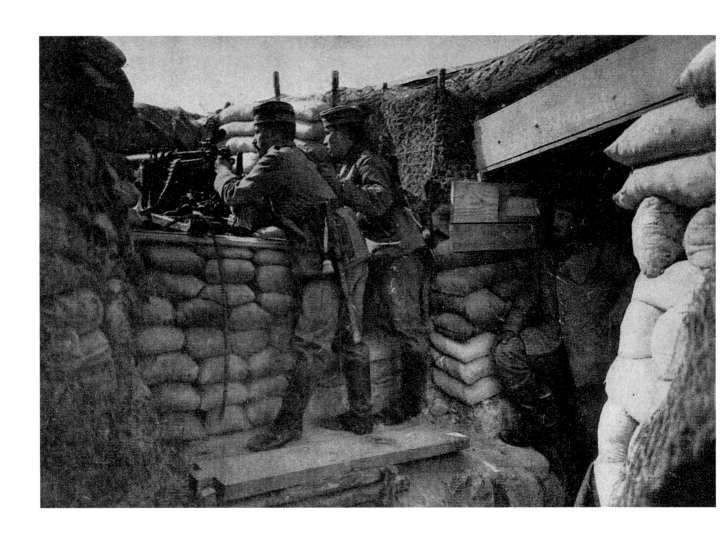

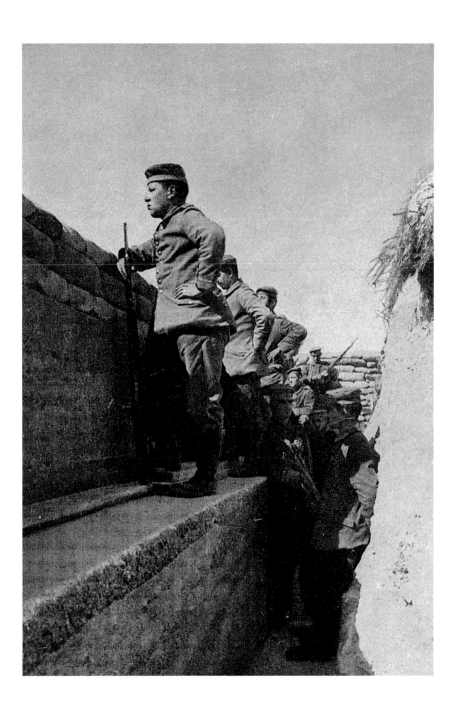

*I awoke to the crack of a grenade. The things
whimper like little children and sob like mothers.
Peculiar. Very peculiar.*

AUGUST STRAMM TO NELL AND HERWARTH WALDEN, 10 FEBRUARY 1915

German Troops in Champagne 1915

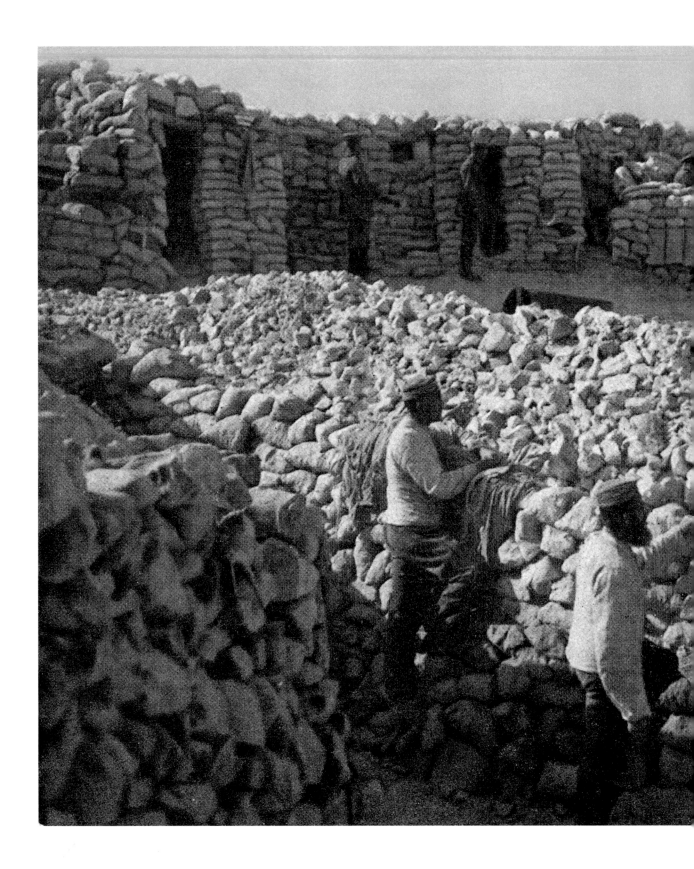

1915 German Troops in Champagne

LEFT
*Shell crater near Courcy. The small town,
with about 1,000 inhabitants in 1914, lay on
the battle line during the entire war and
was almost completely destroyed by 1918.
Initially it was to be abandoned after the war,
like many other places in the Marne area, but
thanks to the dedication of the citizens it
was rebuilt.*

German Troops in Champagne 1915

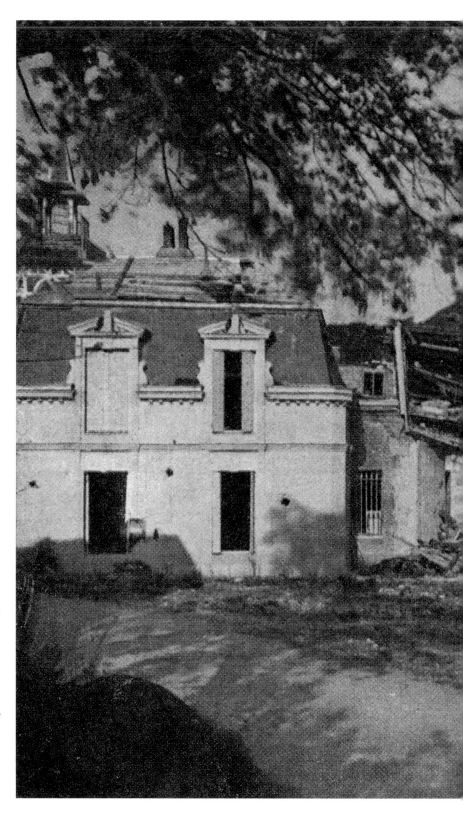

RIGHT
Château de Brimont. The building was destroyed by an assault on 18 September 1914.

PAGE 98 ABOVE
A bombed-out bottle factory in Courcy, 1915.

PAGE 98 BELOW
Ruins in Rethel, 1915.

PAGE 99 ABOVE
Moronvilliers. This village, located ca. 9 miles (15 kilometres) northeast of Reims, was destroyed by the invasion of the German army on 2 September 1914, and was not rebuilt after the war.

PAGE 99 BELOW
Cemetery for fallen German soldiers in Rethel, 1915.

1915 German Troops in Champagne

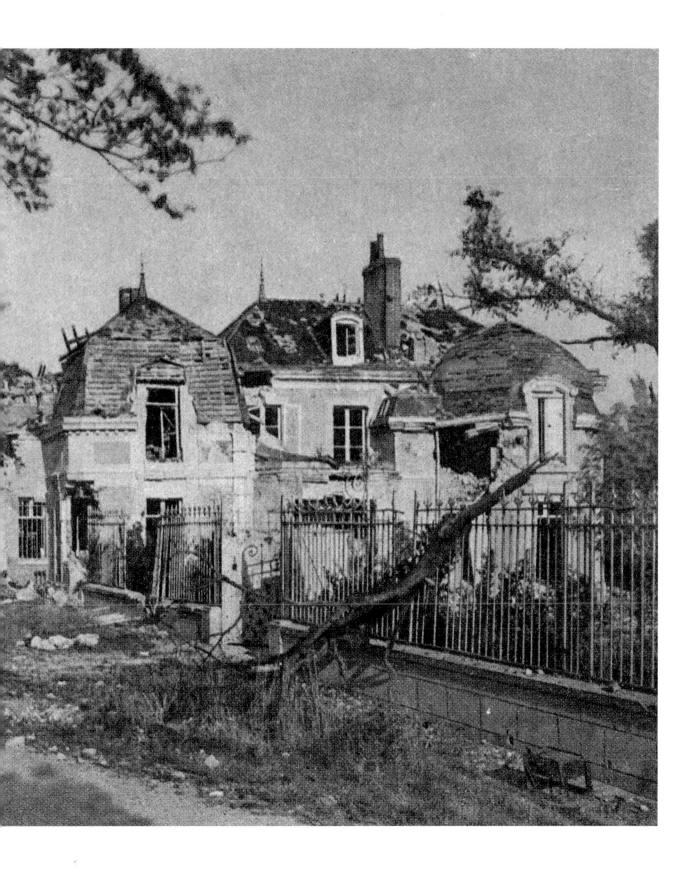

German Troops in Champagne 1915

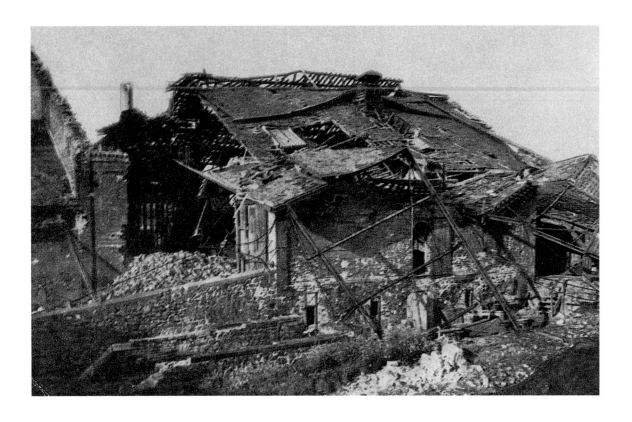

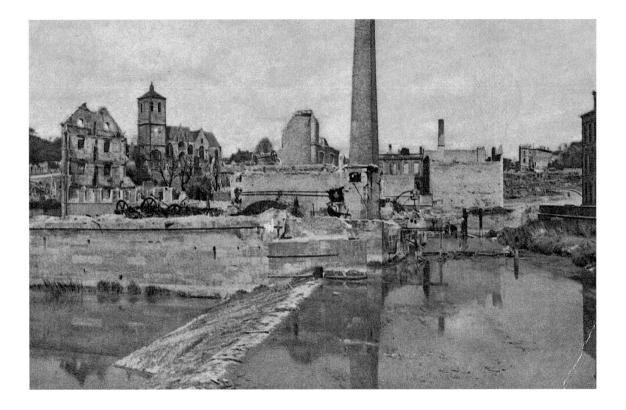

1915 German Troops in Champagne

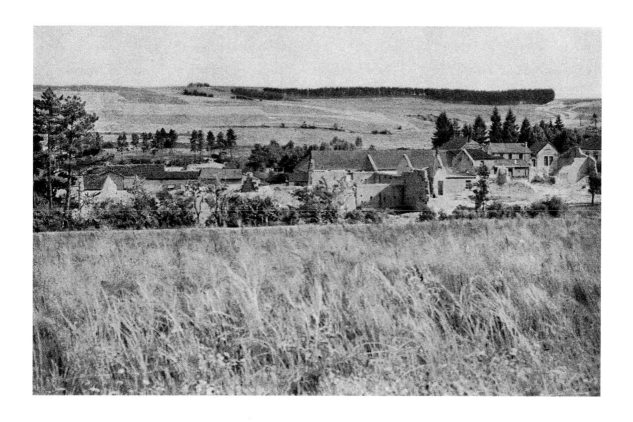

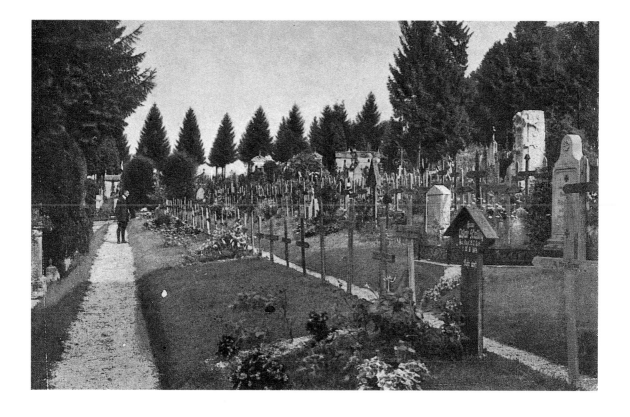

German Troops in Champagne 1915

1915 German Troops in Champagne

LEFT
Poppy field in combat zone. Flowering poppies as an allegory for resurrected nature in contrast to the massive scale of death was already a common image of war for people at the time. The poem by Canadian doctor John McCrae became the best known:
"In Flanders fields the poppies blow
Between the crosses, row on row,
That mark our place; and in the sky
The larks, still bravely singing, fly
Scarce heard amid the guns below."

Aerial War

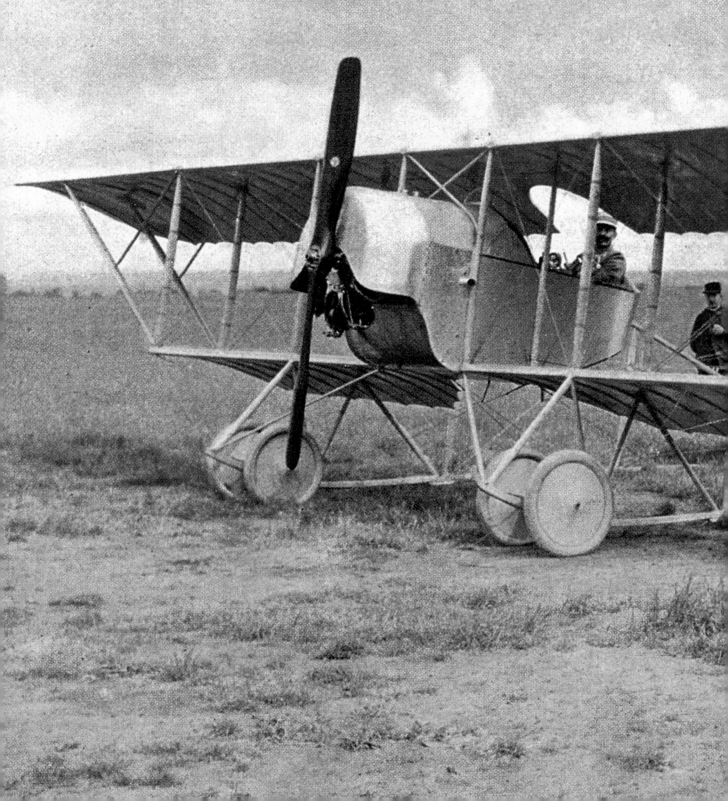

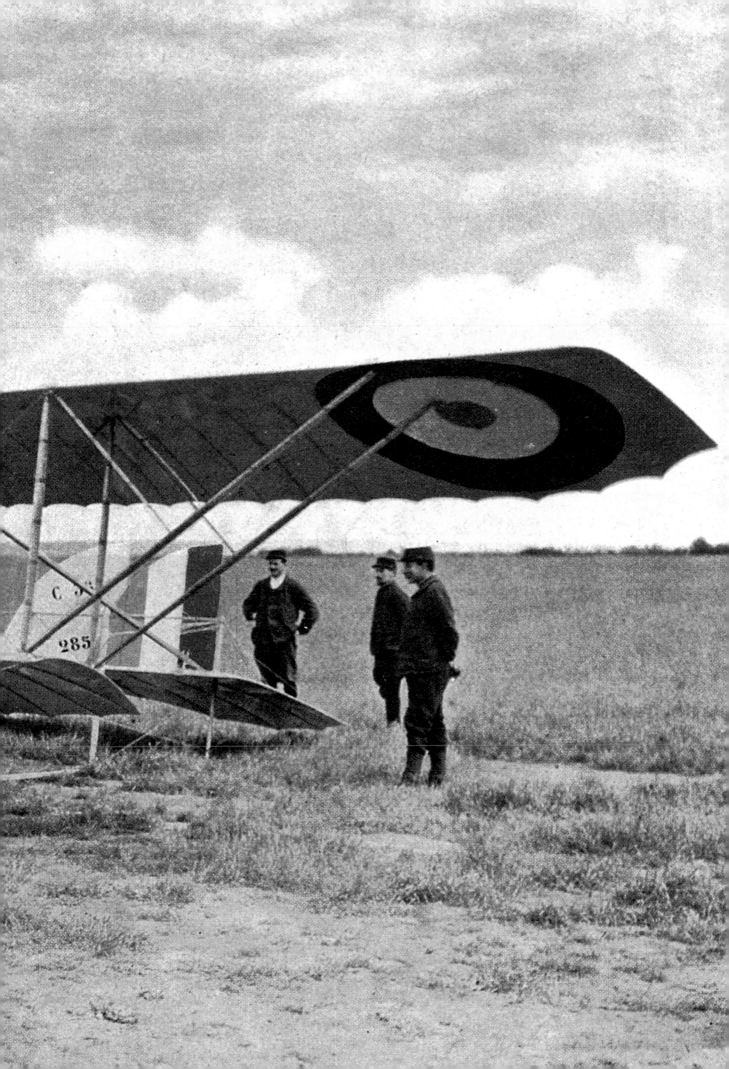

LEFT
French airship Alsace *shot down on
3 October 1915, near Rethel. The crew
survived unharmed and were taken prisoner.
Airships were not just used for aerial recon-
naissance, but also for the bombardment of
civilian and military targets.*
Photo: Hans Hildenbrand

BELOW
*Motorised gun carriage with an antiaircraft
gun, Verdun, 1916.*

PAGE 102/103
*French warplane, Caudron G3, 1914. The
First World War was the first time air war-
fare played a role in combat. Together
the British and the French had at their dis-
posal about the same number of airplanes
as the Germans. Aerial reconnaissance by
the Royal Flying Corps contributed consider-
ably to the stopping of the German advance
on the Marne.*
Photos: Jules Gervais-Courtellemont

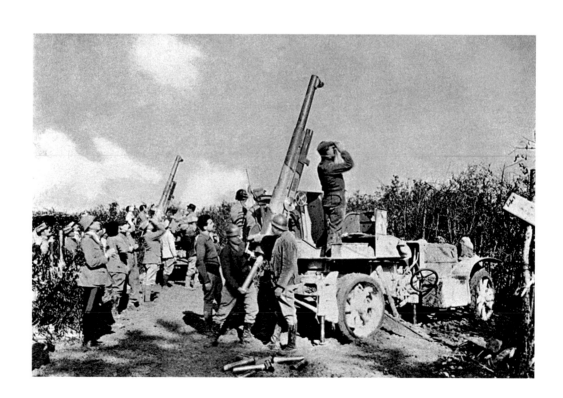

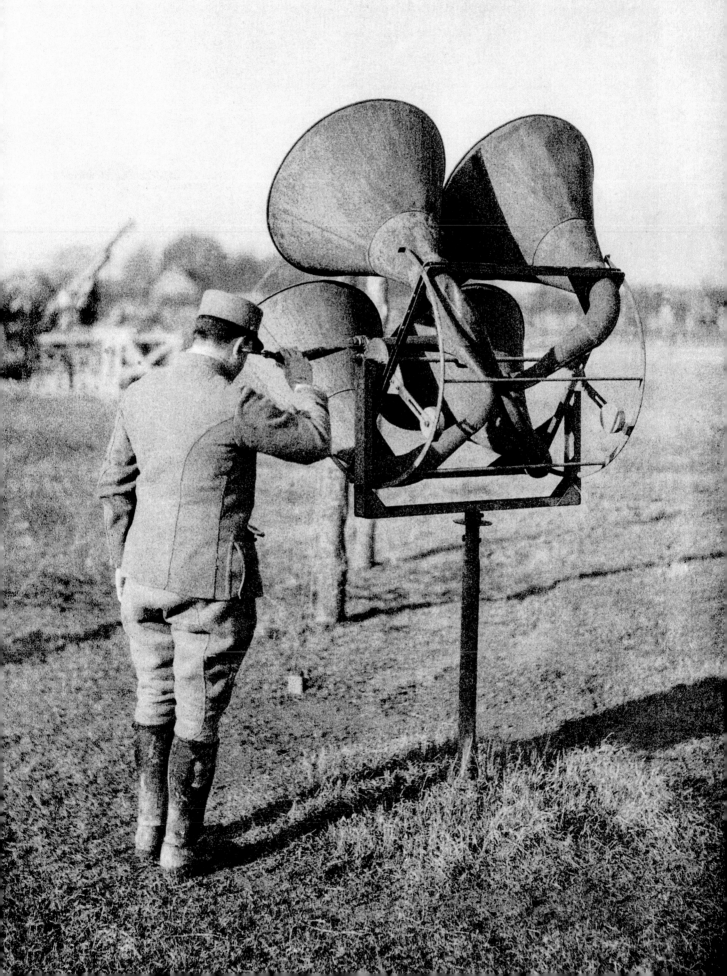

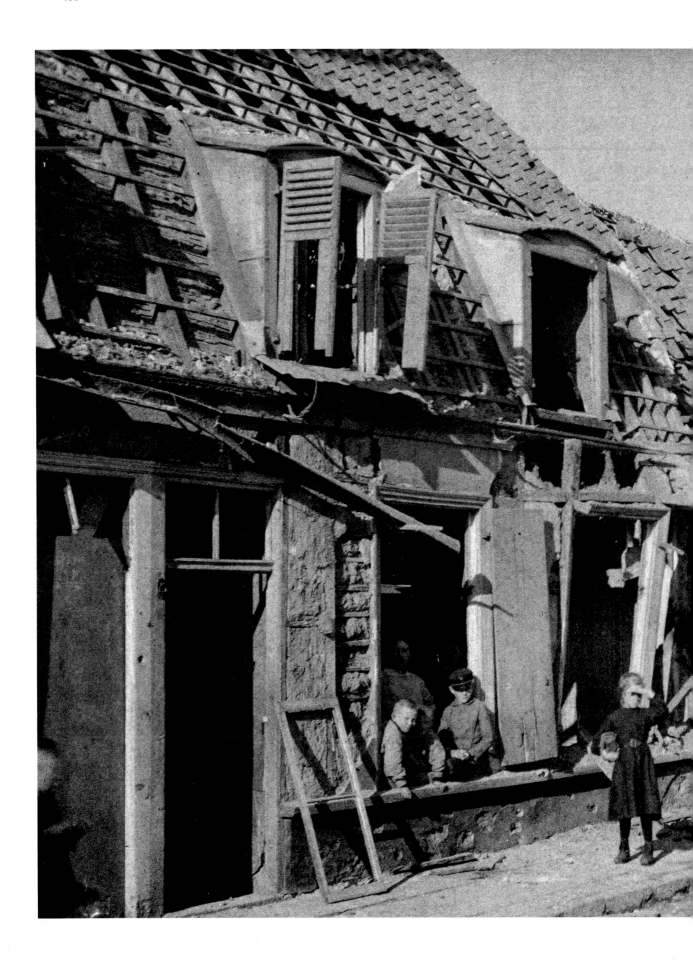

1915 Aerial War

*But to hear incessant thunder,
shaking buildings and ground
and you and everything; and, above,
recurrent wailings, very shrill
and queer, like lost souls, crossing
and recrossing in the emptiness—
nothing to be seen. Once or twice a
lovely glittering aeroplane, very
high up, would go over us; and then
the shrapnel would be turned on it,
and a dozen quiet little curls of
white smoke would appear round
the creature—the whole thing like
a German woodcut, very quaint and
graceful and unreal. Eh, but the
retreat drowned all those
impressions.*

**RUPERT BROOKE TO CATHLEEN NESBITT,
17 OCTOBER 1914**

LEFT
*After a bombardment of civilian targets in
September 1917 near Dunkirk.*
Photo: Paul Castelnau

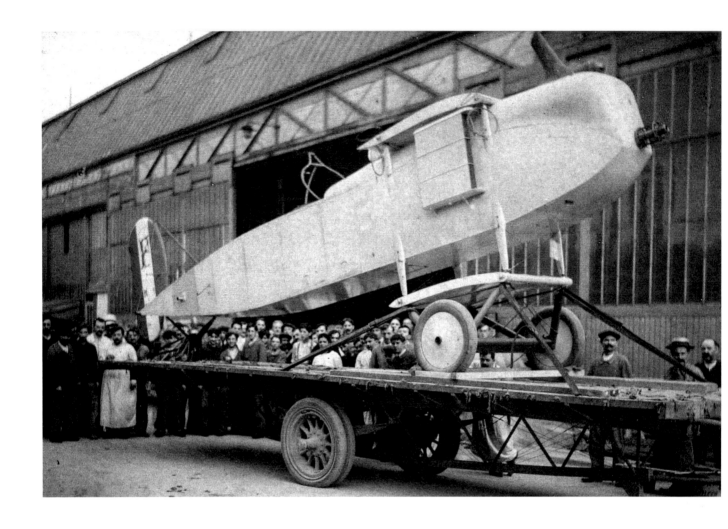

*Zeppelin attack. I find it no more horrible than, for example, shrapnel
and machine-gun fire—and the military duty to inflict the cruelest mutilation
and those sentenced to death no more guilty or less deplorable than civilians,
even women and children, hit by bombs while out walking. That the war
is possible—here, only here lies the horror; everything else is just detail.*
ARTHUR SCHNITZLER, DIARY, 7 FEBRUARY 1916

OPPOSITE
A Farman plane in front of assembly hangar, 1918. Henri, Richard, and Maurice Farman were born in Paris the children of a British journalist and a French mother. They had already begun in 1909 with aircraft assembly and provided the French army mainly with reconnaissance planes during the war.

BELOW
View of the production hall of the Farman factory in Billancourt, 1917.
Photos: Léon Gimpel

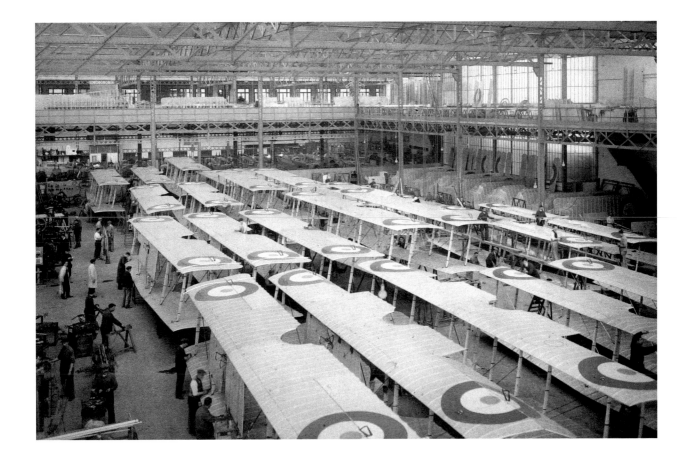

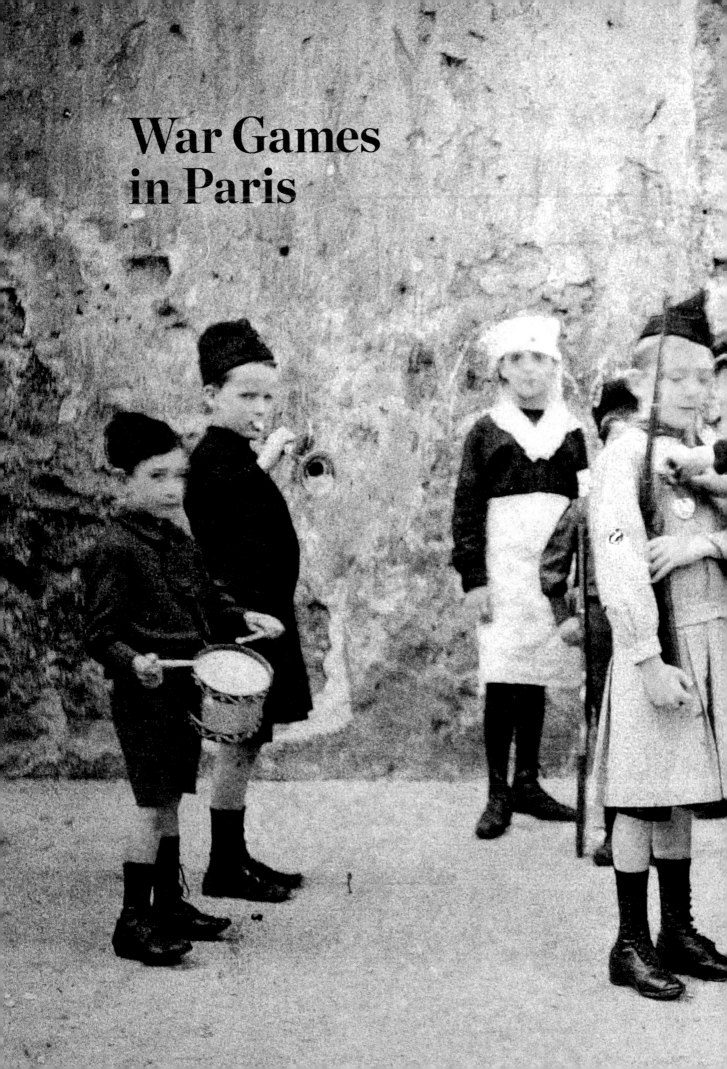

War Games
in Paris

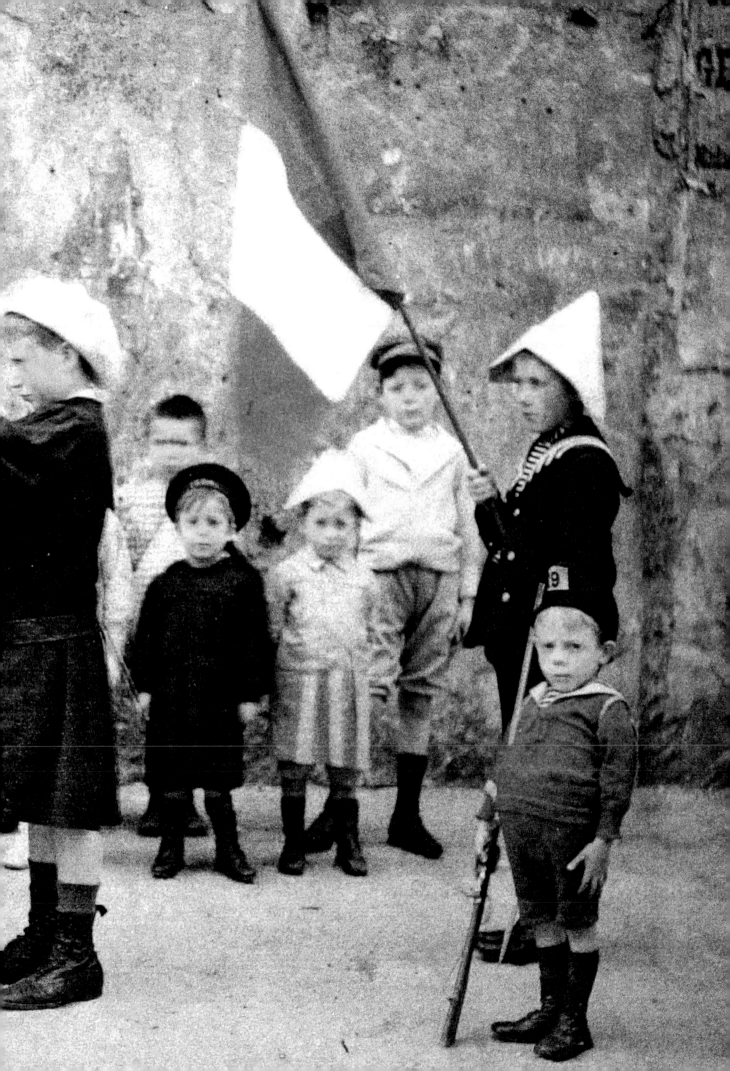

PAGE 112/113
In Paris, on the Rue Greneta in September 1915, Léon Gimpel took a series of Auto-chromes of children re-enacting their war games for him. If nothing else, the images visualise how strongly the German aggressors were hated and the facility for such that the children grew up with. The title of the photo is Decoration of the Victorious Soldiers.

OPPOSITE
The pilot Pépète in action; his airplane was made out of a wooden crate, the machine gun a coffee mill.

BELOW
Defence of a House on the Rue Greneta.
All photos from page 112/113 to page 123:
Léon Gimpel

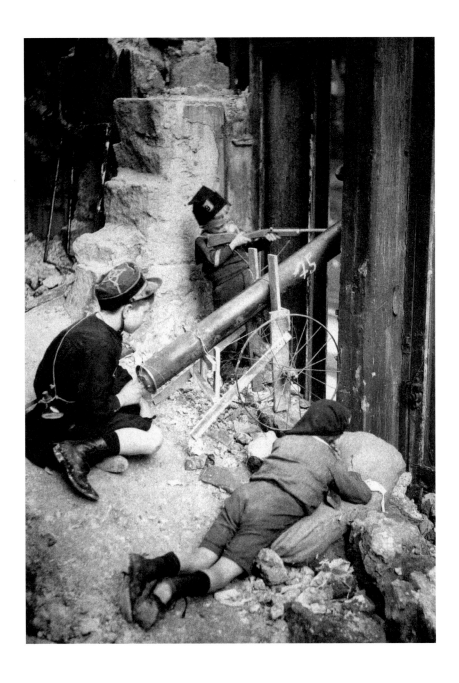

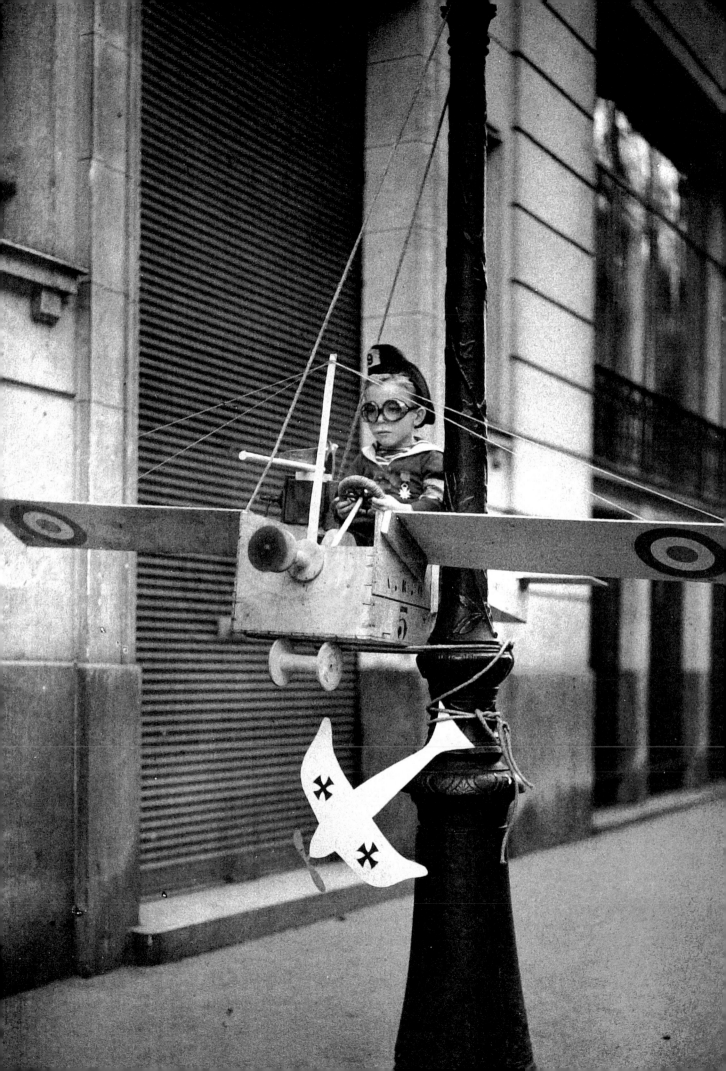

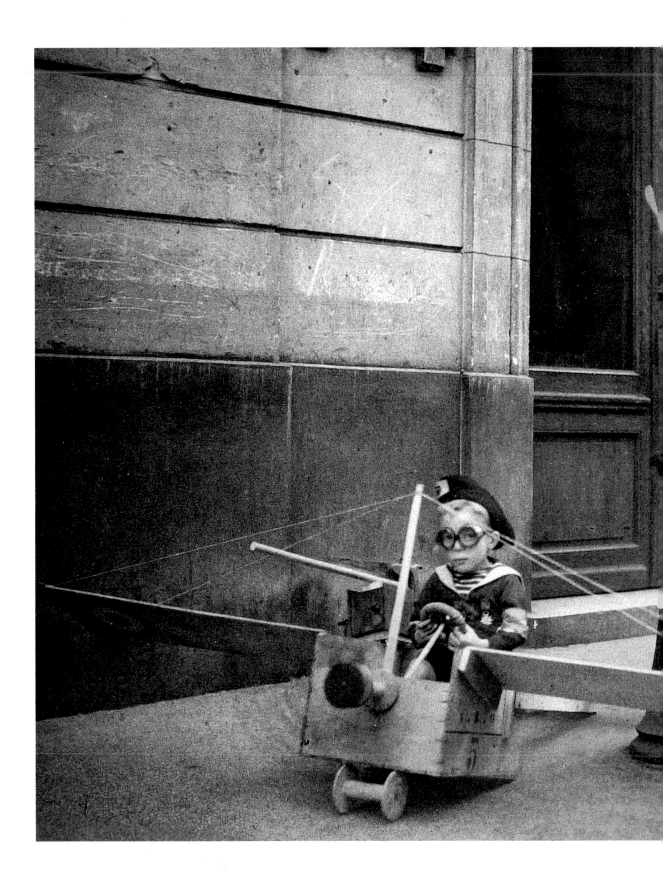

1915 War Games in Paris

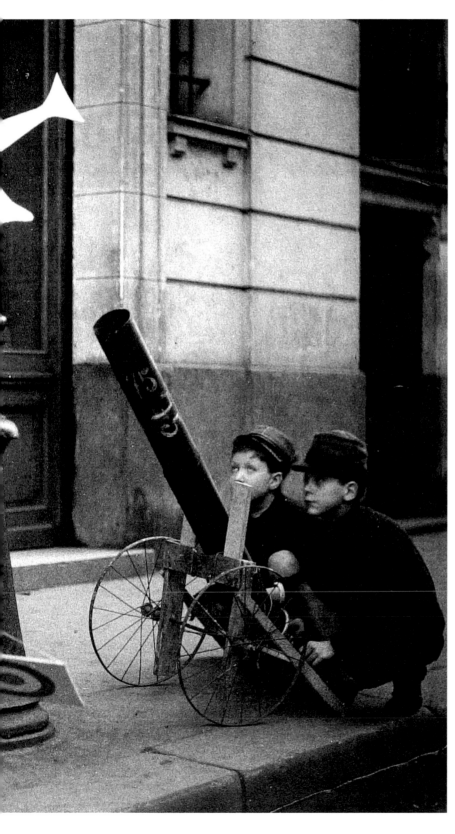

LEFT
The enemy airplane is shot down.

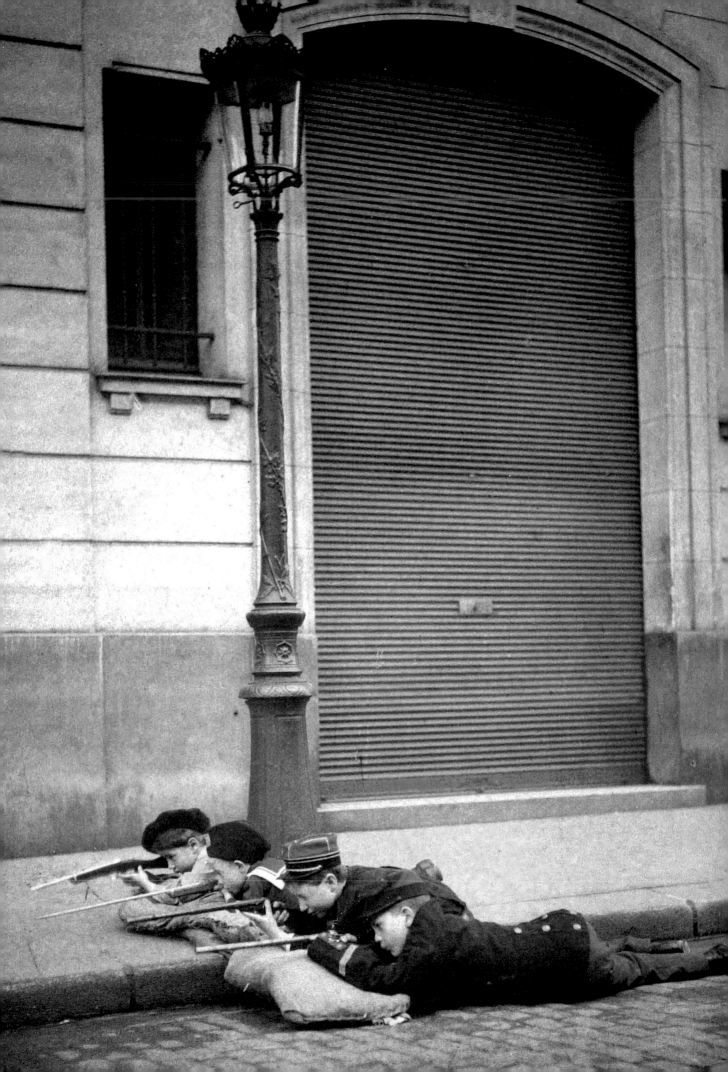

OPPOSITE
Street fighting.

BELOW
The prisoner of war is interrogated.

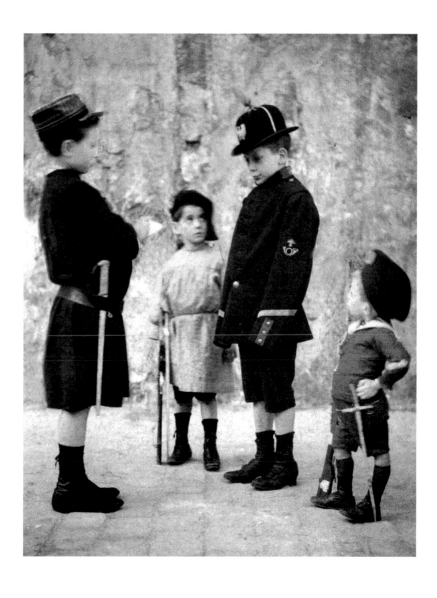

War Games in Paris 1915

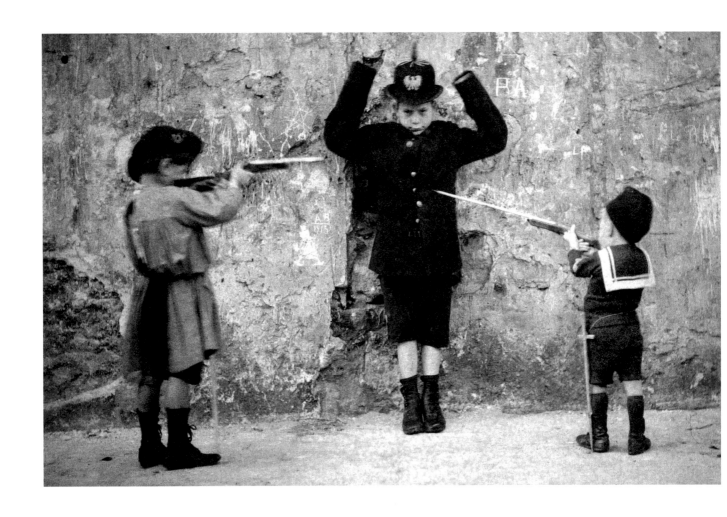

ABOVE
A "Boche" is captured. The eldest child took the role of the German.

OPPOSITE
Execution of a prisoner of war. The photographer noted: the classic firing squad was already lined up when the leader interrupted and after a few minutes returned with a cannon. "To shoot a Boche," he said, "you shouldn't use anything other than a cannon."

1915 War Games in Paris

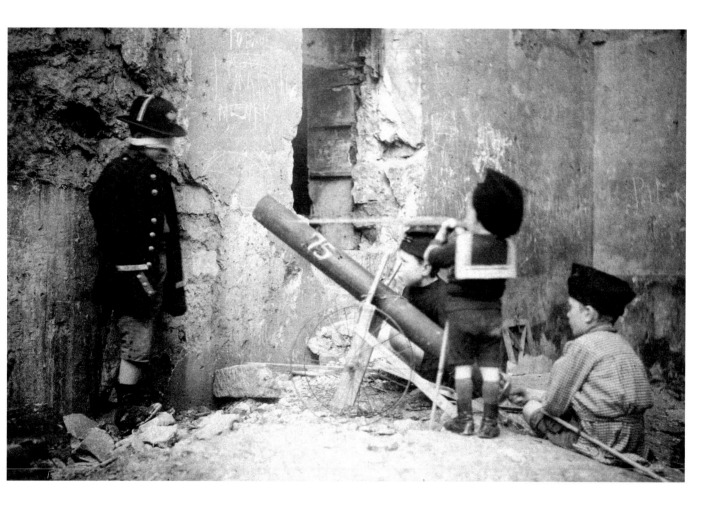

War Games in Paris 1915

ABOVE
The victorious children's army.

OPPOSITE
*Advertising column whose surface was
covered with a continuous poster in the
colours of the tricolour. Gimpel documented
how the streetscape in Paris changed in
the course of the upsurge in patriotism.*

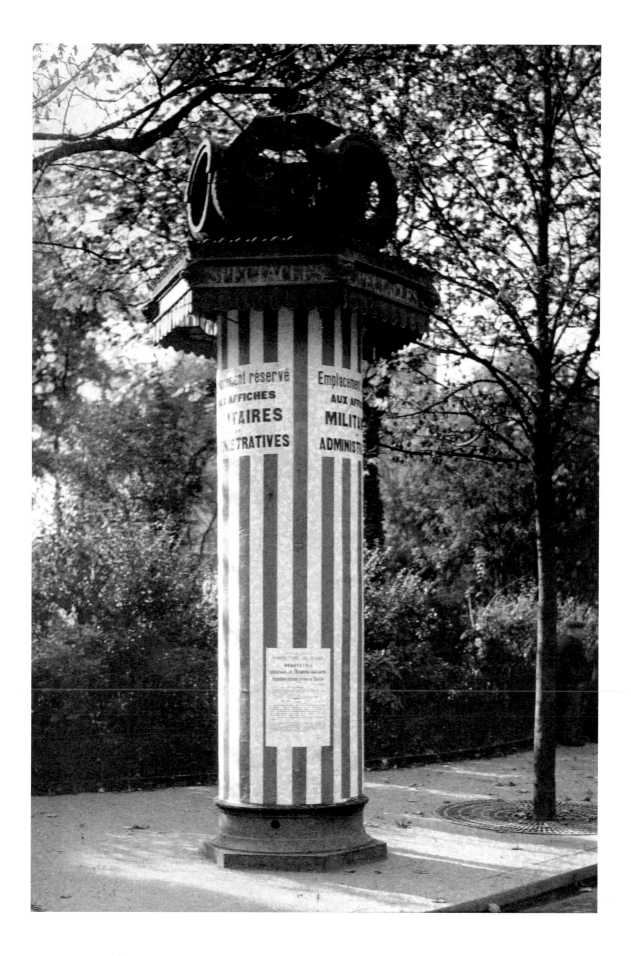

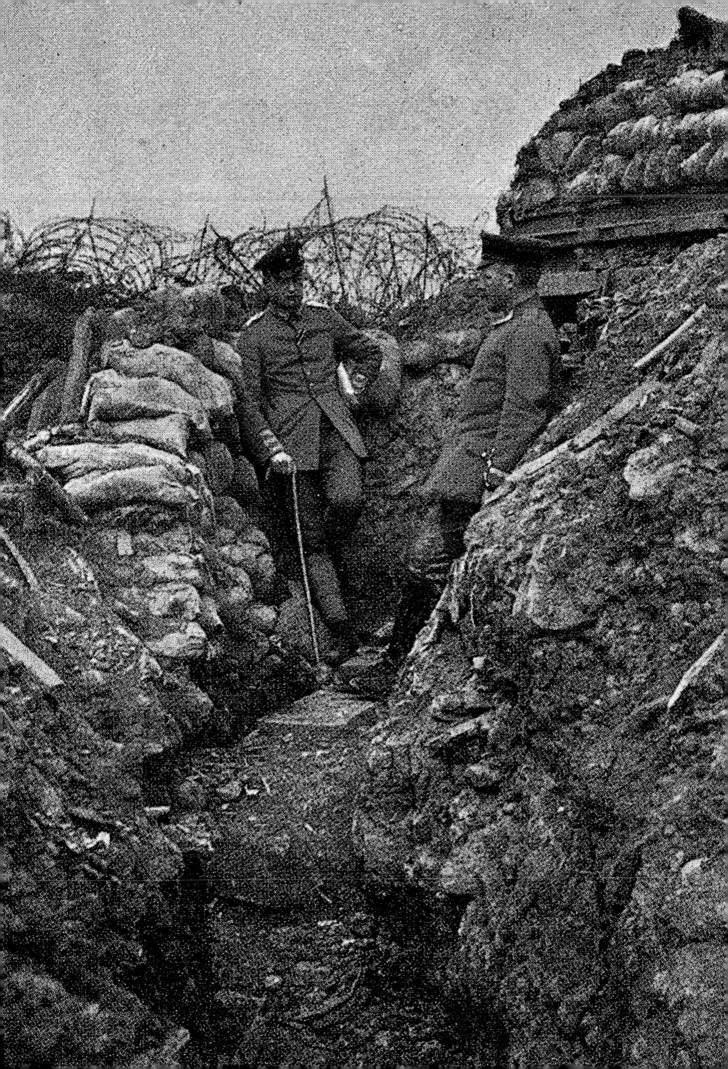

1916 – The Great Slaughter

In 1916 a military resolution was to be forced by will of the Entente and the Central Powers in the West. At the end of February the great German offensive against Verdun began with an enormous deployment of materiel, lasting over four months. Under the command of Henri Philippe Pétain, the Commander of the 2nd Army, the fortifications largely withstood the onslaught of the Germans. Territorial gains of a few hundred yards were paid for with the deaths of tens of thousands. As the German offensive broke in July, both sides mourned the more than 300,000 dead.

In the East, the offensive under command of the Russian General Aleksei Brusilov was to wear down the Central Powers in a two-front war. The successful advance of the Russians led to great losses in the Austrian-Hungarian army and could only be stopped through the efforts of German troops from the Western Front. In late August, entering the war on the side of the Entente was Romania, which had received far-reaching assurances of territorial expansion to the detriment of Austria-Hungary.

In Alsace-Lorraine the front had been stalled since 1915. At the Somme, on the other hand, the Entente offensive against German positions began in July after a continuous five-day-long bombardment. For the British the Somme offensive brought the heaviest losses yet; nearly 20,000 soldiers being killed on the first day in the hail of German machine-gun fire. In two further waves of attacks at the end of July and beginning of August the Entente was able to achieve short-term success against Germany.

By the end of the year the Germans had not been pushed back even 6 miles (10 kilometres). The fighting during the Somme offensive cost the lives of well over a million soldiers. By the war's third year in 1916, battle fatigue spread increasingly in Germany and Austria-Hungary, and also in France and Italy. In December, at the insistence of Austria, the Central Powers proposed taking up peace negotiations with the Entente nations. That was rejected, as was the offer of mediation by U.S. President Woodrow Wilson.

OPPOSITE
Bombed-out German trenches, 1916.
Photo: Hans Hildenbrand

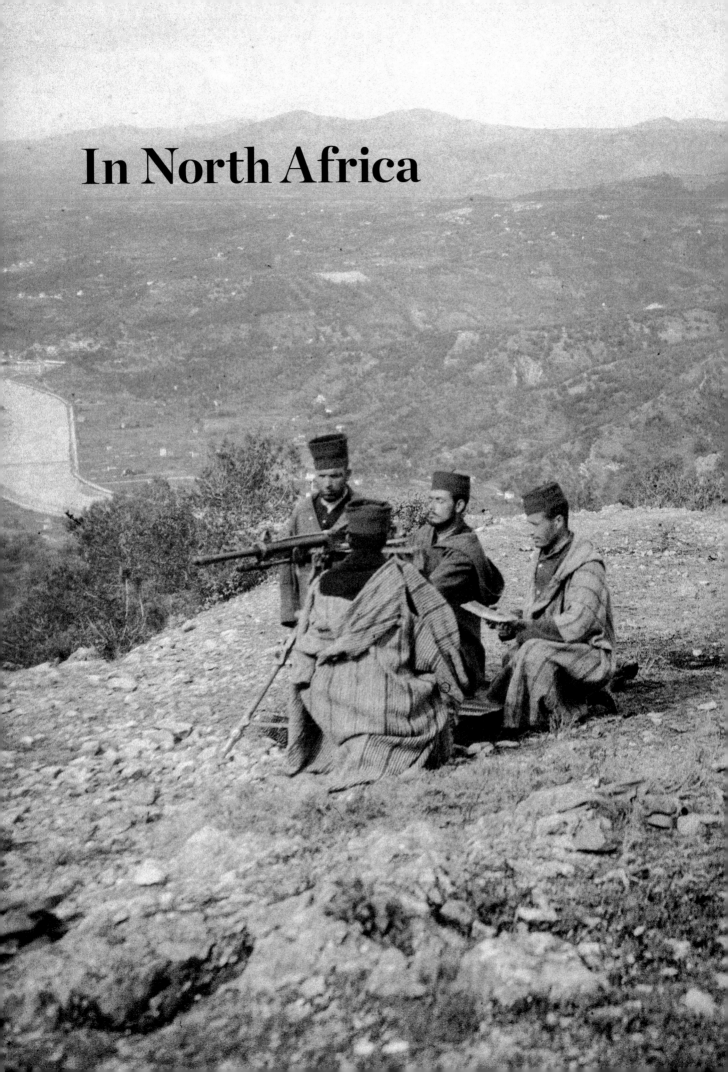

In North Africa

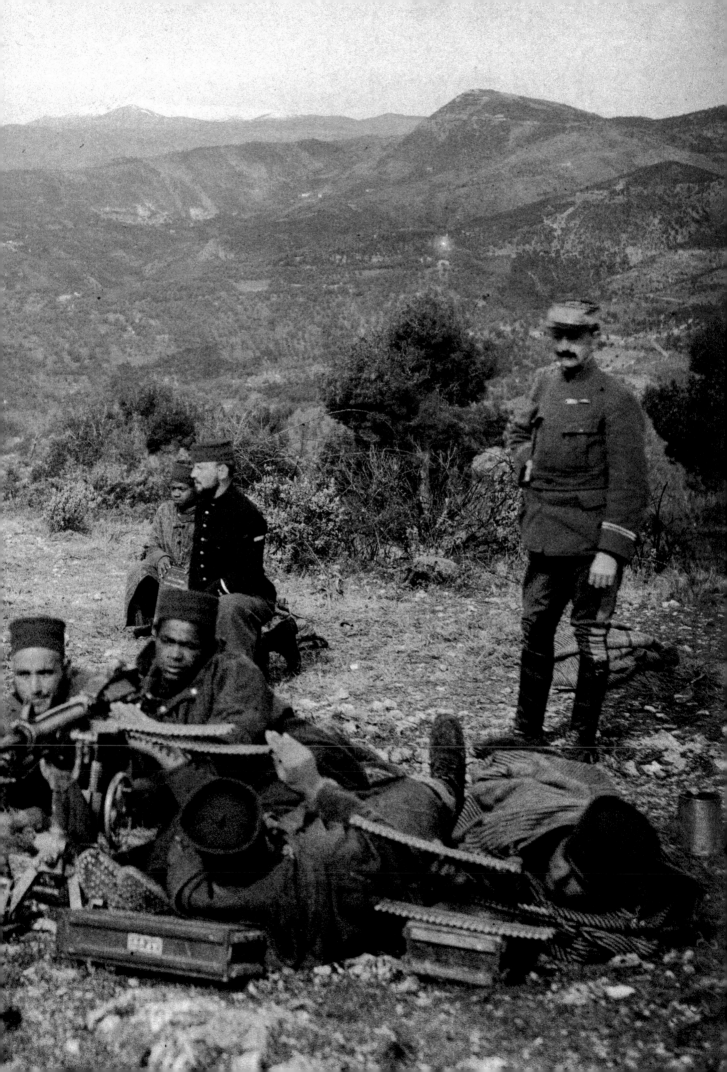

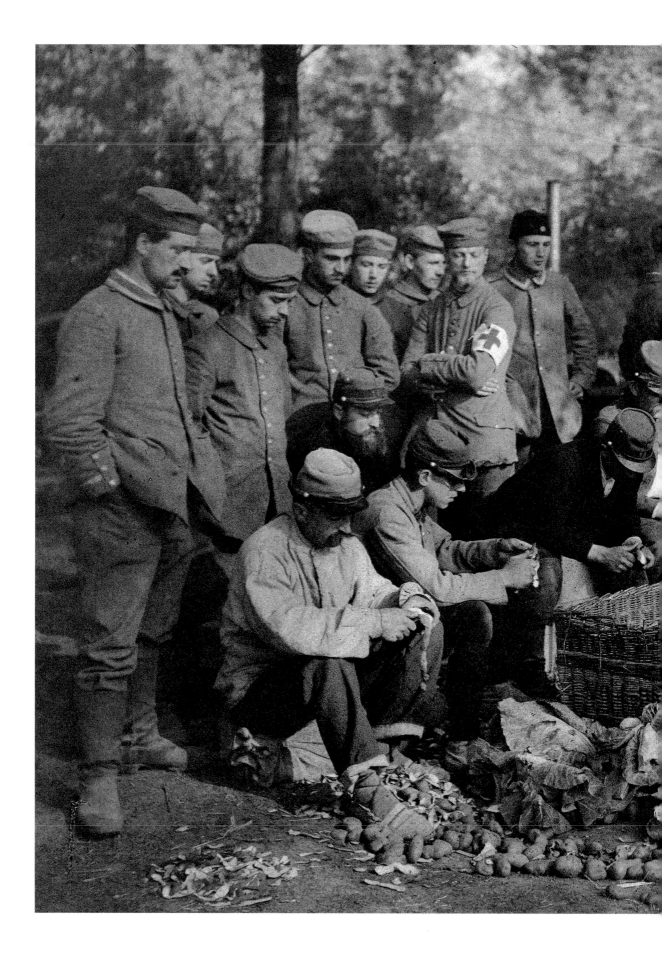

1916 In North Africa

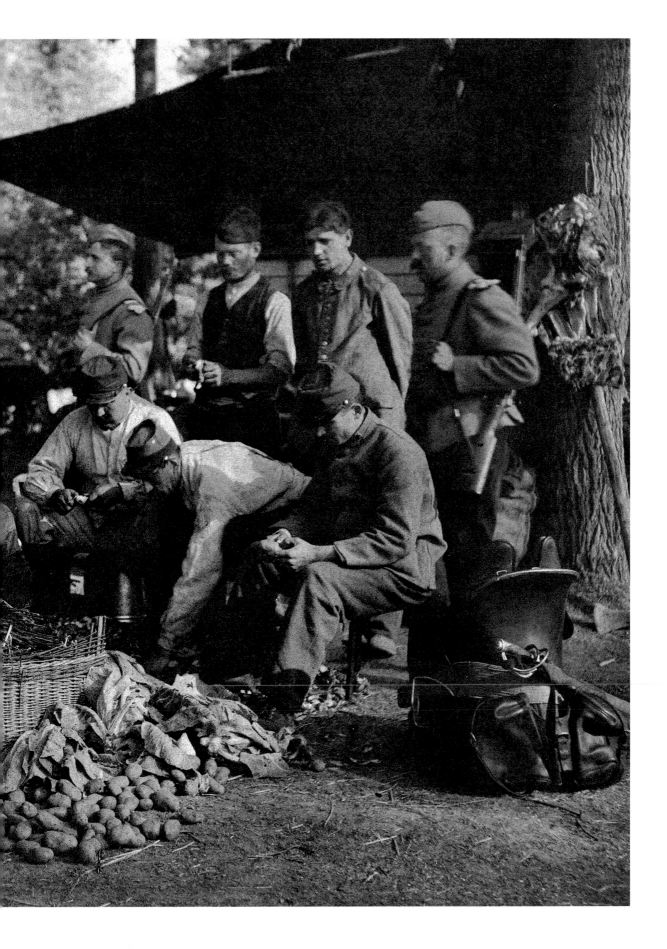

In North Africa 1916

PAGE 126/127
Machine guns protect a convoy,
southern Tunisia, 20 March 1916.
Photo: Albert Samama-Chikli

PAGE 128/129
German prisoners of war watch French
soldiers peeling potatoes as a punishment
under the eyes of Hussars, Barika
(Algeria), around 1916.
Photo: Jean-Baptiste Tournassoud

ABOVE
Medenine. Soup is portioned out to the
families of the rebels, March 1916,
All photos from page 130 to page 133:
Albert Samama-Chikli

ABOVE
Military camp in Medenine in southern
Tunisia, March 1916. An initial nationalist
uprising, supported by the Ottoman Empire,
against colonial rule was repressed in
autumn 1915.

*The war will never end—since even when it
has finished it will continue to poison us,
much like the wounds that kill you six months
after you received them.*

FRANÇOIS MAURIAC TO MADELEINE LE CHEVREL, JULY 1916

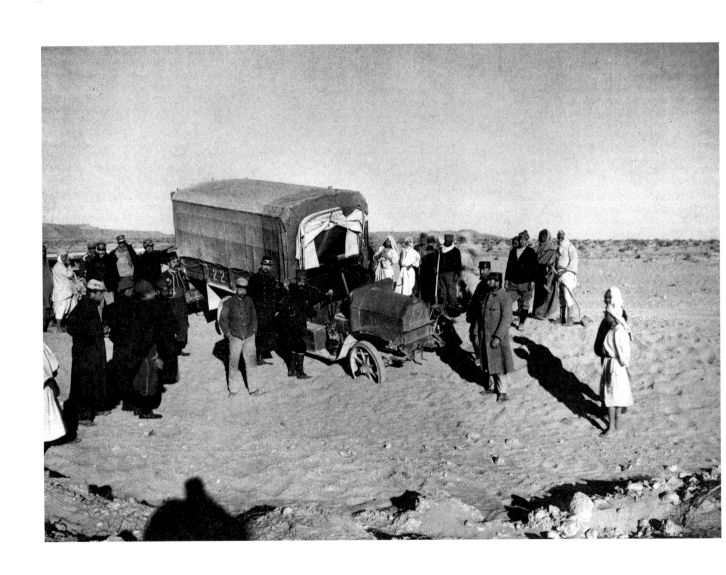

1916 In North Africa

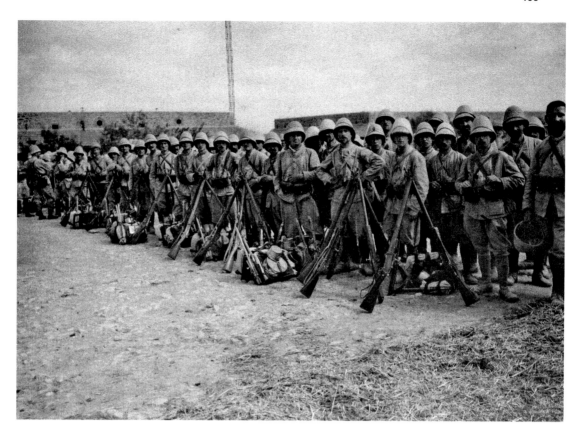

On the way from Gabès to Foum Tataouine,
a truck remained stuck after a sandstorm,
March 1916.

A Zouave Unit returns to Tunisia
from Alsace-Lorraine, late March 1916.
Photos: Albert Samama-Chikli

The Battle of Verdun

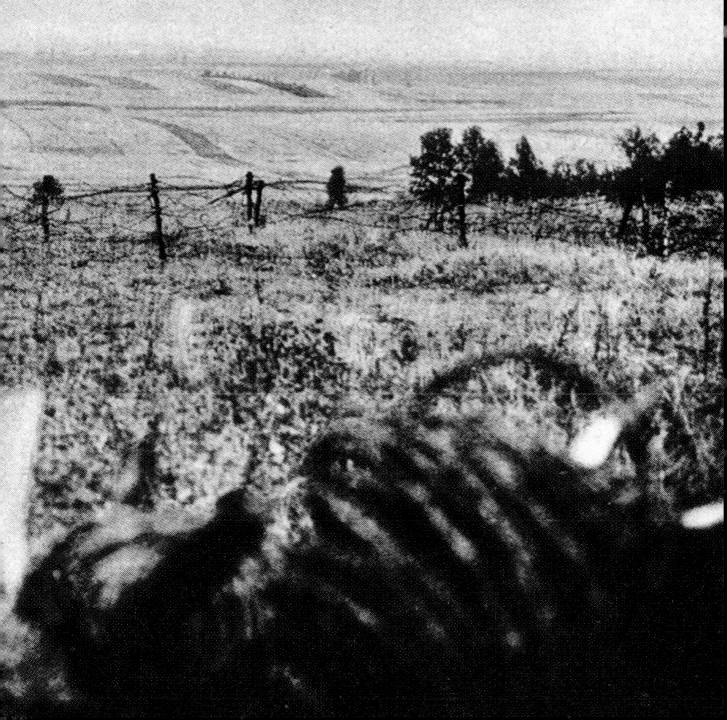

PAGE 134/135

Verdun, Côte 304. This part of the front was of great strategic importance since it was possible to survey the forefields as well as the approaches from here. The hill was fiercely fought over from March 1916, and from May 1916 German troops held the position here, abandoning it only in the French counter-offensive of August 1917.

ABOVE

General Pétain. Philippe Pétain was known as the "Hero of Verdun" and was very popular on account of his strategies that aimed to avoid loss of life. In 1917 he took over com-mand of the French army from Nivelle. As head of state of the Nazi-collaborating Vichy regime during the Second World War (1940–1944) in the unoccupied part of

France he was initially sentenced to death in 1945, but was granted a reprieve of life in prison and exile by Charles de Gaulle. Pétain and de Gaulle had known each other since 1910.

All photos from page 134/135 to page 151: Jules Gervais-Courtellemont

General Nivelle. On both sides about 2.5 million soldiers faced each other at Verdun. The commander of the 2ⁿᵈ Army stationed in Verdun was Robert Nivelle from May 1916 on. Because of his service in the defence of Verdun he was appointed commander-in-chief of the French army in December 1916. The unsuccessful offensive at Chemin des Dames, which was associated with a high loss of life, cost him this position in May 1917.

1916 The Battle of Verdun

LEFT
Field hospital at the front near Verdun, 1916. In late February 1916 the battle that became the epitome of colossal, senseless death in the First World War began. It ended on 20 December 1916, without a significant shift of the front line. It is estimated that during these months around 350,000 soldiers lost their lives on all sides.

The Battle of Verdun 1916

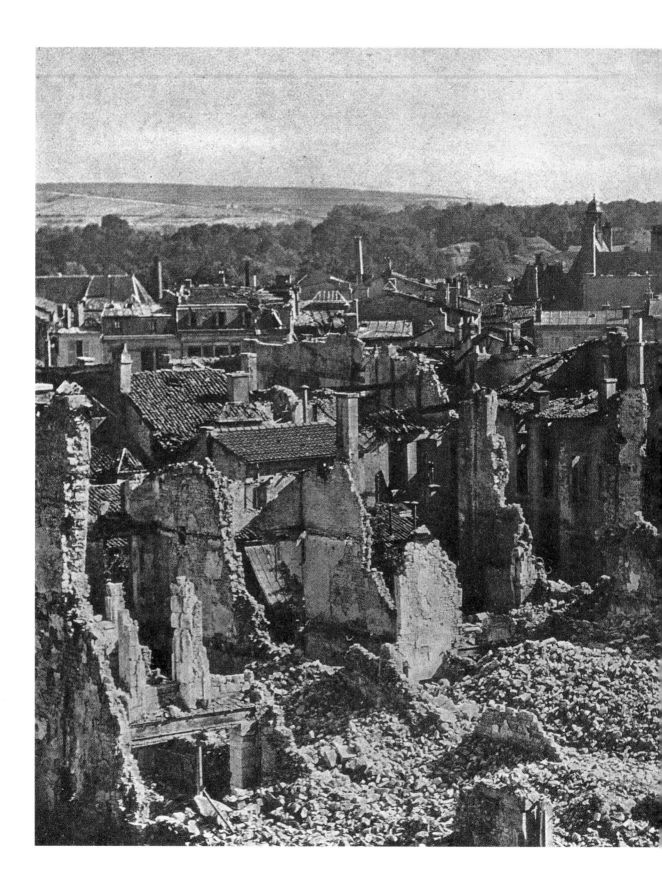

1916 The Battle of Verdun

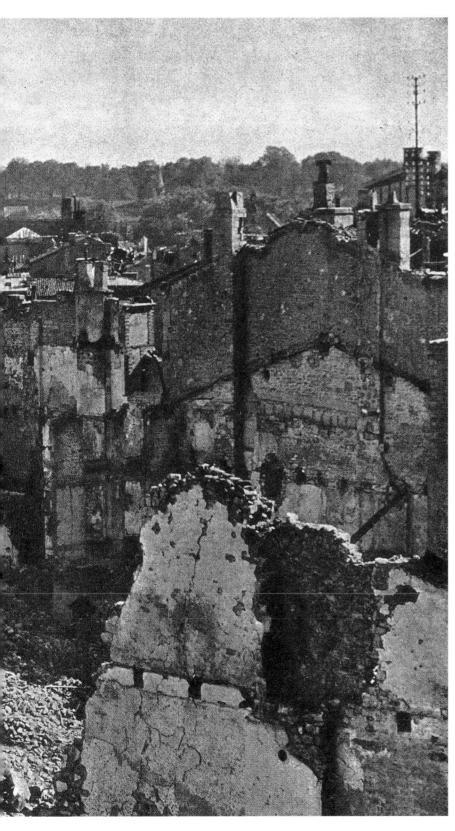

LEFT
View of Verdun, 1916.

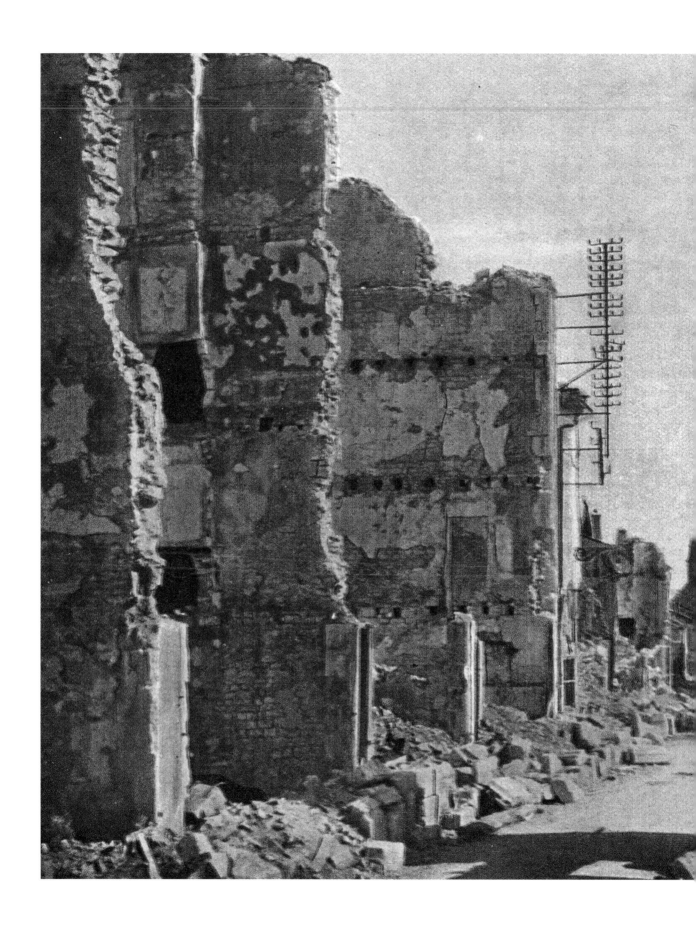

1916 The Battle of Verdun

Standstill at Verdun; the worst that could happen. The war can last years after this failure of our offensive. All those sacrifices, untold sacrifices, made for nothing. The French must have fought incredibly bravely ...

ERNST GLÖCKNER, DIARY, 1 MARCH 1916

LEFT
Street in Verdun, 1916.

The Battle of Verdun 1916

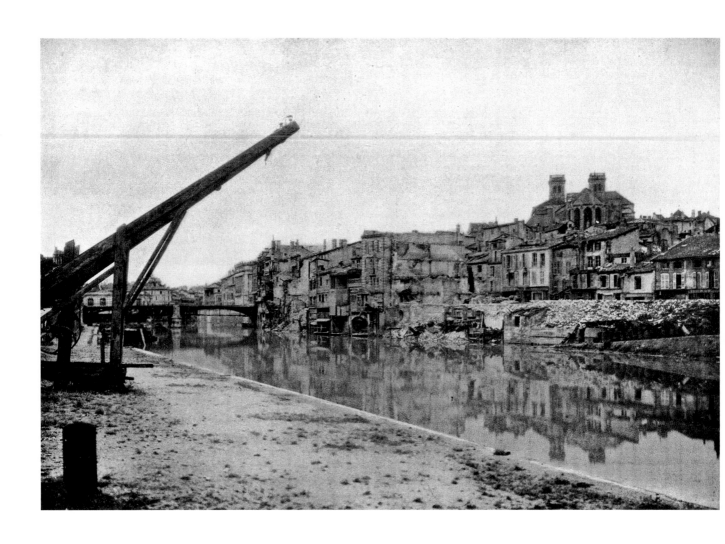

1916 The Battle of Verdun

View across the Meuse of the devastated Verdun.

Barber in the casemate of Verdun, 1916.

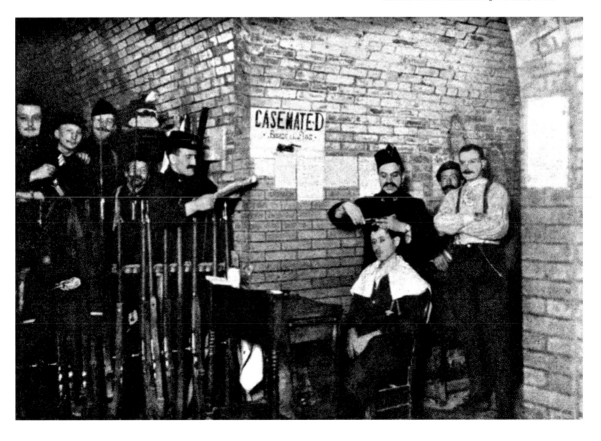

RIGHT

Fort Moulainville. The fort is said to be the most heavily shelled fortification in the First World War. The soldiers had to seek safety from the cannon fumes and penetrating blasts in underground tunnels dug during the bombardment.

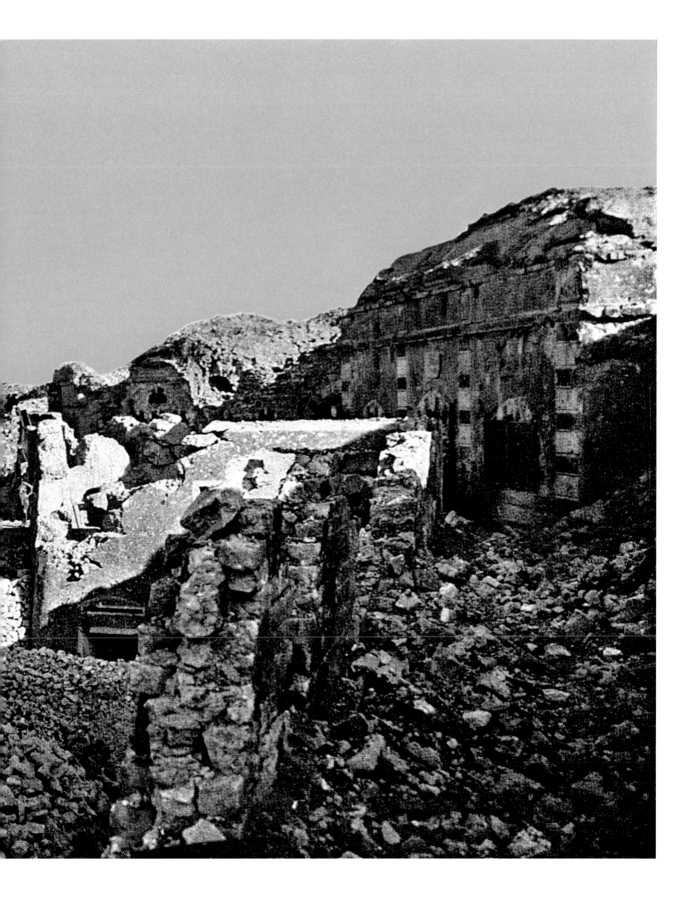

The Battle of Verdun 1916

My dear friend, I would have never believed that the hell of Verdun would be beaten. I suffered dreadfully there. Now that it's over it can be said. But not enough: now we have been sent to the Somme. And here everything is increased: hate, dehumanisation, horror, blood.

PAUL ZECH TO STEFAN ZWEIG, 12 JULY 1916

BELOW
Central assembly point for American ambulances, Verdun, 1916.

RIGHT
An ambulance from the United States.

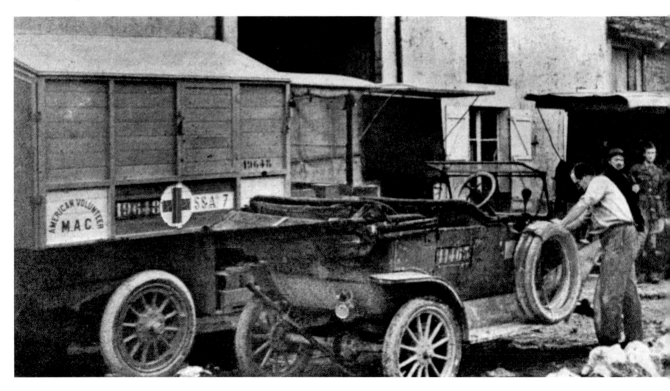

1916 The Battle of Verdun

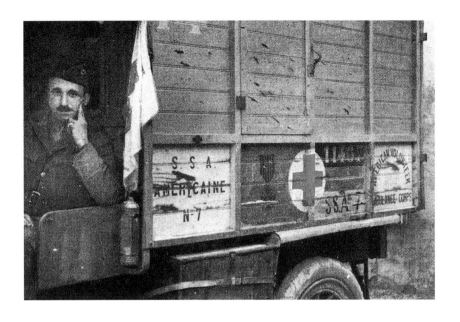

The Battle of Verdun 1916

The Army as a life is a curious anomaly; here we are prepared—or preparing—to lay down our lives for another, the highest moral act possible, according to the Highest Judge, and nothing of this is apparent between the jostle of discipline and jest. Again, we turn from the meanest of jobs scrubbing floors, to do delicate mapping, and while staying in for being naughty, we study the abstractions of Military Law.

WILFRED OWEN TO SUSAN OWEN, 18 MARCH 1916

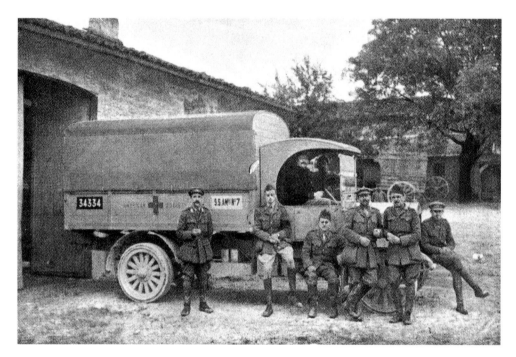

ABOVE
A U.S. ambulance. The United States supplied the Entente with combat equipment long before the official U.S. entry into the war in April 1917.

OPPOSITE
The first gas masks, 1915. The plates were likely to have been inadvertently double-exposed. The expressive visual effect results from the superimposition of the same subject shot in both portrait and landscape format.

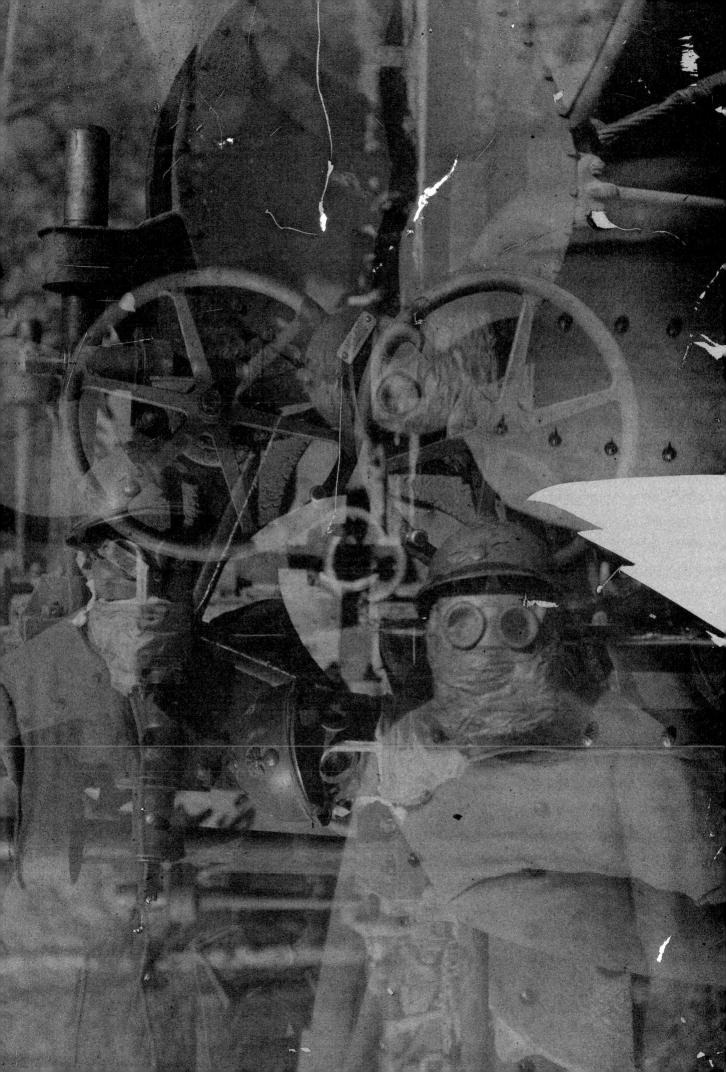

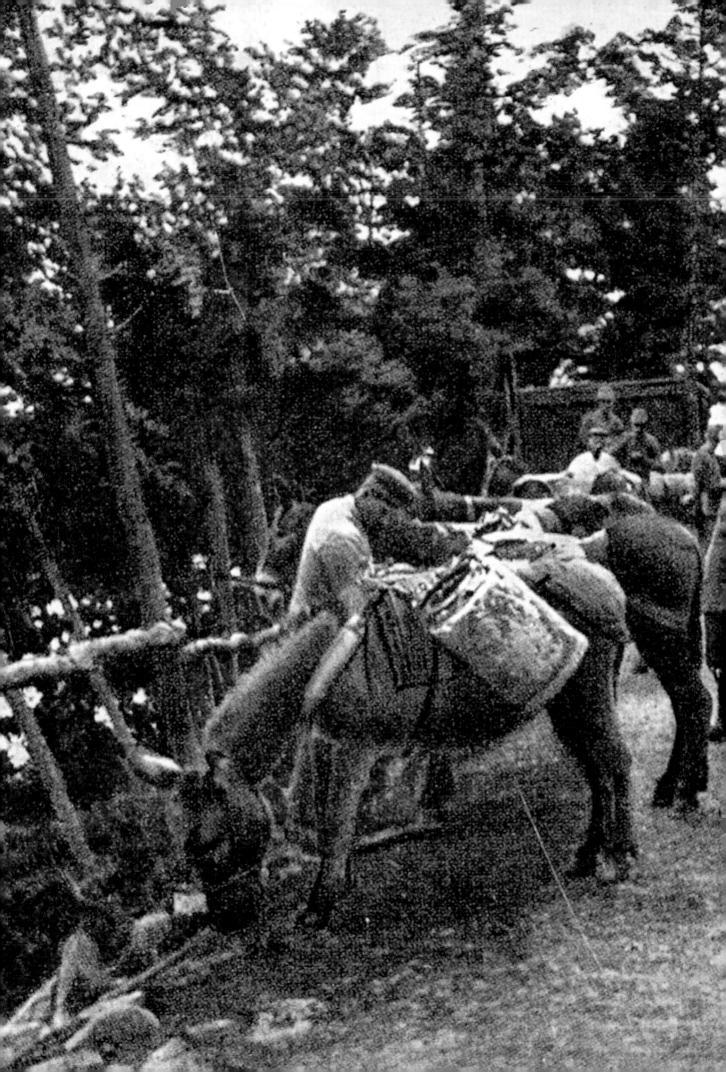

German Troops
in Alsace
and the Vosges

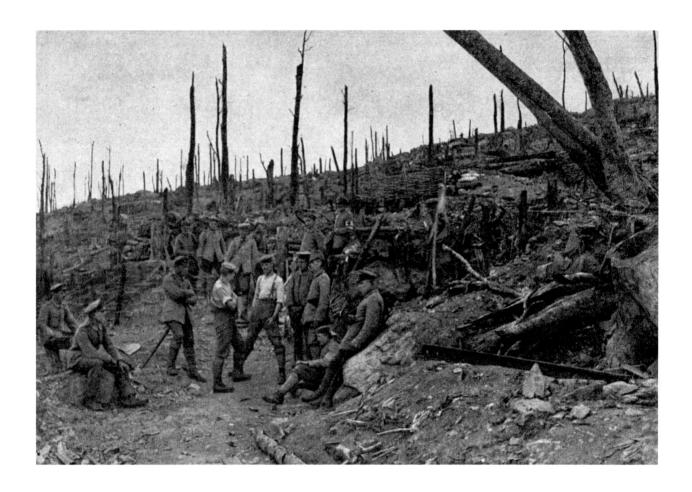

1916 German Troops in Alsace and the Vosges

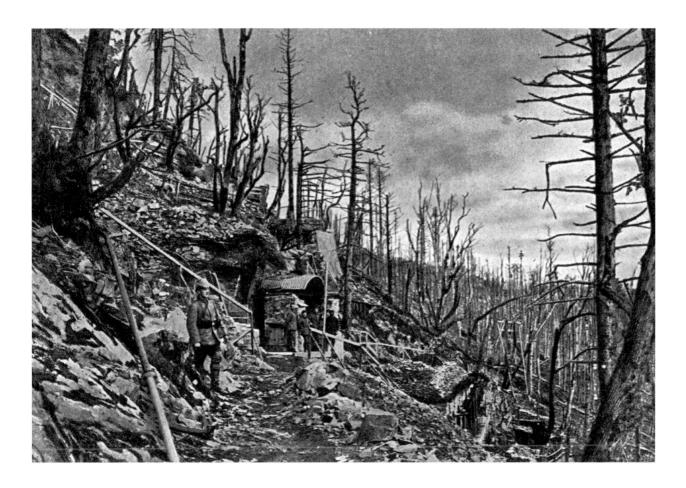

PAGE 152/153
Quarters on Hartmannswillerkopf.
All photos from page 152/153 to page 167:
Hans Hildenbrand

OPPOSITE
On Hartmannswillerkopf. The time between the offensives was used to build up positions. The dugouts were reinforced and made shell-proof with concrete construction.

ABOVE
On Hartmannswillerkopf. As Hildenbrand photographed the war zone in late summer 1916, the front line had been positioned on the mountain for more than a year.

*I am deeply convinced that France—historically, as a whole—
is today without any mission, any mandate, blind to the times,
condemned, disoriented, hopeless, that it fights a lost battle,
a needless fight from every other but the heroic standpoint,
and that all historical law, all real modernity, future, and
certainty of victory is with Germany.*

THOMAS MANN TO PAUL AMANN, 3 AUGUST 1915

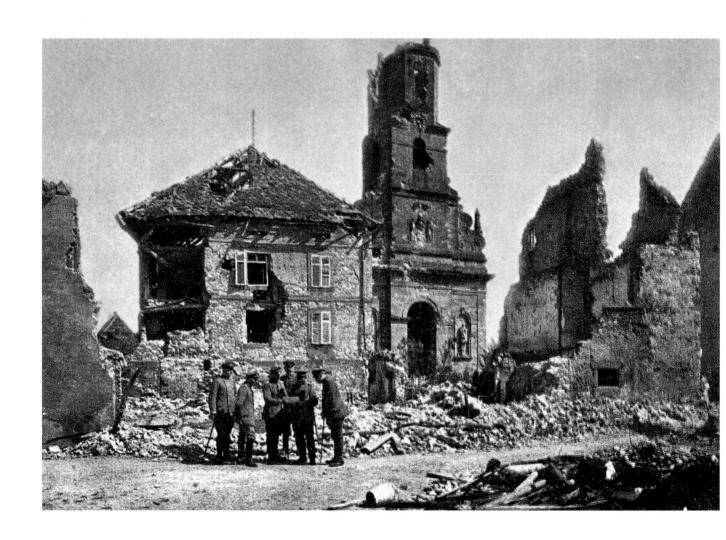

1916 German Troops in Alsace and the Vosges

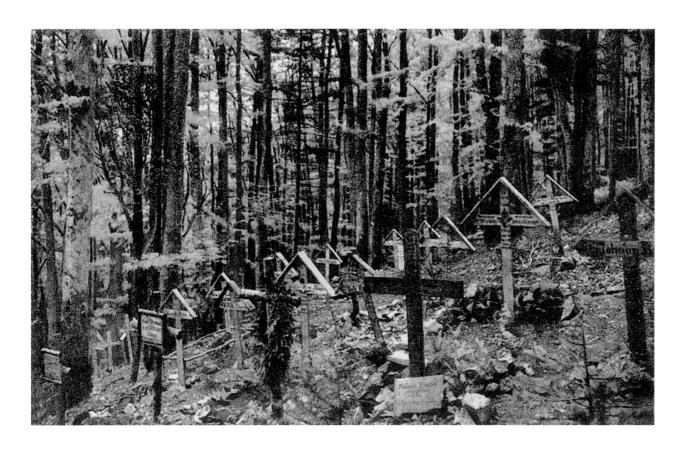

OPPOSITE
*Church in Uffholtz, 1916. The destruction
of churches, which were often military
targets because of their exposed locations,
gained a symbolic character after the bom-
bardment of Reims Cathedral. The motif
of destroyed churches in Alsace, frequently
used by the Germans, could also be seen as
an answer to the propaganda offensive of
the Allies.*

ABOVE
*Graves on Hartmannswillerkopf.
A total of about 30,000 soldiers from
both sides lost their lives here.*

I have to hold on to the words a brave woman back home said to her children: "You can read a poem by Goethe when you don't have butter. Other children cannot."

RUDOLF G. BINDING, DIARY, FEBRUARY 23, 1916

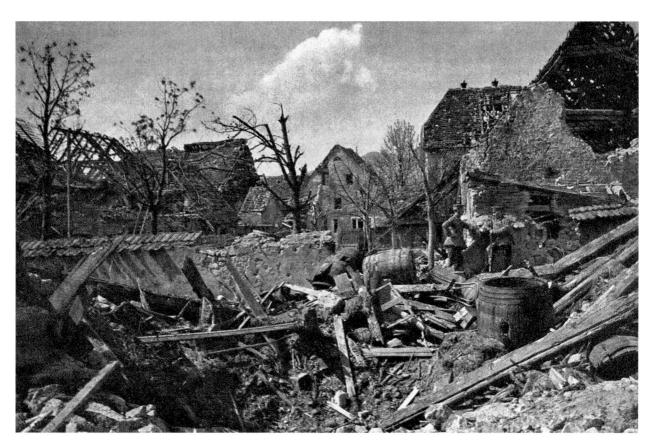

ABOVE
Ruins in Uffholtz (Alsace). The region was contested from the beginning of the war as the French invaded Alsace.

OPPOSITE
Trenches in Upper Alsace.

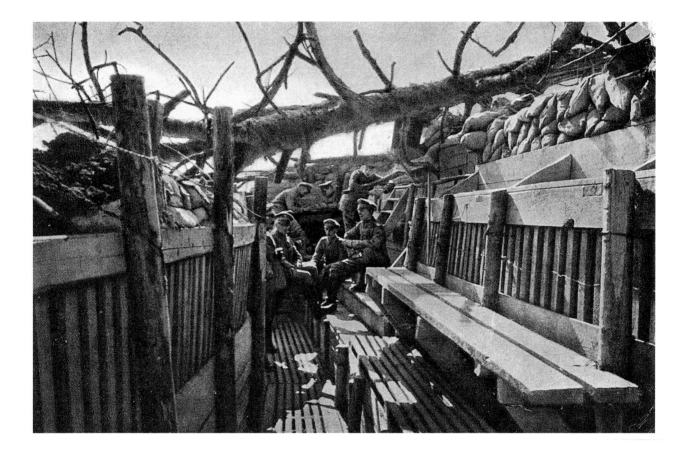

German Troops in Alsace and the Vosges 1916

RIGHT

Hartmannswillerkopf. This mountain in the Vosges was one of the most heavily contested points of the Western Front from January 1915 to November 1918. The barren spots at the summit were caused by months of shelling.

German Troops in Alsace and the Vosges 1916

162

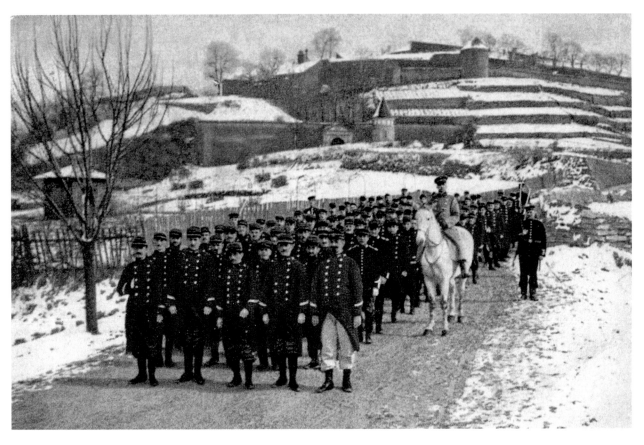

ABOVE
*French prisoners of war at the Hohenasperg
fortress, presumably late 1916.*

OPPOSITE
*The visit by photographer Hans Hildenbrand
on Hartmannswillerkopf is recorded in the
diary of the Guards Rifle Battalion. Assigned
as Hildenbrand's guide was Private Sass,
seen with a helmet at left in the image.*

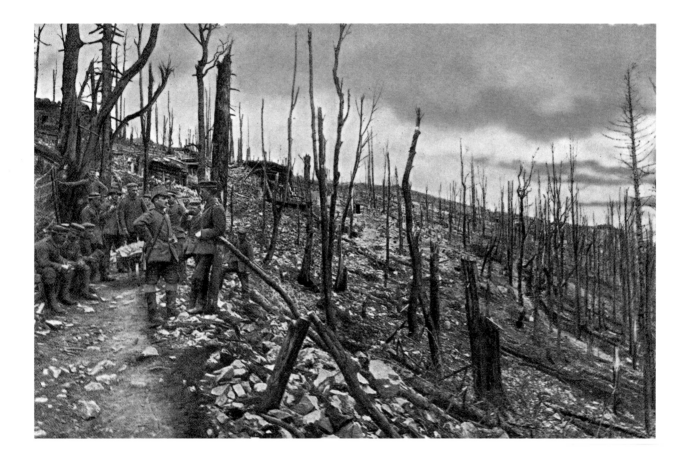

German Troops in Alsace and the Vosges 1916

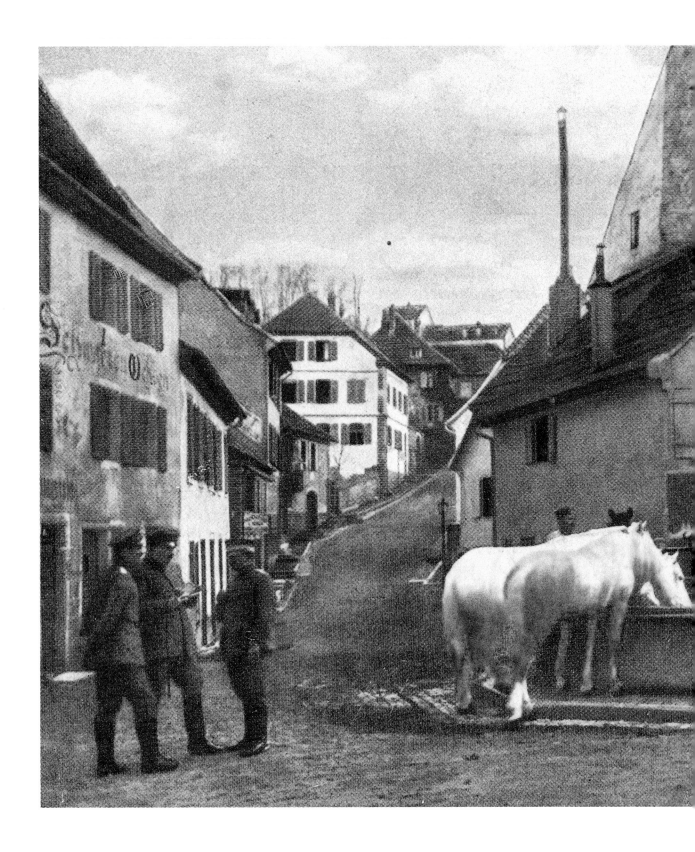

1916 German Troops in Alsace and the Vosges

LEFT
Altkirch in the Vosges, presumably late 1916. The majority of the population in Alsace-Lorraine were characterised as linguistically and culturally German, but mentally and politically rather more oriented towards France. Although the residents of the Alsace-Lorraine that belonged to the German Reich after 1871 stood clearly on the German side in 1914, both the German and the French military mistrusted the loyalty of the population. At the end of the war sentiment tipped in favour of the victorious French, who were greeted as liberators.

German Troops in Alsace and the Vosges 1916

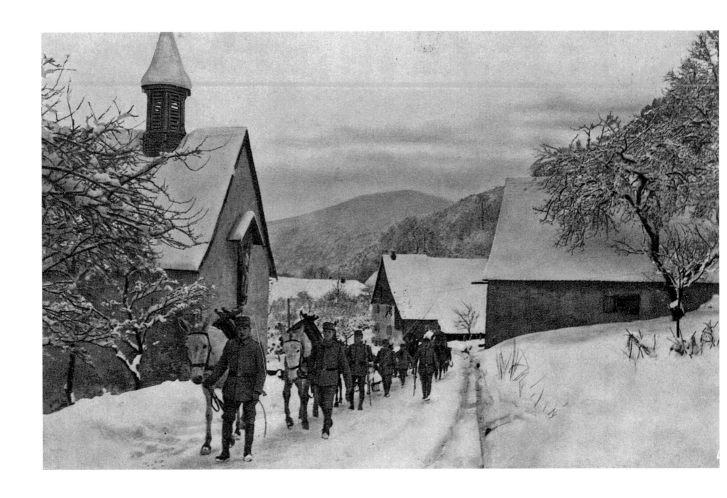

To me, peace or no peace is exactly the same;
on the one hand, I still expect much from the war,
on the other hand, I also have to say that soon
I just want to fly like the petrel into the sunny
distance and let the wide world in all its splendour
inspire me.

ERNST JÜNGER, WAR DIARY, 12 DECEMBER 1916

1916 German Troops in Alsace and the Vosges

OPPOSITE
*German soldiers on the village road
in Linthal, a small town in the Vosges,
winter 1916.*

BELOW
Dugout in the Vosges in winter 1916.

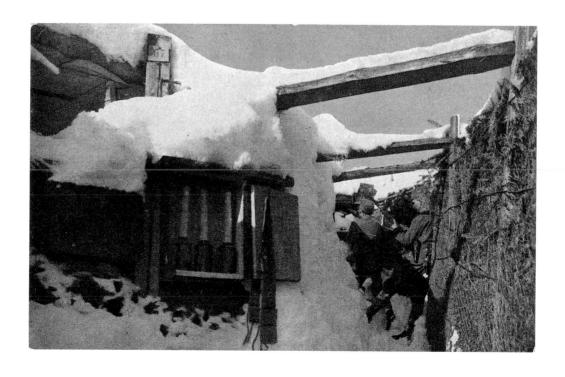

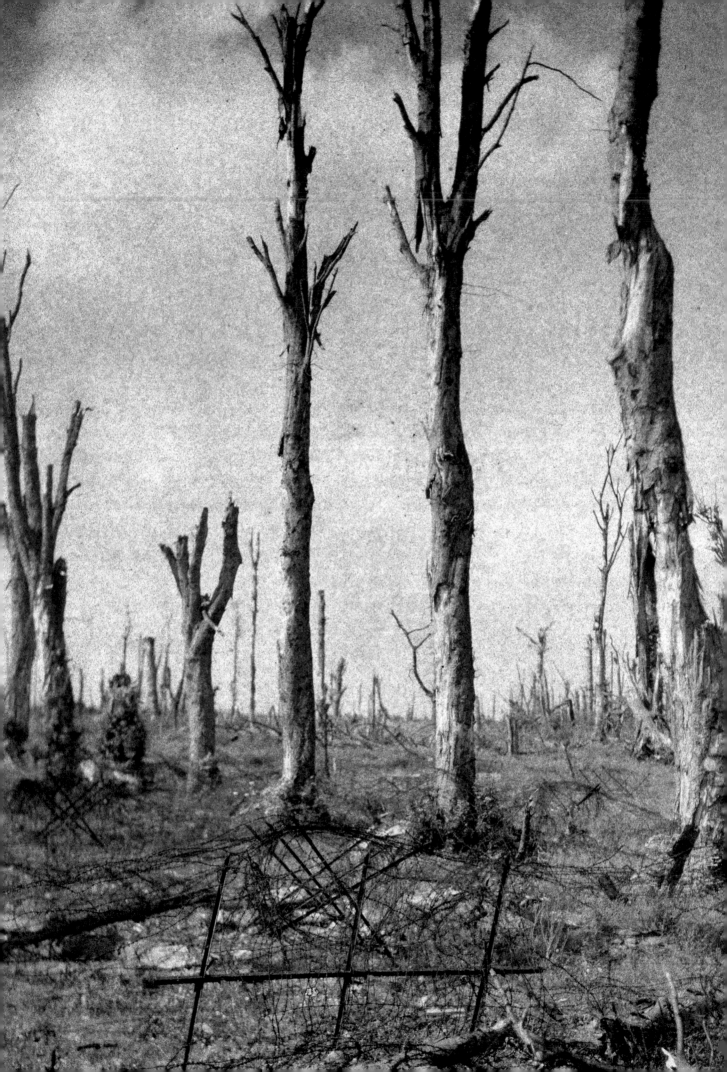

1917 – The Decisive Year

On 8 March (or 23 February, according to the Julian calendar) the February Revolution broke out in Petrograd, today St. Petersburg, which ended the tsarist regime in Russia. To destabilise the situation further the German government enabled the transit of Lenin and a group of Bolsheviks out of Swiss exile through Germany and Finland to Russia. While Lenin banked on the war weariness of the population and pushed for an immediate peace, the provisional Russian government under Alexander Kerensky launched an offensive that soon stagnated. There were large-scale desertions and breakdowns in morale which the Central Powers exploited to conquer large areas in the East. After the Bolsheviks seized power in October, peace negotiations began in December between Russia and Germany.

In the West the Germans scaled down the front line by retreating to the heavily fortified Hindenburg Line. The region they left behind was systematically devastated and partly mined. In April and May the French and British pushed forward in coordination in the Battle of Arras as well as in the two battles on the Aisne and in Champagne against the Hindenburg Line. The attack by the French on the line between Soissons and Reims was initially successful, however, the territory was lost again in the following year. Both offensives had to be broken off in May with heavy losses, leading to mutinies in the French army. General Pétain, who took over the French command from General Robert Nivelle, managed to stem the mutinies. In November the British armed forces were able to deploy tanks for the first time, which penetrated the German lines up to 6 miles (10 kilometres) deep near Cambrai in Nord-Pas-de-Calais department.

The final decisive development was the entry of the United States into the war in April 1917. A resumption of unrestricted submarine warfare preceded this. In May 1915 the *Lusitania*, a British passenger ship sailing from the United States, was sunk without warning off the Irish coast by a German U-boat. Close to 1,200 people lost their lives, including 128 Americans. The ship sailed without a flag and was loaded with munitions. U.S. President Wilson gave two ultimatums to the German government for the guarantee of free movement of ships from neutral countries from then on. In February 1917 Germany took up unrestricted submarine warfare again. And in March it was made known that Germany addressed a secret offer of alliance to Mexico in the foreseeable event that the United States would break its neutrality. Both events strengthened the anti-German atmosphere in the United States and ultimately led to the U.S. military engagement on the side of the Entente.

OPPOSITE
View of the Chaulnes castle grounds, 1917. The town was part of the "Red Zone" in the territories that were especially affected by the war and was initially not to be rebuilt.
Photo: Fernand Cuville

Life
in the Ruins

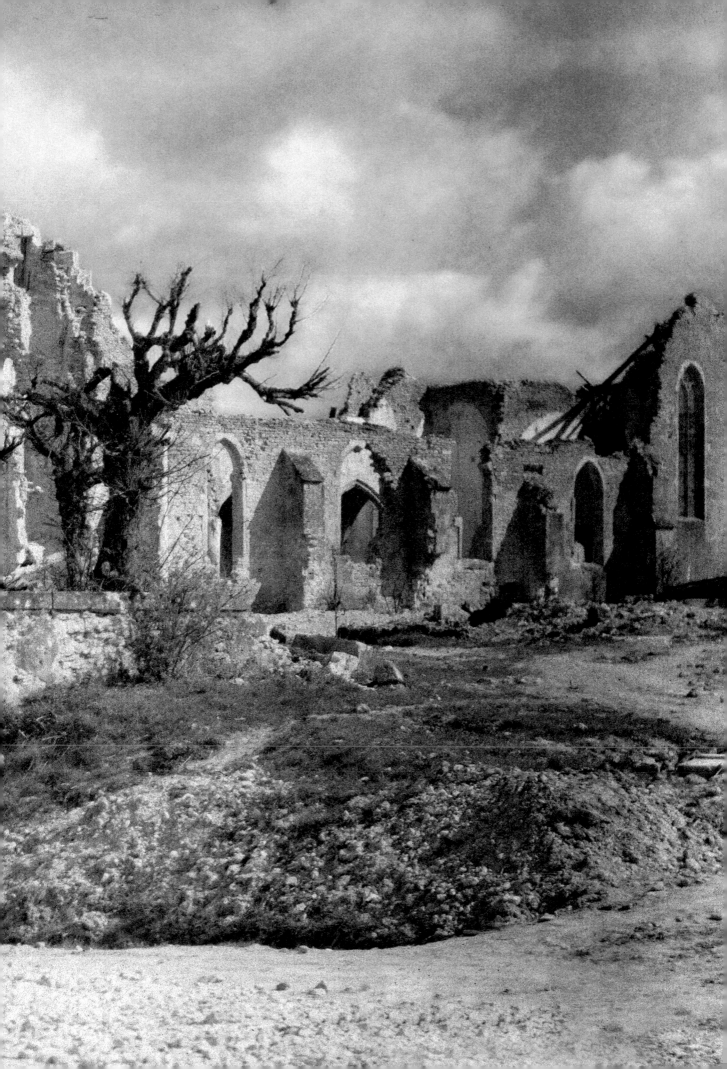

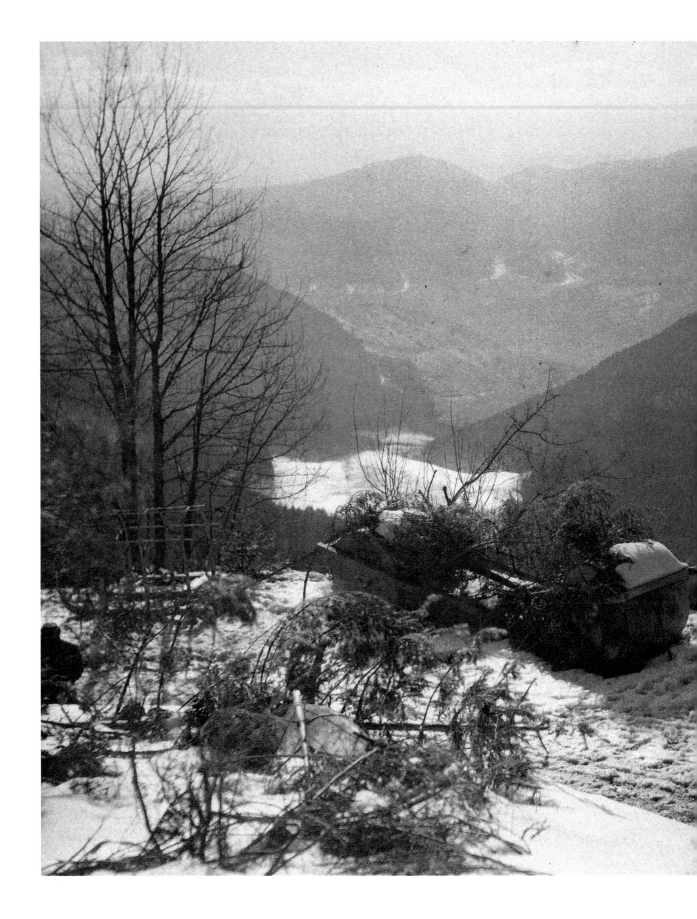

1917 Life in the Ruins

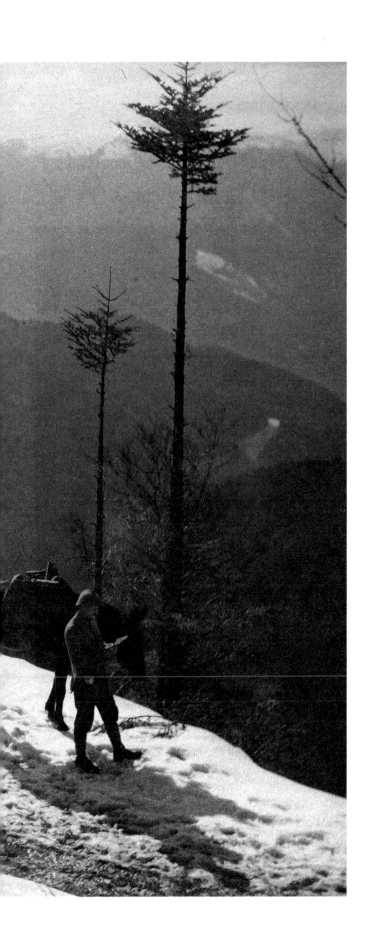

PAGE 170/171
A destroyed church.
Photo: Jean-Baptiste Tournassoud

LEFT
A French soldier in the Vosges, 1917.
Mules were put to use in the First World War
predominantly by the mountain troops.
Photo: Pierre Machard

Life in the Ruins 1917

*Filling of kegs with gunpowder, the men
barely protected with aprons and goggles,
1917.*
Photo: Jean-Baptiste Tournassoud

*French Officers at machine-gun training,
around 1917.*
Photo: Albert Samama-Chikli

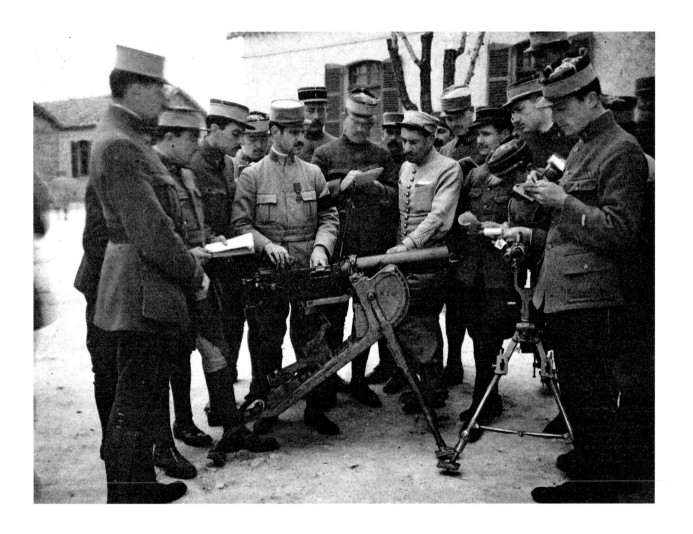

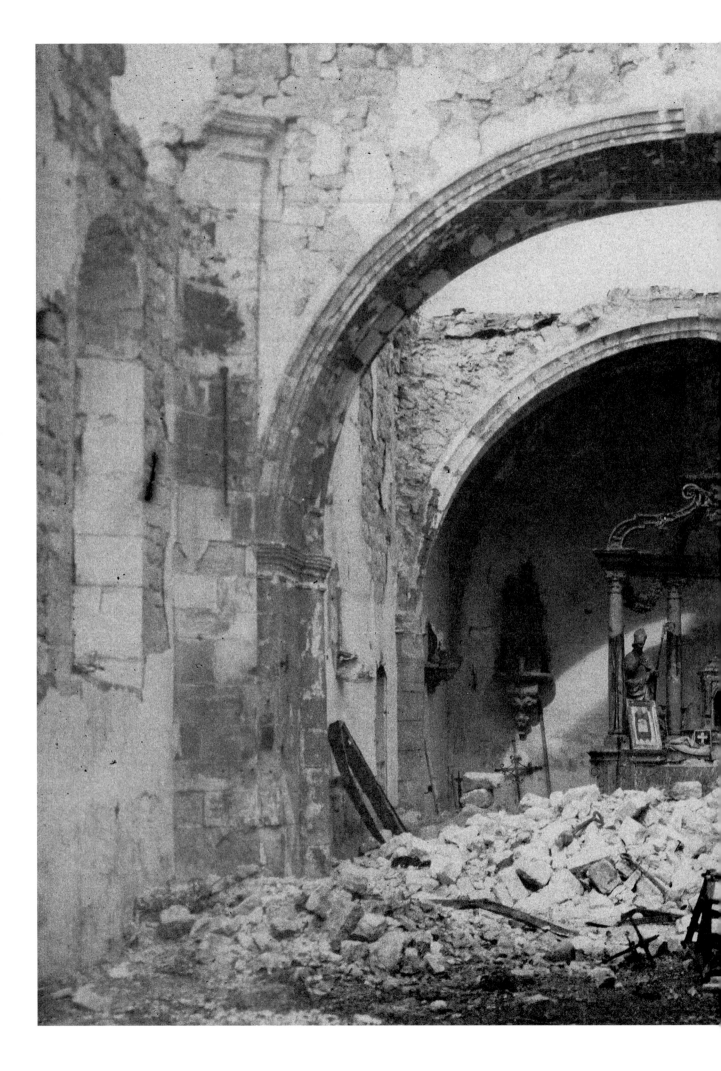

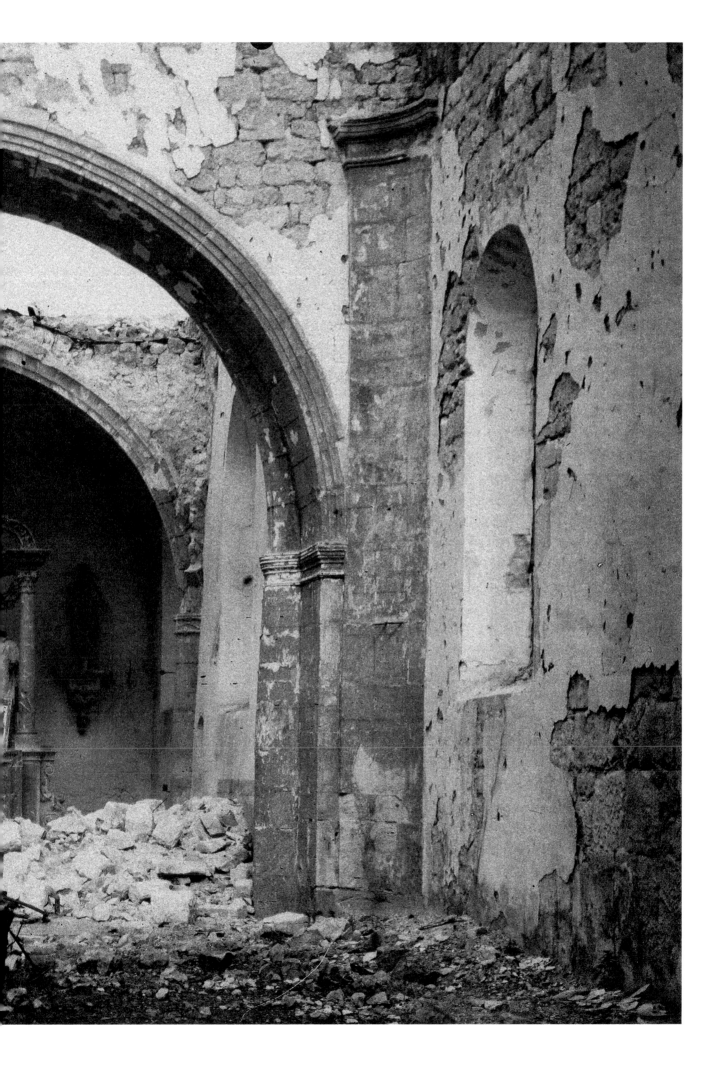

PAGE 176/177
View of the altar in a ruined church, 1917.

RIGHT
*The town hall of Arras devastated by
shells, 1917. The Battle of Arras began
Easter Monday 1917 with the assault
by British troops. In the next six weeks
more than 300,000 soldiers from both
sides lost their lives.*
All photos from page 176/177 to page 183:
Jean-Baptiste Tournassoud

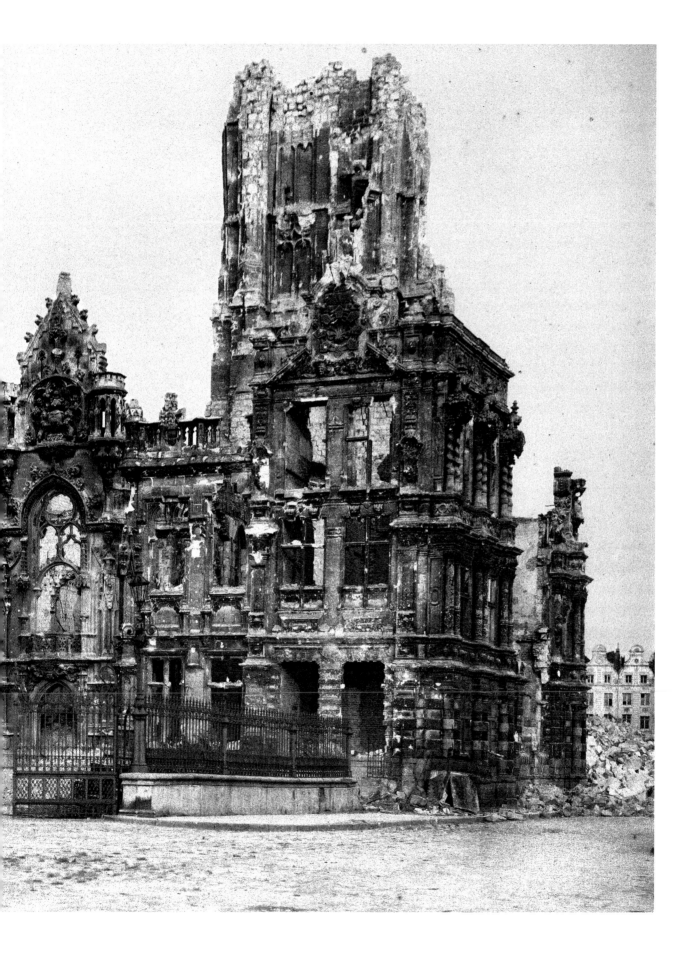

Life in the Ruins 1917

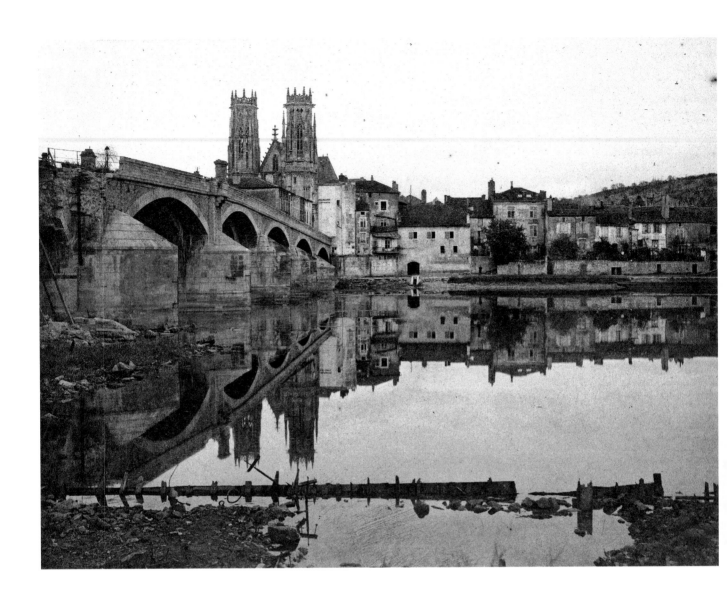

1917　Life in the Ruins

OPPOSITE
Destroyed Moselle bridge near Pont-à-Mousson (north of Nancy), 8 June 1917.

BELOW
Residents in front of the burned-out remains of their house, 1917.

Isn't the enclosed card with the old lady blowing in the fireplace with her dog shocking? A fateful image of poor France. Our life is surrounded by such images.
I know for my soul nothing more horrible as the strange sight of this old and in all imagination lonely dotard and grandmother of France.

FRANZ MARC TO HIS WIFE, MARIA, 9 OCTOBER 1915

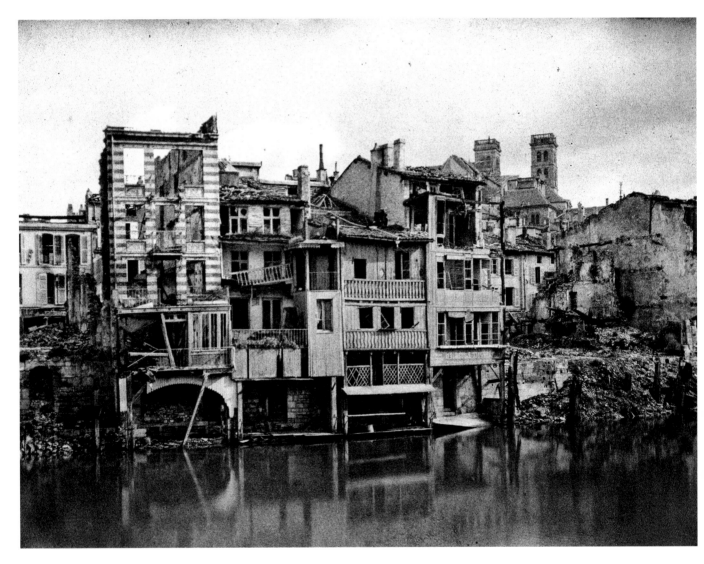

ABOVE
*The ruins of Verdun with the Meuse in the
foreground; in the background on the right
is the cathedral, 1917.*

A family in Alsace in front of their house, 1917.

Graves of French soldiers buried in a garden decorated with the tricolour and wreaths, after they were killed during a bombardment of the area. Goldbach-Altenbach, Alsace, 8 June 1917.

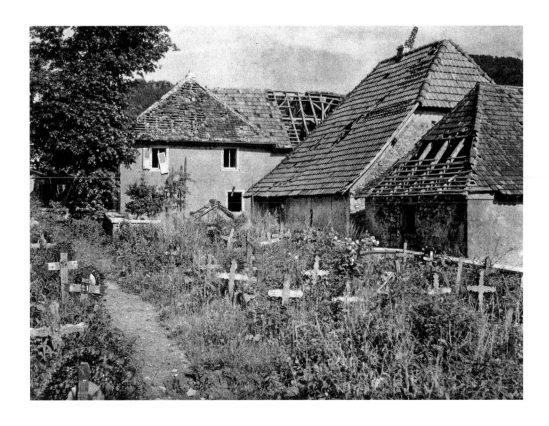

Life in the Ruins 1917

Reims

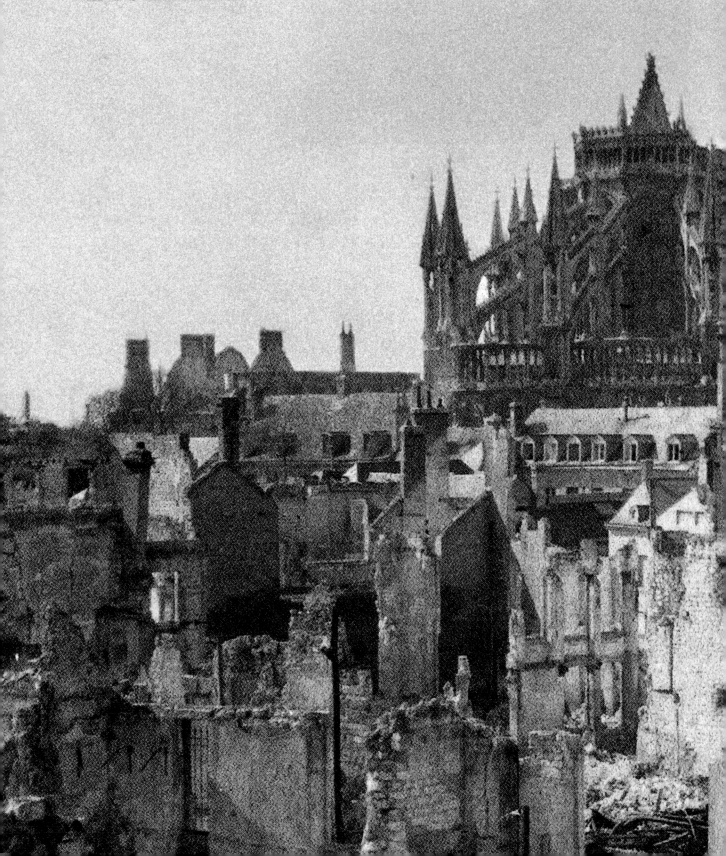

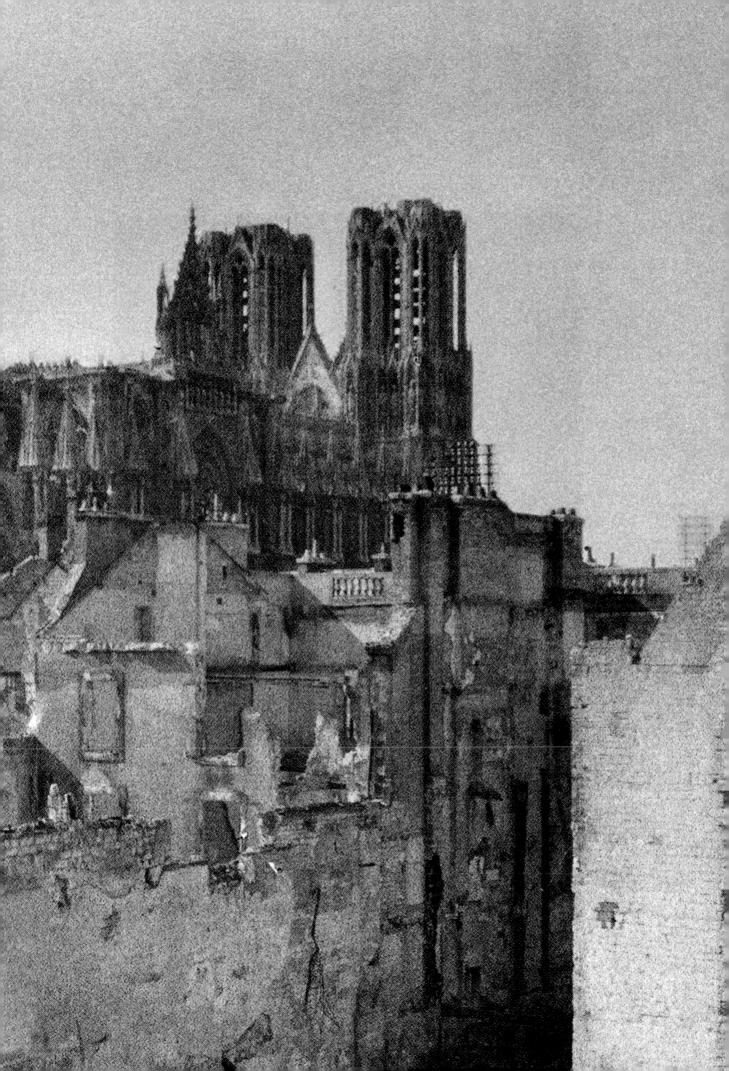

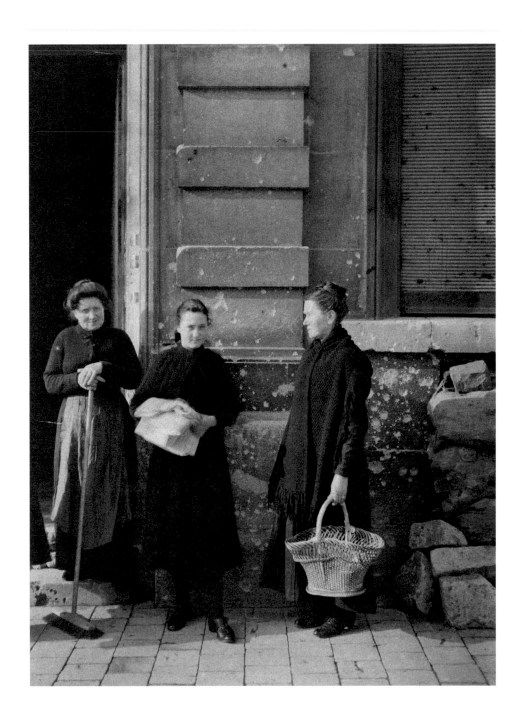

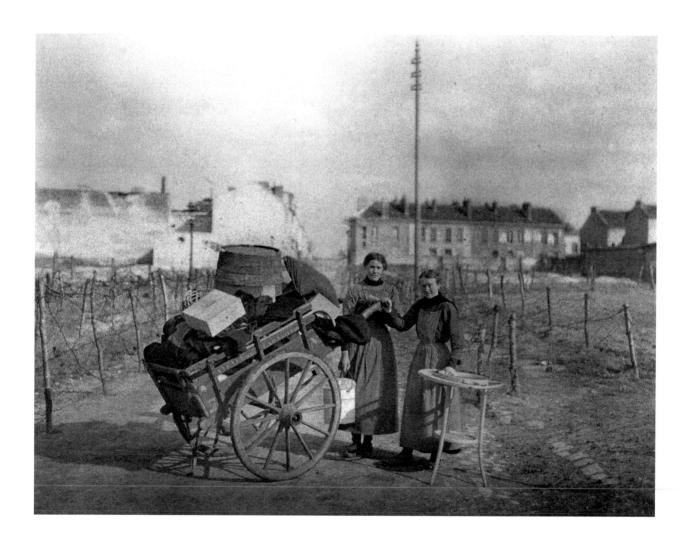

PAGE 184/185
Notre-Dame Cathedral of Reims, 3 April
1917. The population of the city, where
around 120,000 people lived at the start
of the war, was evacuated in spring 1918.
By summer 1919 a mere 25,000 inhabitants
had returned.
Photo: Paul Castelnau

OPPOSITE
Reims, 1917, three women conversing in
front of a building.
Photos: Jean-Baptiste Tournassoud

ABOVE
Reims lay near the front for years and was
more than 60% destroyed by shelling.
The citizens were instructed to leave the city
in March 1918.

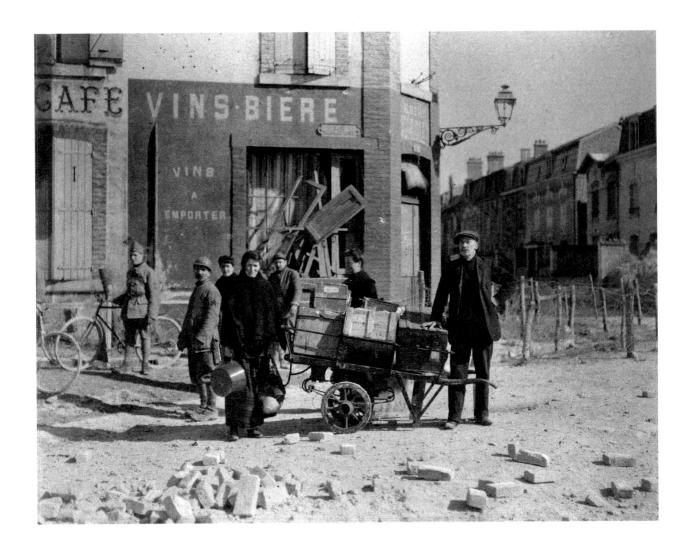

*Evacuation of the civilian population
from Reims, April 1917.*
Photo: Jean-Baptiste Tournassoud

In front of a hardware shop in Reims, 1917.
Photo: Paul Castelnau

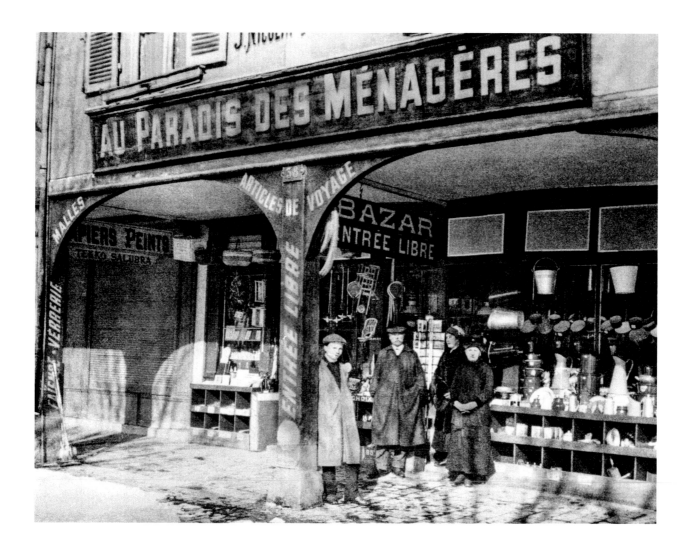

Ruins of a destroyed forge on
Rue des Trois Raisinets, Reims, 1917.
Photo: Fernand Cuville

Rusted machinery of a destroyed factory
on rue des Trois Raisinets in Reims,
28 March 1917.
Photo: Paul Castelnau

By Rosenfeld's was Mrs. Henle, the wife of a rich manufacturer who
has factories or properties near Reims and is now captured in France.
She told much of that place, often with barely restrained tears, knew
and loved this whole now devastated region. All details of the war that
one hears sound grisly, and one always stands aghast before this
disaster, to which no end is in sight.
HERMANN HESSE, DIARY, 7 OCTOBER 1914

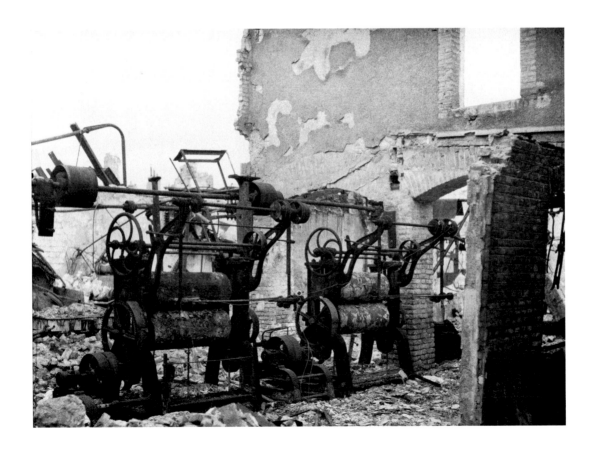

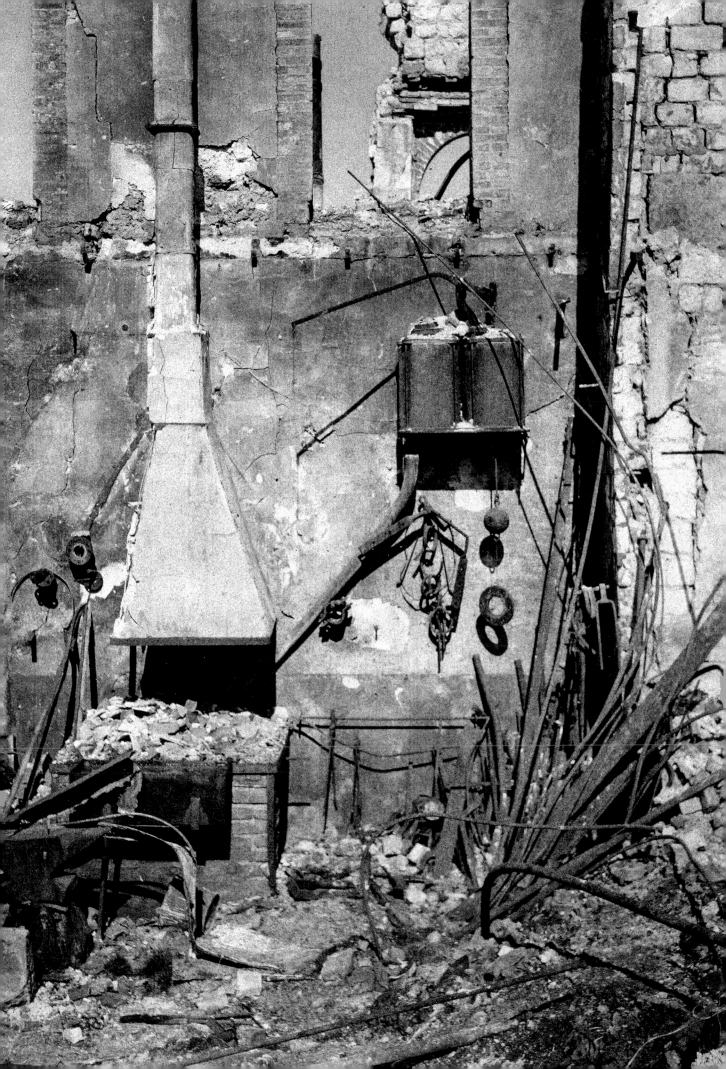

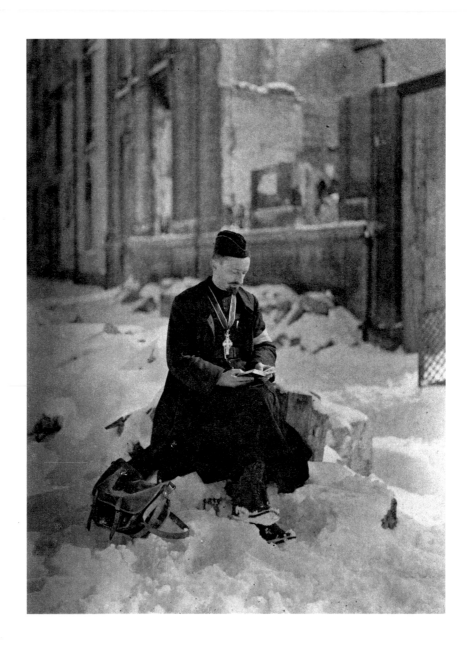

A military chaplain in the ruins of Reims, 1917.
Photo: Paul Castelnau

An old man in the ruins of Reims, 1917.
Photo: Jean-Baptiste Tournassoud

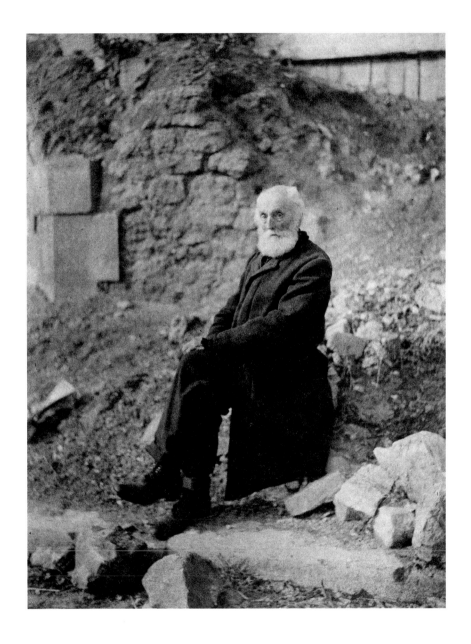

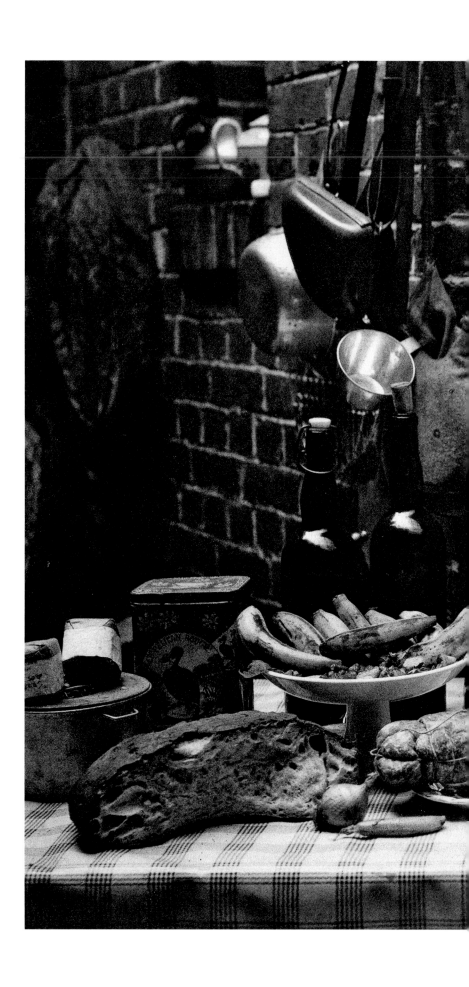

RIGHT
Still life, presumably Reims, 1917.
Photo: Jean-Baptiste Tournassoud

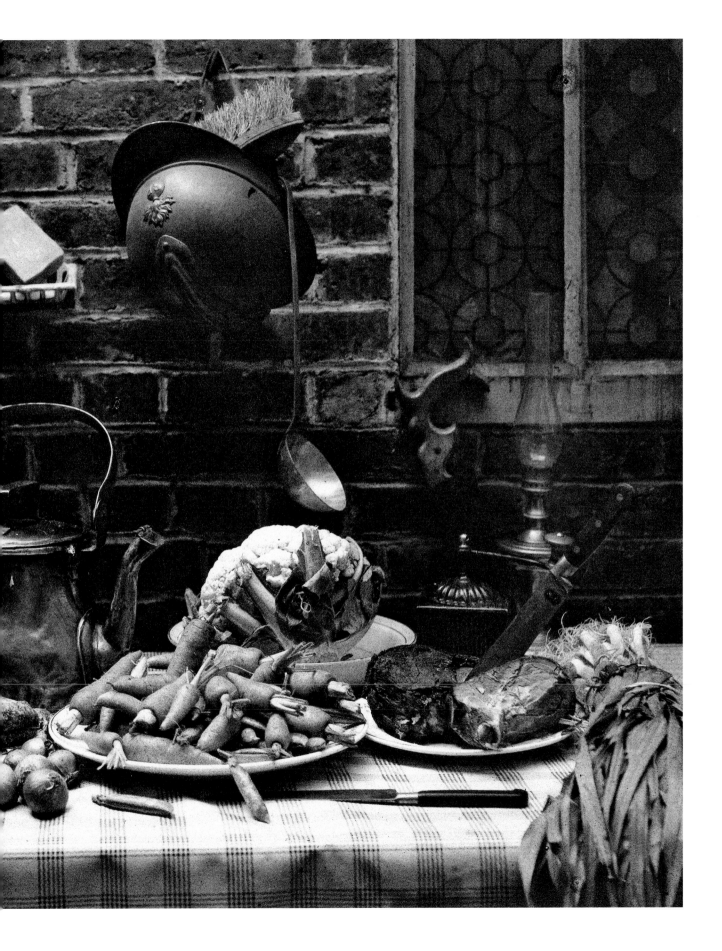

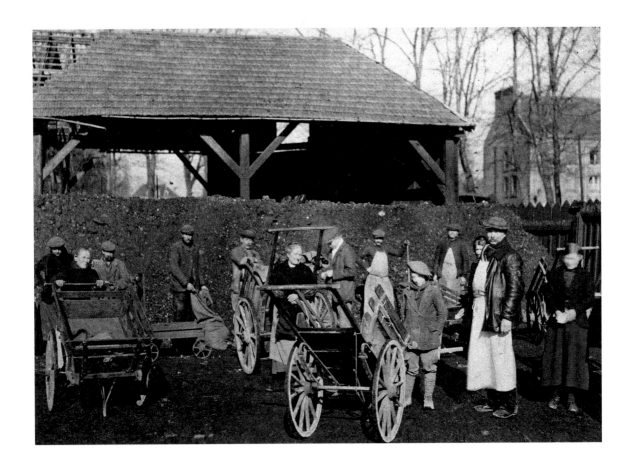

ABOVE
Coal yard in Reims, March 1917.

OPPOSITE
The Erhart Restaurant, reserved for mem-
bers of the Zouave Units, was damaged by
shelling in Reims, 10 March 1917.
Photos: Paul Castelnau

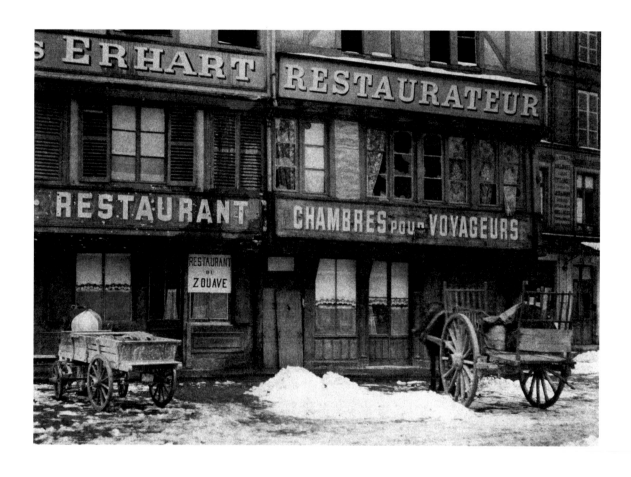

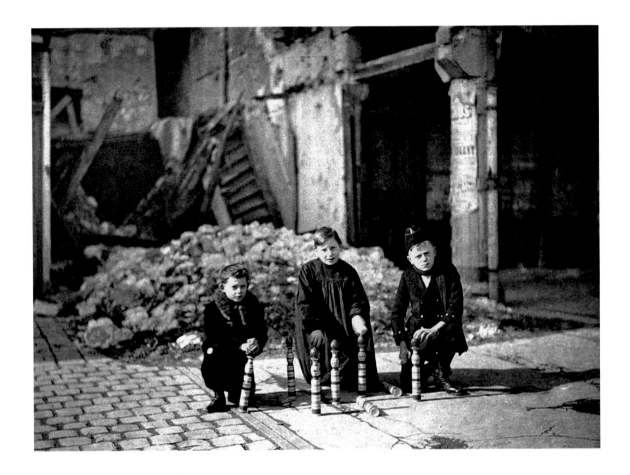

ABOVE
Children playing skittles, Reims, 1917.

OPPOSITE
*A girl plays with a doll, next to her a knapsack
and rifles, Reims, 1917.*
Photos: Fernand Cuville

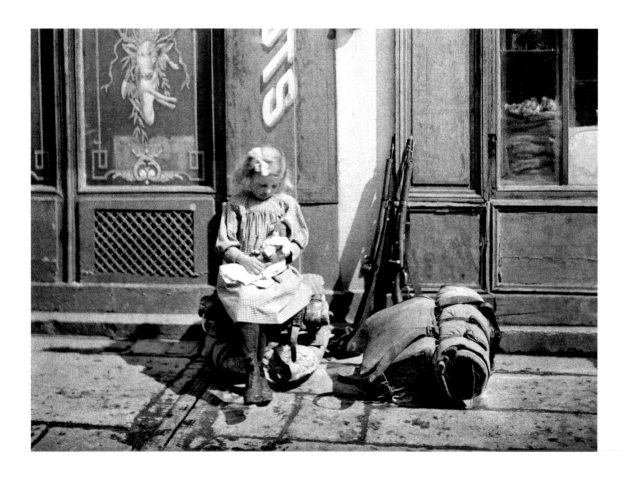

1917 Reims

LEFT
Grocery shop, Reims, 1917.
Photo: Fernand Cuville

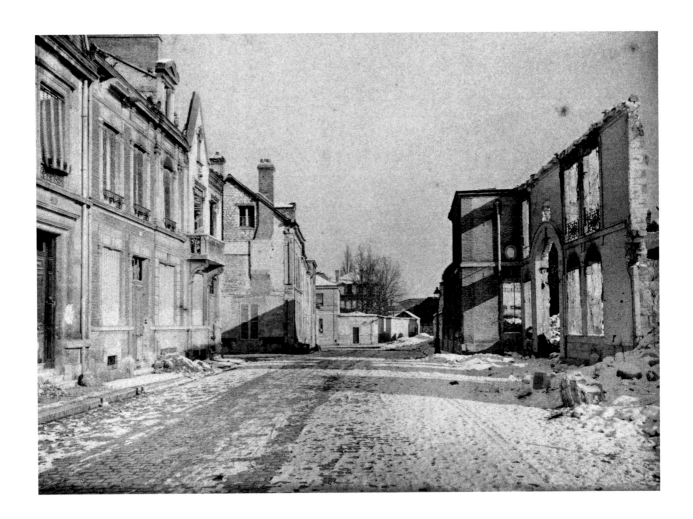

ABOVE
Ruins in snow, Reims, 1917. Aside from
Tournassoud, Paul Castelnau and Fernand
Cuville also photographed here, all three
working for the photography department of
the French army.

OPPOSITE
Milk delivery with a hand cart,
Rue de Talleyrand, Reims, 9 March 1917.
Photos: Paul Castelnau

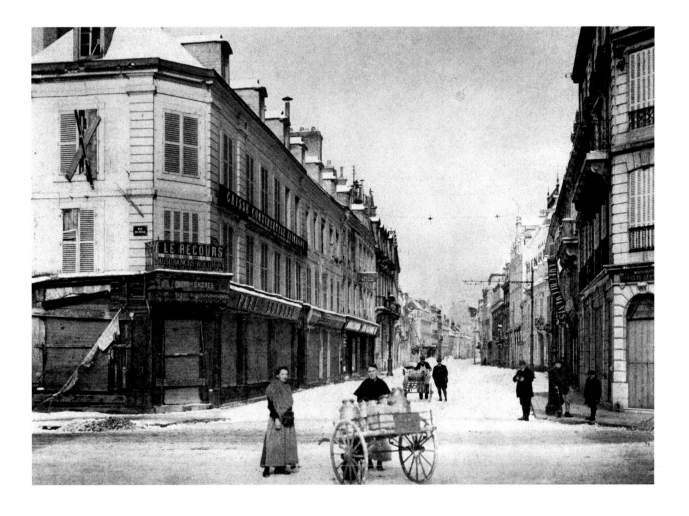

Reims 1917

BELOW
Panorama of the city from the house of the Cardinal with a view of the cathedral, 1917. Reims was the site of the coronation of French kings since 816. The Frankish king Clovis I was baptised here in the 5ᵗʰ century. The division of the Carolingian Empire by Charlemagne's grandsons in 843 was the starting point of the development of the nation-states of France and Germany. The city and the cathedral of Reims therefore possessed a highly symbolic significance for both sides.
Photo: Fernand Cuville

OPPOSITE, TOP
Cardinal Luçon (left) and Bishop Neveu in Reims, 1917. Louis-Joseph Luçon (1856–1930) was archbishop of Reims from 1906. Until the evacuation ordered by the military in March 1918, he shared the same fate as the inhabitants of Reims. As a symbolic figure of the spirit of resistance he was made a knight of the Legion of Honour in 1917.
Photo: Paul Castelnau

OPPOSITE, BELOW
Cardinal Luçon (left) with a delegation of the Red Cross, 1917.
Photo: Fernand Cuville

Now it is blue skies again. We sit the whole day in trenches at the gunner's station. We are here four days now. It is actually like a summer holiday. The cathedral glows over here.
OTTO DIX TO HIS PARENTS, 4 JUNE 1916

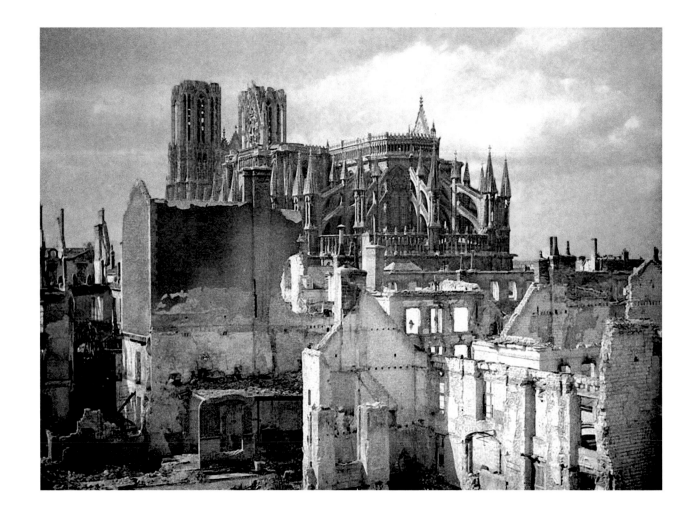

1917 Reims

Reims 1917

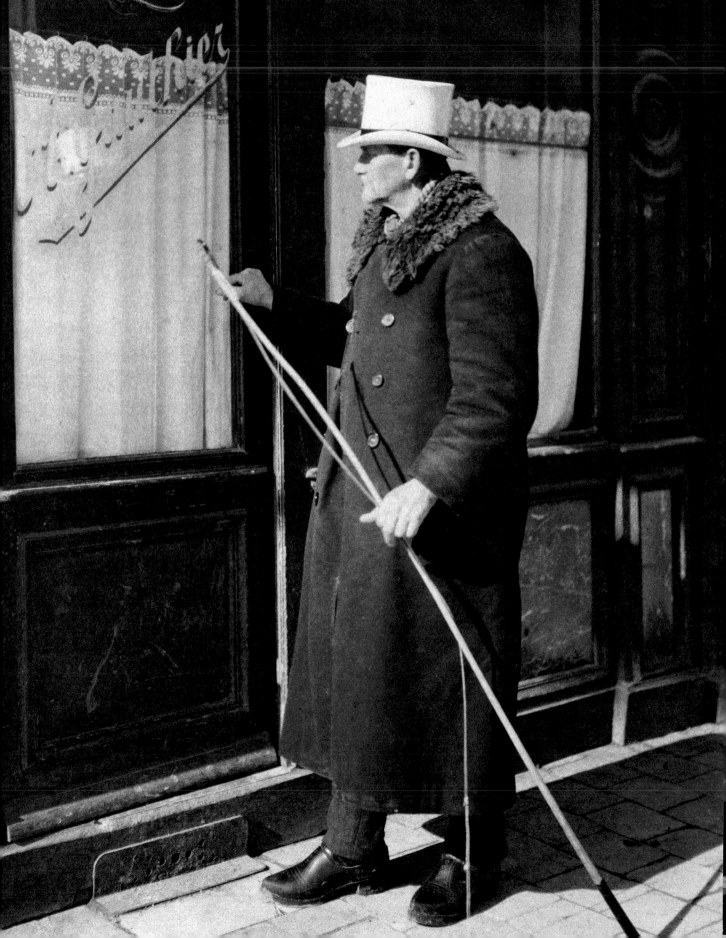

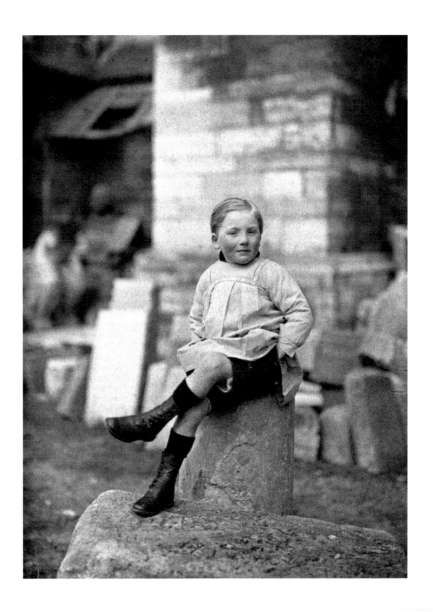

Portrait of a coachman, Reims,
17 April 1917.

ABOVE
Jean, a young boy, sits on a stone
near the cathedral, Reims, 1 April 1917.
Photos: Paul Castelnau

1917 Reims

OPPOSITE
*In the historic university district,
3 April 1917.*

LEFT
*Portrait of an old woman in Reims,
5 April 1917.*
Photos: Paul Castelnau

BELOW
*An old woman with a wheelbarrow
and broom, Reims, 1917.*
Photo: Fernand Cuville

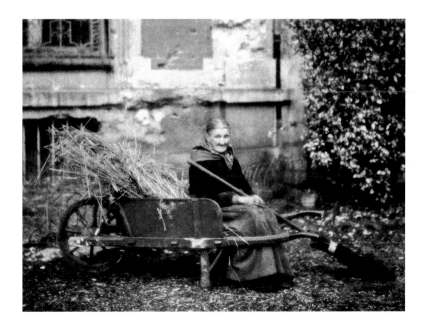

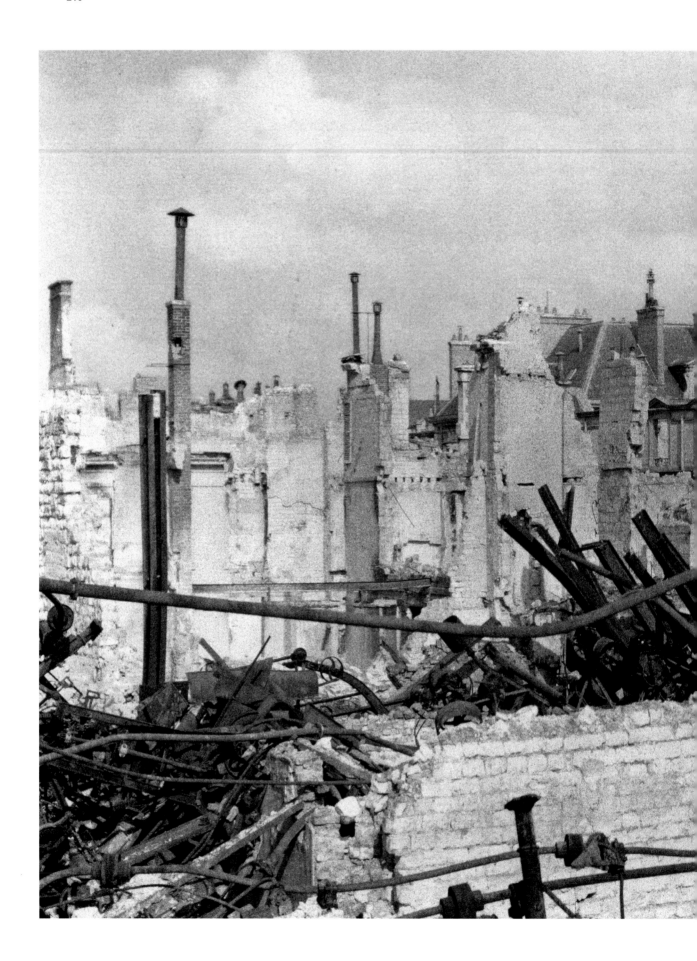

1917 Reims

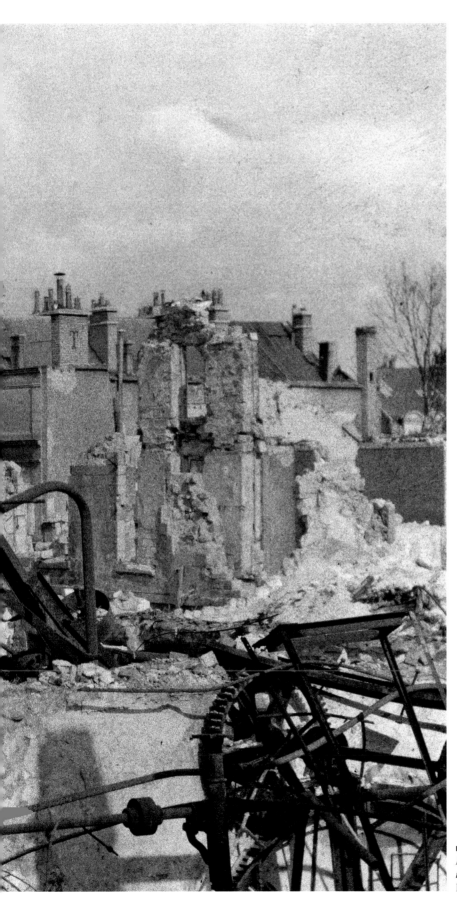

Ruins, rusty metal, and remnants of equip-
ment and machines, Reims, 23 March 1917.
Photo: Paul Castelnau

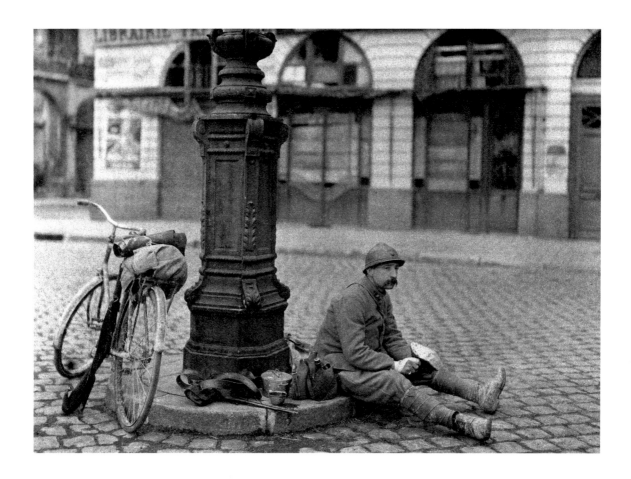

*Lunch on the street; in the background
a destroyed bookshop, Reims, 1 April 1917.*
Photo: Paul Castelnau

*Soldiers from the pioneer corps work
in the ruins, 1917.*
Photo: Fernand Cuville

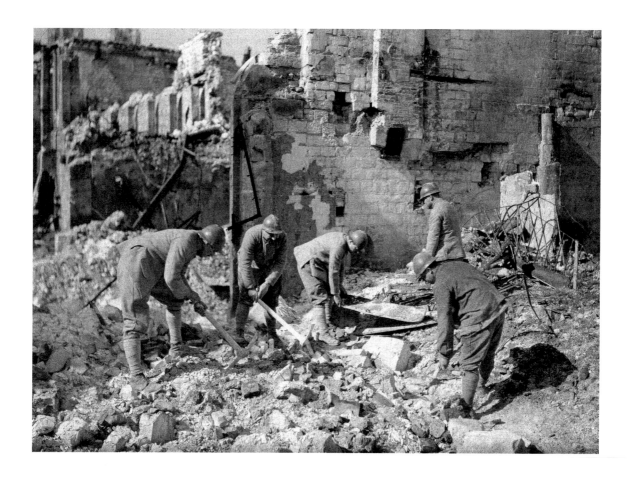

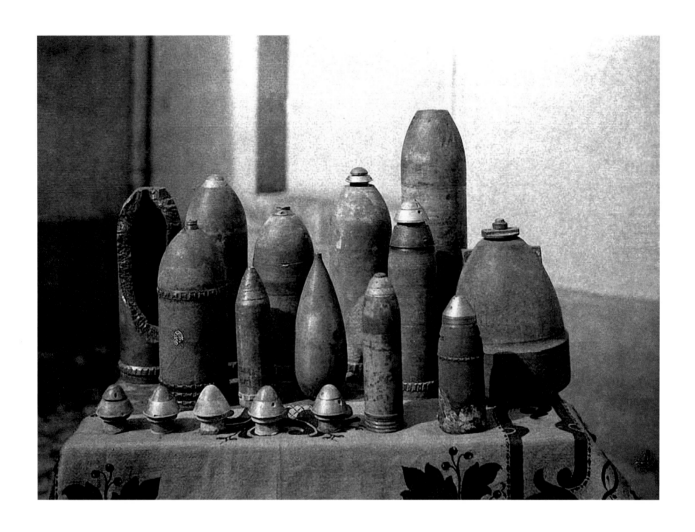

1917 Reims

LEFT
Portrait of a postman, 4 April 1917.
Photo: Paul Castelnau

OPPOSITE
Unexploded German shells, Reims, 1917.

BELOW
*The commander of the fire department
of Reims, Édouard Eloire, with unexploded
German shells, 1917.*
Photos: Fernand Cuville

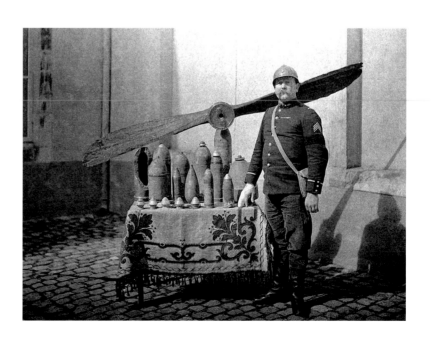

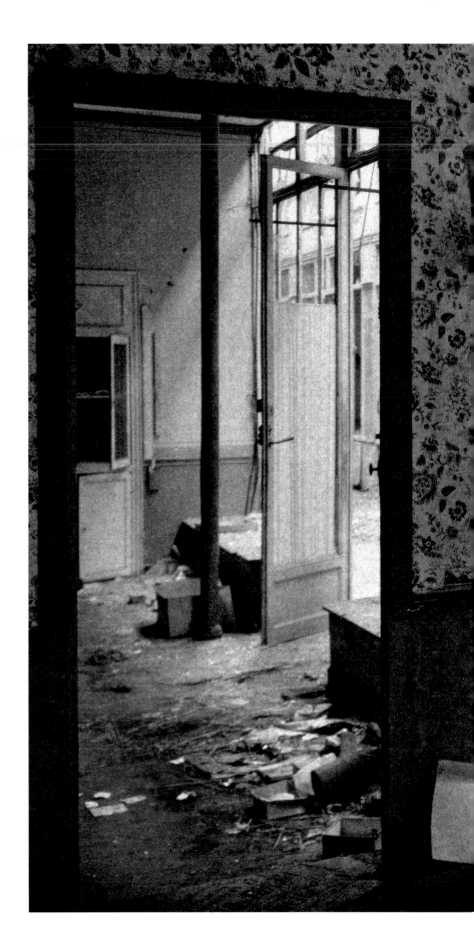

RIGHT
Interior of a damaged shop, Reims, 1917.
Photo: Paul Castelnau

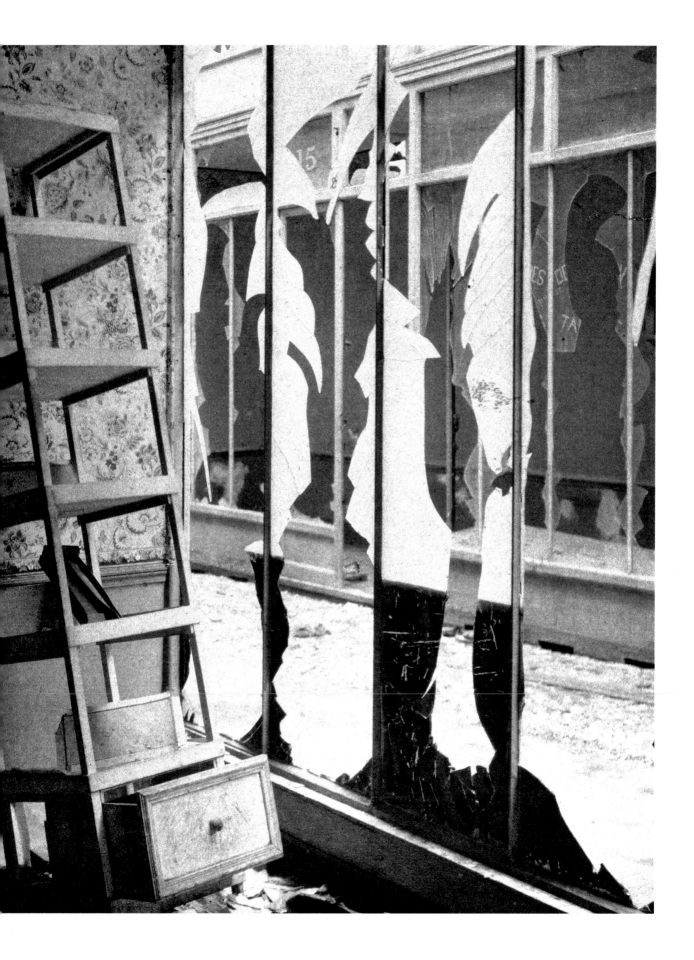

Reims 1917

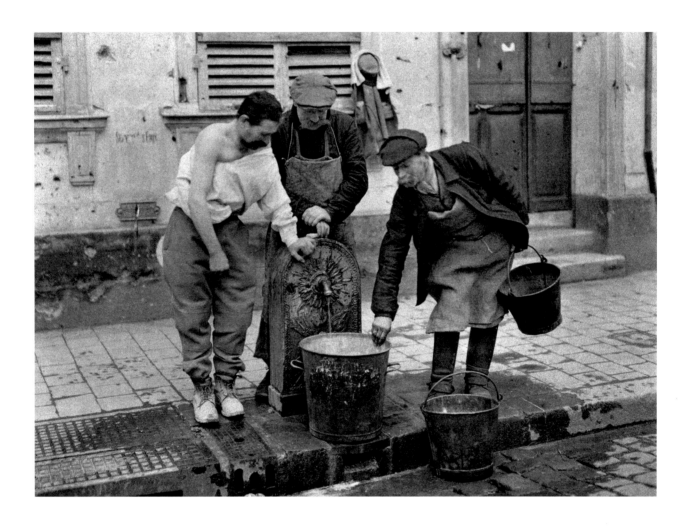

1917　Reims

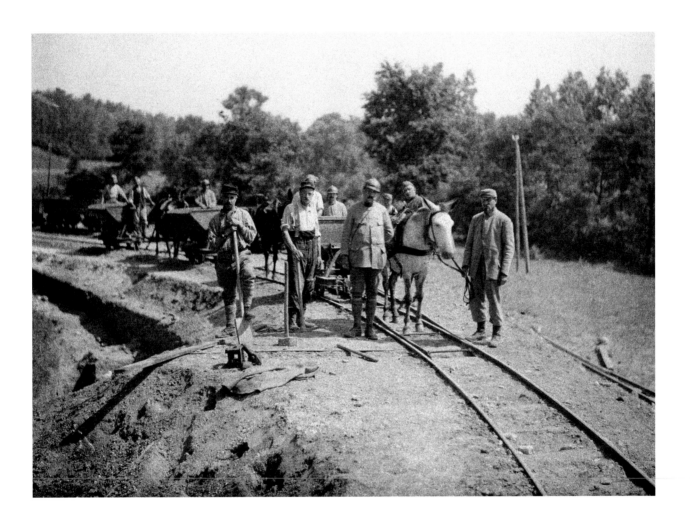

OPPOSITE
A soldier and two civilians see to the
water supply, 4 April 1917.
Photo: Paul Castelnau

ABOVE
The 11ᵗʰ Artillery Regiment builds a narrow
gauge railway, 1917. The rail system with
a track width of 23.6 inches (60 centimetres)
was already established by the French mili-
tary as an efficient transport system before
the war.
Photo: Fernand Cuville

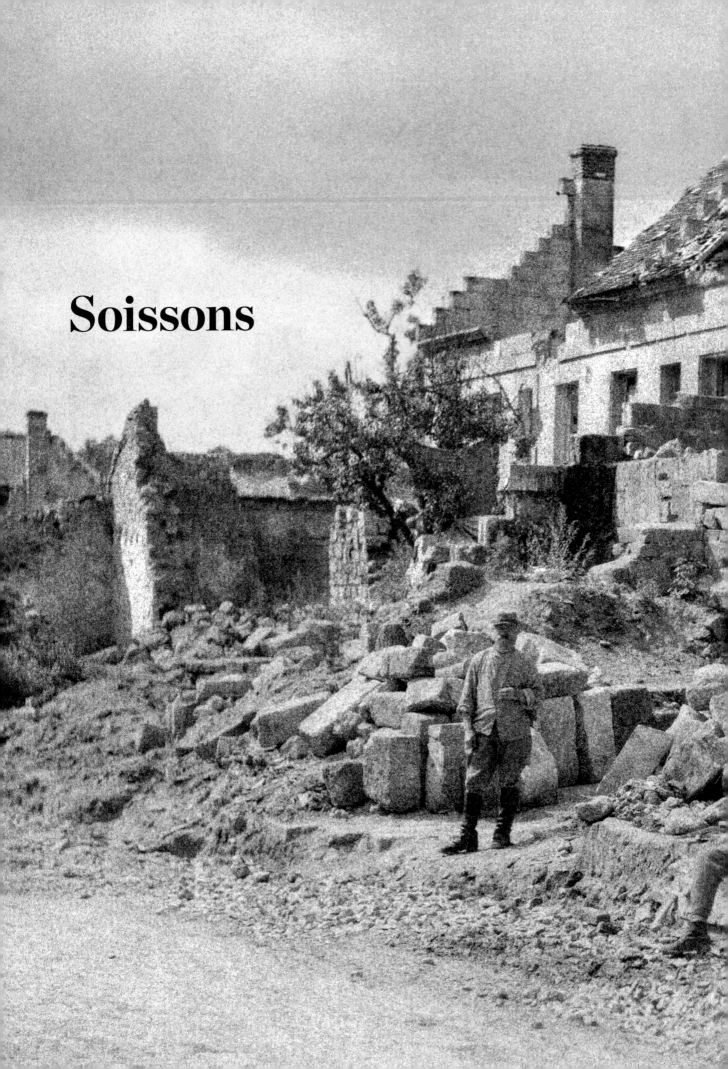

Soissons

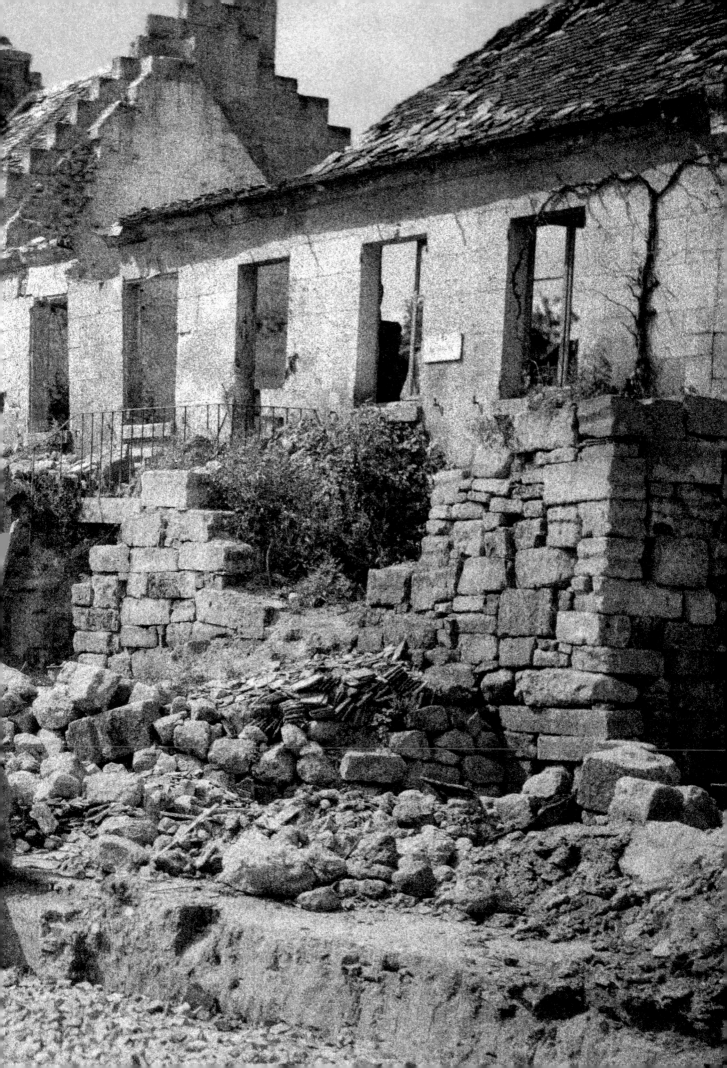

PAGE 220/221
Ruins of a house on Rue d'Osly in Pommiers, 1917.

ABOVE
Algerian sentry on a bridge near Soissons, 1917.

OPPOSITE
Corporals of the 370th Infantry Regiment, who were attacked by German troops on 8 July at Chemin des Dames, pose here with bicycle and regimental flags, July/August 1917.
All photos from page 220/221 to page 273: Fernand Cuville

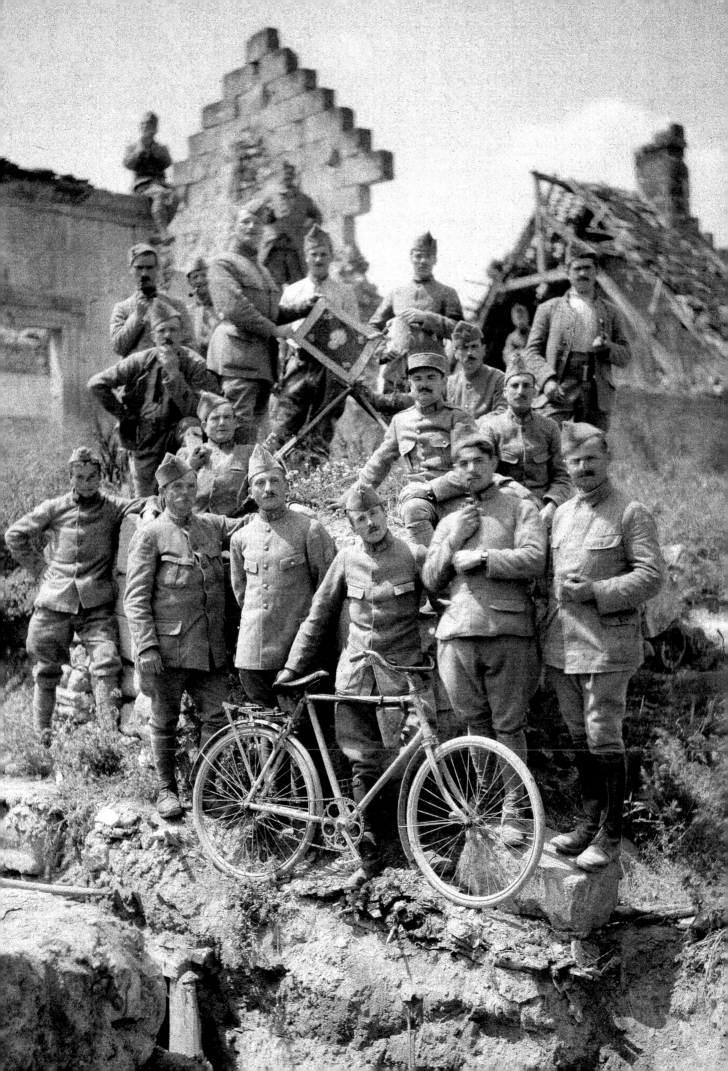

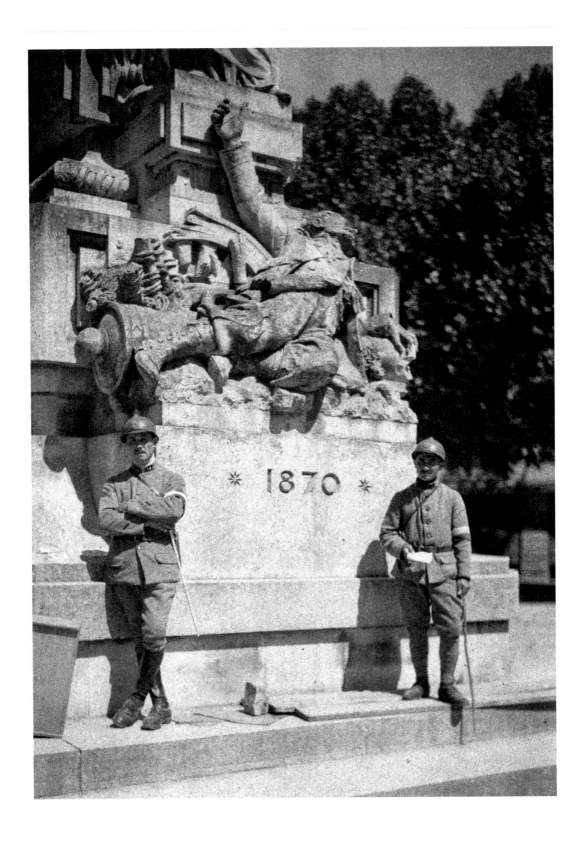

1917 Soissons

OPPOSITE
Memorial of the Franco-Prussian War of 1870/71. In Soissons, a fortress was captured by Prussian troops in October 1870 and more than 4,700 soldiers taken prisoner.

RIGHT
Street scene in Soissons: a soldier being shaved, 1917.

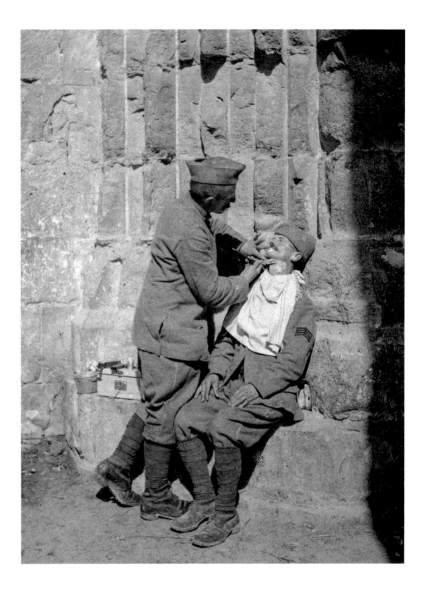

The war, if it leads us to victory, will surely bring one good thing, our inner political circumstances will become more liberal. We see now a German advance from Soissons against Paris. If it's successful, then perhaps France's ego can be broken, so that they would deign to negotiate. Your hardships do have to come to an end one day.
FRANK WEDEKIND TO ARTUR KUTSCHER, 16 JANUARY 1915

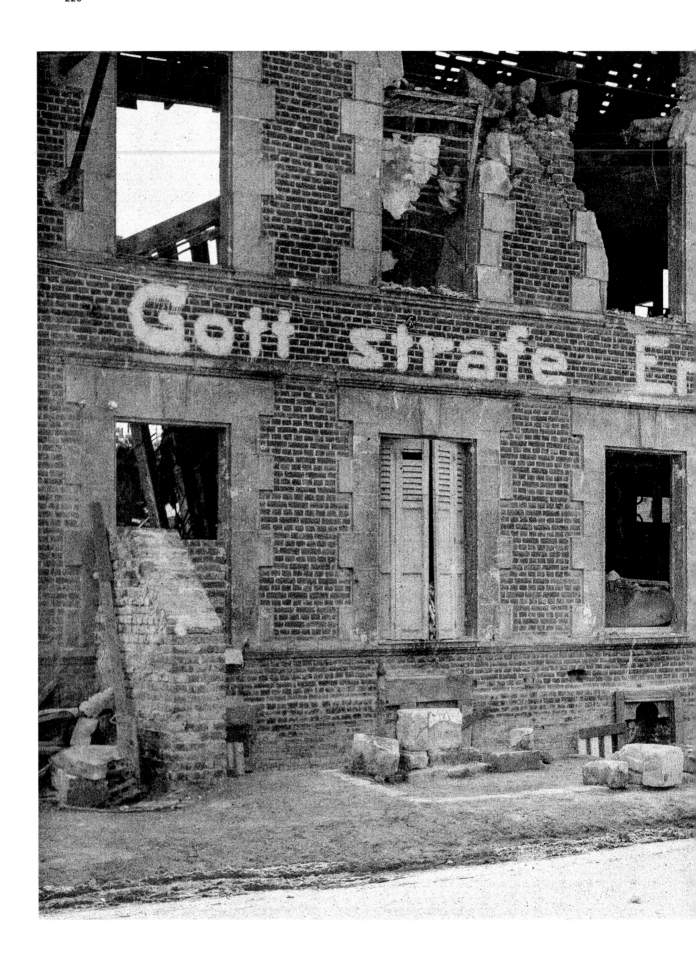

1917 Soissons

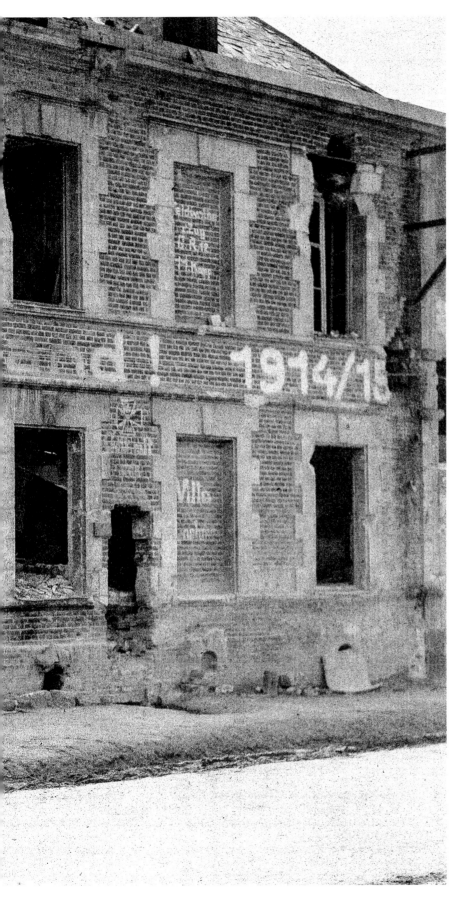

LEFT
The German inscription "God punish England!" on the wall of a ruin in Bucy-le-Long. Up until July 1914 the neutrality of the "English cousins" was hoped for in Germany, which found itself circled by enemies. A wave of hate and vilification erupted in Germany at Britain's entry into the war. "Perfidious Albion" was denounced, the low point of this sentiment in Germany was marked by the popularity of Ernst Lissauer's poem "Song of Hate against England."

The tragic thing in this heroic fight of Germanness is that almost nothing worse could happen to us than to prevail on all sides—particularly against England. We have no ability to take up this inheritance and would become despicable and foolish over it.

KURT RIEZLER, DIARY, 23 SEPTEMBER 1914

Soissons 1917

BELOW

The kitchen staff of the hospital prepare meat in the yard of the Vauxbuin castle, spring 1917.

OPPOSITE

Soldiers prepare food for themselves outdoors, Soissons, 1917.

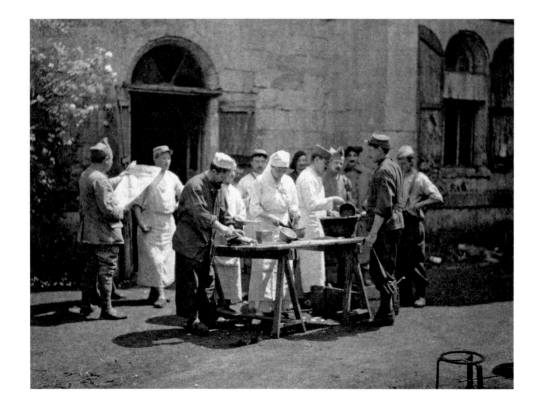

1917　Soissons

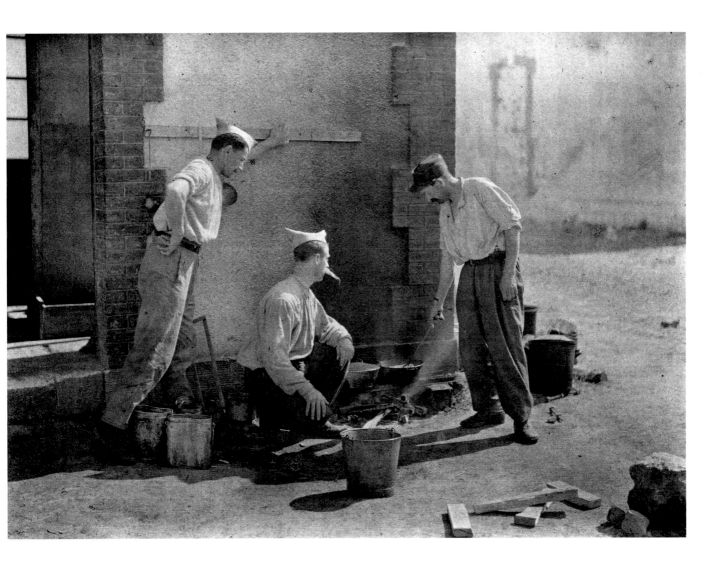

In my walk this afternoon, considering at leisure the sunshine and the appearance of peace (I don't mean from the news) I determined what I should do after the war. I determined to keep pigs. It occured to me that after five years development of one pig-sty in a careful & sanitary manner, a very considerable farm would establish itself.

WILFRED OWEN TO COLIN OWEN, 24 MARCH 1917

Soissons 1917

OPPOSITE
Display in a shop window in Soissons, 1917.
In the First World War Soissons was occupied
twice by German troops and was at least
three-quarters destroyed by artillery shelling
from both sides.

BELOW
A shop in Bucy-le-Long after the retreat
of German troops, spring 1917.

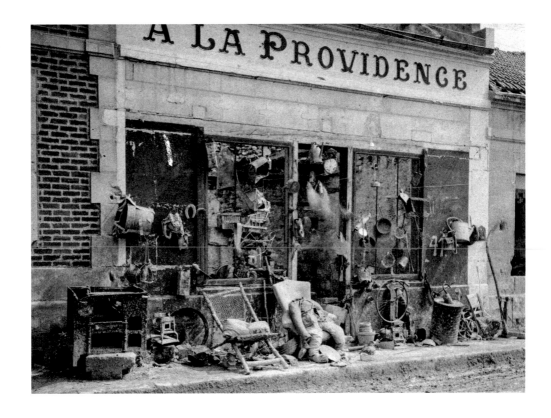

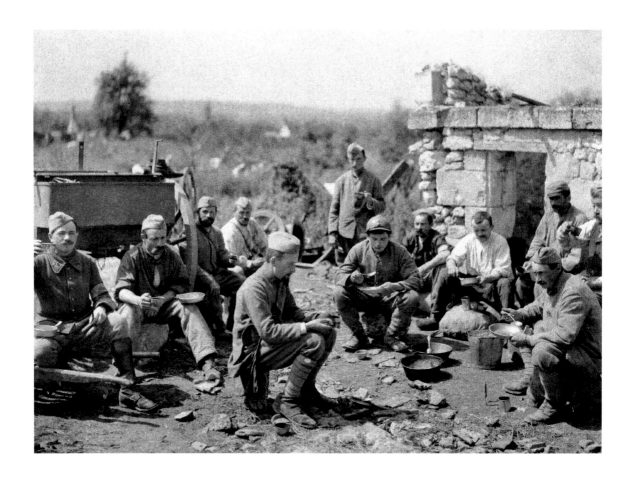

For twelve days I did not wash my face, nor take off my boots, nor sleep a deep
sleep. For twelve days we lay in holes, where at any moment a shell might put us out.
I think the worst incident was one wet night when we lay up against a railway
embankment. A big shell lit on the top of the bank, just 2 yards from my head.
Before I awoke, I was blown in the air right away from the bank!

WILFRED OWEN TO SUSAN OWEN, 25 APRIL 1917

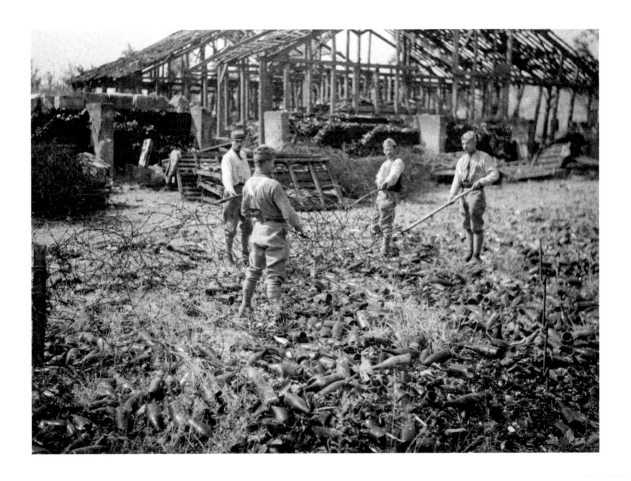

*Time for soup for the 370ᵗʰ Infantry
Regiment, 1917.*

*Workers in clean-up efforts in
Soissons, 1917.*

Soon even the journalists will not have a voice anymore.
After three years of monotonous slaughter all poetry will be
impossible. One loses the attitude. Indeed, on this evening
a storm and a nameless solitude touches me more than the
retreat of the Russians to a front of 300 kilometres [186 miles].

FRANÇOIS MAURIAC TO JACQUES ÉMILE BLANCHE, 25 APRIL 1917

ABOVE
The destroyed Château Saint-Paul
in Crouy, 1917.

OPPOSITE
Apse of the destroyed church in
Missy-sur-Aisne, 1917.

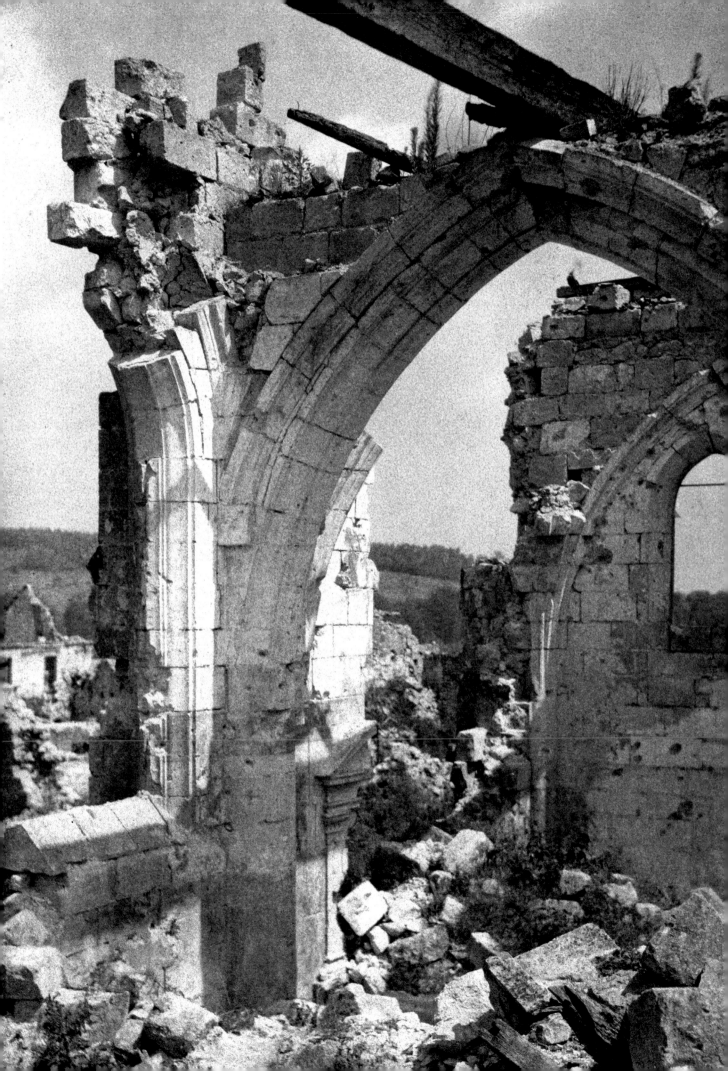

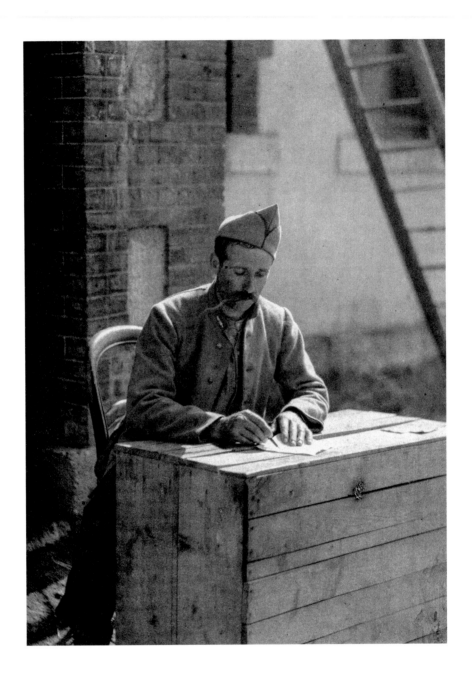

A soldier attends to his correspondence
on a wooden crate, Soissons, 1917.

OPPOSITE
Soldier from the then French Indochina,
Soissons, 1917.

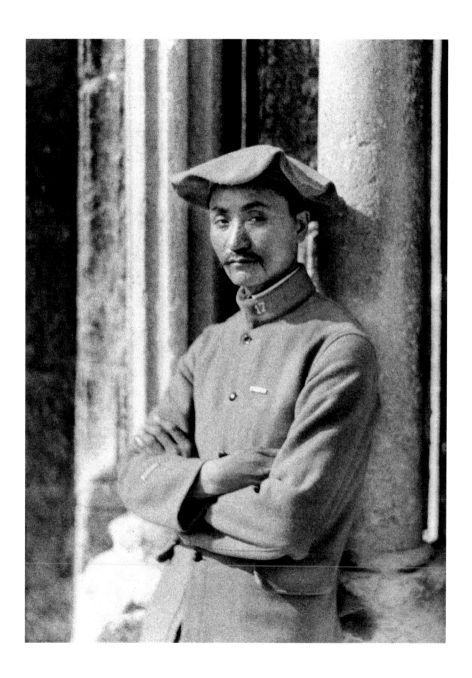

ABOVE
Workers transport a block of stone,
Rue des Mimimes, Soissons, 1917.

OPPOSITE
Senegalese soldiers cook on a makeshift fire,
Soissons, 1917.

1917 Soissons

Soissons 1917

BELOW
Rue du Coq Lombard in Soissons, 1917.

OPPOSITE
*View of the Cathedral Saint-Gervais-
et-Saint-Protais, Soissons, spring 1917.*

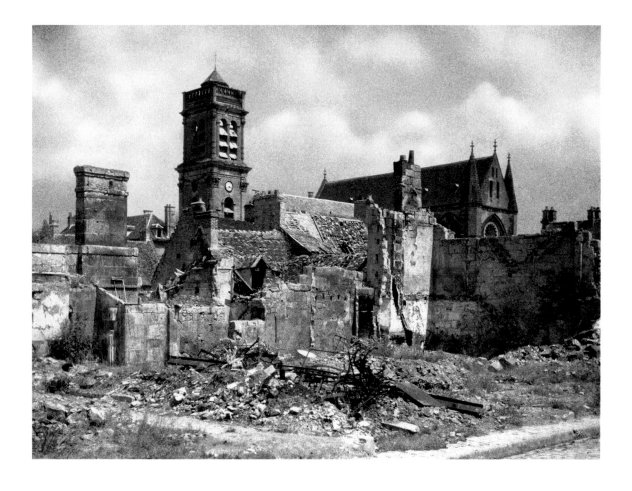

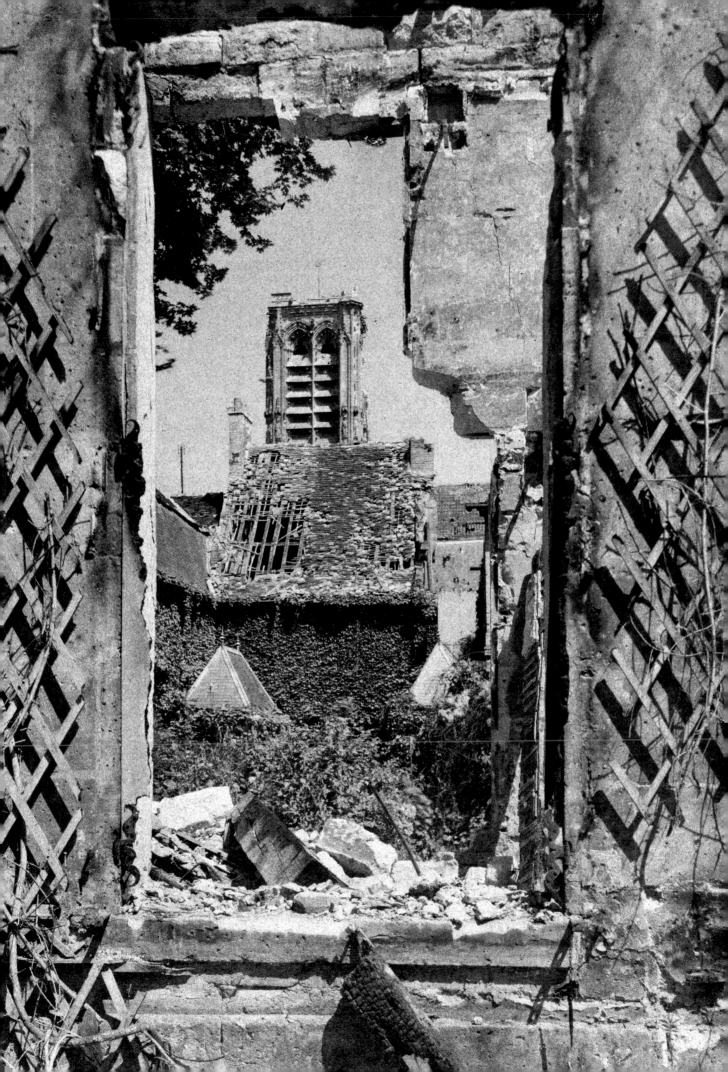

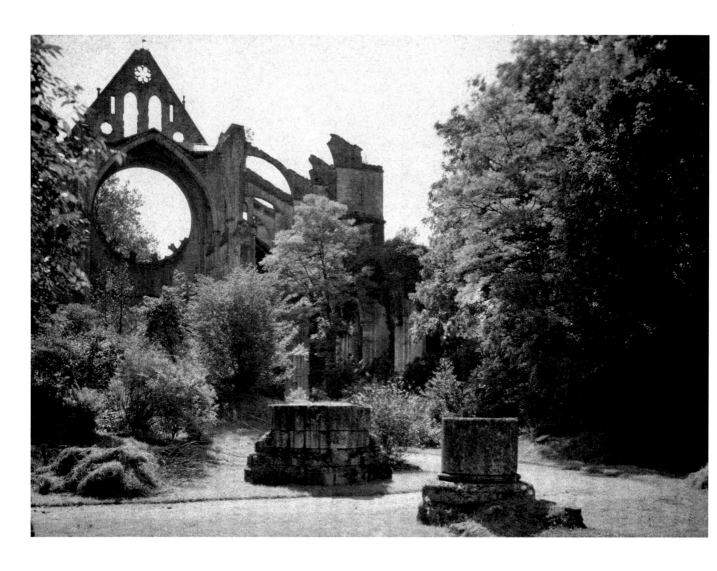

Ruins of the Cistercian monastery of Longpont,
a small town near Soissons, 1917. The monastery
founded in 1131 by Bernard of Clairvaux was
already derelict by the early 19th century.
In the First World War the south wing of the
cloister also burned down.

Graves of soldiers who died near Laffaux
on 14 May 1917, Soissons, 1917.

One has to see things as they are. The connection between yesterday and tomorrow is fundamentally broken. My utter hate for war (and especially this war) does not keep me from recognising that it is like a rain of seeds on deeply furrowed earth; as soon as the sun emerges again, everything will rise up, all seeds the earth over will break apart and the next ten years will be witness to the most extraordinary transformation of civilisation there ever was in history.

ROGER MARTIN DU GARD TO MAURICE MARTIN DU GARD, 27 AUGUST 1917

Soissons 1917

BELOW
*German notice on a wall in Soissons pointing
the way to a bridge over the Aisne, 1917.*

OPPOSITE
*Pioneers work on a pontoon bridge over
the Aisne, 1917.*

1917 Soissons

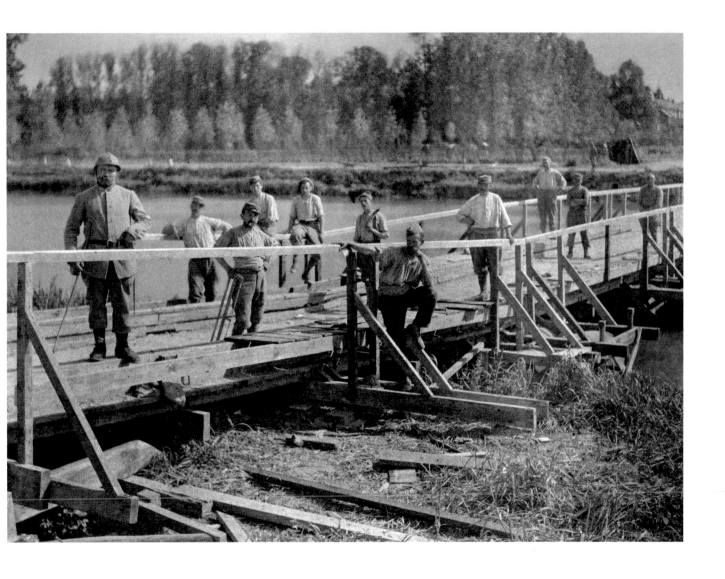

Soissons 1917

We are having many fine days, bright and warm even at times, and we begin to see larks as well as aeroplanes. I wish we did not see so many of the enemy's. Every dear day we are continually hearing the whistle blowing the alarm. It incenses the artillery very much as the planes spot us and then tell their batteries how to hit us.

EDWARD THOMAS TO ROBERT FROST, 6 MARCH 1917

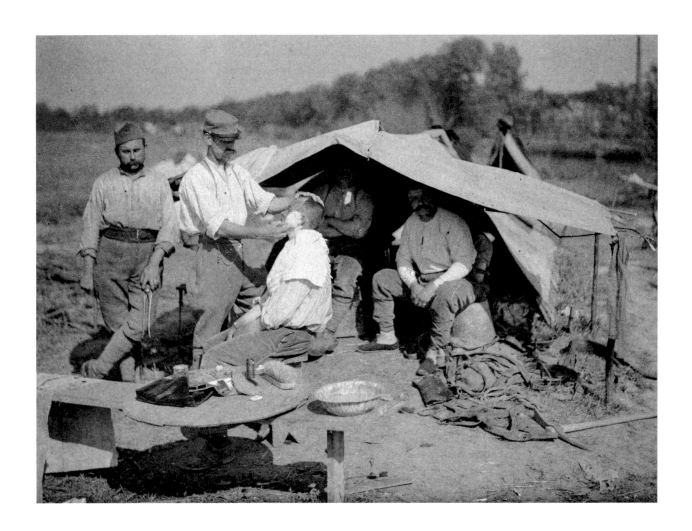

1917 Soissons

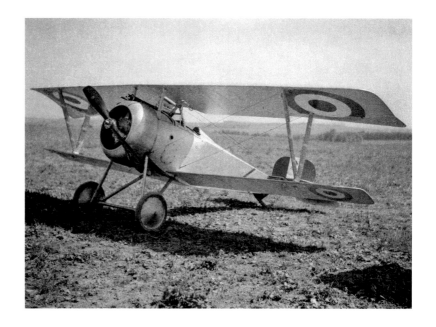

OPPOSITE
The troop's barber shaves a soldier, near Soissons, 1917.

ABOVE
A Nieuport 17 on the ground, 1917. The biplane of the French company Nieuport was one of the most successful fighter aircrafts in the First World War, and was also flown by the Allied forces: British, Americans, Belgians, Russians, and Italians.

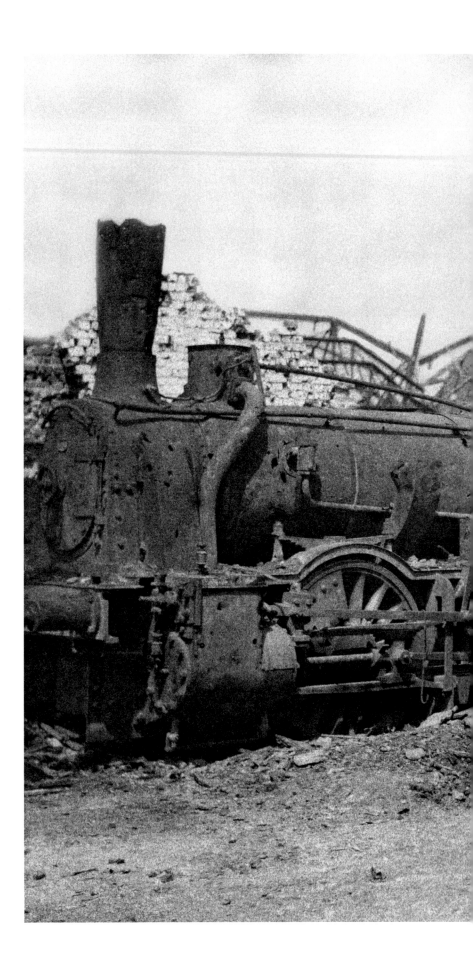

RIGHT
*Destroyed trains, Cuffies
(near Soissons), 1917.*

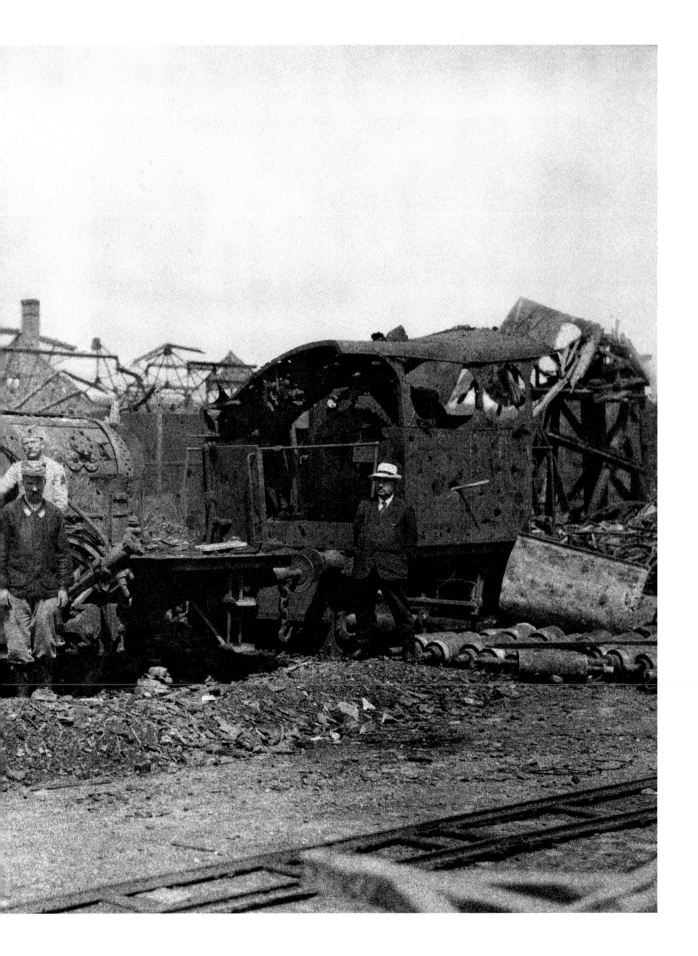

Soissons 1917

1917 Soissons

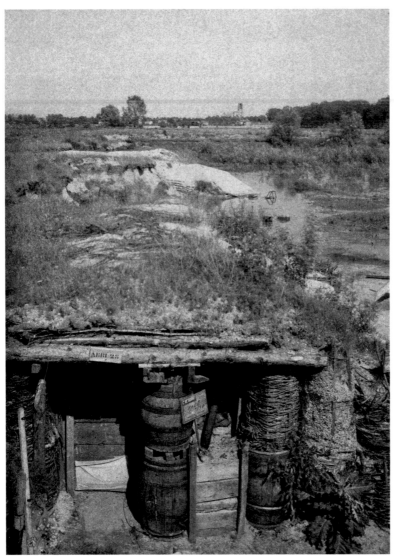

PAGE 250
The actor Félix Galipaux, Soissons, 1917.

PAGE 251
Mademoiselle Carlotta Zambelli from the opera in Soissons, 1917.

LEFT
Trenches near a stream, the cathedral in the background, La Maison Rouge, Soissons, 1917.

OPPOSITE
Dugout in a trench, La Maison Rouge, Soissons, 1917.

It was a satisfaction at least to get out of the trenches, to meet the enemy face to face and to see German arrogance turned into suppliance.
We knew many splendid moments, worth having endured many trials for.
But in our larger aim, of piercing their line, of breaking the long deadlock, of entering Vouziers in triumph, of course we failed.
ALAN SEEGER TO HIS MOTHER, 25 OCTOBER 1915

*I am less and less inclined to believe that the decision can be won by guns.
Since the Russian Revolution it seems to me clear that this enormous war is
itself going to be swallowed up by social questions. I have ceased despairing
of seeing Germany as a republic. Well then, England too? All the states
of Europe as republics; the war will not end otherwise. For neither will
Germany triumph over us, nor shall we triumph over her; and even if we do
triumph, we shall be unable to keep ourselves from being even more stricken
by our victory than she by her defeat. The question today is: just how far
on the road toward death shall we go because we do not want to admit this?*

ANDRÉ GIDE, THE JOURNALS, 3 MAY 1917

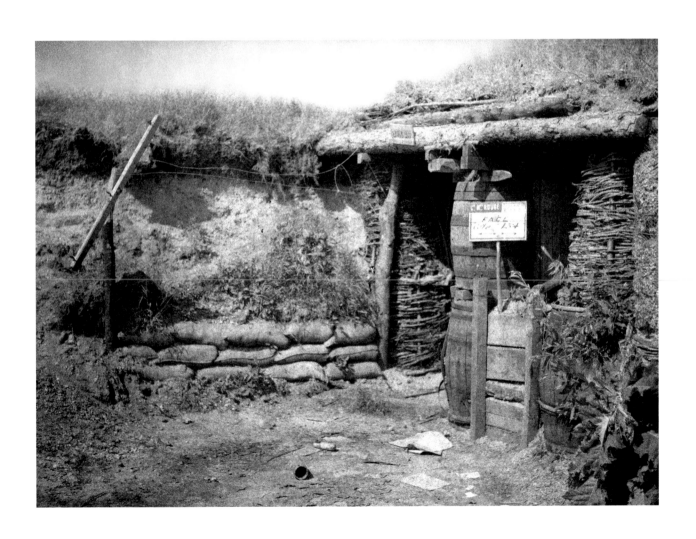

1917 Soissons

OPPOSITE
Soldiers doing laundry, Soissons, 1917.

ABOVE
Laundry duty in quarters, near Soissons, 1917.

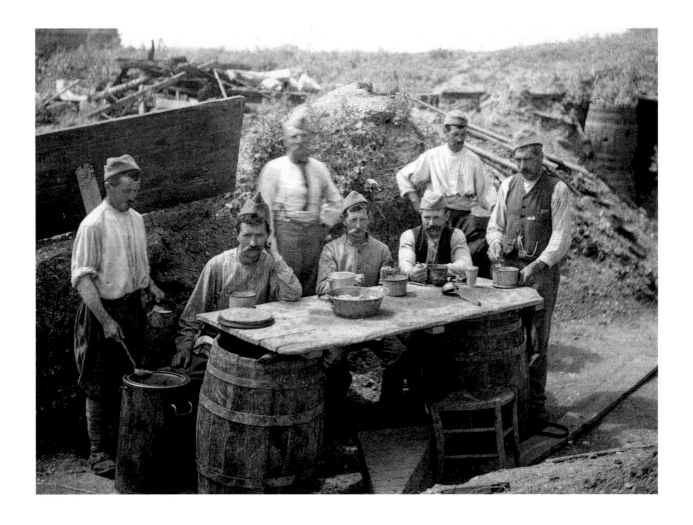

1917 Soissons

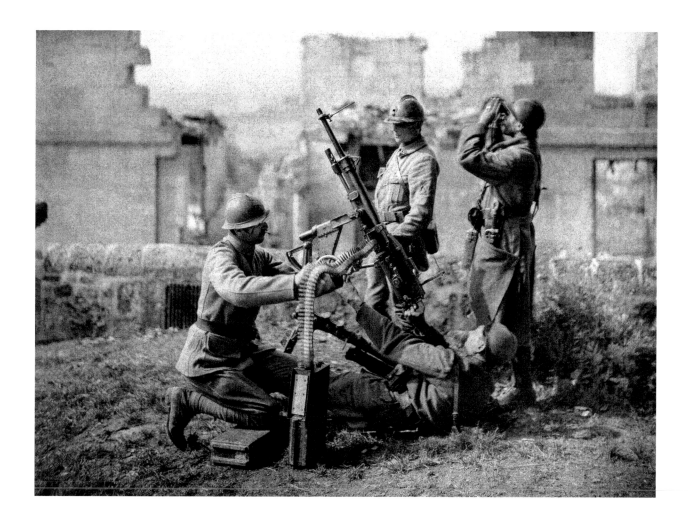

OPPOSITE
Time for soup in a trench, near Soissons, 1917.

ABOVE
*Machine-gunners defend against low-flying
fighter planes in the ruins of Bucy-le-Long,
1917.*

1917 Soissons

OPPOSITE
*Portrait of the director of Saint-Paul
Hospital in Soissons, 1917.*

ABOVE
*A group of doctors and nurses in front of
Saint-Paul Hospital, with, in the centre,
an American military doctor, Soissons, 1917.*

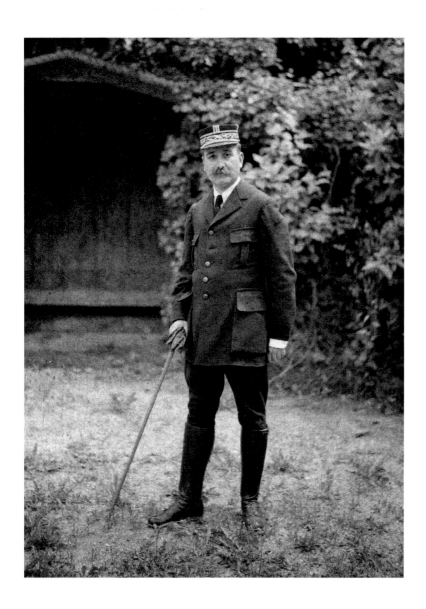

Monsieur Andrieu, subprefect of Soissons, 1917.

RIGHT
From the German gravestone:
"Died a heroic death on 15 March 1915,
Grenadier P. Roehl," Soissons, 1917.

BELOW
Graves and barbed wire around Soissons,
spring 1917.

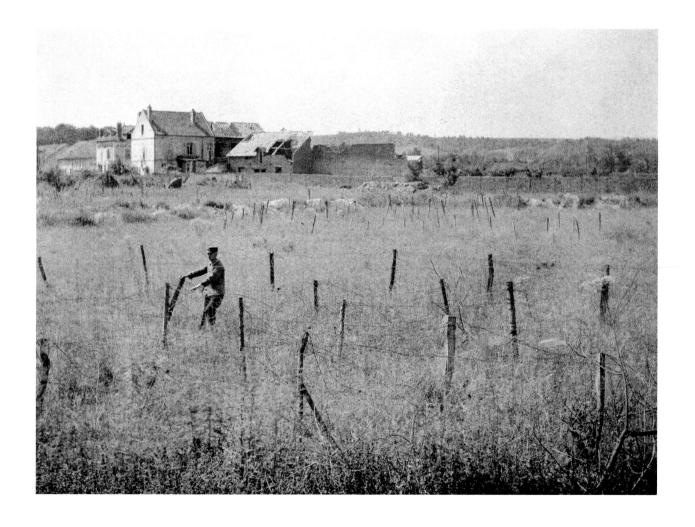

Soissons 1917

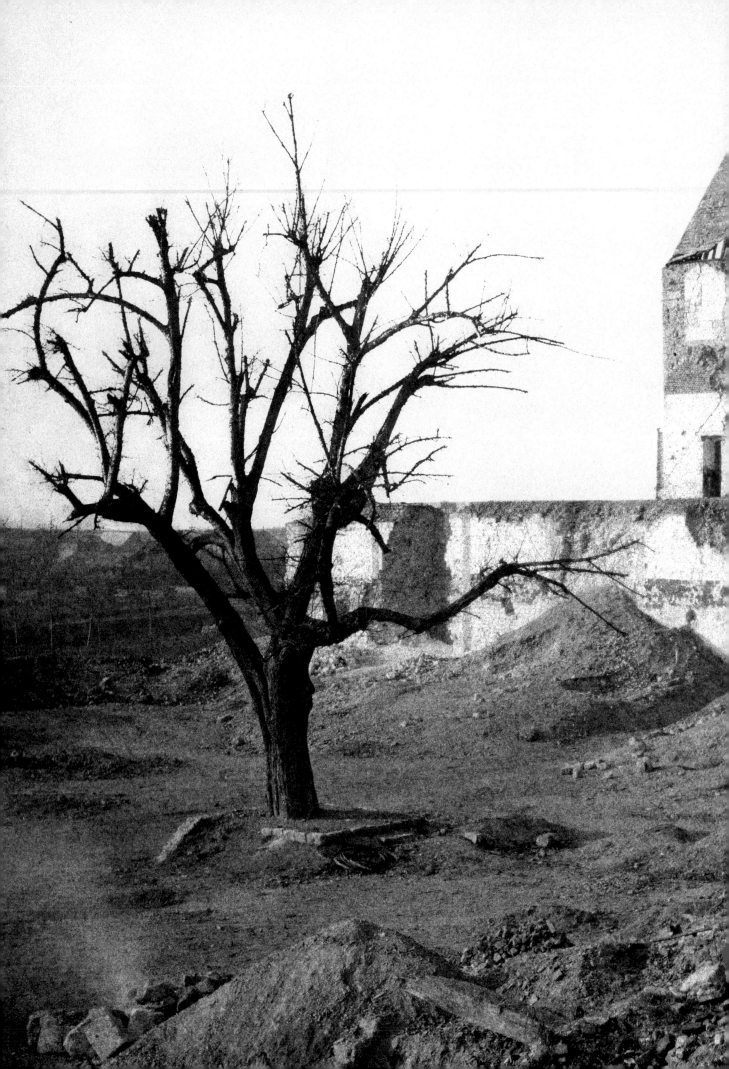

Noyon

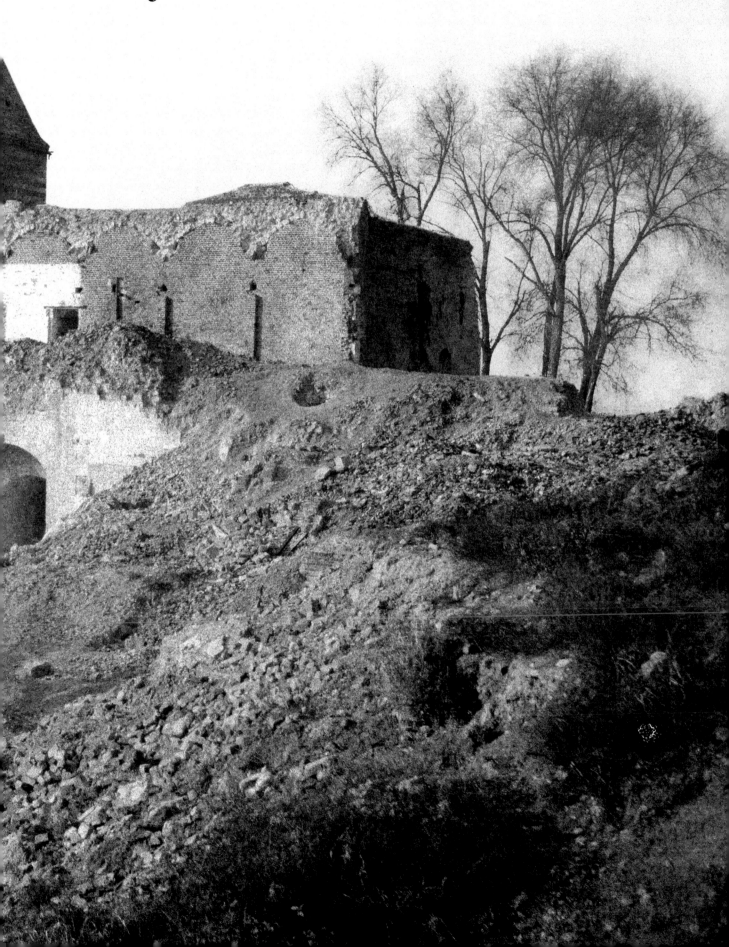

1917 Noyon

OPPOSITE
*Portrait of an Algerian pioneer in Roiglise
(near Noyon), 1917.*

ABOVE
*A group of Algerian pioneers in Roiglise
(near Noyon), 1917.*

PAGE 262/263
*Chaulnes Castle. Cuville visited this area
shortly after the retreat of the Germans to the
"Hindenburg Line" in March 1917. The castle
was not reconstructed after the war; in
its place a new building was built in 1929.*

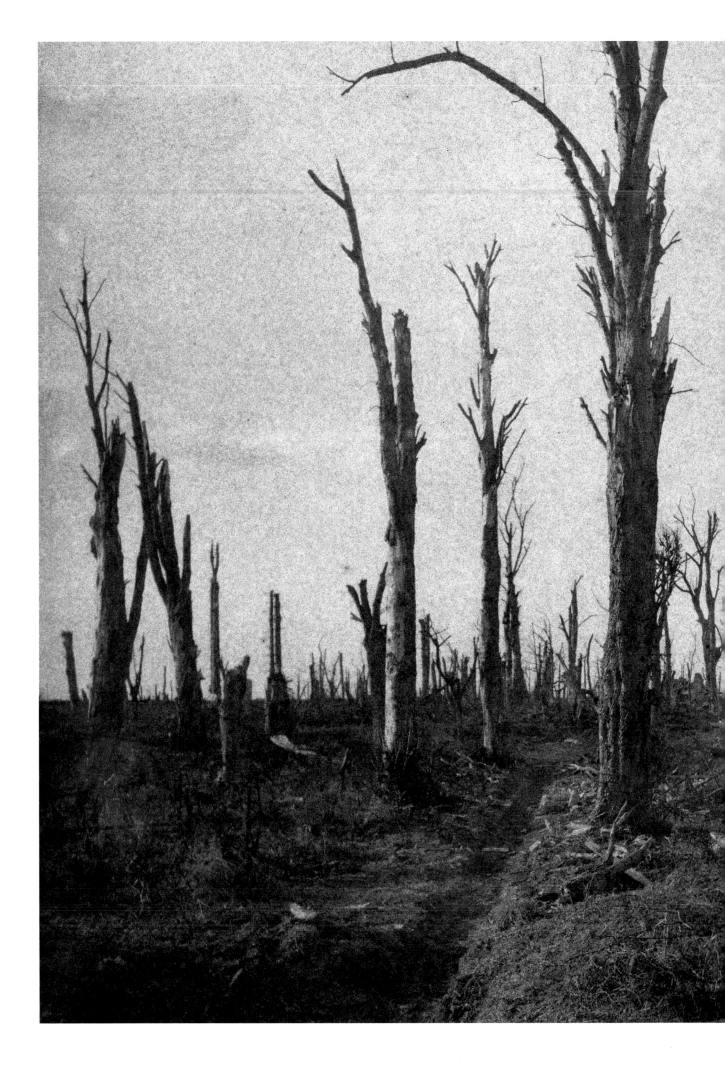

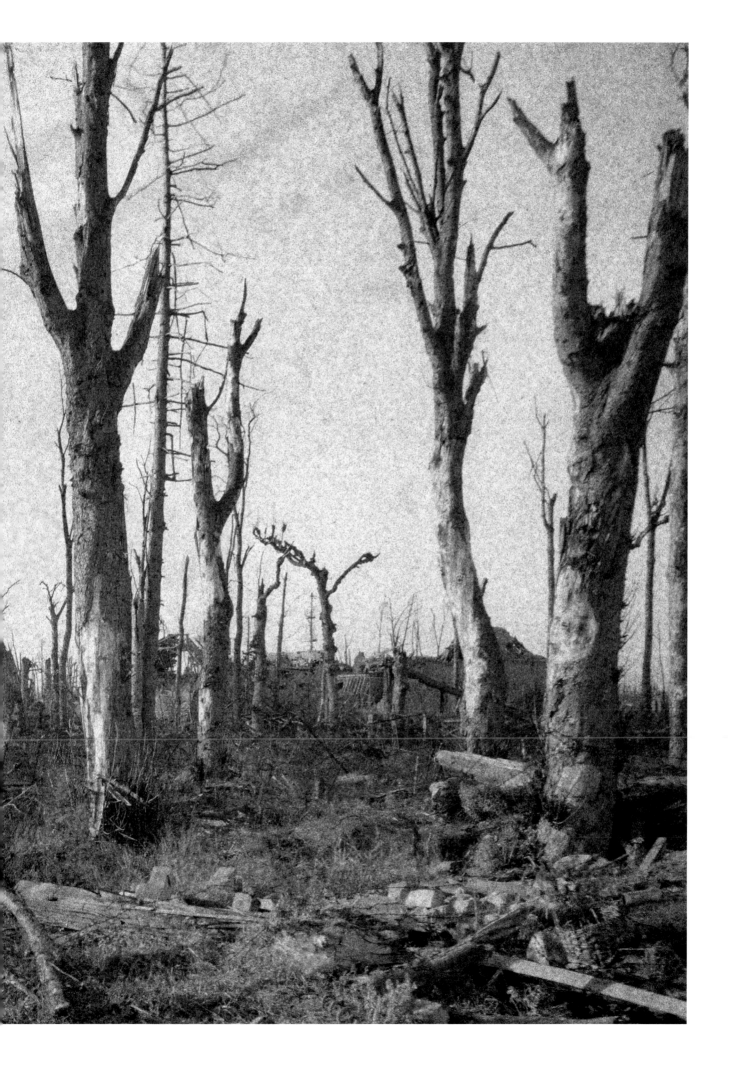

268

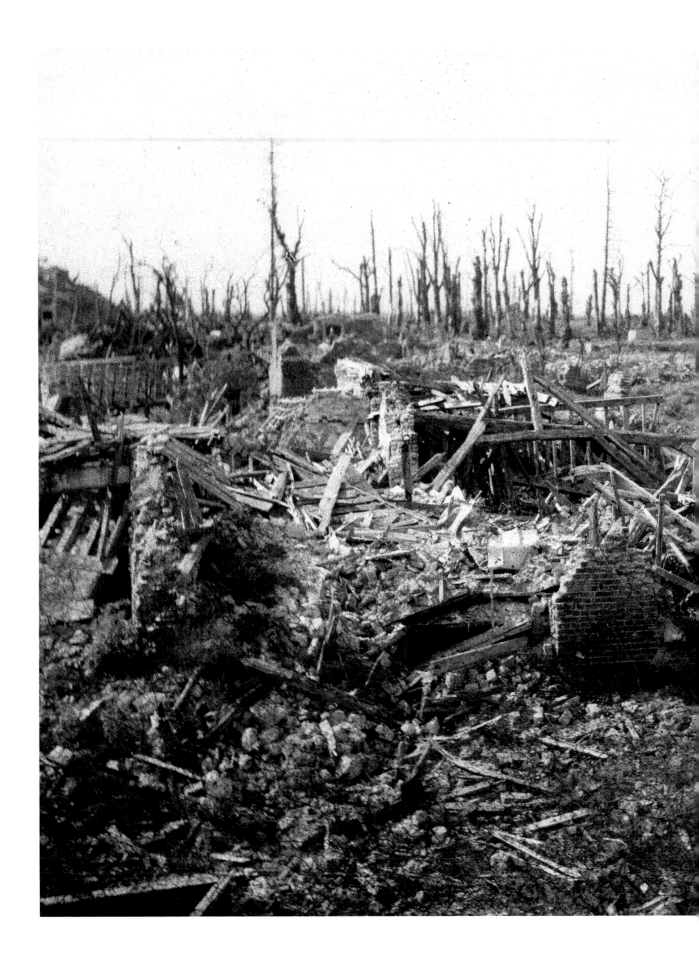

1917 Noyon

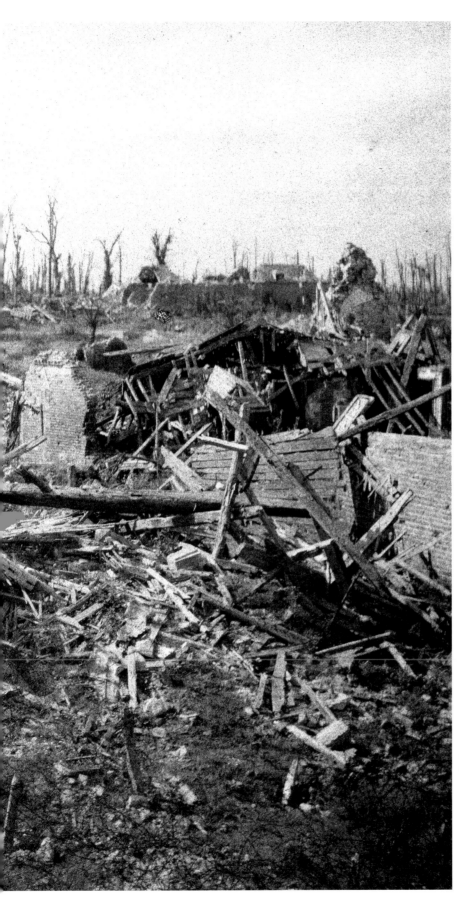

PAGE 266/267
Chaulnes, dead trees near the castle, 1917.
Chaulnes was first destroyed in September
1914 when captured by German troops.
A city of 1,300 inhabitants at the time, it was
also contested in the Battle of the Somme in
summer 1916.

LEFT
View of Chaulnes, spring 1917. A year later
Chaulnes was occupied once again during
the German Spring Offensive in 1918. At the
end of August 1918 Australian troops took
back the city.

Noyon 1917

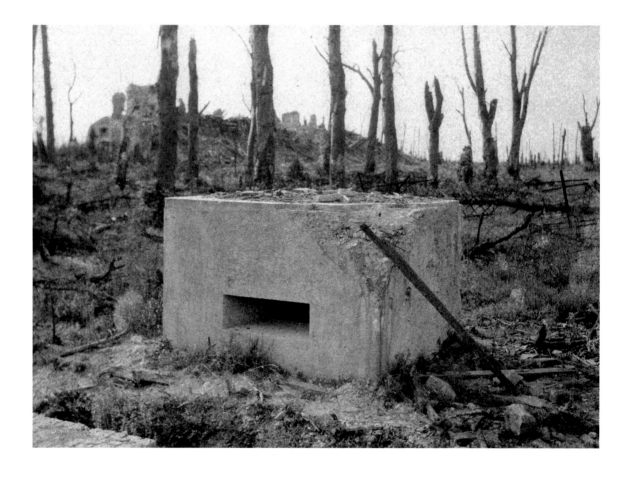

1917　Noyon

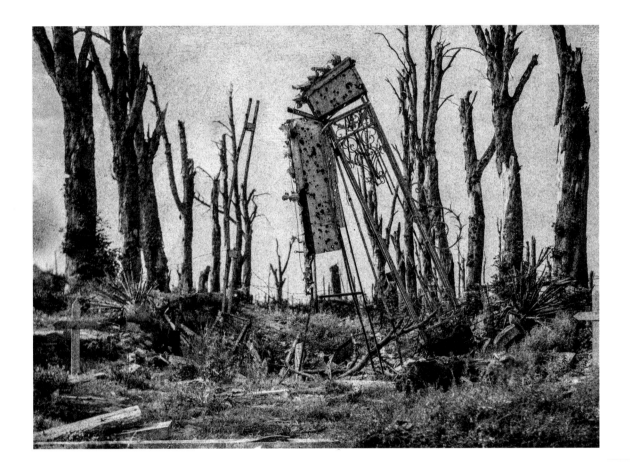

The front line in March 1917 near Noyon;
a concrete bunker and dead trees.

Driveway to the castle at Chaulnes, 1917.

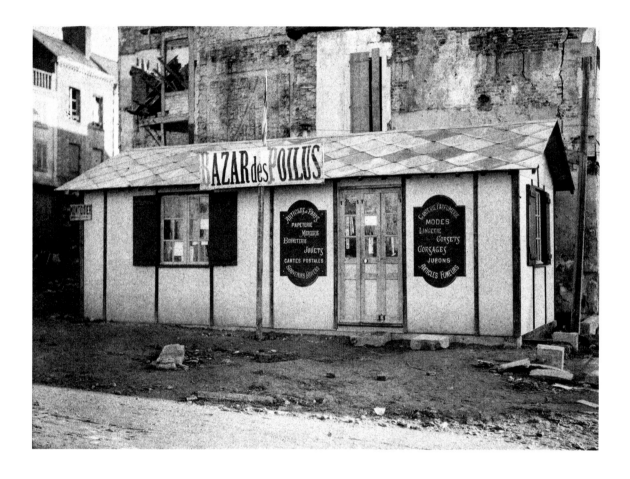

ABOVE
A makeshift shop for soldiers in Roye,
a neighbouring city of Chaulnes, 1917.

OPPOSITE
Soldiers with horse and wagon in
the midst of the ruins of Chaulnes, 1917.

1917 Noyon

Noyon 1917

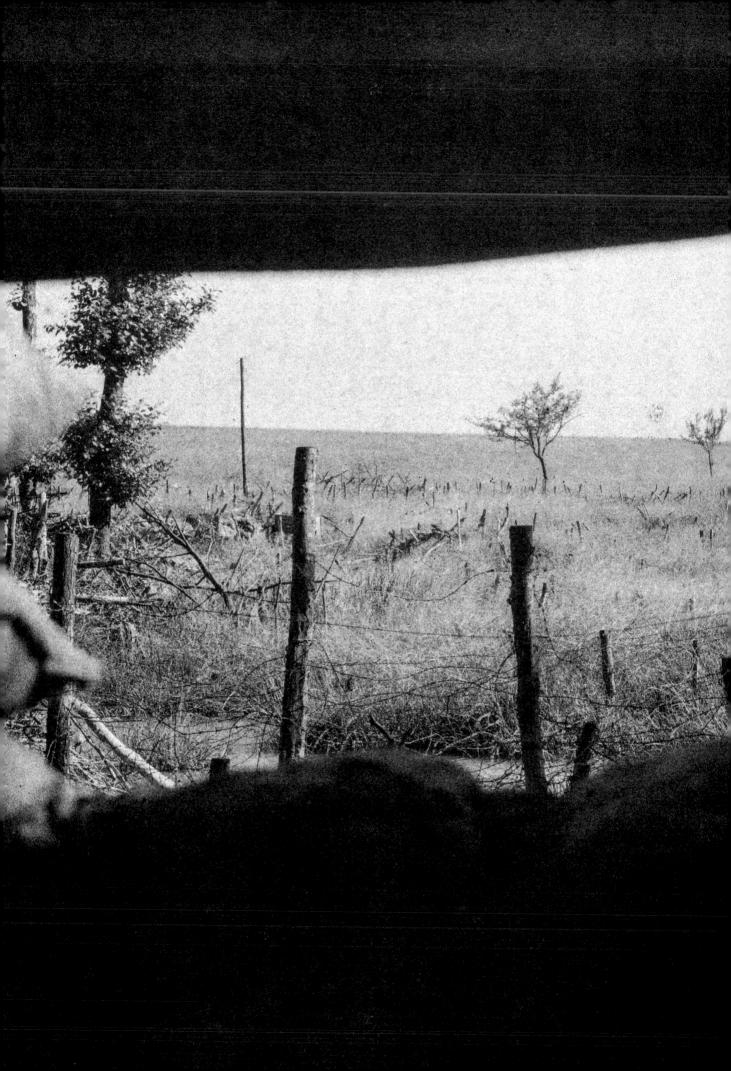

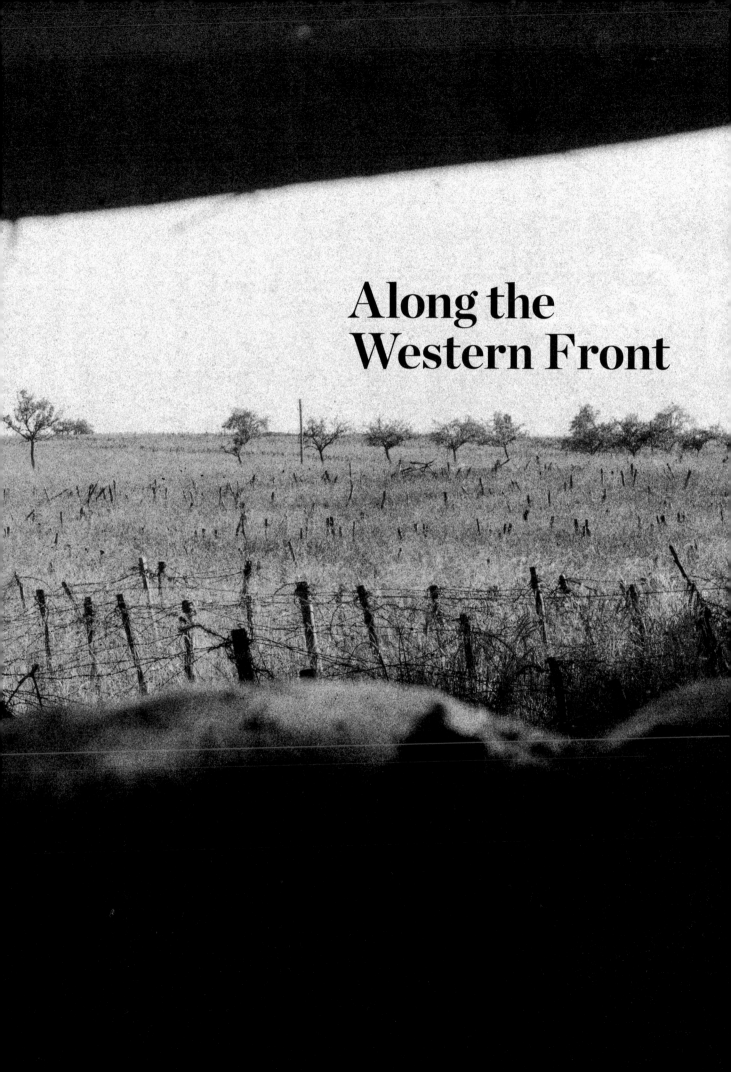

Along the
Western Front

PAGE 274/275
*Lookout post in a trench at the front near
Hirtzbach; in the foreground are sandbags,
16 June 1917.*

OPPOSITE
*A group of soldiers in a trench at the front,
a forest near Hirtzbach in Alsace,
16 June 1917. In summer 1917 Castelnau
travelled the Western Front from
Alsace to Belgium, documenting daily
life with Autochrome plates.*
All photos from page 274/275 to page
312/313: Paul Castelnau

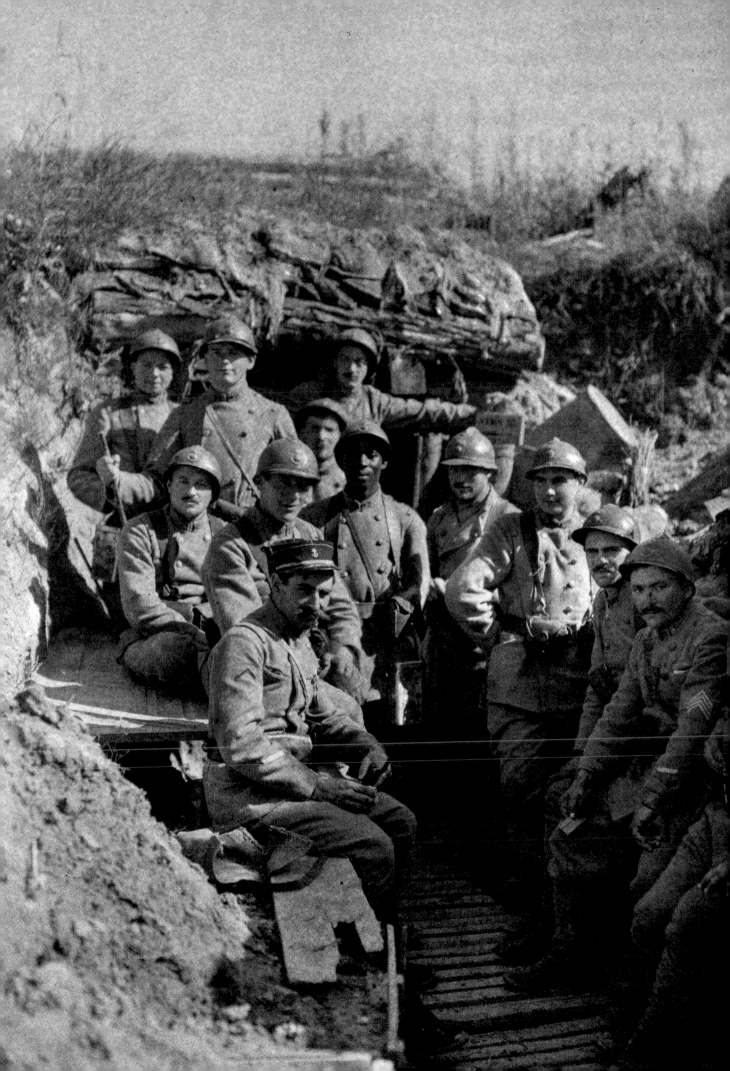

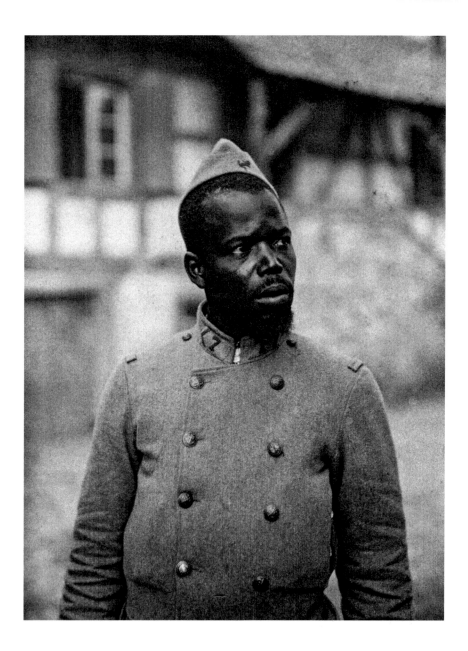

1917 Along the Western Front

I have not a great deal to do as a rule. Long hours of waiting, nothing that has to be done and yet not free to do what I want, in fact not consciously wanting anything except, I suppose, the end.

EDWARD THOMAS TO ROBERT FROST, 6 MARCH 1917

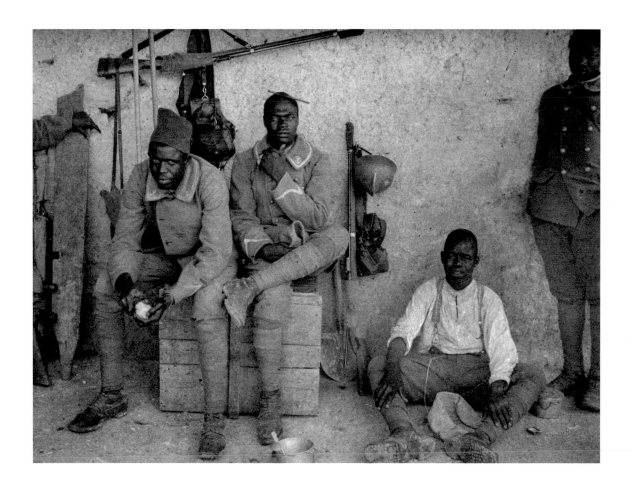

OPPOSITE
Sar Amadou from the 7ᵗʰ Regiment in Ballersdorf in Alsace, 22 June 1917.

ABOVE
Four members of the Senegalese Guard in Saint-Ulrich, Alsace, 16 June 1917. Although the name suggests otherwise, these troops were recruited mostly from Sudan.

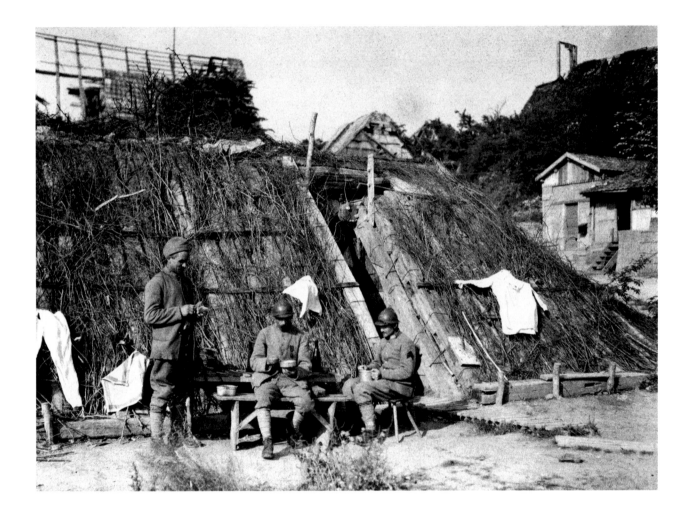

1917 Along the Western Front

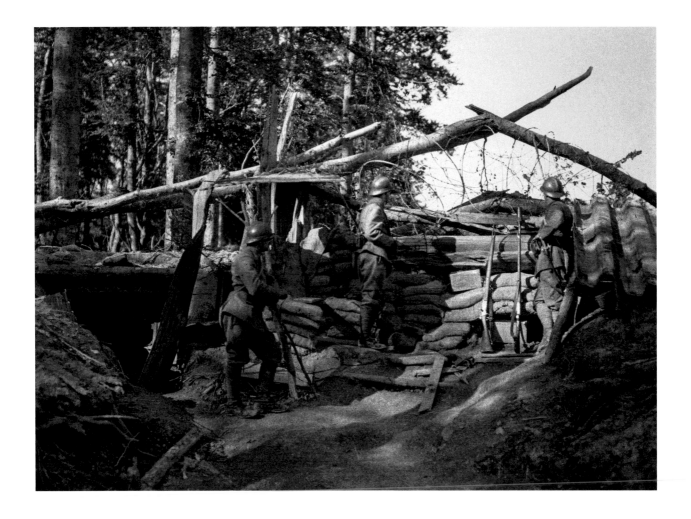

*Mealtime in front of temporary living
quarters in Largitzen, Alsace, 18 June 1917.*

*Three French soldiers at a lookout
protected by sandbags near Hirtzbach,
16 June 1917.*

282

ABOVE
*Swiss soldiers behind the border fence
at Pfetterhouse, Alsace, 19 June 1917.*

OPPOSITE
*Pfetterhouse at the Swiss-German border
near the tri-border area, French and Swiss
officers stand across from one another,
separated by the border fence, 19 June 1917.
Until the French occupation, the small
town was headquarters for Swiss clock-
making, since German import tariffs could be
bypassed through manufacture in Alsace.*

Along the Western Front 1917

RIGHT
Three storage hangars with camouflage nets in Dannemarie west of Hirtzbach, 23 June 1917.

BELOW
French soldiers camouflage a 15 inch (370 milimetre) cannon named Keity near Noyon, 1917.

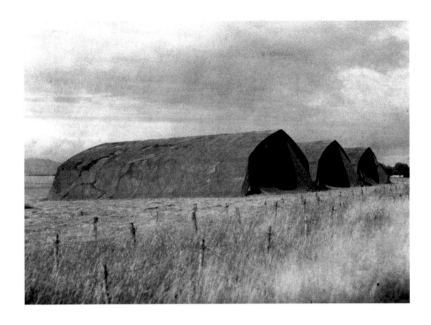

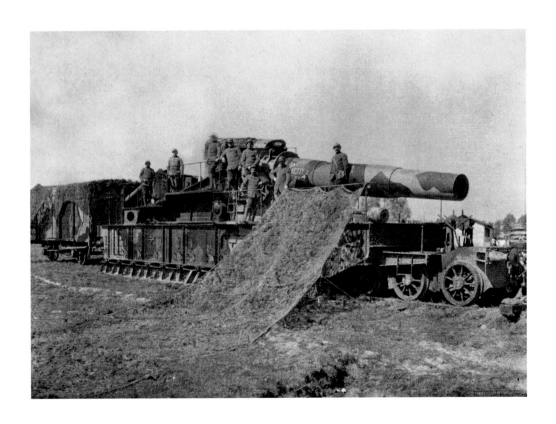

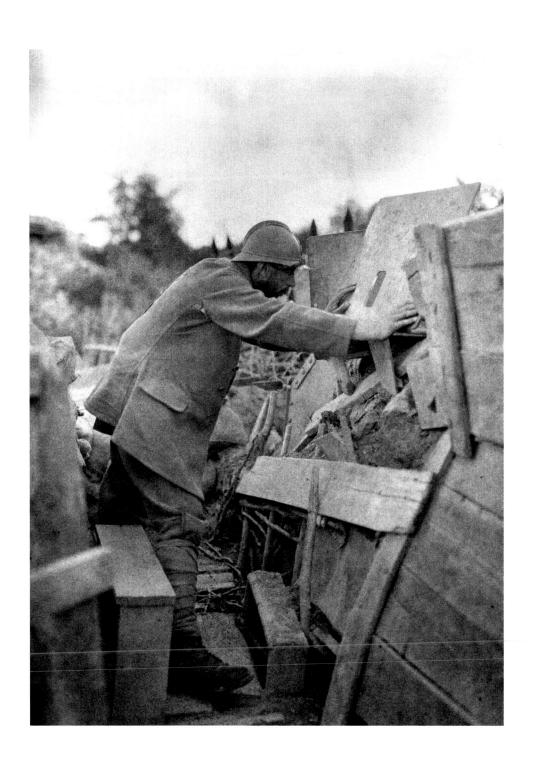

ABOVE
French army lookout in a trench, Eglingen
(Alsace), 23 June 1917.

ABOVE
*In front of the changing tent for troop
entertainment, Saint-Ulrich, 24 June 1917.*

OPPOSITE
*A Belgian gendarme and a French auxiliary
gendarme in front of a damaged house
in Woesten (Belgium), 25 August 1917.*

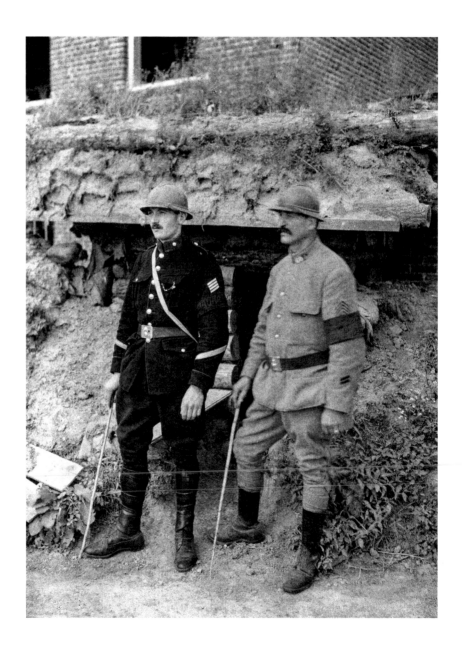

The grave of La Fayette, 6 July 1917.
The grave of French officer and politician
Marquis de La Fayette lay in the Cimetière
de Picpus in Paris, where the victims of the
French Revolution's Reign of Terror and their
relatives lay buried. La Fayette took part
in the American Revolution and played an
important role in the French Revolution. Each
year on 4 July, U.S. Independence Day, a cer-
emony takes place at La Fayette's gravesite.

Along the Western Front 1917

BELOW
Civilian population and French and
Allied soldiers in front of an inn in Rexpoëde
in northern France, 2 September 1917.

OPPOSITE
Destroyed building with the advertisement
"le pneu Michelin boit l'obstacle"
("Michelin tyres swallow obstacles"),
Woesten (Belgium), 25 August 1917.

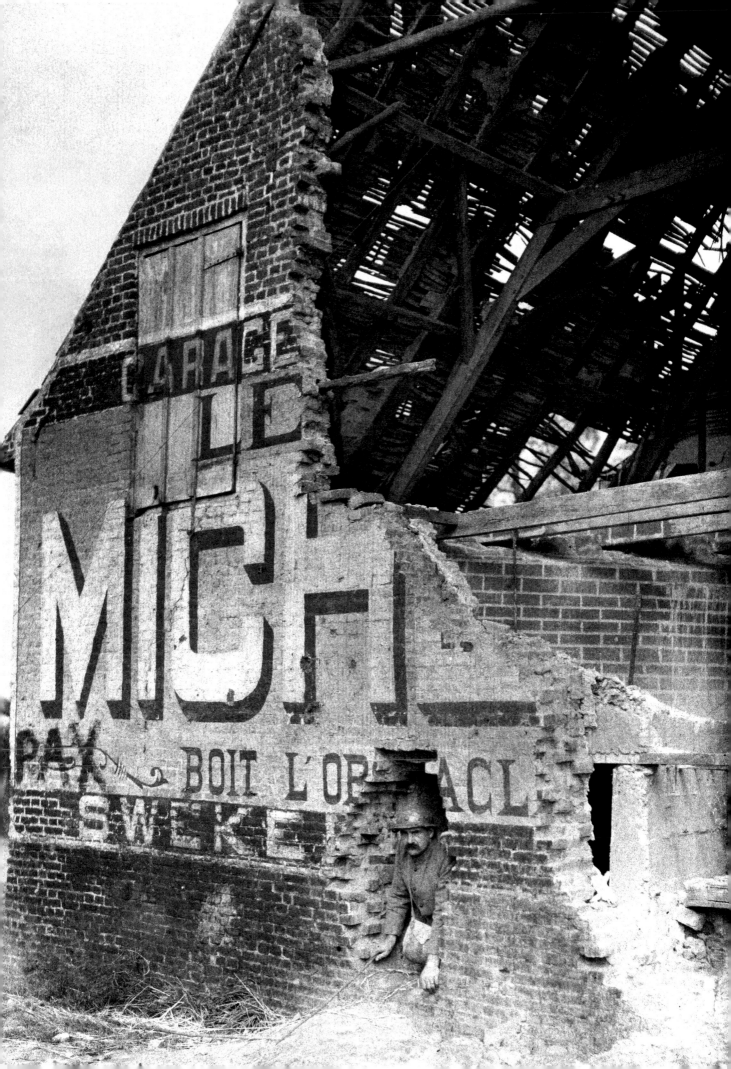

1917 Along the Western Front

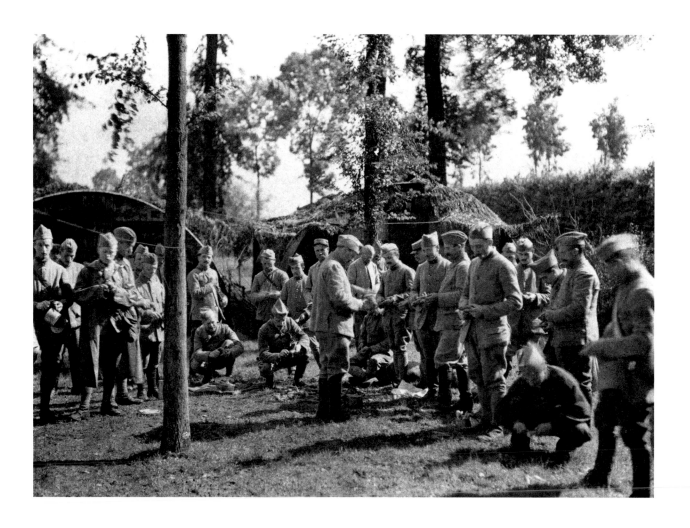

OPPOSITE
Headquarters of the 1ˢᵗ Army, camouflaged
outhouse, Rexpoëde, 31 August 1917.

ABOVE
Headquarters of the 1ˢᵗ Army.
The tedious duty of carrot peeling,
Rexpoëde, 31 August 1917.

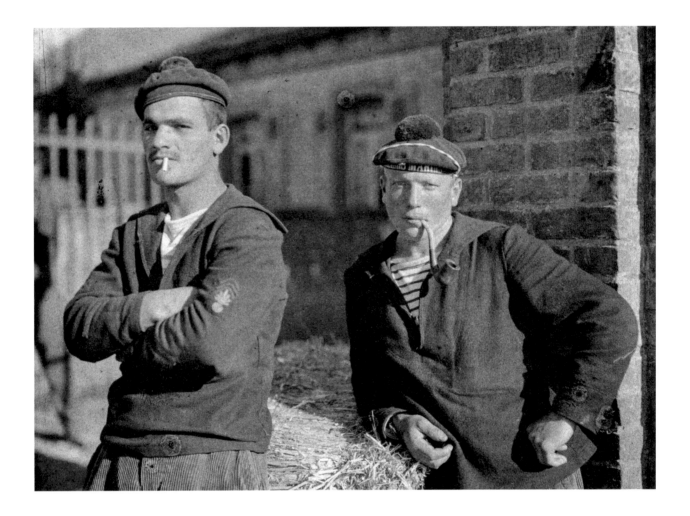

OPPOSITE
The heroes of the three canals, Drie Grachten (Belgium), 3 September 1917. At the beginning of the war, Belgian pioneers erected a defensive position along the canals. At the end of October 1914 the Allies flooded the plain, making the canals impassable. The Germans succeeded in taking the Allied defence positions in April 1915.

RIGHT
The heroes of the three canals, Drie Grachten (Belgium), 3 September 1917. Portrait of Commander Maupeou, commander of the marines.

BELOW
The heroes of the three canals, Drie Grachten (Belgium), 3 September 1917. A group of sailors, officers, and soldiers.

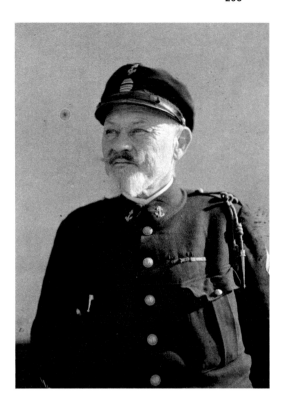

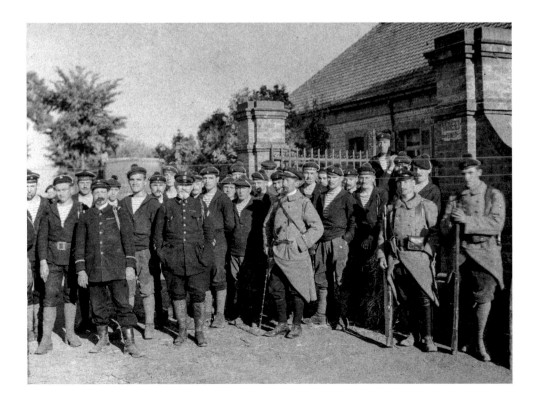

BELOW

Military driver in front of a covered truck, Bergues, 2 September 1917. Trucks like this one allowed the staff of the photography department of the French army to move around more easily with their equipment at the front. The small town of Bergues on the French–Belgian border is known for its two landmarks, La Tour Carrée and La Tour Pointue, both seen in the background.

OPPOSITE

Orderly officer of the Belgian General Michel, Veurne near Dunkirk, 4 September 1917. Baron Michel du Faing d'Aigremont (1855–1931) commanded the 4ᵗʰ Division of the Belgian army. After the war he became the supreme commander of the Belgian occupying forces in Germany.

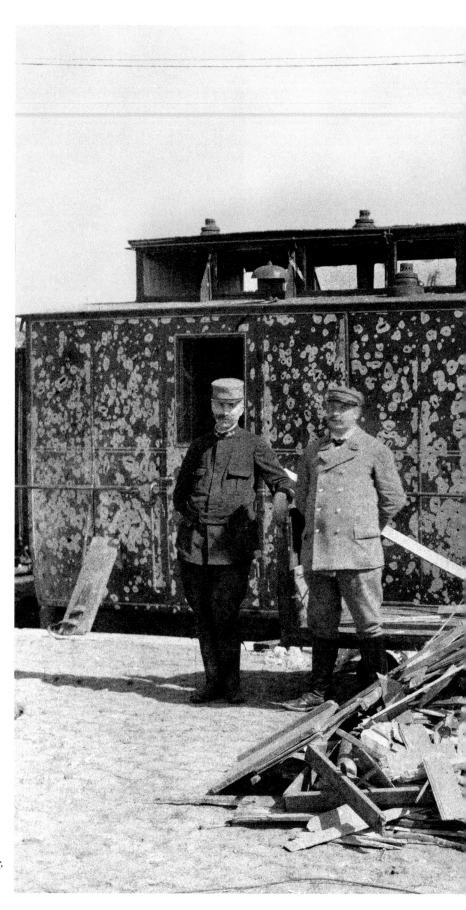

RIGHT
After the bombardment of 2 and 3 September,
a mail van with bullet holes, Dunkirk,
3 September 1917.

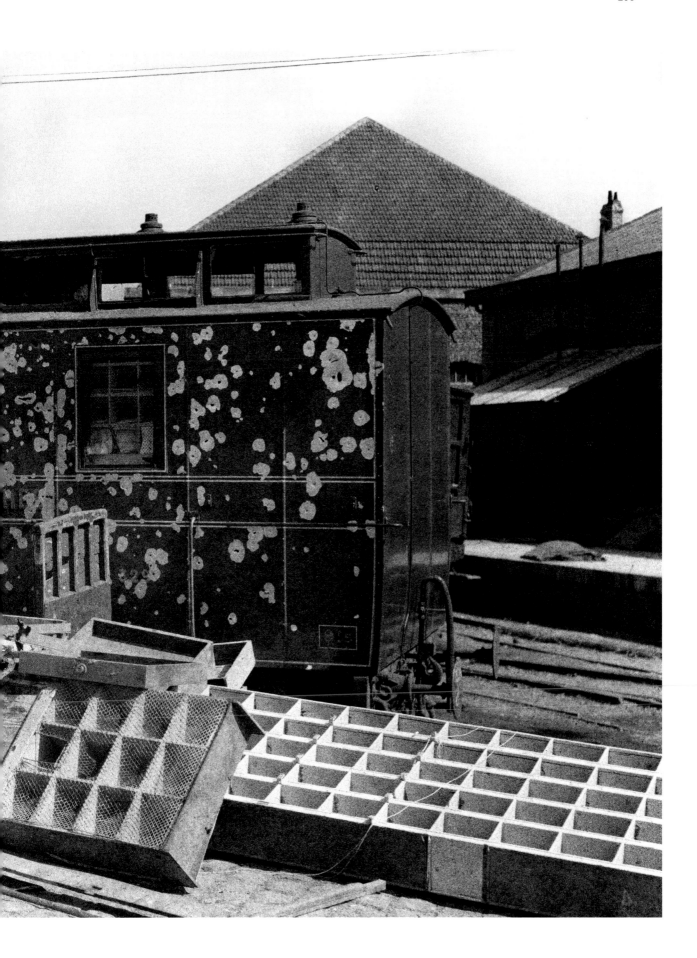

Along the Western Front 1917

1917 Along the Western Front

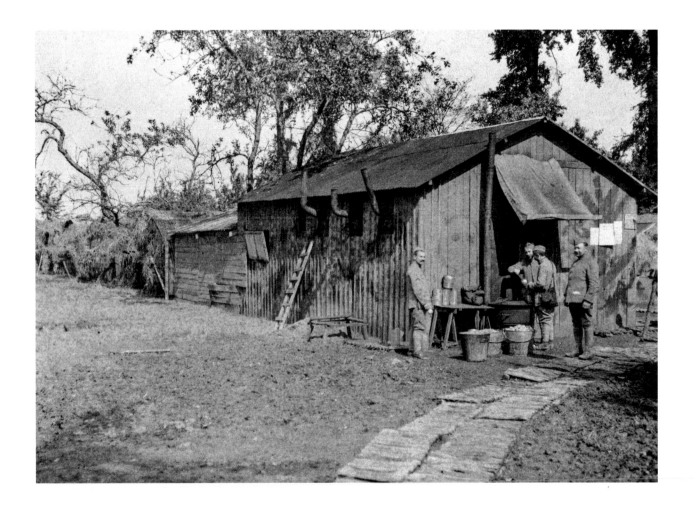

OPPOSITE
Scene from Veurne near Dunkirk: cutting
the grass at the wayside, 4 September 1917.

ABOVE
The kitchen at headquarters of
Rexpoëde, 6 September 1917.

Along the Western Front 1917

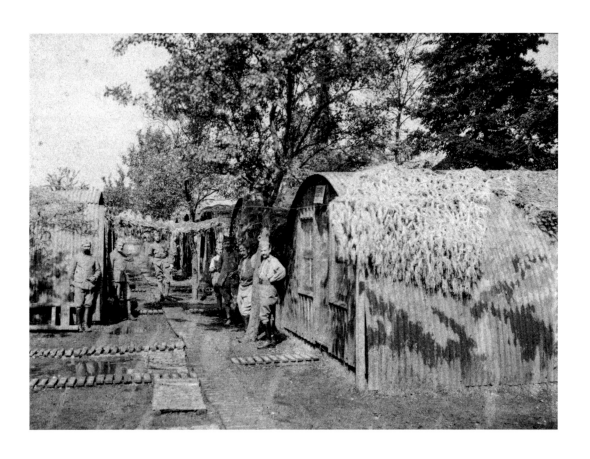

LEFT
Abbé Even, chaplain of the 51st Division in uniform, Boezinge (Belgium), 10 September 1917.

BELOW
A 12.5 inch (320 milimetre) cannon on rails, Hogstade (Belgium), 5 September 1917. This weapon was nicknamed "Cyclone."

OPPOSITE
Ambulances stand ready to transport the wounded, Boezinge (Belgium), 17 September 1917.

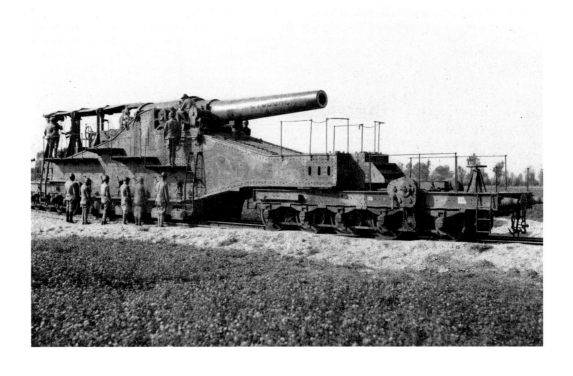

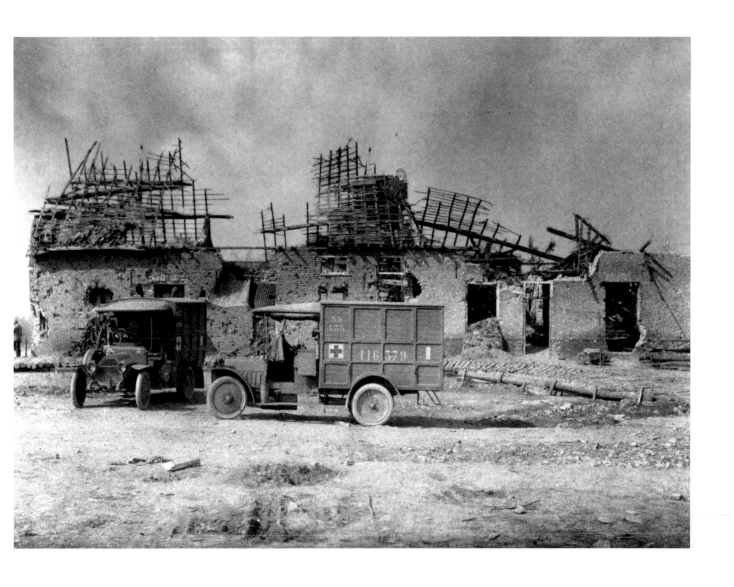

1917 Along the Western Front

LEFT
*Tent lodging in Ypres near Roesbrugge
(Belgium), 7 September 1917.*

Along the Western Front 1917

This morning I was hit! We were bombing and a fragment from somewhere hit my thumb knuckle. I coaxed out one drop of blood. Alas! no more!! There is a fine heroic feeling about being in France, and I am in perfect spirits. A tinge of excitement is about me, but excitement is always necessary to my happiness.

WILFRED OWEN TO SUSAN OWEN, 1 JANUARY 1917

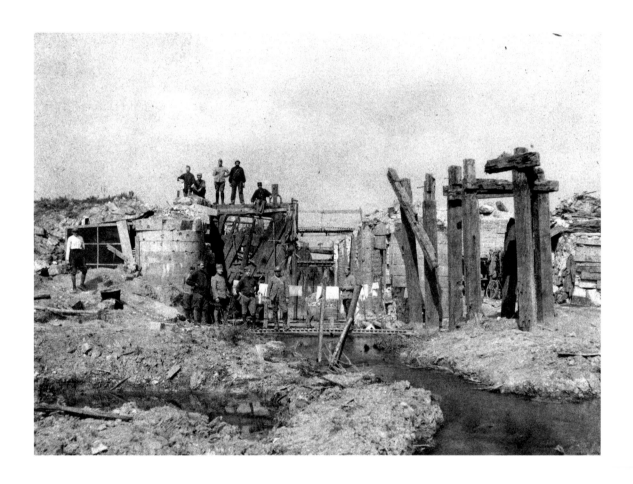

Building a makeshift bridge over a terrain studded with shell craters, Boezinge, 9 October 1915.

A lock destroyed by shelling in Het Sas near Boezinge, 10 September 1917.

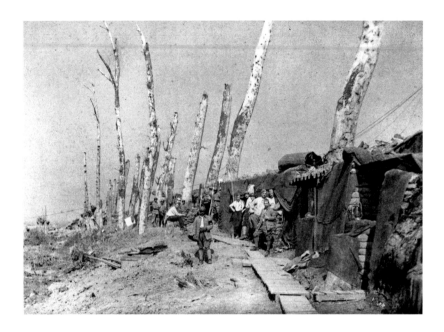

Three stretcher-bearers who got up were hit, one after one. I had to order no one to show himself after that, but remembering my own duty, and remembering also my forefathers the agile Welshmen of the Mountains I scrambled out myself & felt an exhilaration in baffling the Machine Guns by quick bounds from cover to cover. After the shells we had been through, and the gas, bullets were like the gentle rain from heaven.

WILFRED OWEN TO SUSAN OWEN, 8 OCTOBER 1918

ABOVE
*French line near Het Sas (Boezinge)
in Belgium, ca. 25 miles (40 kilometres)
north of Lille, 10 September 1917.*

OPPOSITE
*Two officers in terrain ploughed up by shells,
Boezinge (Belgium), 10 September 1917.*

Through flesh and blood mankind hacks itself a way of the "idea" through living people—later in the schoolbooks it will read quite nicely, one should just not be involved.

KURT TUCHOLSKY TO HANS ERICH BLAICH, 20 FEBRUARY 1917

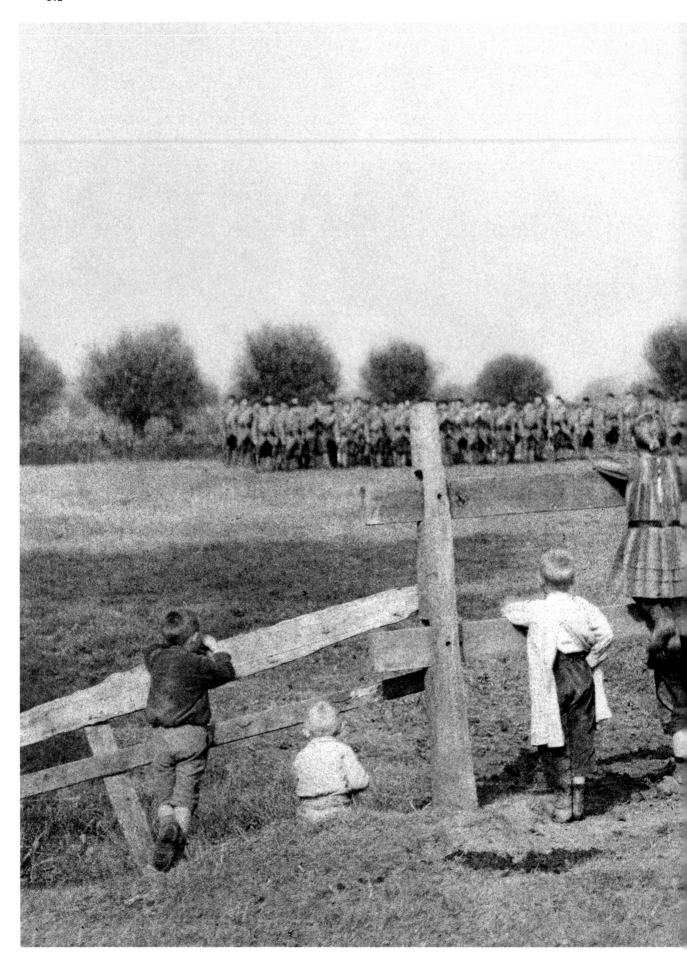

1917 Along the Western Front

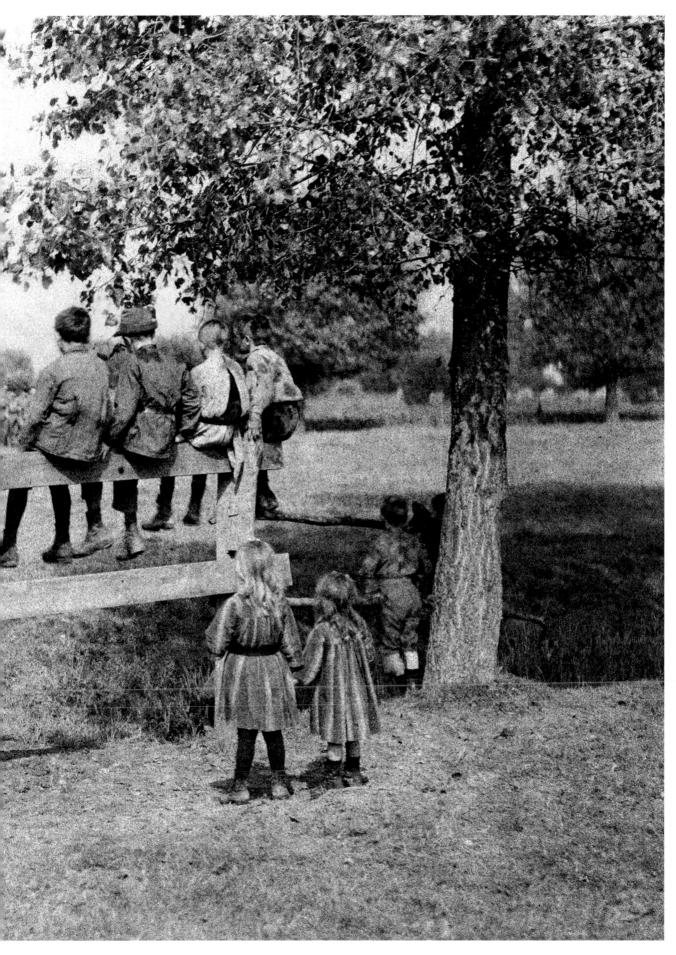

Along the Western Front 1917

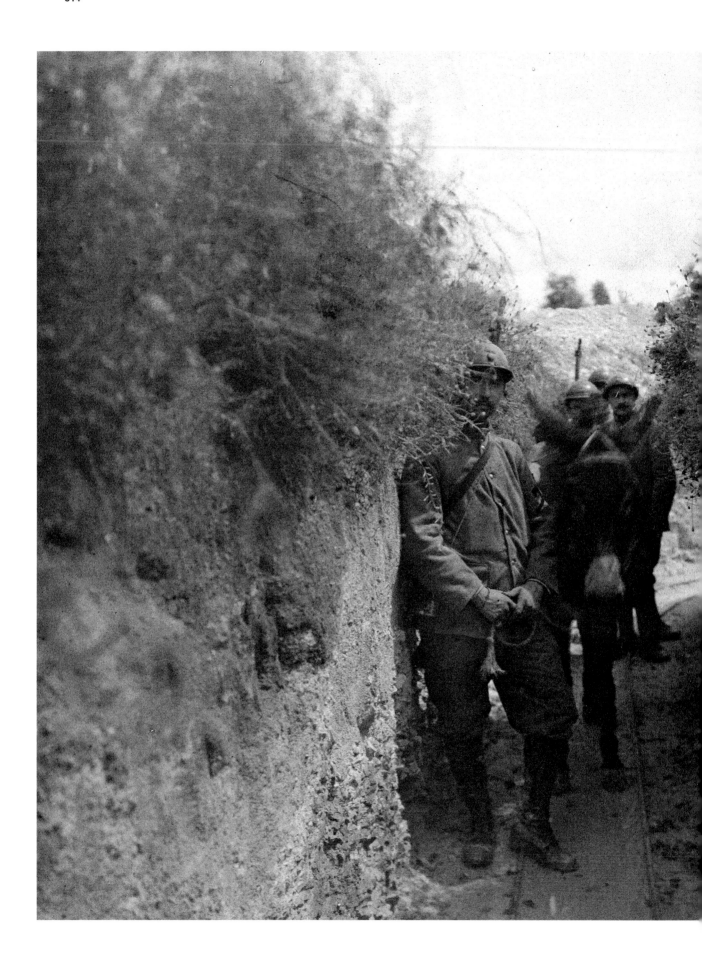

1917 Along the Western Front

PAGE 312/313
*Admiral Ronarc'h decorates sailors,
children watch from a distance, Saint-Folquin
(near Dunkirk), 10 September 1917.*
Photo: Paul Castelnau

LEFT
*A supply patrol moves through the narrow
passageways. A donkey named "Komprintz"
(whose name was meant to poke fun at the
Prussian crown prince) carries the supplies,
8 July 1916.*
Photo: Albert Samama-Chikli

Along the Western Front 1917

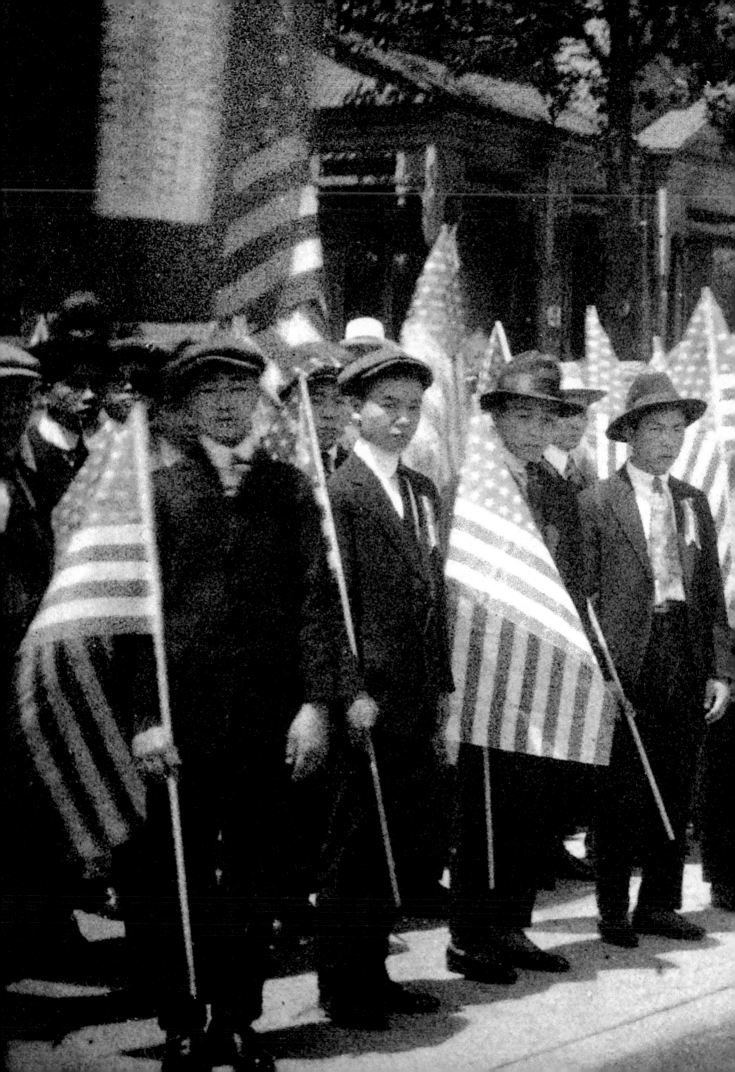

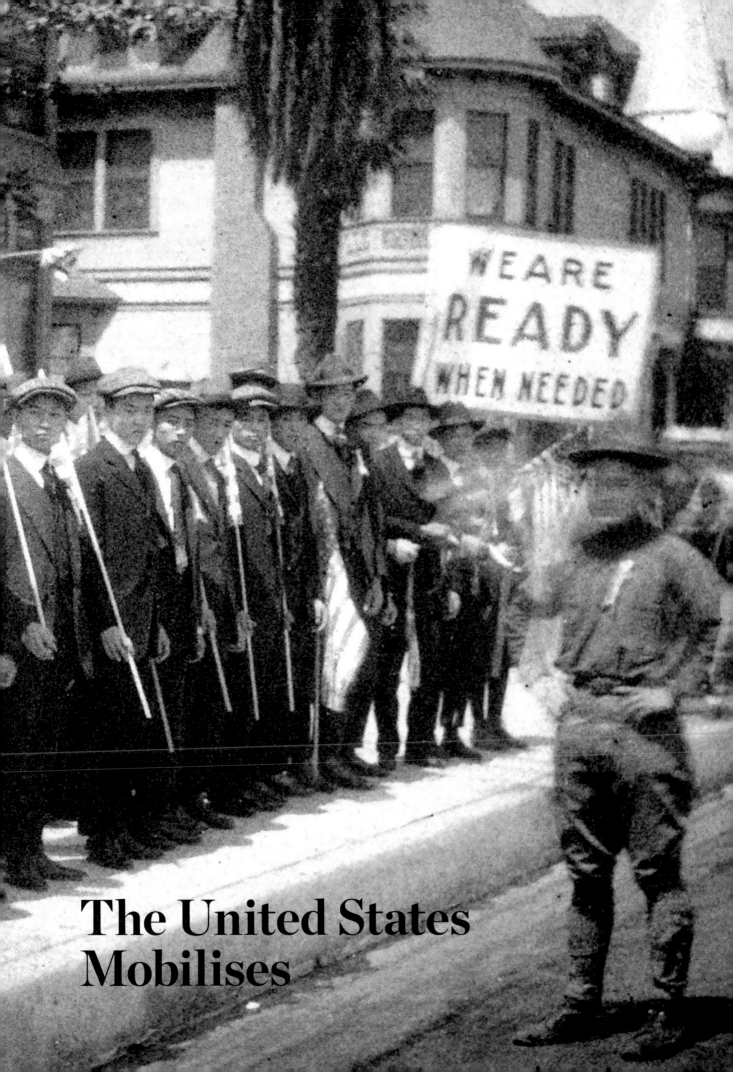

The United States Mobilises

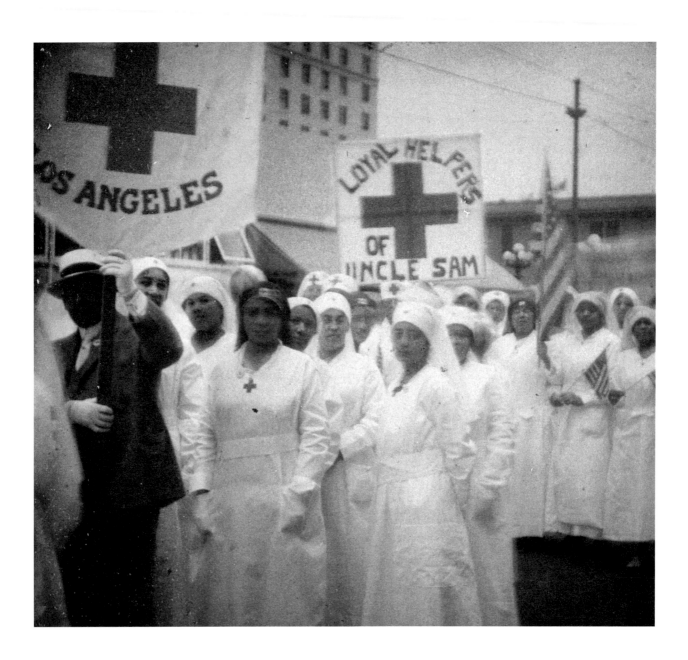

1917　The United States Mobilises

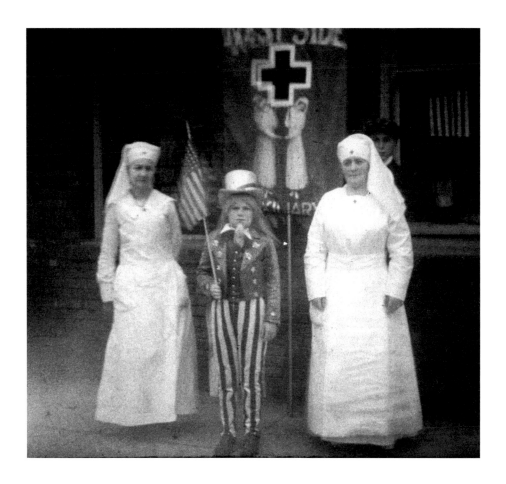

PAGE 316/317
Men of Asian origin at a parade to support the U.S. entry into the war, presumably Los Angeles, 1917. California was the main destination of Japanese and Chinese immigrants in the early 20th century. Japan participated in the war on the side of the Entente from 1914.

OPPOSITE
Red Cross nurses support the First World War mobilisation at a parade, presumably Los Angeles, 1917.

ABOVE
Two nurses and a child dressed as Uncle Sam at a parade in Pasadena (Los Angeles), 1917.
All photos from page 316/317 to page 323: Charles C. Zoller

Children in costume with U.S. flags at
Jones Square Park, Rochester, ca. 1918.

Parade float meant to symbolise
American–British solidarity,
presumably Los Angeles, 1917.

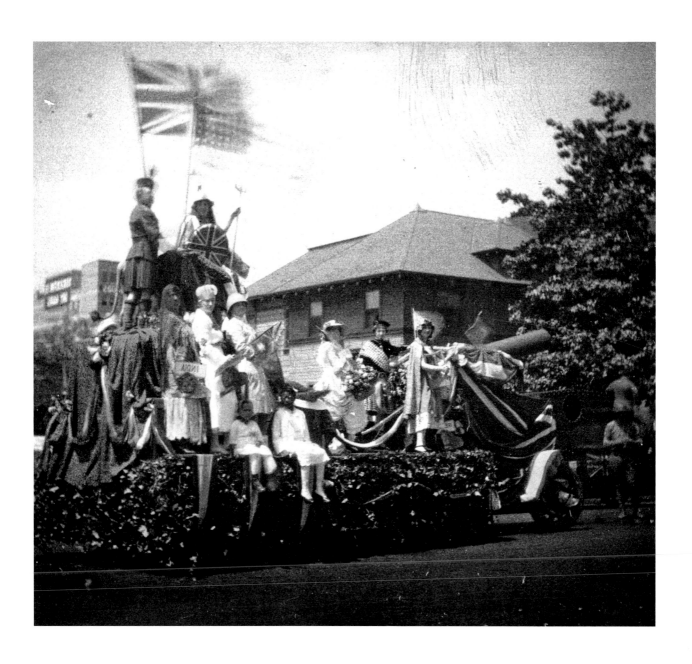

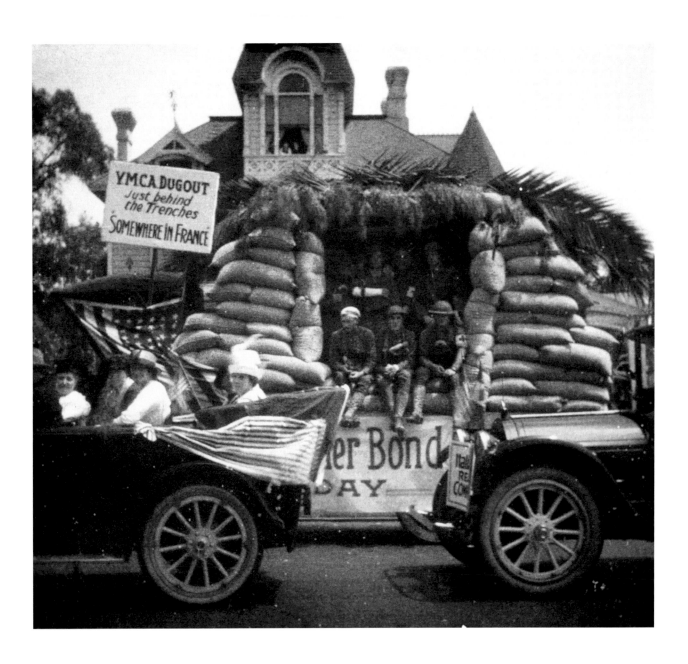

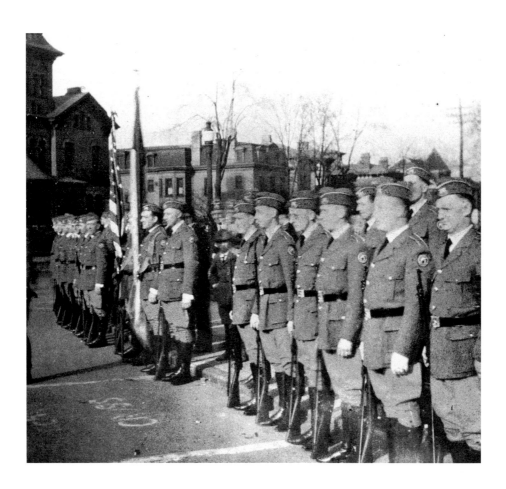

OPPOSITE
Vehicle with patriotic slogans, presumably Los Angeles, 1917.

ABOVE
A paramilitary unit on parade. Until entry into the war in April 1917, the United States had relatively small armed forces. Soon the famous "Uncle Sam" poster by James Montgomery Flagg ("I want you for U.S. Army") would recruit a large army in a relatively short time.

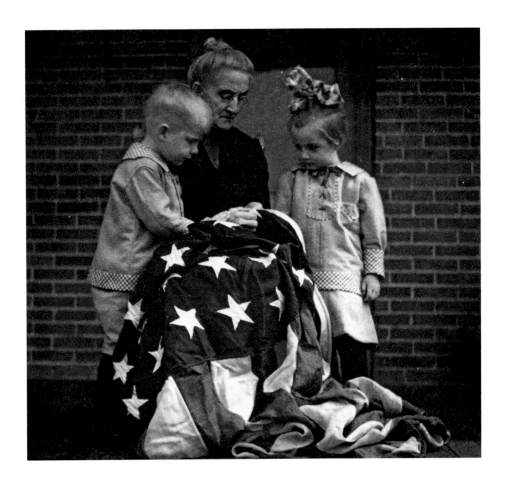

*Kate Marion Hosley with children Marion
Burt Hosley and John Oak Hosley, 1916. The
United States had declared itself neutral at
the start of the war, but supported the Entente
early on with assets and armaments. As
the German Reich defended itself against the
international law-defying British naval*
blockade with the announcement that hence-
forth defenceless ships of neutral states would
also be attacked, the United States soon
declared war on the German Reich, which
was crucial to the outcome.
Photo: Harry H. Hosley

*Children at a parade in support of
the entry into war in Los Angeles, 1917.*
Photo: Charles C. Zoller

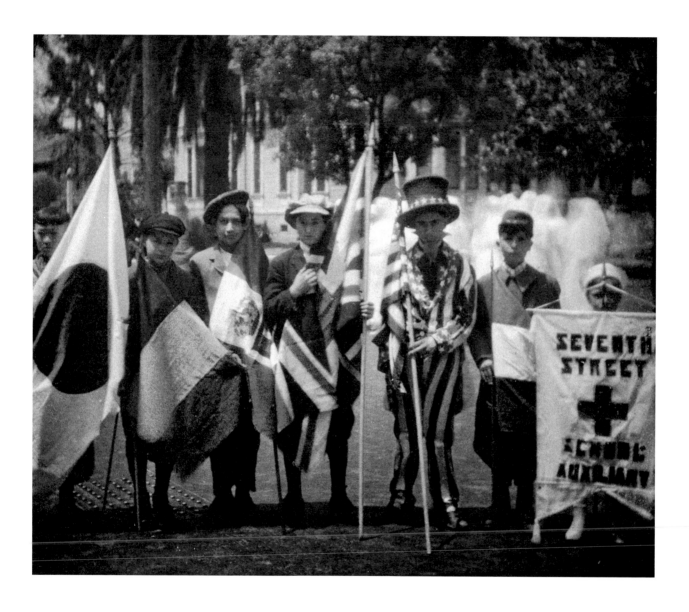

Agony and Death

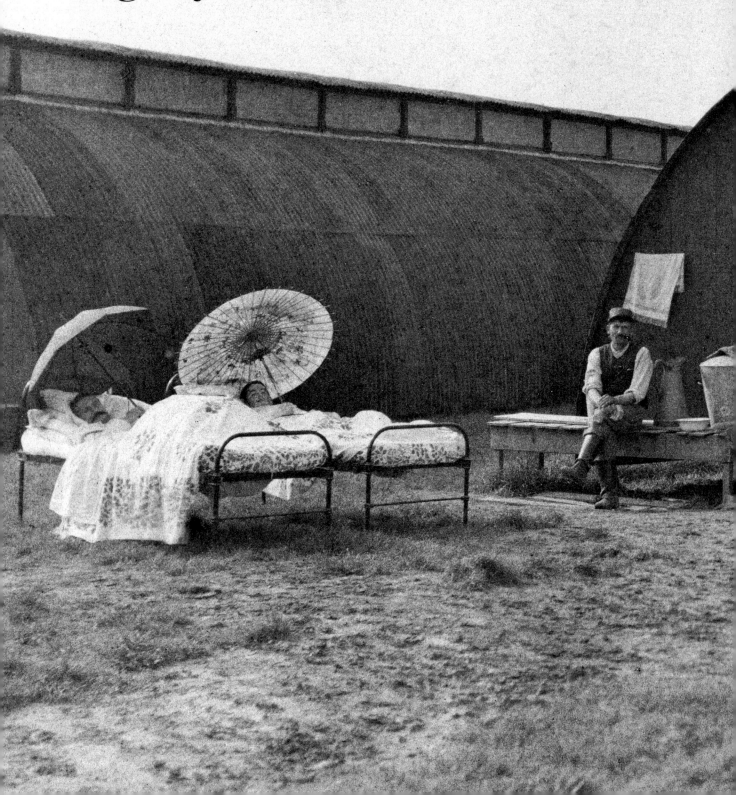

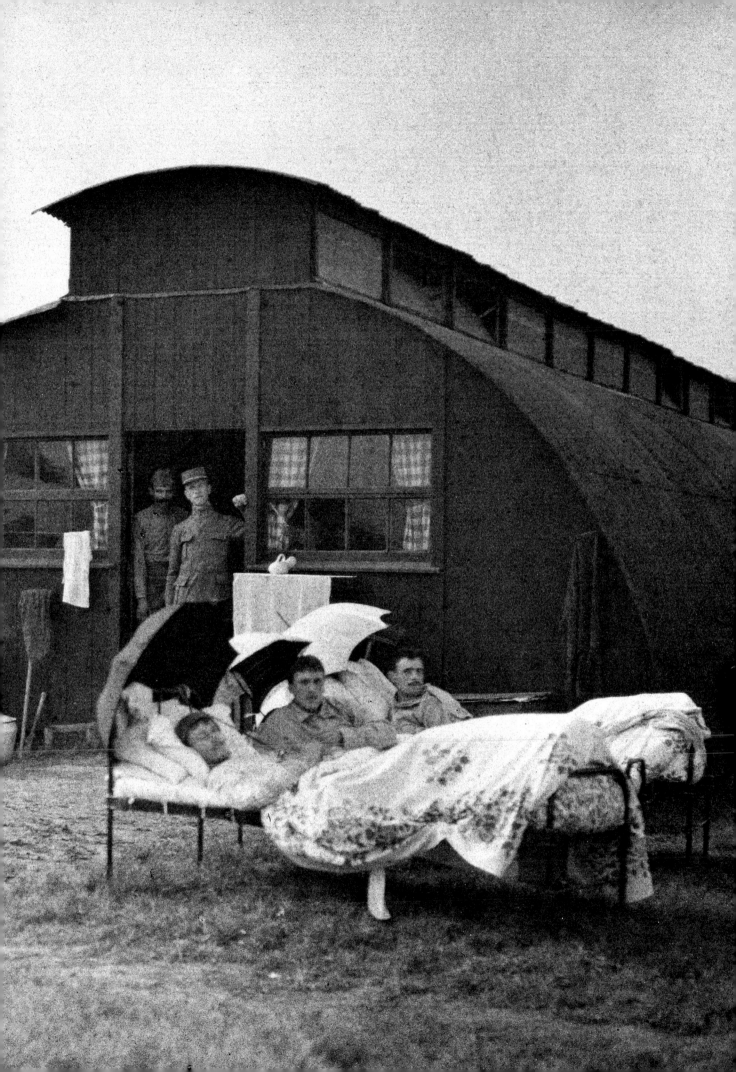

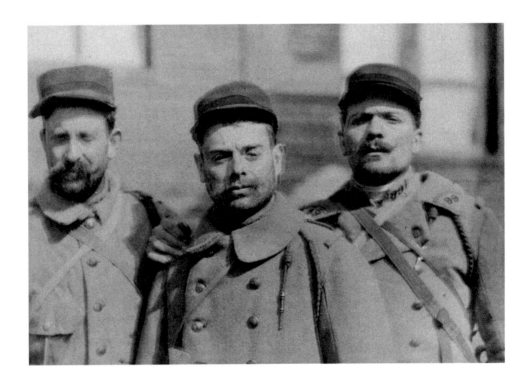

PAGE 326/327
*Surgery centre in Roesbrugge (Belgium),
7 September 1917.*
Photo: Paul Castelnau

ABOVE
*Three soldiers with conjunctival poisoning,
medical photograph, 23 March 1918.*
Photo: Aubert

OPPOSITE
*British ambulance, 1914. Motorisation
made possible the large-scale and relatively
quick transport of the wounded to the
medical staging area for the first time.*
Photo: Jules Gervais-Courtellemont

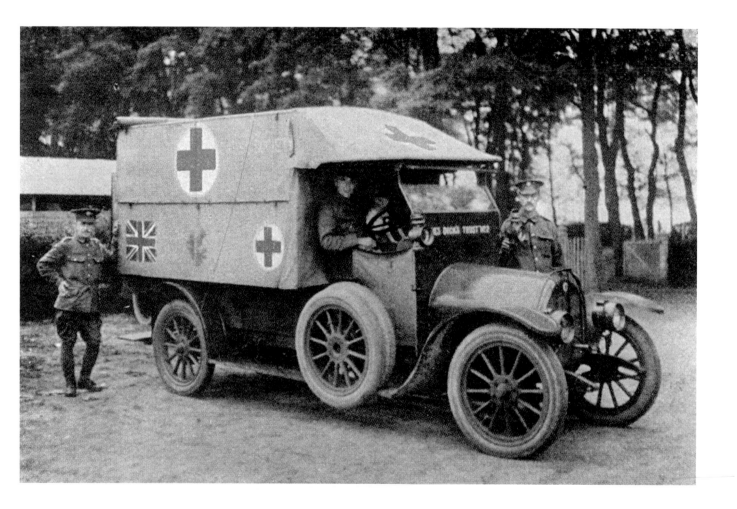

Corpse of a soldier of the French 99th Infantry Regiment who died of a lung infection, medical photograph, 1 April 1918.
Photo: Aubert

German field hospital in Champagne, 1915. First aid for wounded soldiers took place just a few hundred yards behind the front in dugouts of the batalion; the medical station of the regiment was located ca. 1.5 miles (2 to 3 kilometres) away from the front. From here the soldiers, if needed, were transported to the field hospital and for longer treatment to the military hospitals in the rear.
Photo: Hans Hildenbrand

What is the point of slaughter and murder, over and over? I fear that it will destroy too much, and too little will remain to rebuild. The war has surely woken in me a longing for the blessings of peace.

ERNST JÜNGER, WAR DIARY, 1 DECEMBER 1915

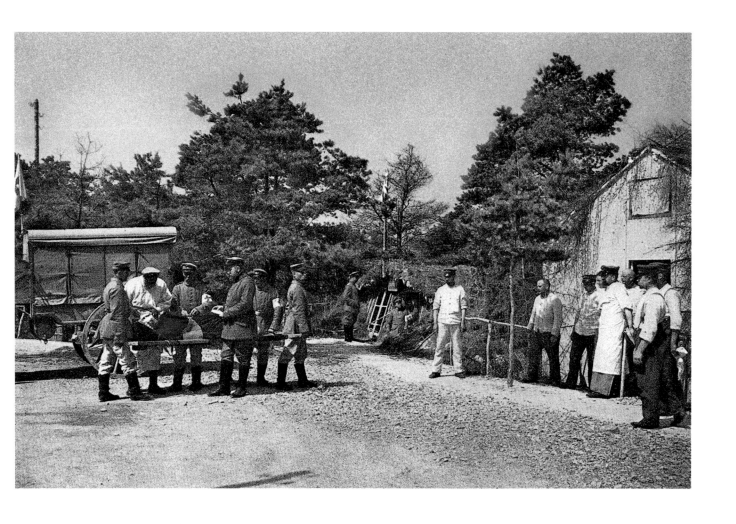

1917 Agony and Death

LEFT
Castle in Moreuil used as a hospital by the French army, ca. 9 miles (15 kilometres) southeast of Amiens, in summer 1916.
Photo: Stéphane Passet

Agony and Death 1917

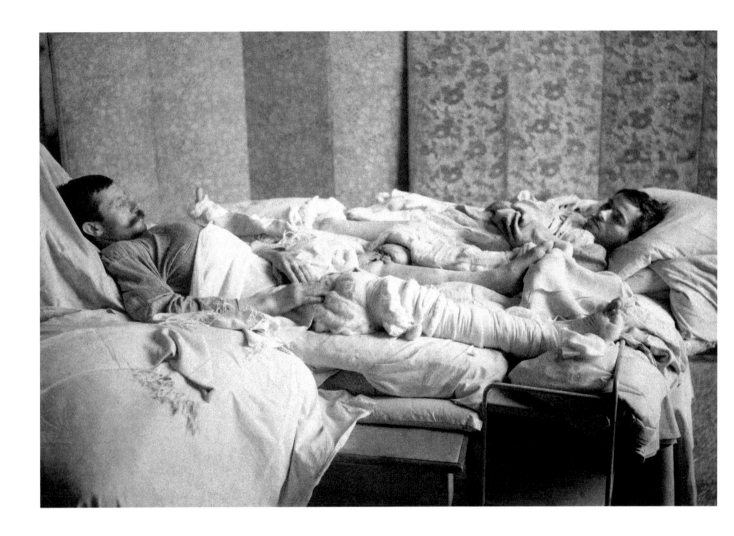

ABOVE
Two soldiers eight days after a bone trans-
plantation by Dr. Laurent in the Grand Palais
Hospital in Paris. 8 February 1917.
Photo: Paul Queste

OPPOSITE
Nurses and military doctors in front of
Hospital 66 in Bourbourg (near Dunkirk),
1 September 1917.
Photo: Paul Castelnau

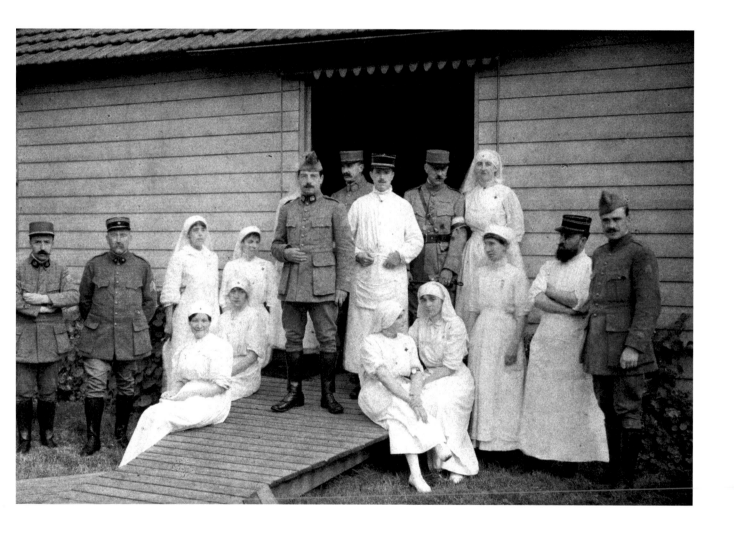

The sight of the wounded and dead,
this whole death pit of war is dreadful.
HENRI BARBUSSE TO HIS WIFE, 20 JUNE 1915

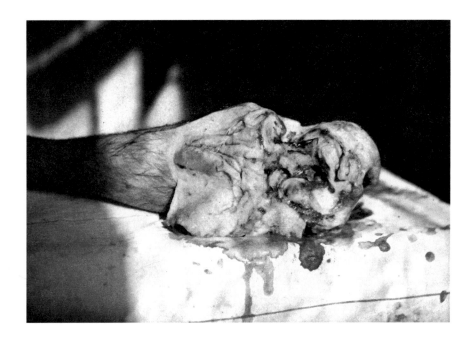

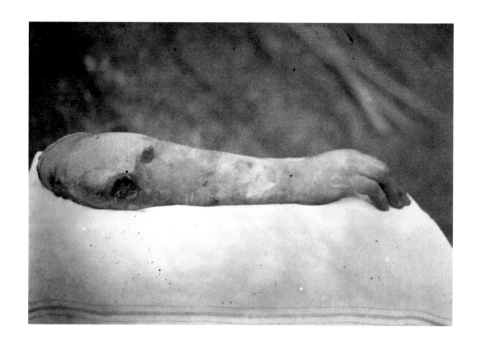

OPPOSITE
Amputated leg with knee joint, 1915.

ABOVE
Amputated arm. Medical photograph, 1915.
Photos: Émile Chautemps

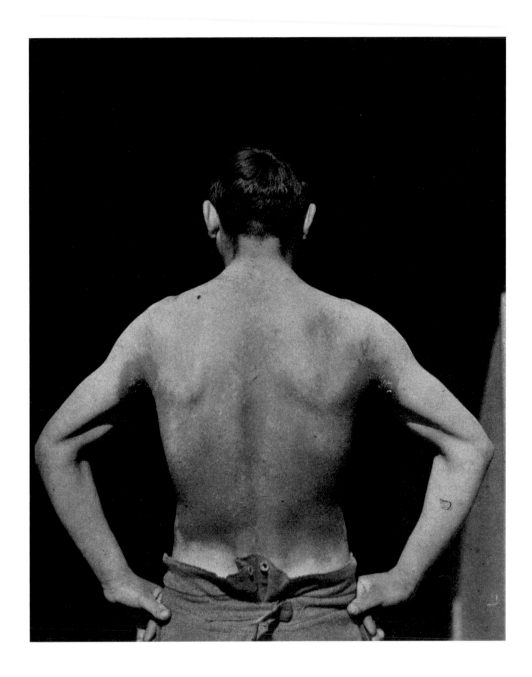

ABOVE
A soldier of the French 99th Infantry
Regiment with skin irritation of the back
and shoulders. Medical photograph,
23 March 1918.

OPPOSITE
A soldier of the French 99th Infantry
Regiment with blisters and redness on the
elbows. Medical photograph, 7 April 1918.
Photos: Aubert

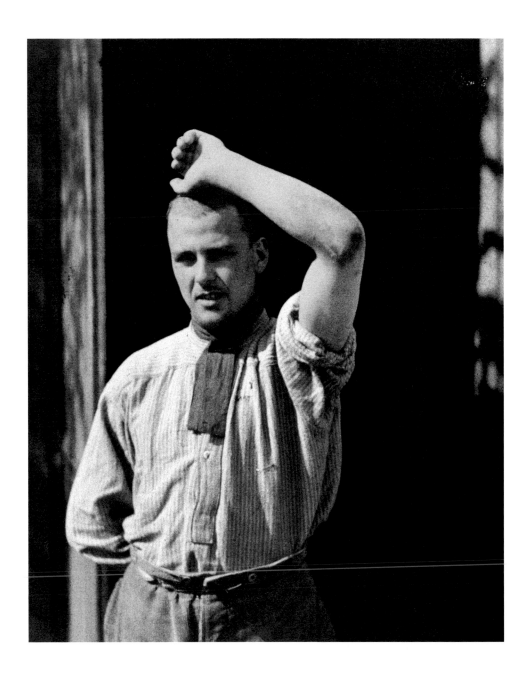

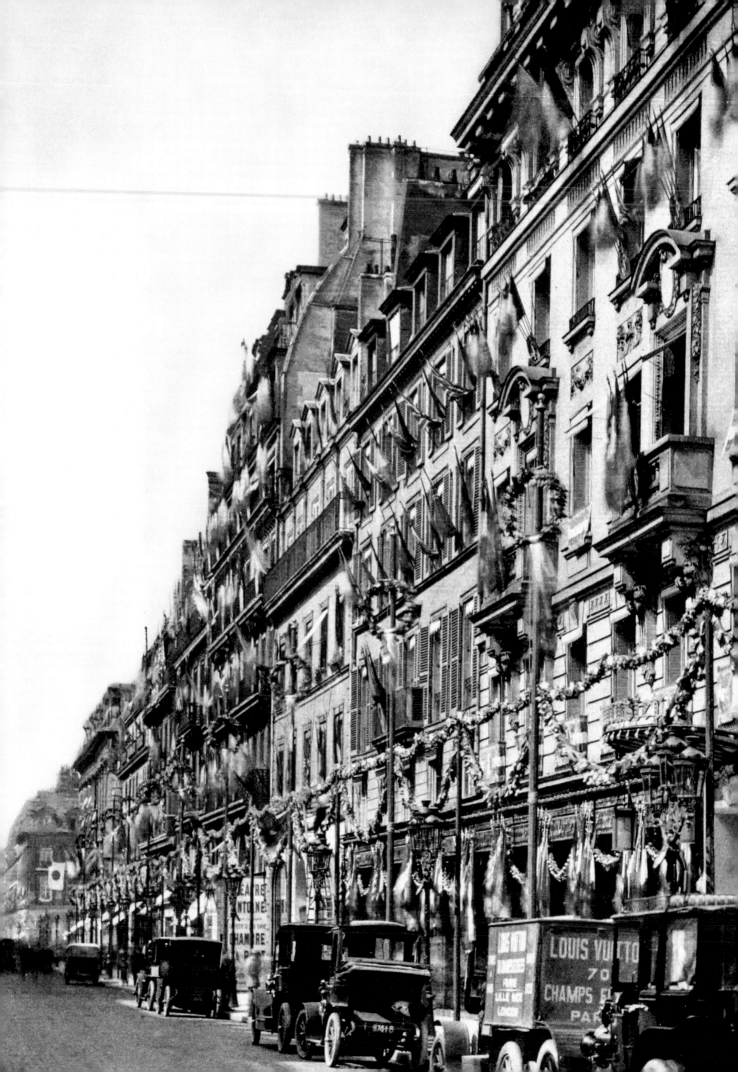

1918 – Peace without Permanence

In January 1918 U.S. President Wilson announced his 14-point programme in which he insisted upon the right of self-determination as core to the postwar order in Europe. Germany and Russia signed the Brest-Litovsk peace treaty in March which in content and style was more a peace dictated by Germany. In March on the Western Front the Germans tried to force a decision with the major offensive in Picardy, before the balance of power shifted in favour of the Entente again through the arrival of the Americans. This offensive was unusually successful, likewise the two further advances in Ypres and at Chemin des Dames.

In the counter-offensive of the Allies in July, following the arrival of the overwhelming superiority of the Americans, what remained for the exhausted Germans, however, was only a retreat to their old positions. The Battle of Amiens marked the real end of the war. The Germans could no longer offer resistance to the over 500 tanks and more than 1,000 war planes. General Erich Ludendorff, head of the supreme command, admitted the hopelessness of the military situation and at the end of September called for the German government to negotiate a ceasefire.

On 11 November 1918, the German delegation signed the armistice in a railway carriage in the forest near Compiègne, which amounted to an unconditional surrender. A few hours later came an end to the fighting, which had claimed nearly 10 million victims in four years and caused untold suffering.

The people of the victorious nations celebrated the end of the massive killings and the liberation from the burdens of war. Vast tracts of land were left behind in Belgium and France that had been devastated in four years. In the defeated countries the war ended in chaos, revolution, and the downfall of monarchies. In Europe a whole generation was traumatised and brutalised by the experiences of the war.

As a result of the First World War the United States rose to world power, while Europe lost its position of economic, political, and cultural hegemony. The Treaty of Versailles followed in large part the old logic of European power politics. Nationalism and political agitation had poisoned the atmosphere. The fragmentation of German territory and the attribution of sole liability for the war by the Allies encouraged political radicalisation in Germany. The First World War created the basic political constellations that remained influential in the 20th century, which only lost validity with the collapse of Communism in 1989.

OPPOSITE
The Rue de la Paix in Paris decorated
in celebration of victory, 13 July 1919.
Photo: Auguste Léon

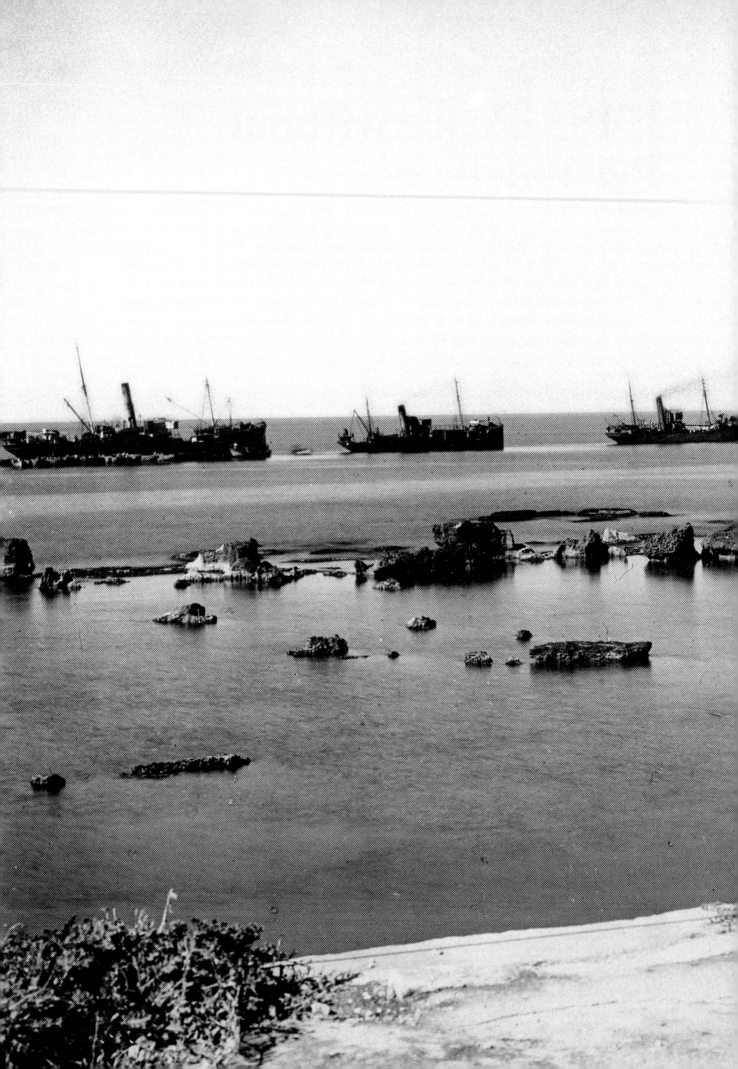

In Palestine

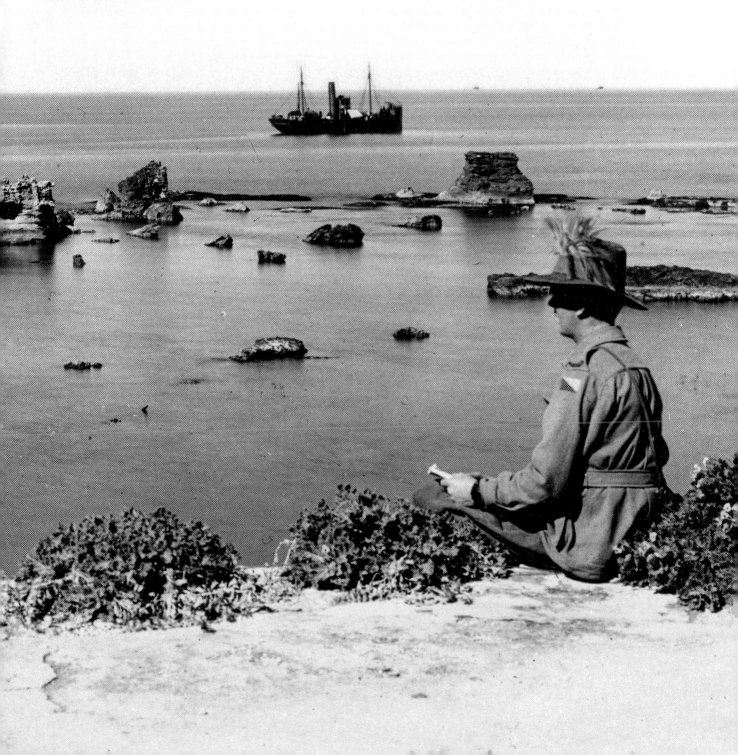

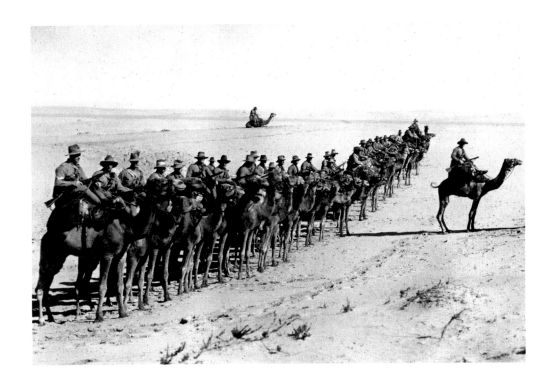

PAGE 342/343
Coast in Palestine, February 1918.

ABOVE
*Australian camel corps, Rafah, Palestine,
12 February 1918. In February 1918 Frank
Hurley visited the Imperial Camel Corps
in Palestine. Hurley wrote in his memoirs
how on this occasion, presumably for the
photographers, the Battle of Rafah from 1917
was re-enacted.*

OPPOSITE
*Camel ambulance of the Imperial Camel
Corps, Rafah, Palestine, 12 February 1918.
All photos from page 342/343 to page
348/349: Frank Hurley*

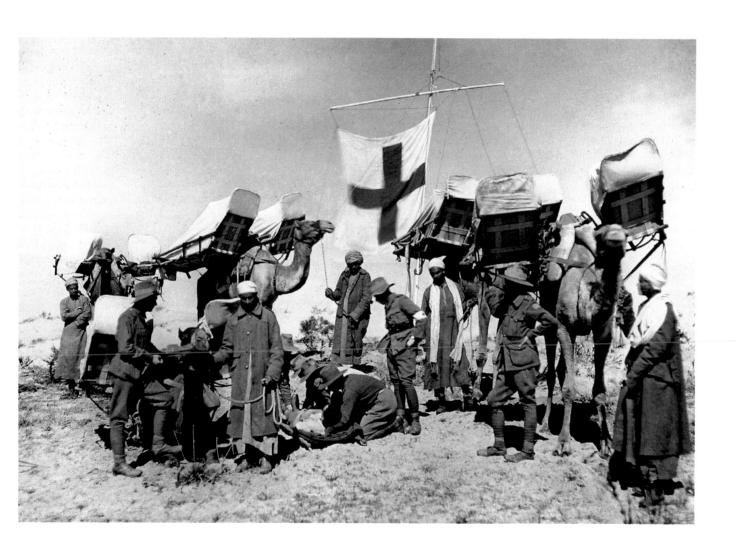

In Palestine 1918

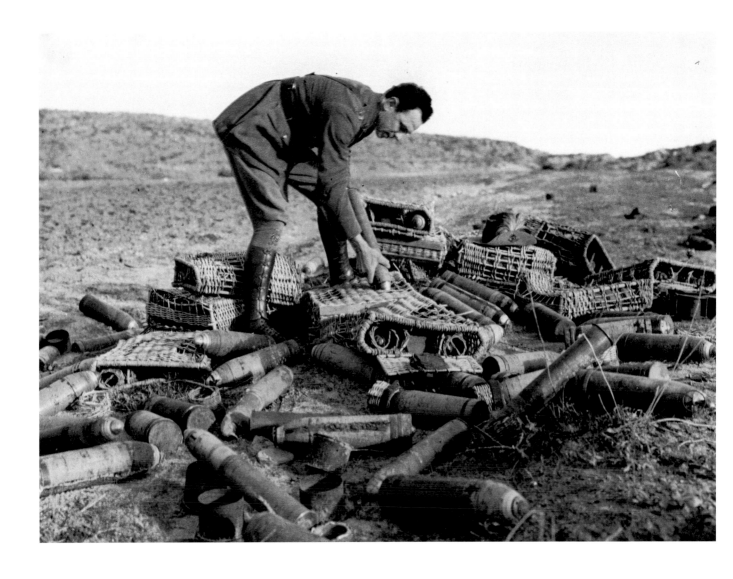

1918 In Palestine

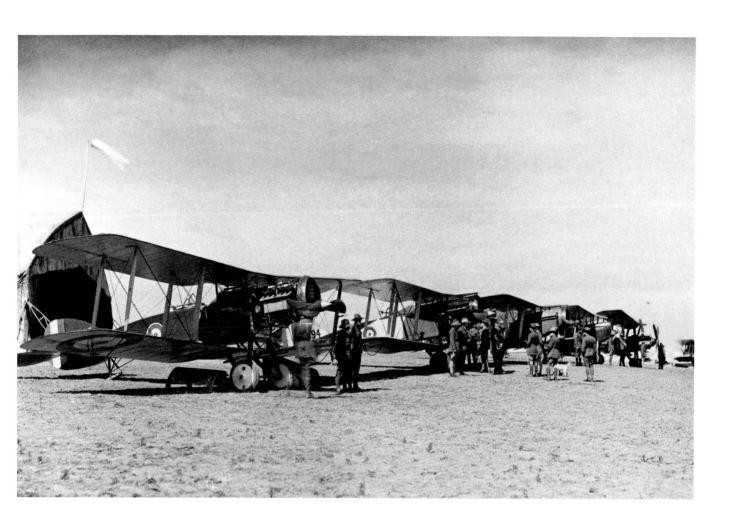

RIGHT
An Australian lighthorseman (member of the light cavalry) picks anemones, Palestine, 1918. In January 1915 the Ottoman Empire opened a secondary theatre of war as it attacked the Suez Canal. The British were able to stop the advance and gradually captured back the Sinai Peninsula. Rafah was taken in February 1917 by the British.

1918 In Palestine

In Palestine 1918

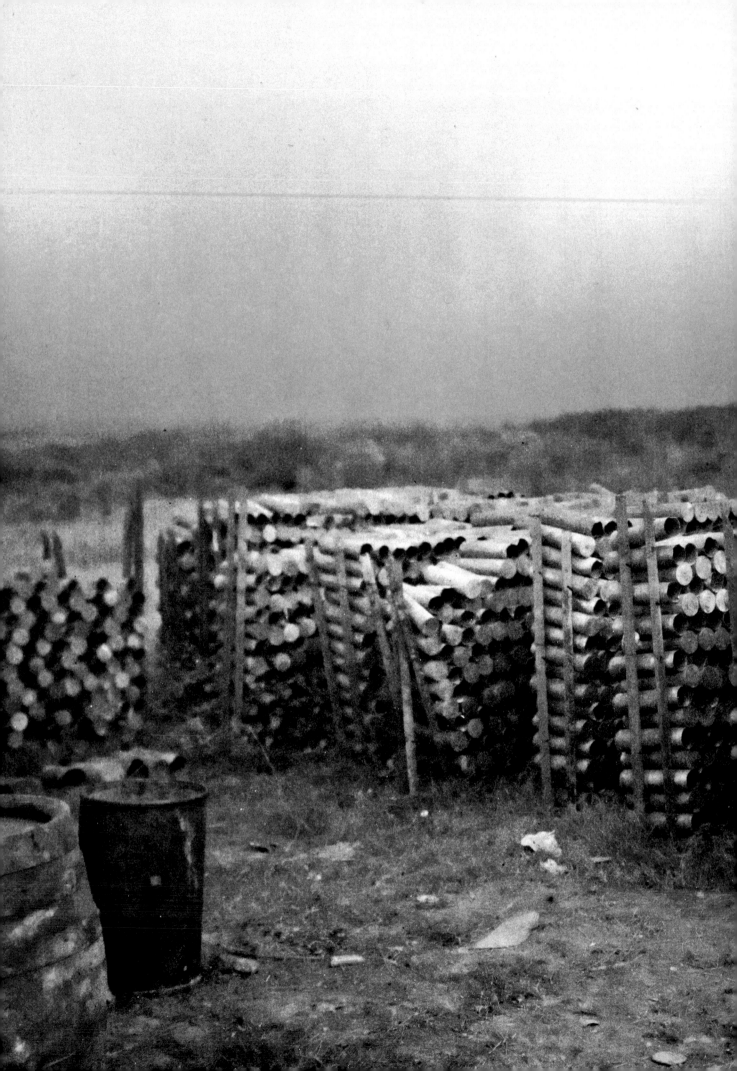

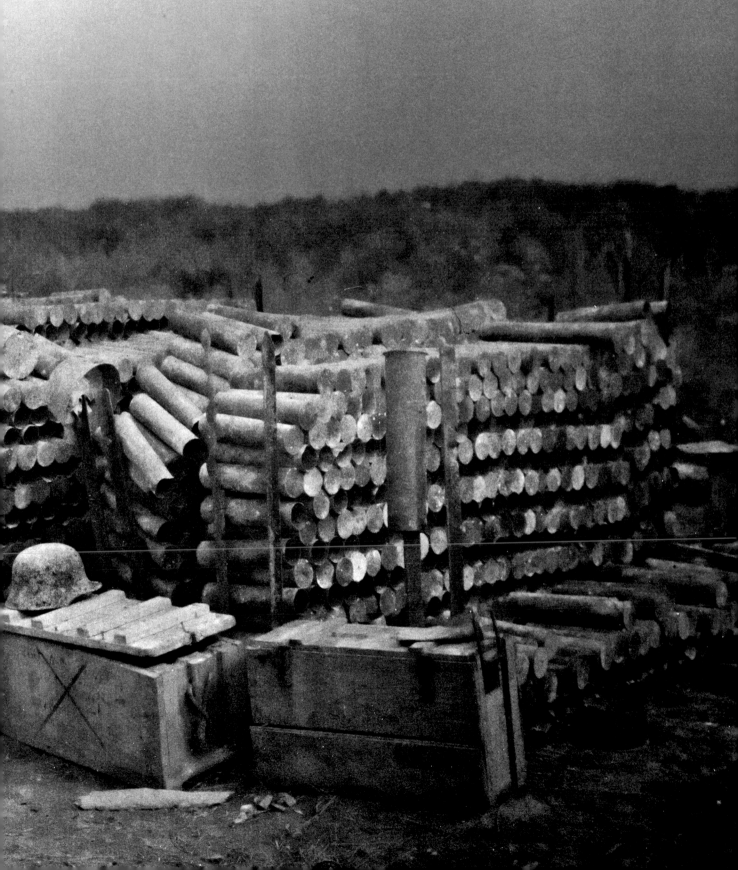

The Last Summer
of War

PAGE 350/351

*Ammunition depot in France, 1918. The photo
was taken on assignment of the American
Committee for Devastated France (1917–24).
Founded by Anne Morgan (1873–1952), a
daughter of financier J. P. Morgan, this
committee tried to assuage the suffering of
French war refugees. The photographs were
used to illustrate the situation to Americans
and in soliciting donations.*
Photo: Shells-Lafaux

ABOVE

*Patriotic window decoration in New York,
1918.*

OPPOSITE

*Liberty Bond Rally, New York City, 1918.
In the First World War the U.S. government
issued four war bonds to finance the military
engagement, with the third advertising offen-
sive being issued in April 1918. The Auto-
chrome photographs by Willis are among the
extremely rare early colour images of New
York, of which less than two dozen have been
preserved.*
Photos: John D. Willis

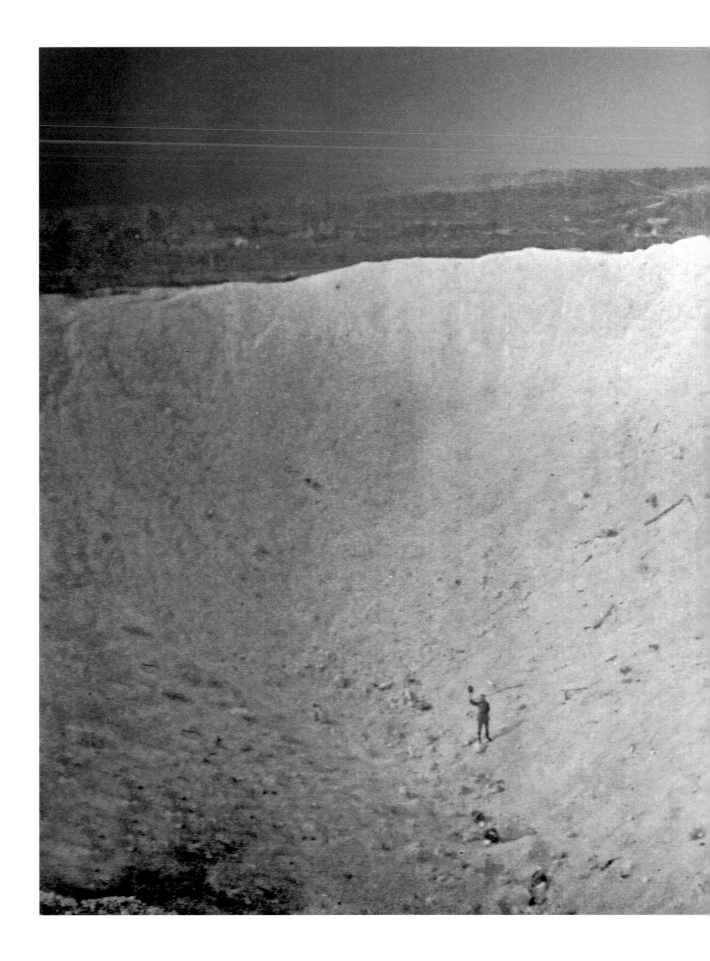

1918 The Last Summer of War

*Bomb crater, Berry-au-Bac
(near Reims), 1918.*
Photo: The American Committee
for Devastated France

We are all in the same boat: it is an era organised for death,
and those who escape it for reasons of age or infirmity can
no longer bring order to their lives nor peace to their thoughts.

FRANÇOIS MAURIAC TO JACQUES ÉMILE BLANCHE, 12 JULY 1918

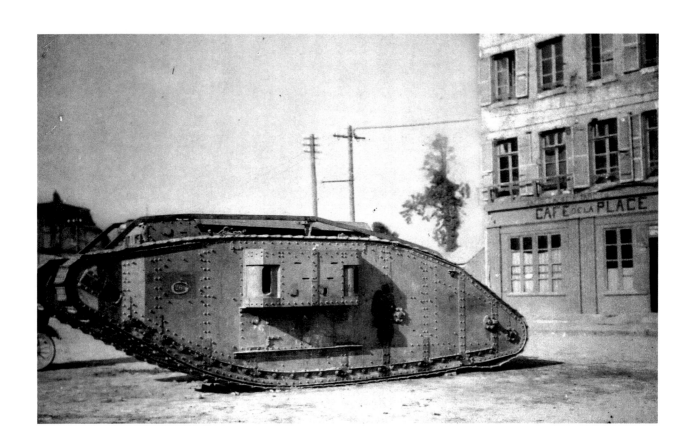

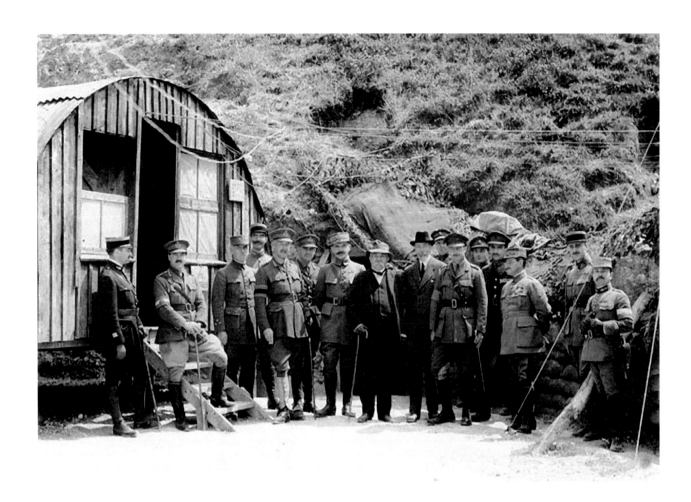

*An British tank from the Mark series in
Péronne near Amiens. Tanks were first used
in autumn 1916 by the British to break the
deadlocked fronts. Their first success was
in November 1917 in the Battle of Cambrai.
The Allies could muster up to 6,000 tanks. In
Germany the importance of the new weapon
was initially underestimated. Not until spring
1918 did the only German-made tanks, A7V,
come into use in combat. Just 20 of these
tanks were manufactured by the end of the
war.*
Photo: The American Committee for
Devastated France

*The French Prime Minister Georges
Clemenceau at the headquarters of the
4th Australian Division, Bussy-lès-Daours
(near Amiens), 7 July 1918. On 4 July,
U.S. troops and Australians under General
John Monash (2nd from left) attacked the
Germans at Hamel. A little later the German
Spring Offensive was finally stopped in the
Battle of Amiens. For his services in this battle
Monash was knighted by King George V.*
Photo: Hubert Wilkins

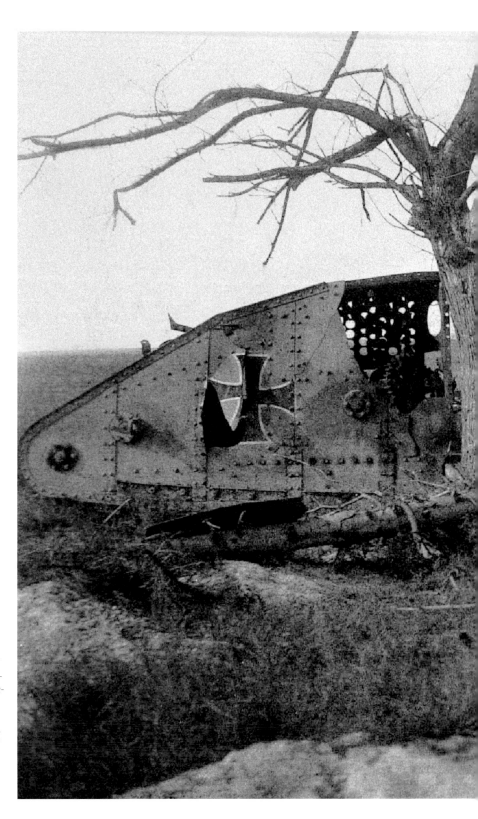

RIGHT
*The Germans captured several Mark tanks
from the British and painted them with
imperial emblems. The tanks were deployed
in the Battle of Reims in July 1918. The stan-
dard crew consisted of eight soldiers, who en-
dured interior temperatures of up to 160° F,
which occasionally caused the spontaneous
combustion of the accompanying munitions.
The tanks were outfitted with new colourful
camouflage markings, which were adopted
in the German army starting in 1918 for the
type A7V, the only German-built tanks.*
Photo: Charles Adrien

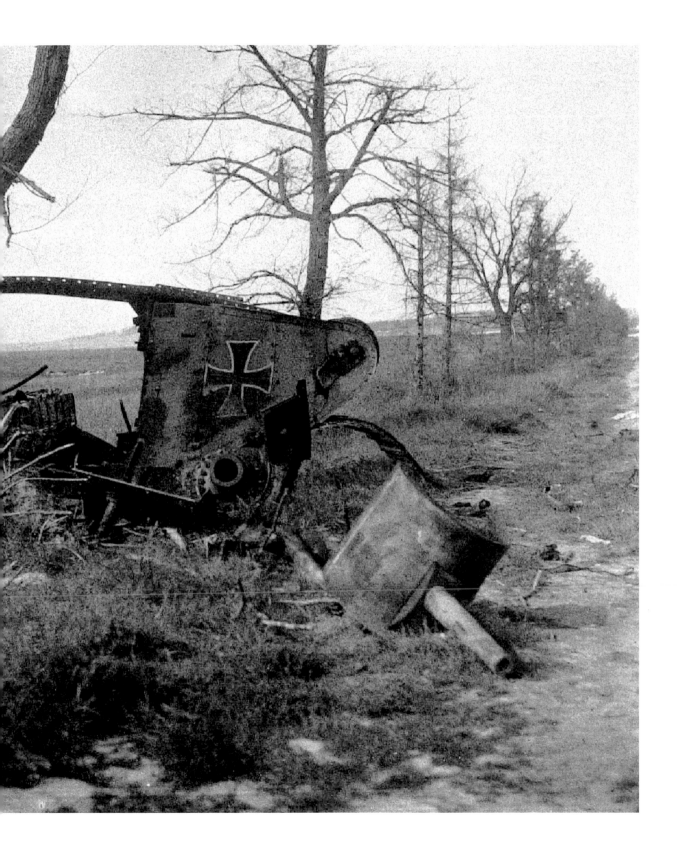

Victory
Celebrations
and Aftermath

PAGE 360/361
The victory festivities in Paris on 14 July 1919, with the illuminated Seine. This auto-chrome was taken from the roof of the Louvre.

BELOW
Seized German combat equipment on the Place de la Concorde, 17 July 1919.
Photos: Léon Gimpel

OPPOSITE, ABOVE
Casualty of war on the terrace of the Hôtel des Invalides in Paris, 1918.
Photo: Jules Gervais-Courtellemont

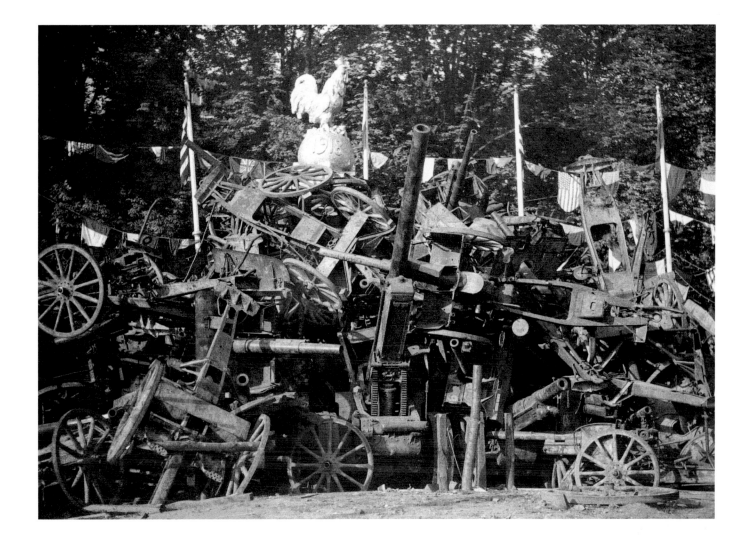

1918 Victory Celebrations and Aftermath

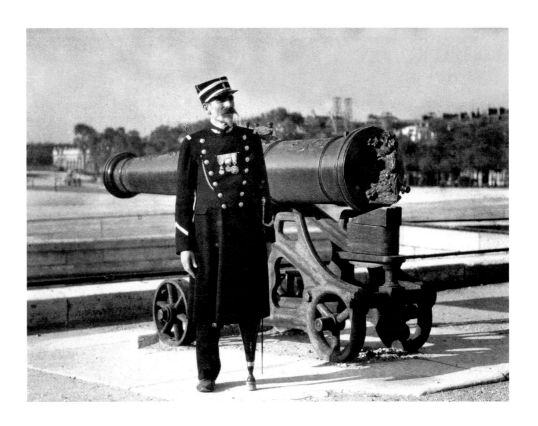

*Sometimes I think with horror that in our hearts
the victory for France that we hope for could be one
of the past over the future.*

ANDRÉ GIDE, DIARY, 1 JUNE 1918

PAGE 364/365
*The illuminated Grands Magasins du
Louvre, Paris, 30 July 1919.*
Photo: Léon Gimpel

365

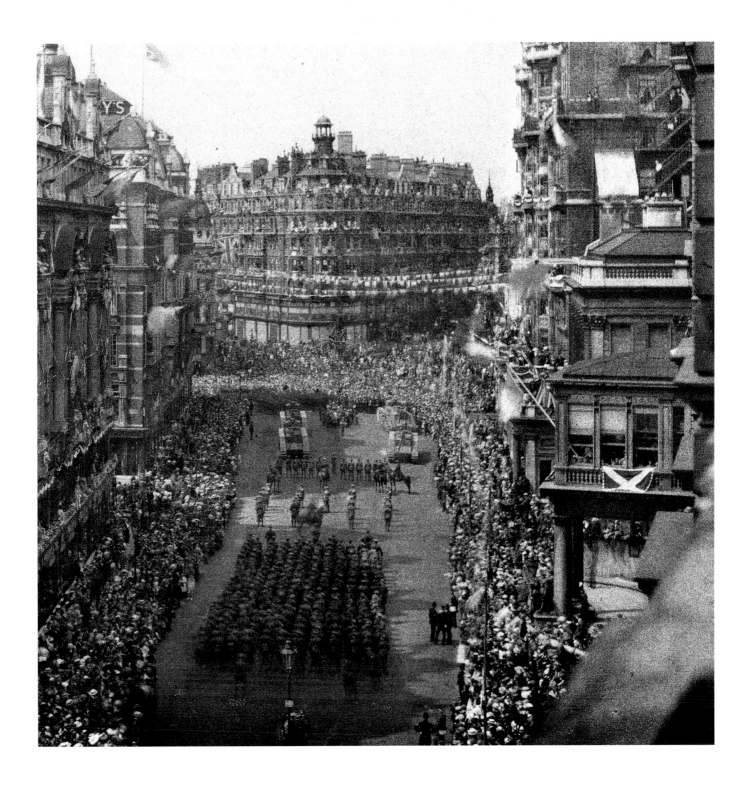

1918 Victory Celebrations and Aftermath

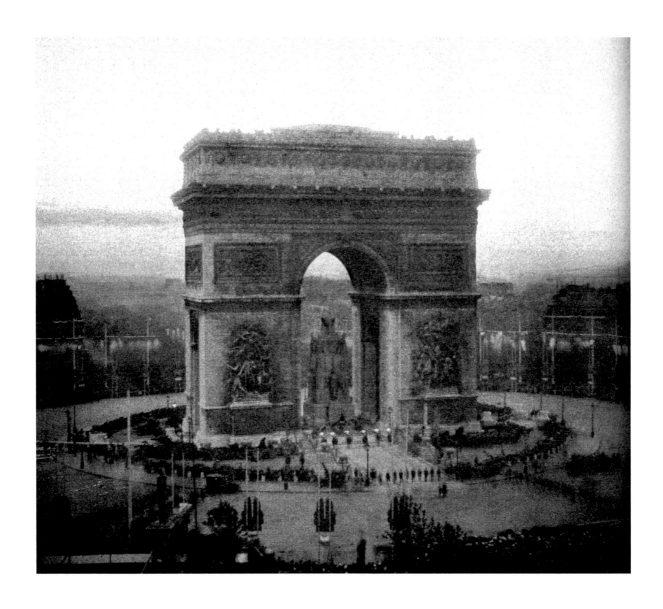

OPPOSITE
Victory parade in London with the partici-
pation of over 15,000 soldiers, 19 July 1919.
Photo: Fernand Cuville

ABOVE
Victory celebration at Arc de Triomphe,
Paris, 14 July 1919.
Photo: Léon Gimpel

ABOVE

French troops in the Rhineland, Ratingen,
11 May 1921. The region on the right bank of
the Rhine from Recklinghausen to Düsseldorf
was occupied by both Belgium and France in
accordance with the provisions of the Treaty
of Versailles.

OPPOSITE

A military band of the French cavalry rests
near Ratingen, 11 May 1921.
Photos: Frédéric Gadmer

*We all fight for the law and civilisation
and we will be victors in practice and in law.*

GUILLAUME APOLLINAIRE TO ARDENGO SOFFICI, 25 AUGUST 1915

370



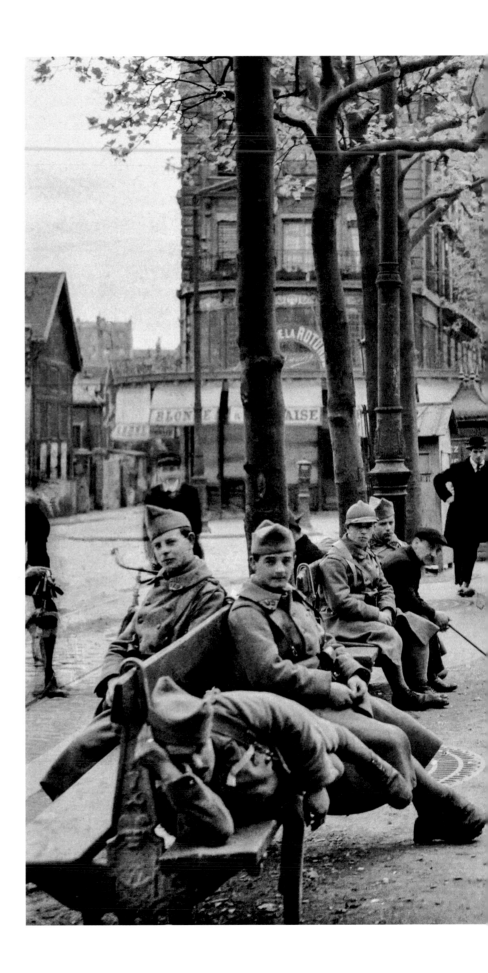

RIGHT
French soldiers in Paris in May 1920.
Photo: Frédéric Gadmer

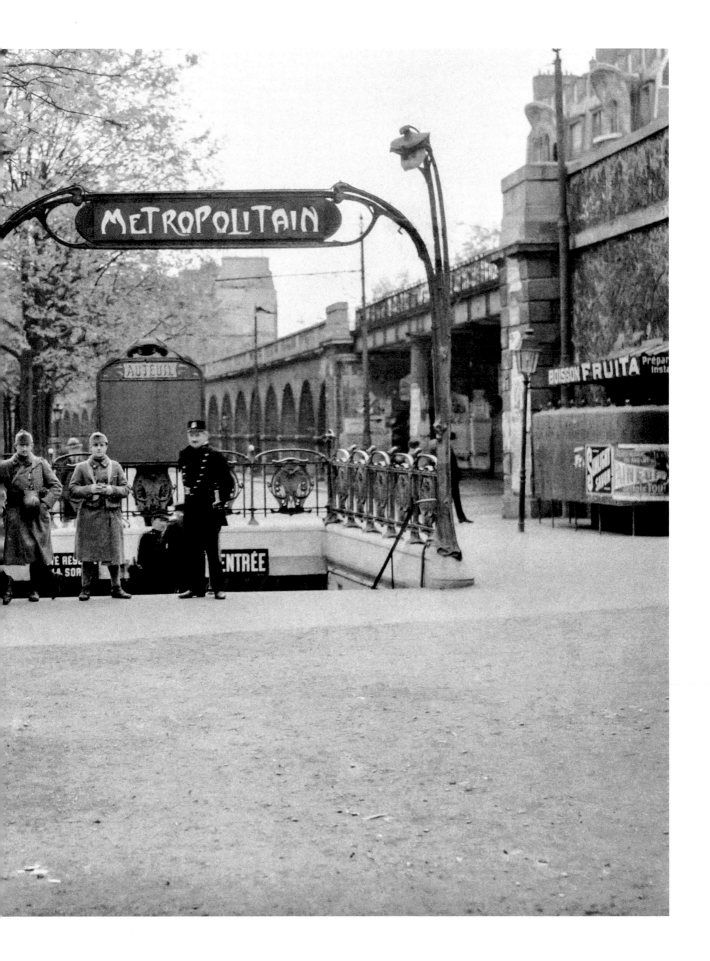

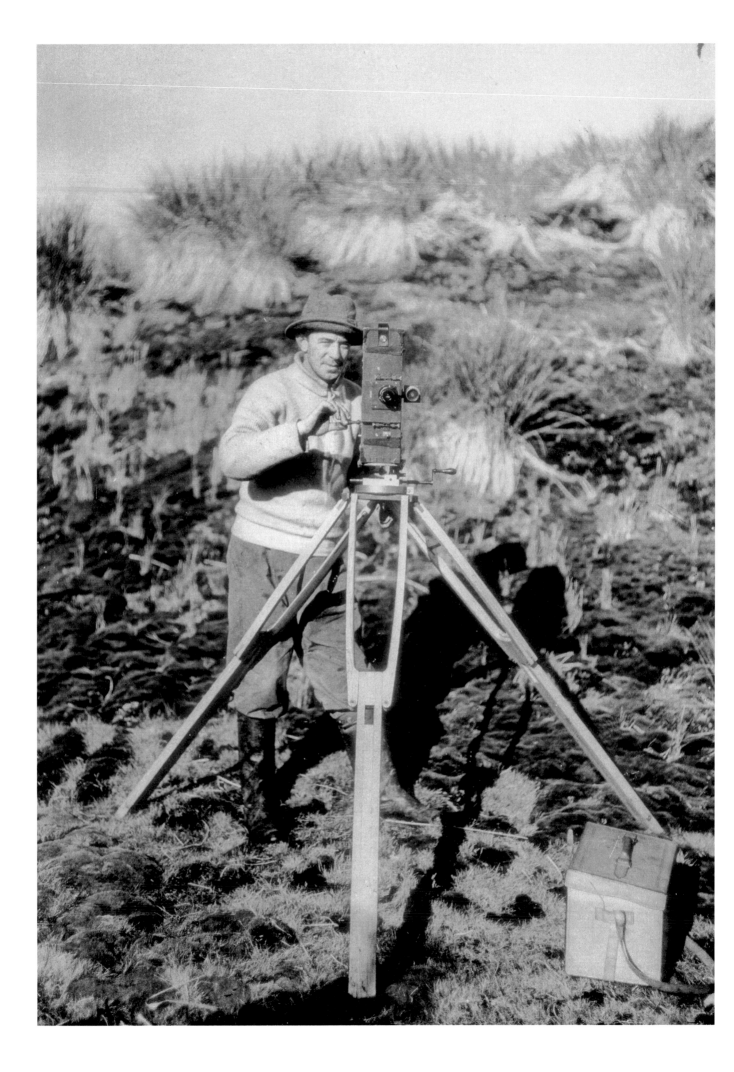

Photographer Biographies

Charles Adrien *(1866–1930)* was from 1907 an active member of the Société Française de Photographie in Paris. He mainly worked as an engineer. In addition to more than a thousand Autochromes, particularly portraits of women and landscapes, a few photos by Adrien that document the events of the First World War are preserved.

Aubert
There is no known biographical information on the photographer Aubert. Eleven Autochromes that he took of war victims in March/April 1918 in a military hospital in Morvillars near the Swiss border have been preserved.

Paul Castelnau *(1880–1944)* studied geography at the Sorbonne. At the start of the war he was initially drafted into the geographical service of the French army. In October 1916 he and Fernand Cuville transferred to the Section Photographique de l'Armée (S.P.A.). The two photographers partly co-operated in their photographic enterprises. From January to April 1917 Castelnau photographed in Reims, in June in Alsace, in the first half of July in Paris, in August/September in Flanders, in October 1917 in Verdun, and from February 1918 also in Palestine, Egypt, and Cyprus.

After the end of the war Castelnau documented in photographs the rebuilding of Aisne and Marne until 1919. He completed a doctorate in geography in 1920, took part in various expeditions as filmmaker and geographer on assignment from Albert Kahn, and was active, at times successfully, as a documentary filmmaker in the second half of the 1920s (*Voyage à la Terre de Feu*, 1926). Around 1930 Castelnau worked as a surveyor. After France's liberation from German occupation in 1944 Castelnau was indicted as a collaborator and executed, although the accusations were never proven.

Georges Chevalier *(1882–1967)* was taught by Auguste Léon, who had worked for Kahn from 1909, and began working at the Archives de la Planète in 1913. He photographed not only in Paris and the war-torn regions of France, but also in various other countries. Photographs of many well-known guests that Kahn visited in the interwar period were taken by Chevalier. After Kahn's financial ruin Chevalier voluntarily watched over the collection of Autochromes and films for two years. After the Département de la Seine became the new owner of the collection Chevalier was appointed as official administrator. He continued with his own photographic work and organised presentations of Autochrome plates during the Second World War. At the end of 1949 he retired from his work, and in 1967 he died in Boulogne-Billancourt.

Fernand Cuville *(1887–1927)* grew up in the Bordeaux region. Educated as a musician, he served in auxiliary services in a military hospital at the beginning of the war for health reasons. When it came to finding suitable colleagues for Autochrome photography in the S.P.A., personnel were recruited from this sector.

Cuville, like Castelnau, joined the S.P.A. in early 1917. Both were trained as photographers by Auguste Léon. During the war Cuville often photographed in collaboration with Castelnau, mostly in the region of Reims and Soissons. In 1918 he undertook an expedition to Mount Athos.

After Cuville was discharged from the army at the end of July 1919, he continued to work for the Archives de la Planète. He shot photographs, partly with Georges Chevalier among others, in Versailles, Paris, and England, and documented the rebuilding in the Marne, Meuse, Aisne, and the Upper Rhine. From 1919 to 1920 he photographed exclusively in the southwest regions of France.

As Albert Kahn ran into financial difficulties in 1931, Cuville was forced to look for other work.

Cuville was married to the pianist Marie-Antoinette Elesco with whom he had two children.

Frédéric Gadmer *(1878–1954)* came from a Protestant family that emigrated from Switzerland to France. Before the First World War he worked as a photographer in Paris, completing his military service in 1898. With the mobilisation in summer 1914 he was drafted into the French army. In the next year Gadmer was able to transfer to the newly created photographic department of the army. He took photographs at the front in the Dardanelles and in Cameroon.

In 1919 Gadmer was hired as a photographer for the Archives de la Planète. Here he was reunited with Paul Castelnau and Fernand Cuville, his colleagues from the S.P.A. He travelled to Syria, Lebanon, Turkey, and Palestine. Gadmer took the first colour portrait of Mustafa Kemal Atatürk.

Other photographic expeditions led Gadmer to Iraq, Persia, Afghanistan, Algeria, and Tunisia. In Germany he took photographs in the French-occupied Rhineland, where he captured on film the political turmoil of the postwar period. With the photos of the burial of Aristide Briand on 12 March 1932, Gadmer ended his work with the Archives de la Planète. Subsequently he worked for the journal *L'Illustration* as well as for postcard publishers. Gadmer died in 1954 in Paris.

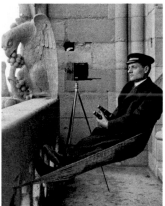

Jules Gervais-Courtellemont *(1863–1931)* was born in the Seine-et-Marne region near Paris but grew up in Algeria. Here he gained formative impressions that later drove his career interests as a photographer in countries in the Near and Far East. In 1894 he converted to Islam. Gervais-Courtellemont financed his excursions through lectures in which he presented slideshows of the photographic results of his undertakings.

Following the introduction of the Autochrome by the Lumière Brothers in 1907, Gervais-Courtellemont also used this process and counted among the first photographers whose photos found their way into the collection of the Archives de la Planète. He shot Autochromes on his trips through Turkey, Egypt, Tunisia, Spain, India, Morocco, and China. By 1911 Gervais-Courtellemont opened the Palais de l'Autochromie in Paris, which served as an exhibition hall, a meeting room with seating for 250 people, and also as a studio. He was the first photographer who, as early as September 1914, used the Autochrome process for the documentation of the war zones. From December 1914, he organised exhibitions of the colour photos in Paris, arousing a great response. Gervais-Courtellemont had the Autochromes printed in individual fascicles which could be bound in

book form. In 1915 the instalment *Les Champs de Bataille de la Marne* was published, a year later *Les Champs de Bataille de Verdun*, both illustrated with four-colour reproductions of Autochromes of the events of the war.

After the end of the war he resumed his journalistic activities. A total of more than 3,000 photos by Gervais-Courtellemont appeared in periodicals like *L'Illustration, Le Journal des Voyages, Le Journal des Débats,* and *National Geographic.*

Léon Gimpel *(1873–1948)* was born to a Jewish family in Strasbourg; they moved to Paris after Alsace was annexed by the German Reich in 1870/71. His interest in photography was kindled while he was an adolescent. He documented the World's Fair in Paris in 1900 and published, although still a teenager, numerous images in periodicals like *L'Illustration, La Vie au Grand Air,* and *La Vie Illustrée.* He was active as a photographer for *L'Illustration* until 1932.

Gimpel had become acquainted with the Lumière Brothers and their Autochrome process in 1904. At his suggestion, the introduction of the Autochrome on the occasion of its commercial launch in June 1907 took place in the offices of *L'Illustration.* He was the first photographer to introduce the new technology in a publication: four of

Gimpel's Autochrome photographs appeared in a special issue of *L'Illustration.*

He made use of Autochrome plates from the beginning, and he also contributed personally to their technical improvement, making possible an increased sensitivity of the materials. Gimpel could thus take colour photographs of lighted façades or the illuminated Eiffel Tower at night.

During the war he shot photographs mostly in Paris; but visited munitions plants and trenches on the Western Front as well. In 1920 he succeeded in capturing a lunar eclipse on Autochrome plate. Numerous aerial photographs resulted from balloon flights. In 1939 Gimpel married and settled in Béarn. He died in Sévignacq-Meyracq in 1948.

Pierre Élisée Grange *(1873–?)* studied medicine and worked as a doctor in Lyon. His passions in addition to opera and cycling included photography. As the Lumière Brothers introduced the Autochrome plate in 1907, Grange was one of the earliest enthusiasts of the process. He undertook, frequently by bicycle, photo excursions in the south of France, Italy, Switzerland, Belgium, Monaco, Germany, Austria, Britain, and Tunisia. In a period of three decades more than 3,700 photographs were created, many in colour.

In 1915 Grange was drafted into the army and served as a trainer in a Zouave regiment. Several Autochromes were created here as well. Grange was not just active as a photographer, he contributed at the same time to the development of the process, especially as regards the chemical development process of the Autochrome and their projection with arc lamps.

Hans Hildenbrand *(1870–1957)* was born in Bad Boll (Württemberg), completed an apprenticeship as a photographer in Pforzheim, worked in Geneva and Frankfurt, and founded his own studio in Stuttgart in 1896. Before the turn of the century he was awarded the title Royal Photographer of Württemberg. For his work he received a commendation at the World's Fair in St. Louis in the United States.

By 1909 Hildenbrand began to work with Autochrome materials as well. In 1911 he founded the Colour Photographic Society in Stuttgart in order to capitalise on his colour photos as postcards and so-called Chromoplast cards, colour stereoscopic photo pairs that appeared as three-dimensional images with the help of a special viewing device. During the First World War Hildenbrand was the only photographer on the side of the Central Powers who captured the events in colour. In two expeditions

PAGE 372
Frank Hurley

FROM LEFT TO RIGHT
*Jules Gervais-Courtellemont,
Léon Gimpel, Pierre Élisée
Grange, Hans Hildenbrand*

in 1915 and 1916 he was permitted by the Ministry of War to visit the war zones in Champagne and in the Vosges. The only known colour stereoscopic photos of the events of the war were created in Champagne.

In 1919 after the war Hildenbrand's Colour Photographic Society merged with a new society founded by Arthur Traube, a pioneer of research into colour photography. With Traube's Latinised surname as the brand name, the Uvachrome colour postcards became the dominant colour-photo medium in Germany until the introduction of Agfacolour in 1936.

After the First World War Hans Hildenbrand counted among the most important contributors of colour photographs for the American magazine *National Geographic*, in which more than 600 of his photographs are documented. Hildenbrand last published colour photographs in 1937 for their article "Changing Berlin," which reflected the development of Berlin under the National Socialist regime from an American perspective. The archive of the photographer was destroyed in the bombing of Stuttgart in 1944. The Autochromes from the First World War are thus preserved only in the form of contemporary picture postcards. Hans Hildenbrand died in Stuttgart in 1957, and the Photo-Hildenbrand company existed in Stuttgart until 1997.

Harry Hugh Hosley *(1884–1923)* worked as a photographer in Ulysses and Coudersport, Pennsylvania. Further biographical information has not proved possible to locate.

Frank Hurley *(1885–1962)* began his career in photography shooting images for a postcard company in Sydney in 1905. He achieved fame after taking part in a total of six Antarctic expeditions starting in 1911. Among them was the disastrous undertaking of the British explorer Ernest Shackleton, in which Hurley risked his life many times to save photographic materials.

Serving with the rank of captain, he became the first official photographer of the Australian armed forces in August 1917. Hurley documented the events of the war on the Western Front in Ypres, Belgium. The photographer was known for his fearless attitude and was called the "mad photographer."

Some of the most well-known photographs of the First World War were taken by Hurley, for example, a photo from the battlefield at Passchendaele (near Ypres). The photographer admitted to technically manipulating his photos in order to intensify the image's message through dramatic visual effects. For him the photograph as documentary evidence was of little importance, its applicability

as part of a pictorial narrative was primary. This led in the late stages of the First World War to conflicts with his employers. In early 1918 Hurley was transferred to the Ottoman front in Palestine.

In the interwar period he again took part in Antarctic expeditions and worked in New Guinea, Europe, and the United States. Hurley was also the official photographer of the Australian armed forces in the Second World War. In the years after 1945 he worked mostly in Australia and had great success with landscape photography and images of Australian daily life that were published in photo books and calendars. He died in 1962 in Sydney.

Auguste Léon *(1857–1942)* was initially active as a photographer in Bordeaux before he sold his business and moved to Paris in 1906. He was the first professional employee that Kahn hired in summer 1909.

Léon accompanied Kahn on his trips to South America and Norway; further photographic undertakings led him to numerous European countries as well as to Turkey and Egypt. Léon documented these trips not only with Autochrome photos, but with numerous black-and-white and stereoscopic photographs. Many portraits of visitors received by Kahn were taken by Léon. From 1919 to 1937 he ran a lab in Bou-

logne and lived, like Georges Chevalier, on the edge of Kahn's estate.

Pierre Machard worked from 1915 to 1918 for the photographic department of the French army and photographed not just in the French war zones, but also in Turkey and Greece. Further biographic information could not be found.

Mangold
No biographical information can be found for the photographer Mangold from Basel.

Stéphane Passet *(1875–1941)* served 15 years in the army and subsequently settled in the Paris region. In 1912 he was hired for Kahn's Les Archives de la Planète and travelled that same year to China, Mongolia, Japan, and Turkey. In 1913 Passet travelled to Morocco, followed by another stint shooting in China and Mongolia and trips to Greece and India.

During the First World War Passet served in the artillery. At the same time he shot for Kahn's project in Paris and from 1915 to 1917 in other regions of France as well. By the end of the war he left the project and produced documentary and feature films. Passet remained in contact with Jean Brunhes, the research director of the Archives de la Planète, and returned to work for Kahn again in 1929/30. He shot photographs at the Hague

Conference of August 1929, during which German reparations were renegotiated.

Sergei Prokudin-Gorskii
(1863–1944) was born on his family's estate near Kirzhach, a town outside Moscow. He studied physics and mathematics for two years in St. Petersburg, attended the military academy until 1890, and subsequently worked in the administration of a women's college. He was encouraged by his father-in-law in 1896 to become involved in photography and opened his own photo studio in St. Petersburg in 1901. He was the publisher of one of the first Russian photography magazines.

Prokudin-Gorskii received the chief motivation for his colour photography practice in Berlin, where he sat in on the lectures of Adolf Miethe in 1902. Miethe improved the practical application of the three-colour photo process which had been developed mainly by Frederic Ives. Thus even before the introduction of the Lumière Autochrome hundreds of colour photos were created and published as postcards from 1902 and also in books after 1904. Prokudin-Gorskii had a camera made in Berlin after the design of Miethe's natural-colour camera and undertook self-funded photographic excursions in Russia until 1908. With presentations of his three-colour photos and their publication as postcards he had

great success. In 1909 he had the opportunity to present his images to the czar, who pledged financial and logistical support for his project to document Russia with colour photography.

In Prokudin-Gorskii's subsequent photographic excursions, which because of the strain of the war had to be abandoned in 1915, thousands of colour photographs were taken. As he fled Russia in 1918, Prokudin-Gorskii succeeded in taking a majority of the plates with him. Attempts to establish himself as a photographer in Norway and Britain in 1918/19 fell through. From 1921 onward Prokudin-Gorskii operated a photo studio in Nice with his son; he died in 1944 near Paris. In 1948 his son sold over 2,600 originals to the Library of Congress in Washington, D.C., where they were made accessible to the public.

Paul Queste *(1877–?)* was part of the photography department of the French army and directed the black-and-white photography section. Three Autochromes of the Grand Palais hospital in Paris are preserved—they depict the same subjects as corresponding black-and-white photographs by Queste.

Albert Samama-Chikli
(1872–1934) was born in Tunis and grew up in a well-to-do family of Spanish-Jewish ancestry; his

father was a financial consultant and a successful businessman. He received his education from Jesuits in Marseille. He later undertook extended trips to South America, China, and Australia. In 1896 he returned to Tunis, took up contact with the Lumière Brothers, and organised in the following year the first film screening in Tunisia with technology and films from France.

Samama-Chikli's technical interests were broad: he was the first to use wireless telegraphy in Tunisia, he introduced the bicycle and x-ray machine there, and he made the first aerial photographs of Tunisia from a balloon in 1908. He filmed documentary films for French film societies, and took photographs in Tunisia for French magazines like *Le Matin* and *L'Illustration*.

Samama-Chikli—the suffix "Chikli" is derived from a small island off the coast of Tunis—was one of the photographers of the S.P.A. during the First World War. He filmed in the trenches of Verdun, and from 1916 to 1917 he photographed in Tunisia, Algeria, and France, where around 2,700 black-and-white photos and several hundred Autochromes resulted. After the war Samama-Chikli, who was married to an Italian musician, acquired French citizenship. He made the first feature films to be shot in Tunisia in 1922 and 1924. He died in Tunis in 1934.

Shells-Lafaux
No biographical information could be found for photographer Shells-Lafaux, who worked for the American Committee for Devastated France.

Jean-Baptiste Tournassoud
(1866–1951) grew up in an artisan family in the Burgundy region. He forged a military career and was promoted to captain in 1905. During his time in Lyon he met and befriended the Lumière Brothers. He also became acquainted with their Autochrome process. In 1915 Tournassoud was among the founding members of the S.P.A., becoming their director in October 1918.

During the war Tournassoud took over 800 Autochromes. Next to scenes of events at the front and behind the lines, there are also portraits of high-ranking military officers like Ferdinand Foch, Joseph Joffre, Philippe Pétain, Robert Nivelle, and others. A great number of his photos appeared in publications like *L'Illustration*, *Sur le Vif, Pages de Gloire* or were printed as postcards. After the war Tournassoud published 150 photographs from the war years 1914 to 1919 in a book to which Marshal Pétain contributed a foreword.

In 1920 Tournassoud left the army and settled in his hometown as a photographer. He photographed landscapes, the people in the surrounding area, animals,

FROM LEFT TO RIGHT
Sergei Prokudin-Gorskii, Albert Samama-Chikli, Jean-Baptiste Tournassoud, Alfonse Van Besten, Hubert Wilkins, Charles C. Zoller

and still lifes. Although he was long retired he remained in contact with the army and published a brochure with photos in 1929 that was used for military training purposes.

Alfonse Van Besten *(1865–1926)* was a Belgian painter who became aware of the creative possibilities of the Autochrome process very early on. During the First World War Van Besten lived in the Netherlands. Together with his friend A. Van Son he appeared before the photographic society Meer Licht in Nijmegen multiple times, where he gave reports on his work with Autochromes.

Piotr Ivanovich Vedenisov *(1866–1937)* graduated from the Moscow Conservatory in 1888 and moved to Yalta, where he worked as a pianist. His interest was not just in music, but also regional history, meteorology, and photography. Vedenisov founded the first ensemble in Yalta with students from Alexander grammar school; the practice sessions took place at his home. He also founded the philosophy-theology society of Yalta and maintained contact with famous contemporaries like Maxim Gorky, Anton Chekhov, Alexander Glazunov, and Feodor Chaliapin. From 1909 onward Vedenisov photographed with Autochromes—about 150 of his

photographs taken up to 1914 have survived to this day.

Hubert Wilkins *(1888–1958)* was born in Mount Bryan East in South Australia, the thirteenth child of a farming family. He took up studies in engineering and developed an interest in film and photography early on. In 1908 he went to England and worked there as a newspaper-, film-, and photo-journalist. He was a correspondent in the Bulgarian-Turkish war in 1912 and took part in a 1913–16 Canadian Arctic expedition. He learned of the outbreak of the world war only after his return.

Back in Australia, Wilkins was drafted as a lieutenant with the air force in May 1917 and came to Europe. In April 1918 he became the official photographer of the Australian armed forces, where Wilkins's duty consisted of objectively documenting the events of the war, in contrast to the propaganda work of Frank Hurley. A selection of Wilkins's war photographs were already published in 1918 by the Australian Imperial Force.

After the end of the war he participated in an air race from Britain to Australia, however, he had to quit because of engine trouble. Wilkins took part in an Antarctic expedition, photographed in 1922/23 the effects of the famine due to collectivisation in the Soviet Union, and explored the tropical regions

of Australia on assignment from the British Museum. In April 1928 he succeeded in flying across the Arctic from Alaska over the Polar Sea to Spitsbergen. He was given a knighthood, one of many honours he received.

In 1931 he attempted to reach the North Pole with a submarine. He undertook four more Antarctic expeditions. At the outbreak of World War Two he offered his service to the British and Australian governments, but was turned down due to his advanced age. Wilkins later settled in the United States. He died in November 1958 in Massachusetts.

John D. Willis *(died 1928)* lived in the United States. Detailed biographical information could not be found. One Autochrome photograph by Willis taken on 4 August 1918, is in the collection of the George Eastman House in Rochester, New York.

Charles C. Zoller *(1856–1934)* was a successful furniture dealer in Rochester who was independently engaged as a passionate photographer. He was in Paris by chance in 1907 as the Autochrome process of the Lumière Brothers was introduced. He was the first amateur photographer in the United States to make Autochrome photographs.

In the following decades Zoller documented life in Rochester in

colour. He photographed with the Autochrome process on extended trips along the coasts of Florida and California as well. On one of these trips one of Zoller's most famous images was created: the first colour photograph of Charlie Chaplin (1917/18).

Author
Biographies

Guillaume Apollinaire *(1880–1918)* Apollinaire enlisted voluntarily at the outbreak of war. His enlistment was initially declined, as he was a Russian citizen. In December 1914 Apollinaire was accepted into the French army, and in April 1915 he went to the front where he was posted as a gunner, in the cavalry, and after November 1915 in the trenches. He was promoted several times. In March 1916 Apollinaire was hit by shrapnel and suffered a head wound. After a one-year convalescent leave he was employed on the censorship board of the war ministry in 1917. He died on 9 November 1918, from the epidemic Spanish flu in Paris and as a result of his war wounds. *Calligrammes*, a collection that included concrete poems that originated during the war years, was published in 1918. Publication: Guillaume Apollinaire, *Letters to Madeleine*, Chicago 2010

Henri Barbusse *(1873–1935)* The author of the novel *L'Enfer* (Hell), spurred on by the general enthusiasm for war, enlisted voluntarily at 41 years old. Barbusse fought on the front from December 1914 as a private and was later deployed as an auxiliary medic. In August 1917 he was declared unfit to serve because of health problems and was discharged from the army. In 1916 Barbusse released the novel *Under Fire: The Story of a Squad*, which was awarded the Prix Goncourt in the same year. Publication: Henri Barbusse, *Lettres de Henri Barbusse à sa femme, 1914–1917*, Paris 1937

Maurice Barrès *(1862–1923)* Novelist and politician Barrès was among the leading exponents of a nationalistic and anti-German bias, which also characterised his novel trilogy *Les bastions de l'Est*, completed in 1913. In 1914 he became the leader of the anti-Semitic and anti-parliamentary Ligue des patriotes. During the First World War from 1914 to 1918 he was active at the front as a journalist writing a multitude of anti-German, militaristic newspaper articles. Publication: Maurice Barrès, *The Undying Spirit of France*, New Haven 1917

Rudolf G. Binding *(1867–1938)* was born in Switzerland and at one time was a jockey in England and a thoroughbred horse breeder. He took part in the First World War as a cavalry captain in the German army and then as an orderly officer of a German infantry division. Publication: Rudolf G. Binding, *Dies war das Maß. Die gesammelten Kriegsdichtungen und Tagebücher*, Potsdam 1941

Rupert Brooke *(1887–1915)* Brooke, who had studied 1906–09 in Cambridge, was already a well-known poet before the start of the world war, in whom even Churchill expressed an interest. He made contact with the Stefan George Circle in Munich, and longer tours led him to Cannes and Berlin and to Canada and the United States. In 1913 he received a professorship at King's College in Cambridge. At the beginning of the war he joined the army, but never took part in action. His five sonnets from the end of 1914 (including "The Dead" and "The Soldier") established his fame during his lifetime. Brooke died during the crossing to Gallipoli as a consequence of sepsis caused by a mosquito bite. Publication: Rupert Brooke, *Letters from America*, New York 1916

Otto Dix *(1891–1961)* Dix was drafted as an alternate reservist in August 1914, trained in heavy machine guns, and was stationed from February 1915 in Bautzen. In September 1915 he enlisted for the front and was deployed as a machine gunner and platoon leader in Champagne, at the Somme, in Artois and Flanders, and in 1917 to the Eastern Front. In 1916 he received the Iron Cross 2nd Class. Many works resulted during the war, mostly in pencil, chalk, and India ink. Publication: *Otto Dix in Selbstzeugnissen und Bilddokumenten*, Hamburg 1980

André Gide *(1869–1951)* Well-known for his works *Strait is the Gate* and *Lafcadio's Adventures* (*The Vatican Cellars*) but only read and appreciated by a small elite, Gide withdrew from the journalistic and literary public at the outbreak of war. He travelled between his estate in Cuverville in Normandy and Paris, where he cared for refugees from the devastated regions as a volunteer at the aid organisation *Foyer franco-belge*. The literary journal *Nouvelle Revue Française* that he cofounded in 1908 ceased publication during the war. Publication: André Gide, *The Journals of André Gide, 1914–1927*, New York 1948

Ernst Glöckner *(1885–1934)* The accounts of Glöckner are among the few sources that give information about Stefan George's stand on the war. As the life partner of the conservative novelist Ernst Bertram from 1906, he belonged to George's inner circle. Publication: Ernst Glöckner, *Begegnung mit Stefan George. Auszüge aus Briefen und Tagebüchern 1913–1934*, Heidelberg 1972

Hermann Hesse *(1877–1962)* Hesse, a German citizen, had been living for two years in a suburb of Bern as the war broke out. He followed the beginning of war with sympathy for Germany, and at the end of August he volunteered but was deferred as unfit to serve due to severe myopia. This displacement grew in the following months to a rhetorical mobilisation. In summer 1915 Hesse was exempted from field service for his work in the Bern office of the German prisoner of war welfare organisation. He worked on setting up libraries for prisoner of war camps and was officially employed until mid-April 1919 for the German PoW welfare programme. Publication: Hermann Hesse, Romain Rolland, *Correspondence, Diary Entries, and Reflections, 1915 to 1940*, Atlantic Highlands 1978

Ernst Jünger *(1895–1998)* Jünger, who had enlisted in the Foreign Legion in 1913 and was released shortly thereafter at the instigation of his father, volunteered at the start of the war. After an accelerated high school graduation, he served on the Western Front in France and Flanders and was promoted to officer and commanded various companies. The frequently wounded officer was decorated numerous times, including the Orden Pour le Mérite, the highest German military honour, in 1918. He spent the end of the war in a military hospital. His initially self-published 1920 war diary *Storm of Steel* is to this day one of the most influential accounts of the experience at the front in the First World War. Publication: Ernst Jünger, *The Storm of Steel*, Oxford 2003

Wilhelm Klemm *(1881–1968)* Klemm was chief doctor on the Western Front 1914–1918. He became known through his expressionistic antiwar poems that were published in *Aktion* in October 1914 (including "Schlacht an der Marne" [Battle of the Marne], 1915).

Publication: Wilhelm Klemm, *Ich lag in fremder Stube*, Munich, Vienna 1981

Thomas Mann *(1875–1955)*
For Thomas Mann the outbreak of war meant the end of an existential and creative crisis. His November 1914 *Gedanken im Kriege* (Thoughts in Wartime) published right at the start of the war is among the most respected journalistic observations of a German writer. Thomas Mann suspended work on *The Magic Mountain* for the duration of the war, writing *Reflections of a Nonpolitical Man* from autumn 1915 to spring 1918. As the book was published in 1918, it stood as a rearguard action in opposition to the revolutionary mood of the time. Mann was discharged at the start of the war, and lived most of the war period in Munich.
Publication: Thomas Mann, *Letters of Thomas Mann 1889–1955*, Berkeley 1990

Franz Marc *(1880–1916)*
At the start of the First World War Marc volunteered for military service. The letters that he wrote to his wife starting in 1915 were published in 1920 and had a broad impact. Marc, a lieutenant of the reserve, was killed by shrapnel on a dispatch ride near Verdun on 4 March 1916. His body was recovered only in 1917, transferred to Kochel am See and was interred there.
Publication: Franz Marc, *Briefe, Schriften und Aufzeichnungen*, Leipzig et al. 1989

Roger Martin du Gard *(1881–1958)*
Despite his pacifist attitudes Martin du Gard was conscripted into service on 2 August 1914 and was posted as a corporal in a transport unit. After the end of the war he continued to be stationed in the occupied Rhineland until March 1919.

L'Été 1914, the seventh volume of the eight total volumes of his novel series *Les Thibault*, dealt with an exact analysis of the mood in France before the outbreak of war in 1914. One year after it was published Martin du Gard was awarded the Nobel Prize for Literature in 1937.
Publication: Roger Martin du Gard, *Summer 1914*, London 1941

François Mauriac *(1885–1970)*
Mauriac, who was associated with the Renouveau Catholique, was rejected from military service for health reasons despite his desire to serve fatherland France. He enlisted in the Red Cross as an auxiliary medic in November 1914 and was deployed to Châlons-sur-Marne in July 1915. He worked just three months in a hospital in Salonika and had to return to France in March 1917 due to a serious fever.
Publication: François Mauriac, *Nouvelles lettres d'une vie*, Paris 1989

Wilfred Owen *(1893–1918)*
Owen is one of the most important English poets to take part in the First World War. In 1911 he began studies in London and worked as a private English teacher in Bordeaux at the outbreak of war. In October 1915 he enlisted in the British army. In 1917 while on a military mission he was trapped in the rubble of a shell crater for three days. He went to Edinburgh for treatment of his war trauma, where he met the poet Siegfried Sassoon. In July 1918 Owen returned to France. He died a few days before the announcement of the armistice.
Publication: Wilfred Owen, *Collected letters*, Oxford 1967

Kurt Riezler *(1882–1955)*
Kurt Riezler was confidant and political advisor to Reich Chancellor Theobald von Bethmann

Hollweg. Riezler, later a U.S. immigrant, had his brother promise in 1955 to destroy his diaries, which however did not happen. Rather the Bavarian Academy of Sciences and Humanities published in 1972 an edition of his account preserved by the historic commission. In 1983/84 the authenticity of Riezler's August 1914 diary entries became a matter of controversy in regards to their date of origin.
Publication: Kurt Riezler, *Tagebücher, Aufsätze, Dokumente,* Göttingen 1972

Romain Rolland *(1866–1944)*
At the outbreak of war Rolland resided in Switzerland. He remained there as he was no longer obliged to serve in the military. In September 1914 Rolland engaged in the Europe-wide debate on the intellectual elite's stance on the war with an open letter to Gerhart Hauptmann and the article "Au dessus de la melée" (Above the Fray). In July 1915 he ended his ten-month-long volunteer work at the prisoner of war information centre of the international Red Cross in Geneva and moved back to Thun. Rolland was awarded the 1915 Nobel Prize for Literature. He processed the war in literary form in *Pierre et Luce* (1919) and *Clérambault* (1920).
Publication: Hermann Hesse, Romain Rolland, *Correspondence, Diary Entries, and Reflections, 1915 to 1940*, Atlantic Highlands 1978

Arthur Schnitzler *(1862–1931)*
Schnitzler was among the few authors in 1914 who were not inspired with enthusiasm for the war. In his stead, Theodor Reik spoke out on 7 September 1914 , in an insert of the newspaper *Berliner Tageblatt* ("The War by Arthur Schnitzler"), which the contemporary public interpreted as an apology for the

conspicuous silence of the poet.
Publication: Arthur Schnitzler, *Tagebuch 1913–1916*, Vienna 1983

Alan Seeger *(1888–1916)*
Seeger was born to a New York entrepreneur family, began studies at Harvard in 1906, and lived in Paris starting in 1910. He enlisted in the Foreign Legion in late August 1914 and took part in battles including the Second Battle of Champagne. After a stay in a military hospital he returned to the front in May 1916 and was killed not long after in the Battle of the Somme in the attack on a German position in Belloy-en-Santerre. His poetry was published posthumously in 1917 under the title *Poems*.
Publication: Alan Seeger, *The Diary of a Dead Officer*, London 1918

August Stramm *(1874–1915)*
Stramm was conscripted into the Baden Landwehr Infantry Regiment 110 at the beginning of the war. Until early 1915 he was stationed mostly behind the front at the upper Rhine and in Alsace. In February 1915 he received the Iron Cross 2nd Class, in April he was transferred to the Eastern Front near the city of Gorlice, in May he was promoted to battalion commander, and, after the taking of Russian positions near Gródek, was decorated once again. In September 1915 Stramm was killed in an attack on Russian positions at Dnieper–Bug Canal by a shot to the head.
Publication: August Stramm, *Briefe an Nell und Herwarth Walden*, Berlin 1988

Edward Thomas *(1878–1917)*
Thomas had already emerged as a literary critic during his history studies at Lincoln College in Oxford. Encouraged by his poet friend Robert Frost, he began to write his own poems at the end of

1914. In July 1915 Thomas enlisted as a volunteer in the army. He was assigned to an artillery unit that was transferred to France in April 1917. Only a few days after arrival in Arras he was killed on Easter Monday 1917 by a blast wave that was triggered by the firing of his own unit's cannon.
Publication: Edward Thomas, *Selected Letters*, Oxford 1996

Kurt Tucholsky *(1890–1935)*
Tucholsky was conscripted in the army in 1915 after finishing his law studies. He served as a munitions soldier and later as company writer. From November 1916 on he published the field newspaper *Der Flieger*. In 1918 he was transferred to Romania as a deputy sergeant and field police commissioner. In December 1918 Tucholsky took over as chief editor of Ulk, the satirical insert of the *Berliner Tageblatt*.
Publication: Kurt Tucholsky, *Gesammelte Werke, Ausgewählte Briefe 1913–1935*, Hamburg 1962

Frank Wedekind *(1864–1918)*
Wedekind counted as one of the leading German dramatists at the turn of the 20th century. Despite taking part in a "nationalistic evening" in September 1914 at the Munich Kammerspiele with a patriotic speech, in private he was hostile towards the war from early on.
Publication: Frank Wedekind, *Gesammelte Briefe*, Vol. 2, Munich, Georg Müller Verlag 1924

Paul Zech *(1881–1946)*
Zech was drafted in March 1915 and served as an infantryman in Russia and France. In 1916 he took part in the Battles of Verdun and the Somme; he was badly wounded in the same year, yet remained in service. An initial readiness for war was followed by disillusionment influenced by personal experience.

Zech made the horror of the front a theme of numerous works of poetry and prose.
Publication: Stefan Zweig, *Paul Zech. Briefe 1910–1942*, Rudolstadt 1984

Stefan Zweig *(1881–1942)*
At the start of war Stefan Zweig volunteered at the ministry of the interior in Vienna to be an unpaid editor of strategic proclamations and other announcements for the duration. After this offer was declined he succeeding in earning entry in the "literary group" of the war archive in December 1914. Later a pacifist, he gained a critical distance from the events of the war around 1916. In 1917 Zweig was given military furlough, and later ultimately relieved from service.
Publication: Stefan Zweig, *Briefe 1914–1919*, Frankfurt am Main 1998

Further Reading
Photo Credits

Louis Walton Sipley, *A Half Century of Color*, New York: 1951

Brian Coe, *Colour Photography: The First Hundred Years*, 1840–1940, London: 1978

Roger Bellone & Luc Fellot, *Histoire mondiale de la photographie en couleures*, Paris: 1981

Gert Koshofer, *Farbfotografie*. Vol. 1: *Alte Verfahren*, Vol. 2: *Moderne Verfahren*, Vol. 3: *Lexikon der Verfahren, Geräte und Materialien*, Munich: 1981

Farbe im Foto. Die Geschichte der Farbphotographie von 1861 bis 1981, exh. cat., Josef-Haubrich-Kunsthalle, Cologne: 1981

Jane Carmichael, *First World War Photographers*, London: 1989

Jack H. Coote, *The Illustrated History of Colour Photography*, London: 1993

John Wood & Merry A. Foresta, *The Art of the Autochrome: The Birth of Color Photography*, Iowa City: 1993

Rainer Rother, *Die letzten Tage der Menschheit. Bilder des Ersten Weltkrieges*, Berlin: 1994

Captured in Colour: Rare Photographs from the First World War, Canberra: 2004

Couleurs de guerre, Autochromes 1914–1918. Reims & La Marne: 2006

Anton Holzer, *Die andere Front. Fotografie und Propaganda im Ersten Weltkrieg*, Darmstadt: 2007

David Okuefuna, *The Dawn of the Color Photograph: Albert Kahn's Archives of the Planet*, Princeton, Oxford: 2008

Pamela Roberts, *A Century of Colour Photography*, London: 2008

L'autochrome Lumière: Secrets d'atelier et défis industriels, Paris: 2009

1914 – Welt in Farbe. Farbfotografie vor dem Krieg, cat. LVR-Landes-Museum Bonn, Ostfildern: 2013

Adrien, Charles/© Galerie Bilderwelt/Bridgeman Images *359*

© Association Les Amis de Pierre Élisée Grange, Vernaison *68, 69, 374*

© bpk | Archiv Walther | Hans Hildenbrand *86, 88, 100, 154, 161, 164*

© Courtesy of Multimedia Art Museum Moscow *14*

© ECPAD/France/Castelnau, Pierre, Joseph, Paul *76, 79, 189, 192, 196*

© ECPAD/France/Cuville, Fernand *191, 209*

© ECPAD/France/Machard, Pierre *172*

© ECPAD/France/Queste, Paul *334*

© ECPAD/France/Samama-Chikli, Albert *77, 175, 314*

© ECPAD/France/Tournassoud, Jean-Baptiste *58, 60, 61, 63, 64, 66, 67, 72, 73, 74, 78, 129, 170, 174, 176, 179, 180, 181, 182, 183, 186, 187, 188, 193, 195, 376*

© Galerie Bilderwelt/Bridgeman Images *107, 368*

© Courtesy of George Eastman House, International Museum of Photography and Film, Rochester, NY *316, 318, 319, 320, 321, 322, 323, 324, 325, 377*

Jules Gervais-Courtellemont, *Les Champs de bataille de la Marne*, Paris, 1915 *28, 29, 30, 33, 34, 35, 37, 39, 44, 45, 46, 47, 48, 49, 52, 102, 329*

Jules Gervais-Courtellemont, *Les Champs de bataille de Verdun*, Paris, 1916 *105, 134, 138, 140, 144, 149, 150*

© Jules Gervais-Courtellemont/Cinémathèque Robert-Lynen/Roger-Viollet *18, 26, 31, 32, 32, 34, 36, 38, 40, 42, 51, 136, 142, 145, 147, 148, 363*

Hurley, Frank/© Galerie Bilderwelt/Bridgeman Images *344, 345, 349, 357*

© Imperial War Museum, London (Col. 40) *17*

© Photograph by Frederick E. Ives, Gift of Eugene Ostroff, Division of Culture and the Arts, National Museum of American History, Smithsonian Institution, Washington, D.C. *7*

© Collection Mark Jacobs *9, 336, 337, 350, 352, 353, 354, 356*

© Library of Congress, Prints & Photographs Division, Prokudin-Gorskii Collection, Washington, D.C. *82, 376*

© Library of Congress, Prints & Photographs Division, Washington, D.C. *377*

© LVR-LandesMuseum Bonn *56, 84, 87, 89, 91, 92, 93, 94, 97, 98, 99, 104, 106, 124, 155, 156, 159, 163, 166, 167, 331*

© Ministère de la Culture – Médiathèque du Patrimoine, Dist. RMN-Grand Palais/Aubert (opérateur armée) *328, 338, 339*

© Ministère de la Culture – Médiathèque du Patrimoine, Dist. RMN-Grand Palais/Paul Castelnau *2, 108, 184, 190, 197, 202, 203, 205, 206, 207, 208, 209, 210, 212, 215, 217, 218, 274, 277, 278, 279, 281, 282, 283, 284, 285, 286, 287, 289, 290, 291, 292, 293, 294, 295, 295, 296, 297, 299, 300, 301, 302, 303, 304, 305, 306, 308, 309, 310, 311, 326, 335*

© Ministère de la Culture – Médiathèque du Patrimoine, Dist. RMN-Grand Palais/Fernand Cuville *168, 219, 220, 224, 225, 228, 230, 233, 234, 235, 236, 238, 240, 241, 242, 249, 250, 251, 252, 253, 254, 258, 260, 261, 262, 266, 268, 270, 272, 273*

© Ministère de la Culture – Médiathèque du Patrimoine, Dist. RMN-Grand Palais/Albert Samama-Chikli *4, 126, 130, 131, 132, 133*

© Ministère de la Culture – Médiathèque du Patrimoine, Dist. RMN-Grand Palais/SAP *200, 229, 231, 239, 245, 246, 247, 255, 256, 259, 265, 271*

© Courtesy of Multimedia Art Museum Moscow *14*

© Musée Albert Kahn – Département des Hauts-de-Seine, Fernand Cuville (A 18233) *366*

© Musée Albert Kahn – Département des Hauts-de-Seine, Frédéric Gadmer (A 26840) *369*

© Musée Albert Kahn – Département des Hauts-de-Seine, Frédéric Gadmer (A 21126) *371*

© Musée Albert Kahn – Département des Hauts-de-Seine, Auguste Léon (A 18939) *340*

© Musée Albert Kahn – Département des Hauts-de-Seine, Stéphane Passet (A 7795) *332*

Prokudin-Gorskii, Sergey/© Galerie Bilderwelt/Bridgeman Images *80, 83*

© Rijksmuseum, Amsterdam *20*

© Royal Albert Memorial Museum, Exeter, Devon, UK/Bridgeman Images *369*

© Schweizerisches Nationalmuseum, Zurich *22 (LM-80514.80), 23 (LM-80514.79), 25 (LM-80514.56)*

© State Library of New South Wales, Sydney *342, 346, 347, 372*

© ullstein bild – Leone *15, 198, 199, 205, 213, 215, 222, 243, 257*

© ullstein bild – Photo 12 *11, 374*

© ullstein bild – Photo 12/Société Française de Photographie *1, 71, 110, 111, 112, 114, 115, 116, 118, 119, 120, 121, 122, 123, 360, 362, 364*

© ullstein bild – Roger-Viollet/Aubert *330*

© ullstein bild – Roger-Viollet/Fernand Cuville *204, 214, 223, 226, 232, 237, 244, 261, 264*

© ullstein bild – Roger-Viollet/Jules Gervais-Courtellemont *53, 54, 55, 137, 151*

© Collection F. Van Hoof-Williame *12, 377*

© Collection Peter Walther *8, 10, 90, 152, 157, 162, 374, 375*

© Wikimedia Commons (unknown photographer) *376*

Index

Acknowledgements
Imprint

For numerous suggestions regarding content as well as for their logistical assistance and organisational support in the realisation of this book we would especially like to thank Lothar Altringer, Bonn; Juliette Blanchot, Paris; Kevin Brownlow, London; Colin Harding, Bradford; Gert Koshofer, Bergisch Gladbach; Edward G. Lengel, Charlottesville (Virginia); Andrew Mollo, Ayen; Matthias W. Moritz, Bergisch Gladbach; Rolf Sachsse, Bonn/Saarbrücken; Franziska Scheuer, Marburg; Sonja Schillings, Berlin; Laurent Seillier, Lille; Dorothee Ulrich, Lille.
Peter Walther, Simone Philippi

To stay informed about TASCHEN and our upcoming titles, please subscribe to our free magazine at www.taschen.com/magazine, download our magazine app for iPad, follow us on Twitter and Facebook, or e-mail your questions to contact@taschen.com.

© 2014 TASCHEN GmbH
Hohenzollernring 53
D–50672 Köln
www.taschen.com

Editorial coordination:
Simone Philippi, Cologne

English translation:
Thea Miklowski, Cologne

Design:
Sense/Net Art Direction, Andy Disl, Cologne. www.sense-net.net
Birgit Eichwede, Cologne

Production coordination:
Thomas Grell, Cologne

Printed in Germany
ISBN 978–3–8365–5418–3